CREATIVES ON CREATIVITY

44 CREATIVES IN CONVERSATION WITH STEVE BROUWERS

LUSTER

WHAT IS CREATIVITY?

To me, creativity is everything; it is playing, it is breathing, it is in all of us, it is life. But the fact is that only some of us have the opportunity to make a living out of being creative.

I have the good fortune of being able to live off my creativity every day. Finding innovative ways to give brands exposure on television channels, both on air and online, is what I do. Often this entails finding the right balance between the wishes of the advertiser and the content maker, which is how I've come to perfect my skills in 'creative compromise' and 'meet-me-in-the-middle solutions'. That can be frustrating at times, because it always leaves you feeling like an idea hasn't been utilised to the fullest. Add to that a serious case of imposter syndrome, causing me to think that I'll wake up one day and people will have figured out that I have no skills, that I'm only pretending, and that the jig is up.

In recent years, I have given talks at many international innovative marketing conferences. I have spoken about creativity in all its forms: 'Fail Better' and 'Creativity, fake it till you make it' are just a few of the titles of my talks. I've shared the stage with the world's greatest creative thinkers of our time, and decided to ask them if they could spare an hour to talk to me about creativity. I also drew up a wish list of my personal heroes and contacted them via email or social media, asking them for an hour of their time. I started each interview with the same question: "What is creativity to you?"

The list of people you will find in this book is a personal list of my favourite graphic designers, illustrators, photographers, painters; all of them artists who inspire me and whom I have followed and cherished for years. Artists who will undoubtedly inspire you and challenge your thinking as well.

In the beginning, this was a one-man production, including the photography, but that turned out to leave the picture quality somewhat lacking. So, I decided to invite my best friend and photographer Joost Joossen to join me on this adventure and to take care of the portraits and behind-the-scenes images. Together we travelled by car, boat, train, underground, taxi, and plane, across different continents. Time and time again we were warmly welcomed into the artist's universe. It was crucial to me to have my conversations with the artists face to face, as I was on a personal quest, trying to find an answer to the question of how to find your place in the world as a maker and a creative.

Of course, not everyone said yes. Here is the email reply I received from Magnum photographer Martin Parr:

"There is no real creativity, in my case, so the premise of your book doesn't work for me. I just wander out and shoot lots of photos, it's that simple. It's just the whole notion of creativity that is pretentious, through my eyes! You just have to show up and do the work.
Greetings, Martin Parr."

That's also what my wife, gallery owner Sofie Van de Velde, has taught me. She is a big inspiration to me and encourages me to face things head-on. She is the 'why put off until tomorrow what you can do today'-type. And I am a procrastinator. That's why making this book has been such a gift.

Looking back on the conversations I had with the artists, I realised that everyone deals with the same fears. The fear of failing, of not being good enough, the never-ending quest for an unattainable perfection. Some of them work because they worry that if they stop, everything stops. That the creativity will fade away. They walk to clear their heads, and they often have passion projects to help them escape their daily routine. It has been so enriching to talk to so many great minds, who have challenged me—as they will soon challenge you too—with their way of thinking and questioning life and creativity. Each conversation has been a gift that I'm happy to finally share with you.

Navid Nuur even created an artwork exclusively for this book. You can discover it on pages 212 and 213.

The only artist who seemed to be free from insecurities was art director George Lois. He said: "Fuck failure, I am what I am. My work will be remembered, and I will be remembered as one of the greatest." Maybe wisdom comes with age.

George Lois also said: "The seed of all groundbreaking creative ideas is asking 'what if?'". This piece of advice led to graphic designer Paul Boudens agreeing to both be featured in the book and to design it, and to Marc Verhagen from Luster publishing it.

I'm so proud of and pleased with each of the 44 creatives who agreed to be in this book. The inspiration they provided was addictive and made me want to keep going, but budgets and deadlines can get in the way, as you know. In any case, there will always be more people whose brain I want to pick.

It is what it is,
It is time to let it go out into the world
For you to enjoy reading it
As much I enjoyed making it.

Steve

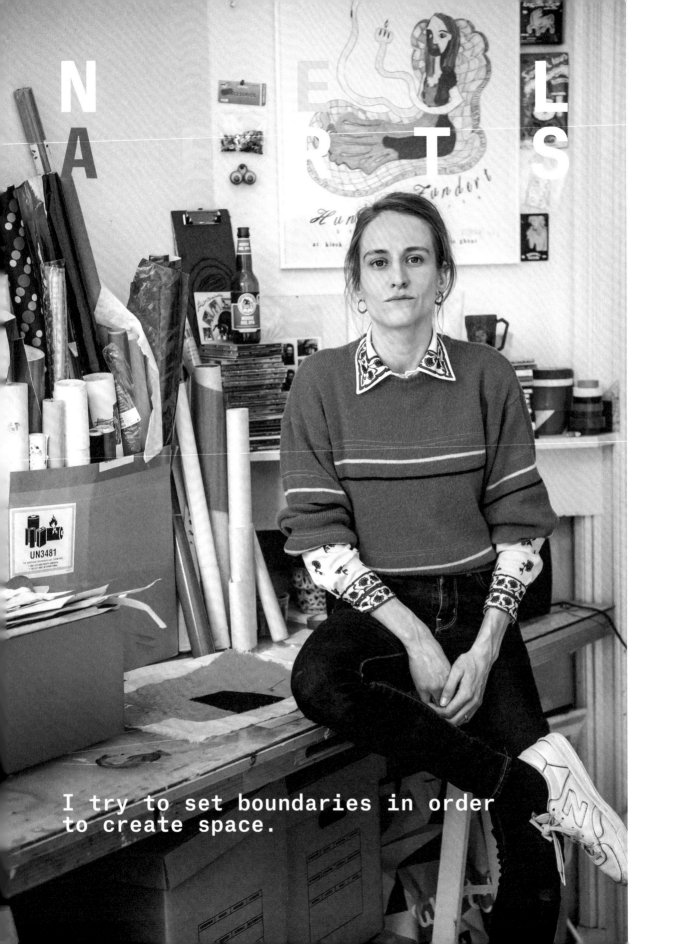

I try to set boundaries in order
to create space.

How would you introduce yourself?

The titles that I give my paintings are a good way to introduce myself, because they often act as alter egos of mine, and thus they indirectly say something about who I am. One of the first works I ever made is called *Dobbermans* and since then I've often referred to myself as 'N. Dobbermans' in my titles. They are very often in Dutch and I tend not to translate them, as they often consist of a play on words, so a translation just wouldn't work. Having viewers read the titles in Dutch, even if they don't understand them, still allows them to catch the rhythm of the sentence.

What kind of family did you grow up in?

My father was a laboratory worker and my mother was a housewife. I grew up in a small village and I had a happy childhood. We're a normal and close-knit family. I'm still very close with my brother, my sister, and my parents.

Was there room for art and culture in your childhood?

It wasn't dominant, but there was always a lot of music in our house. We used to visit a lot of exhibitions. I remember seeing a show about surrealism in Oostende, which had a big impact on me. There are a lot of creative people in my family as well, my grandfather was a painter. When I told my parents I wanted to pursue a career in the arts, they were very supportive.

Was there a specific moment when you realised you wanted to pursue art as a career?

It happened gradually. From the ages of twelve to eighteen my sister and I attended an artistic high school. It was a logical step because that's what we did at home as well: we drew a lot, we built things. But it wasn't until the final years of high school that I realised I really wanted to keep studying art. I used to draw these perverse little figures and scenes, and when I saw Tracey Emin's work for the first time and specifically the portrait *Money photo (Spider legs)*, I saw what an artist could be. That's when it became a conscious decision and I realised that being an artist is a very specific role.

And then you went to art school?

Yes, I attended the KASK (Royal Academy of Fine Arts) in Ghent. I started out in something called Combined Media, but I was making a lot of short animation-type films, so I soon transferred to Media Art. I graduated by doing performative actions that I filmed with super 8 film. After getting my degree, I gradually went into other media like painting and collages.

You still combine many art forms, is that a necessity?

I always do a lot of things at the same time, it's how I work. I can sometimes find it hard to concentrate on one thing. If I'm doing collages, something will trigger me to do something within a painting. An event or a thought can become a small drawing that will then act as a basis for an action or a film. My textile work started as a solution while building up an exhibition, and later became an important and active part of my art practice.

At first sight your world looks fun and colourful, but looking closer you can sense some melancholy, is that deliberate?

It's just what happens while making a painting. The very concrete and direct imagery came naturally as a next step after the collages. They were made out of coloured paper blocks that were very structural and almost architectural. My work can sometimes come from a very personal place so the melancholy swoops in during the work process.

What does creativity mean to you?

For me, it's seeing possibilities in everything.

What do you need to feel free to work?

It's all about a specific headspace. I was recently in Germany for a month, building up two exhibitions. I was there alone, and working solely on those shows, so I had no other obligations. A situation like that allows me to be in a constant flow, acting on every impulse.

I try to set boundaries in order to create space. At the same time, the energy of a group of people singing and screaming in a bar until the early morning can also do the trick.

What does a day in the life of Nel Aerts look like?

I usually wake up quite early. I'm a morning person. I have a coffee and read a little or watch some artist interviews on YouTube. Most days I immediately go downstairs and just start working, then I go out for lunch with my husband Vaast, come back and continue working. I like the fact that I live and work in the same house, so I can easily go from one place to the other at any time, day or night.

What inspires you?

A lot of different sources can inspire me. Coincidental colour compositions in the street, black-and-white painting books, all kinds of textile shops, thrift shops, architecture, cinema, decors, the energy of a frontman or woman, other artists, a writer like Charles Bukowski, strong characters, attitude, comedians, the shit you go through in life. The kinds of things that make it interesting to be here.

What is your work process like? Is it intuitive or do you start out with a clear concept?

My process is very intuitive. I play around in the studio and things happen. When it comes to work, I flow from one thing into another quite easily. I try not to be too strict about it. When I'm stressed or I feel pressured, it stands in the way of my creativity.

Usually I don't start with a clear concept but work gradually defines itself during the process. This can be very performative. There's a lot of play and I can jump quickly from one thing to another. My drawings can sometimes form the basis for a clearer concept. For example, some of my editions or super 8 films came from doodle drawings.

How important are titles in your work and in what part of the creative process do they come in?

I'm almost constantly writing down names or words that I see or hear or think of. I have an archive to draw from for my titles. I title my paintings while I make them or after they're finished and somehow that puts them into the world. The titles aren't defining in the sense that you won't get the work if you don't read them, but they add an extra layer or make the work final. I love playing with titles and creating references between older works and new works, like reusing a title, but adding an element to it.

The name *Dobberman* often pops up in your titles. What does it mean?

'Dobberen' means 'to float around' in Dutch, so it represents the idea of trying to figure things out. The image of the first *Dobberman* piece featured a seascape with a figure moving away into the night, giving it a sense of loneliness, of being left to your own devices. Someone who is drifting along alone and trying to figure it out. Also, I think it's a funny word.

How do you know when a painting is finished?

If you spend enough time with a painting, sometimes you just know. It's always a difficult question, and I don't always know, but it's usually when I feel the painting says enough. When something happened that I didn't foresee. A lot of times my paintings get overcooked. Then I store them and return to them a few years later, with a completely different eye and mindset. I can feel a painting is finished when it's just damaged enough. Being barely standing can make it fully stand out. Sometimes it also feels as if it has been there all along, as if nothing happened before the final layer.

Does your creativity have to be provocative?

I don't know about creativity. Art, yes please!

How important is humour in your work?

It's definitely important. I use it as a tool to put things out there that aren't always convenient or easy to approach. I believe in showing doubts and vulnerability, humour helps me with that.

How important is colour in your work and do you stick to a certain colour palette?

My use of colour is again rather intuitive. It's influenced by my surroundings and the colours in the magazines and textiles I work with. Mostly they've been very direct, but lately that has been changing. They show themself less easily. It's an ever-changing language. I play with colour until the colours themselves take over and start to communicate. My colour palette has developed into a rather personal one over the years. There are no rules to it other than a vibe and a feeling at a certain moment.

Does your work have to create a better world?

I think good art can do that, although it's not necessarily about creating a better world. Maybe it's more about touching upon the idea of how imperfect the world and human beings are and seeing the beauty in that and by doing so perhaps making it a better place. Art can do that if it wants to and if people want to see it. It's about seeing possibilities and energies. It's a gesture and a suggestion.

Is that what you want people to see in your work?

People will see whatever they want to see in your work. Sometimes they link it directly to me personally but I think mostly people will use my work to reflect upon themselves and the world we live in.

Who inspires you?

When I first started out, I was definitely inspired by Tracey Emin. During my studies Bas Jan Ader was very important, as were René Heyvaert, Jimmie Durham, Bruce Nauman's early films, and Paul McCartney.

When I started painting, I looked at a lot of different artists like Philip Guston, René Magritte, Walter Swennen, Mary Heilmann, Chris Martin, Dana Schutz, Nicole Eisenman, etc. At the moment I'm looking at the combines by Robert Rauschenberg, the collages of John Bock and Salvador Dalí. I will always be inspired by people who take risks and artists who are radical in their practice and dare to turn it around.

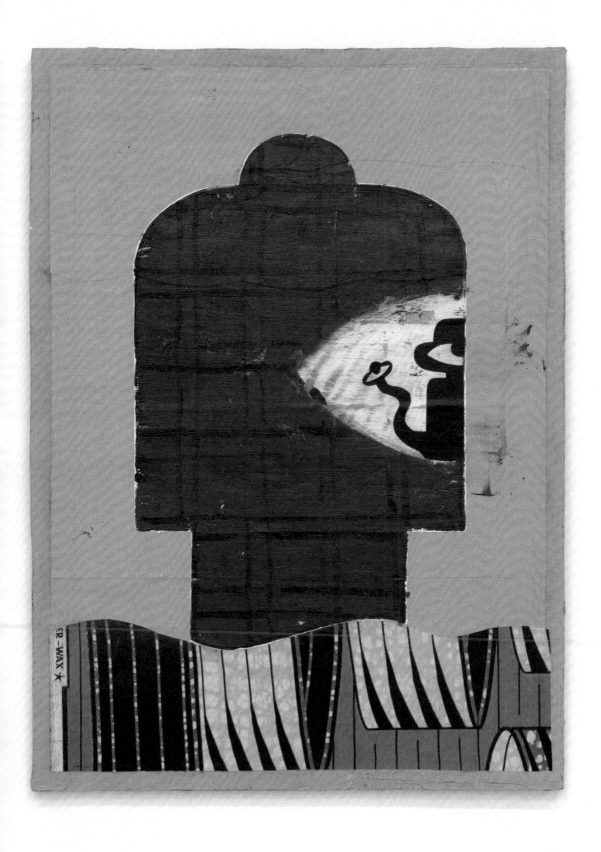

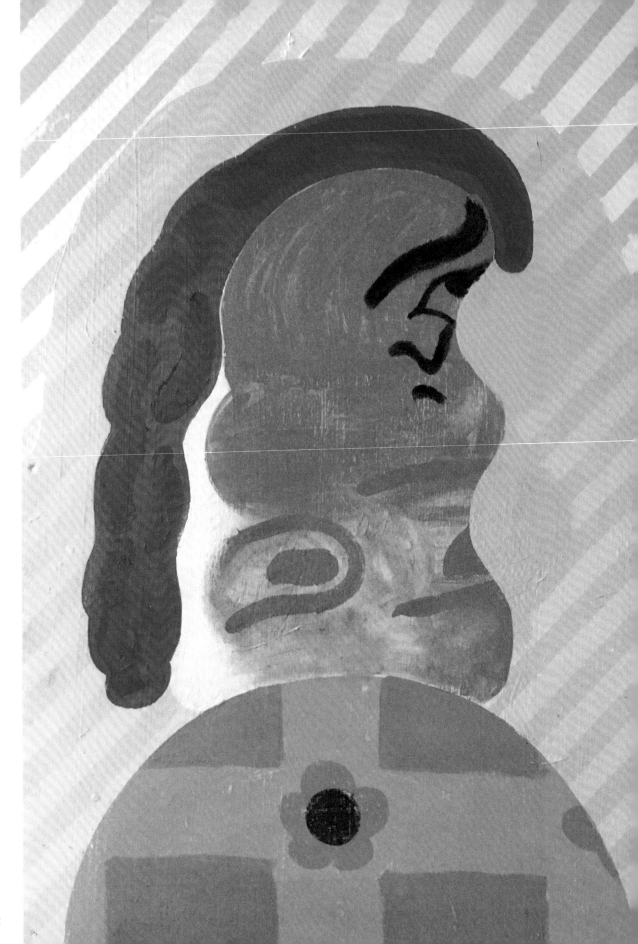

Who—dead or alive—would you like to have dinner with?
Andy Kaufman?

What would you ask him?
I have no idea. Maybe I would ask him to fight me, because I know he fought women.

How important are social media for you?
I'm fascinated by them. People aren't fully aware of the dangers, though. We talk about addiction when it comes to alcohol and drugs for example, but I know a lot of people who are addicted to their phones and social media. They also reduce a painting to a mere image. Young students don't know the difference anymore, which is rather scary to me.

What does failure mean to you?
I use the notion of failure in my work. It's important for me to show failure. It's a part of life and certainly part of the artistic practice. If it's not, you're probably not pushing yourself hard enough. You need to get through failure in order to learn something. In the studio I am confronted with that all the time.

How do you incorporate failure into your work process?
I'm not a fan of 'the right path' in an art practice. You have to be able to constantly turn things around and do something completely different. To me this means not always repeating the same thing and not handling my work in a protected, convenient and safe way. For example, failure is a constant throughout the process of making a painting. That's what makes it interesting and what makes you move forward. If you already know exactly what you will paint in advance, where's the fun in that?

Has the Covid-19 pandemic influenced your creative life?
I'm used to being alone in the studio, and during the second lockdown I experienced a fantastic burst of energy and focus, which is how you always want it to be. Having nothing else to do besides being in your studio is a dream. However, it also gave me anxiety, as it did for most people, probably. The images of an empty world really hit me.

What is the best advice you've heard and still repeat to others?
It's a bit cliché, but: stay as close as possible to yourself, and trust yourself. Take your time, don't try to rush things and don't be too polite. Believe in your first instinct. I ignored mine for too long, and it was a waste of time. Dare to be vulnerable and be self-reflective about that. That's something you have to really want to do as an artist, so it's not for everyone. And it's definitely not always easy.

I play with colour until the colours themselves
take over and start to communicate.

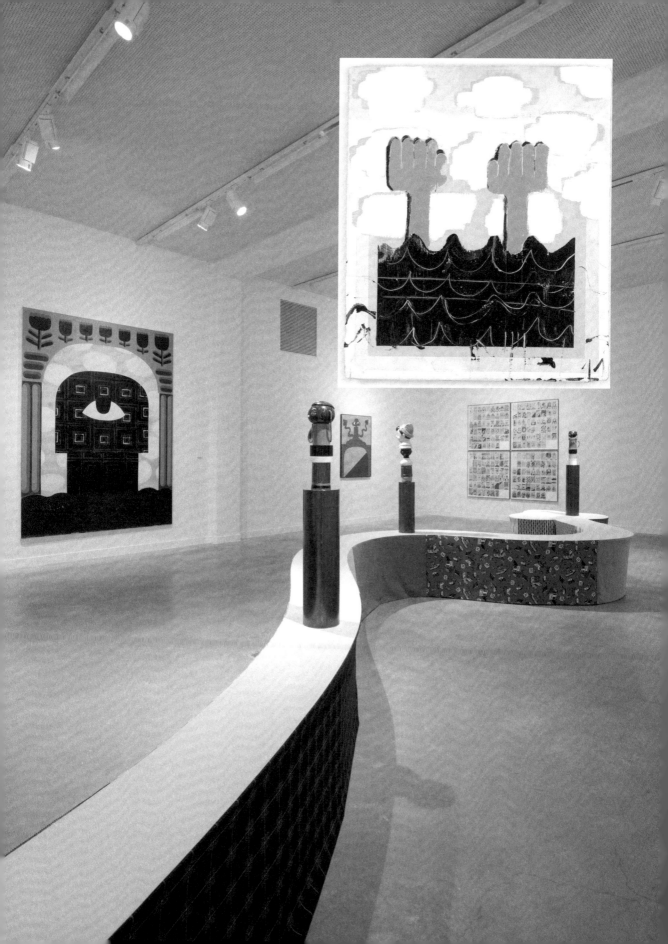

A L A I N
B I L T E R E Y S T

I am inspired by the everyday beauty
I see in the street.

How would you introduce yourself to someone who doesn't know you or your work?

I am a painter who seeks to create a visual representation of the time in which we live.

What kind of family did you grow up in?

I grew up in a hard-working family and have a brother and two sisters. My mother ran a grocery store, while my father had a painting and decorating business. Throughout my childhood I helped out during my school holidays. It was also a loving place—we had large gatherings of family and friends and enjoyed shared meals and holidays abroad.

When did you know you wanted to be an artist?

I always liked to draw and make things. At eighteen I went to art school, but after my first year of painting, my parents put pressure on me to get a 'serious diploma'. I graduated as an interior architect, but kept making art and exhibiting as much as possible, doing occasional commercial projects to make a living. It turned out that I had a flair for the commercial work and little by little it took over. It was a carefree time of creativity, short deadlines and making money.

After 9/11 there was a sudden shortage of paid work, but this gave me the opportunity to rediscover my own work again. In contrast to the large wild paintings I used to make, I now took a quieter, more intimate approach. Having created a studio space in the new house we had recently moved into, I decided to set up my first small show there. I invited friends who had been working in the art field for some time. It was fun and very DIY. Some photos ended up on Facebook and it was not long before I was contacted by a gallery in Chicago and later by Jack Hanley Gallery in New York. In addition to the gallery shows, Jack exhibited my work in art fairs both in the USA and Europe, and that's how it all started—we still work together today.

Where do you get the inspiration for your work?

I take images from pop culture and everyday life and transform them with changes in scale and colour. However, the 'high culture' of art history is also an important source of inspiration and reference for me. As a designer I am passionate about what I see in the street, for example the graphic lines and logos on the sides of trucks. I realised that companies from the eighties and nineties had based their corporate identity on the hard-edge art of that time, to introduce a feeling of modernity to their brands. They wanted to look contemporary, sharp and stylish. I was inspired by that idea and so it now comes full circle: I take these designs and return them to the world of art in the form of paintings. I've always considered my work to be 'recordings of things' somehow. I never really understood pure abstraction.

What does creativity mean to you?

Creativity is observing things and turning them into something new. In my case, I see images everywhere in the things I discover in the street—I see Art. Later it comes down to hard work and making the right choices.

What kind of circumstances need to be fulfilled for you to be creative?

I have lived in Brussels for a long time and I spend a lot of time abroad for my work. I love to walk around in foreign cities and soak up the culture, but since I moved to the countryside a few years ago, I find I really enjoy nature and the peace and quiet. My studio is on the first floor of our house. It's not big but I like to go back and forth between the studio and my office space, where I do my research, select photos and designs and make layouts for shows, etc. Having focus is obviously important, but I think doing a few things at the same time works well for me. Just as I prefer to work on multiple pieces simultaneously.

Do you have a preferred time to work?

I'm in the studio seven days a week. I usually start around 9 am and work until 5 pm, but there is always time for the occasional coffee or tea break. If I have a clear deadline for a project, I can be very disciplined. Without a deadline it's different...

What is your work process like?

In the first stage I like to dive into my archive of images that I have collected over the years. When I spot an interesting shape, I start to distort and rotate it until I find something new—until everything falls into place. I like the sketches on paper that other artists make, but personally I like to work directly on the computer. To begin, I make a series of backgrounds, then I start painting, usually applying several layers until the colour is perfect.

Why do you prefer to work on wooden surfaces?

I love wood. It is strong and has an inherent warmth. You can sand it and cut it into the right sizes, and if you want to hang it up, you just need to drill a hole in the back and you're done! It really has the feel of an 'object', which I also like. One day I found some large panels in my father's barn. They were already painted blue. I had them cut into small panels. That's how it started. And yes, sometimes I think of working on canvas. We'll see.

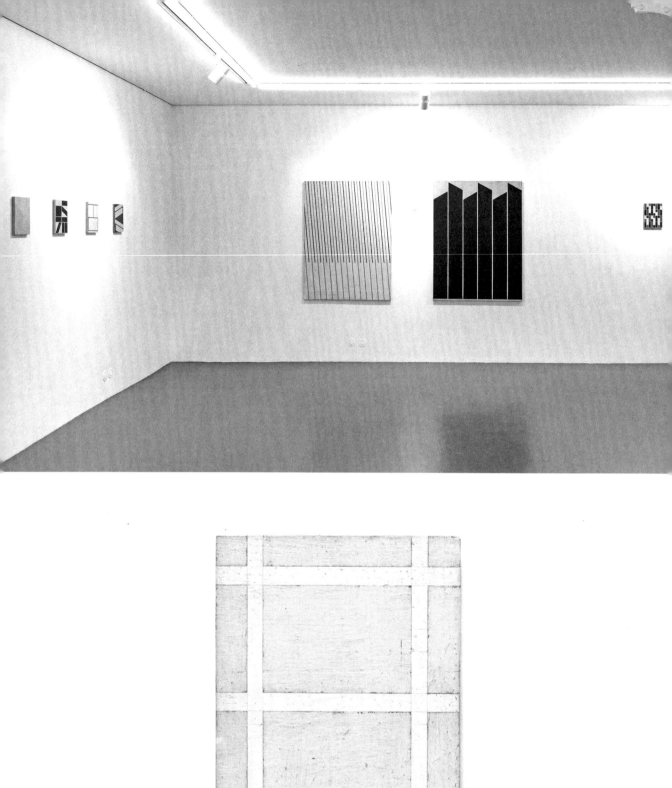

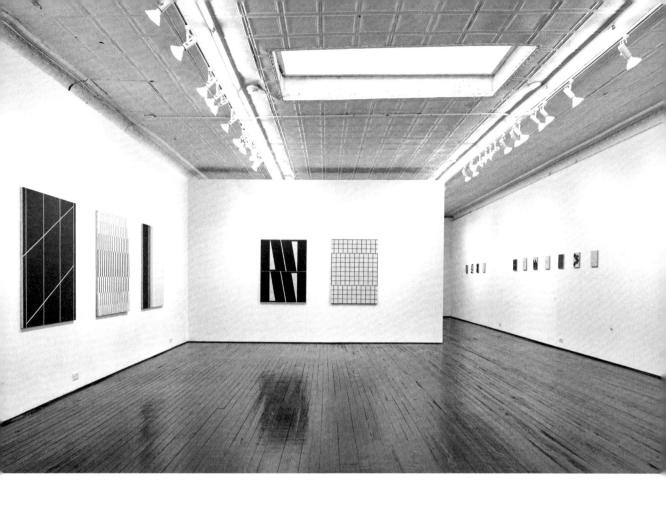

Do you prefer big or small works?

I really like the intimacy of small works. They invite the viewer to get up close and discover details, where, beyond the geometric forms, evidence of the process is revealed. For me, as a painter, it is extremely satisfying when one small work can have the power to hold an entire wall on its own. But I also like to make larger works and murals. Sometimes it's just a matter of blowing up a small work and discovering that it still works. At the same time, I also want to make large, fragile, softer works, with thin lines in pastel shades. This as a counterbalance to the robust small works— it all has to be in balance. Big or small, busy or quiet, hard or soft, dark or light. I also like to combine different sizes. Scale can be a funny thing; my larger paintings require me to take a completely different approach, in the knowledge that the viewer will relate very differently to them.

Is there meaning behind your paintings?

Although my paintings are abstract, I always start from an existing urban reality. The study of signs is a theme that runs through my work. This connection with the present distinguishes me from the abstract art of the past century, which aimed to evoke an ideal world free from reality. In my work there is always a reference to everyday life, to the here and now. One of the best comments I ever received was from a young French artist I met in Spain. He said: "I feel the street in your art", and that is exactly my intention. To absorb the things I see in the street and then translate them into my work.

Do you want people to pay more attention to the world around them?

Yes, I want them to discover the beauty of the everyday, not only the natural landscapes, but the man-made forms and signs. They are the traces we leave behind as human beings. Making art with them blurs the boundaries between culture and subculture.

Who inspires you?

I could say that all those trucks on the highways give me the biggest buzz, but you probably mean which artists do I look up to? I like a lot of different stuff. I can look at a self-portrait by Rembrandt for hours or enjoy a Fernand Léger or, closer to my work, a Piet Mondrian. What I would very much like to have on my wall is a small work by Philip Guston. Among the living I love Carmen Herrera, if only because of her life story. One of the pleasant aspects of being an artist is that we occasionally swap work. That's so great!

How important is colour in your work?

I am very careful with colours. Now and again, I use three colours on a painting, but mostly only two. I use a lot of black and white, and a lot of blue—I'm a big fan of blue. Sometimes I also use yellow, to contrast with the blue. The things I see in the street are often blue and red, colours that seem to make things more official. That's why road signs or national flags are often blue and red.

Do you give titles to your work?

No, never, but I do give them a number. Finding a good title for a show is usually something that keeps me awake at night. So, I keep a list of suitable titles— words and fragments of sentences that I find match what I do or want to say.

How important are social media for you?

They're OK. And it's always fun to get good feedback and compliments. My paintings work very well in miniature, they stand out clearly against the clutter of images and graphics, which helps to attract followers. Once in a while I discover the work of other artists and a conversation starts spontaneously. Social media make the world smaller again.

How important is failure to you?

I've become more and more critical when I make new work. If I am not satisfied, I put it away for a while and then look at it later with a fresh eye. If I am still not satisfied at this point, I paint over it. Then it serves as a nice background for a new painting.

How has the Covid-19 pandemic influenced your creative process?

At the beginning of 2020, I was preparing a solo show in Paris. It was supposed to take place mid-April, but because of Covid-19 it finally happened at the beginning of September, between two lockdowns— I was very lucky. I hear that some of my colleagues are very active at the moment, but I sometimes struggle with the situation and it can affect my desire to paint. I need fresh air and a good walk.

What is some good advice that you have heard and will repeat to others?

I often go to shows that don't make a lot of sense to me. I mean, you have to read a lot of information to understand them. It's usually interesting, but sometimes I just think: oh boy, this guy needs a shrink *(laughs)*. A good friend told me: "Just make that fucking painting". That's more my thing!

It's my intention to make poetic work
that is as simple as possible.

CONRAD BOTES

Whether it's humour or violence,
it's got to have some edge for me.

How would you introduce yourself?

I am an artist. I work in different mediums, but I wouldn't specifically call myself a comic artist or a painter because in my opinion all those things are interconnected. So, I would describe myself as a visual artist.

How did you grow up?

I grew up in a very conservative Afrikaans household during apartheid in South Africa. I was born in 1969 and lived in the Cape Town area for most of my life.

What was it like growing up during apartheid?

I wasn't really aware of apartheid growing up. We were kept from knowing about what was happening. The patriarchal part of society, which consisted of the school, the church and the military service shaped and steered us in a specific direction and it wasn't until much later when I went to university that I discovered what apartheid was really about.

Did growing up in that cocoon influence your creativity?

I grew up pretty much in isolation. I was exposed to very few things that had anything to do with art. But I knew from a very early age that I liked drawing and I made up my mind very early on that that was what I wanted to do. When I finished school, I could either do the compulsory military service or study, and I wanted to study art. My parents and a career guidance counsellor told me that there was no career in art, and that I should pursue graphic design. So, that was what I studied. After I finished my graphic design degree, I studied illustration in the Netherlands for a year and then came back to do my master's in fine arts.

What does creativity mean to you?

Creativity is many things, ideas, concepts. What are you talking about? What are you making? What does it mean? What does it say? What does it question? That is what creativity is about for me. I wouldn't say that creativity is a skill set, like being able to draw well. Ultimately those are just tools that you are using in order to do something else.

Where are you most creative?

I need to be alone. I can be creative anywhere but I'm most productive in my studio. However, having ideas or creative thoughts can happen at any time. I often have my best ideas when I wake up in the middle of the night, and there are no external impulses. I'm quite lazy and I don't write ideas down immediately, so often I forget them *(laughs)*. Just sitting and trying to interact with ideas is often a place where things happen. Often an idea springs up or reveals itself while I'm working on a painting.

Can you describe a day in your life?

I usually wake up at six o'clock and get my daughter ready for school. I get coffee and breakfast and around half past seven I'm back in my studio and start working. At the beginning of the year, I started an experiment: one drawing a day. I became quite obsessed with the project and it was the first thing I did when I came to my studio. It became a bit distracting because I got so caught up in the fact that each drawing had to be a new idea or have an elaborate execution, which kind of defeated the purpose of doing something spontaneous. So now I've stopped. I feel the best drawings are the ones you make by just sitting down and doing something, without thinking too much about it.

Sometimes I make drawings that are the start of a painting or a larger work that is completely thought out. If I have an idea for a figure in a certain position, I'll do a lot of preparation and take photographs for reference. There's no specific pattern that I follow. I force myself to do different things at different times. For example, I'll decide that for the coming week I'm going to work on a certain painting for the first two hours of every day. I set an alarm and put on some music and try not to get distracted. I then work on this specific thing until the alarm goes off and then do the other things that require my attention. After my lunch break I'll often pick up my daughter from school. Then I do some emails and have about two more hours of work until I have supper with my family. My favourite time is after nine o'clock in the evening, when I can work in complete isolation.

What inspires you?

I draw from life. I sit and draw landscapes or people or write down interesting quotes that remind me of something and I'll pair them with a specific image. I'm often inspired by the combination of text with a specific image. That marriage between text and image is often the spark that ignites an idea.

Do you have any personal heroes?

There's one person who stands out above everybody else: Robert Crumb. I admire the fact that he's been doing his thing for so long and he never did anything other than what he completely believed in. He did things his way. That, and the fact that he has completely transcended the comic world; he has exhibited in contemporary art museums from New York to Paris and the rest of Europe. That's quite an inspiration for me.

My favourite artist of all time must be Francisco Goya. I think of his paintings every day. He's my ultimate idol. His work ethic was unbelievable. He was also lucky to live to be eighty years old in a time when the average life expectancy was late thirties or early forties. He did all of his important work in the last half of his life, after fifty. He made a series of etchings named *The Disasters of War* during the Spanish Civil War, which was never published in his lifetime but is arguably one of the most important bodies of work about history ever made, in my opinion. He also made the *Black Paintings* on the walls of his house outside of Madrid, which were just for himself. It really blows my mind that some of the best paintings he ever did were never meant to be seen by anybody. Things like my drawing books are inspired by that. They're not really made for a specific purpose, I do it for myself. I don't show them to anyone other than my close friend Anton Kannemeyer, who works with me.

Tell me about your views on drawing.

Drawing is an interesting thing because it's ever-evolving. I'm interested in drawing as a kind of language. You can tell a story with drawings and in that aspect, it is different from other art forms. Drawing is the core of my creative process. It's where everything starts. If I have a random idea, I'll write it down in my drawing books and in such way that it only makes sense to me. I also write down lists of words that I find have some relationship with each other.

Does your work have to be provocative?

I don't really care very much about what people think, but it's important that work is provocative. I want people to think and my work must question things. The golden rule for me is: it must make me a little bit uncomfortable. It must move me in a certain way. If I'm not moved, excited, disturbed or repulsed by it, then it doesn't have a purpose. Something has to happen. I often say, when I'm doing a painting or artwork that has complex or challenging ideas, that I don't want to provide people with answers, I want to ask questions. And often the best way to ask questions is to have a sort of confrontational approach. Whether it's through humour or violence, it's got to have some edge for me.

What is your relationship with comics?

For me, the place to push boundaries, both my own and those of the viewer, is in the comics that we do at *Bitterkomix*. Comics are a really good medium to explore difficult ideas. There are so many tools that you have at your disposal. People get drawn into a story, like they are watching a movie. You follow the story and all of a sudden you reach a point in the narrative where you are confronted with a situation that can be either disturbing or sad, and that's a way to present a problem and make people question things.

How did your collaboration with Anton Kannemeyer on *Bitterkomix* come about?

Anton and I both grew up during apartheid years in conservative Afrikaans society. We met at university and decided we wanted to do something to fight back. We started the comic magazine *Bitterkomix* in the Afrikaans language and the idea was basically to attack the moral codes of the Afrikaner. The magazine was anti-patriarchy, anti-religion, anti-military, and we used every tool possible to undermine the political dogmas that we grew up with. For instance, in 1994, just after the first democratic elections, the censorship laws changed, making pornography legal for the first time in South Africa. So, the first thing we did was make a pornographic comic with hardcore explicit sex. But we used pornography as a tool for political ideas, so the comic featured interracial sexual relationships, white males being impotent, black males being very potent and strong female characters. We tried to slash open the underbelly of the Afrikaner white male. The reactions to this comic were like chalk and cheese: people either loved it or they completely hated it. A lot of our guy friends at university were like "Oh a sex comic, fantastic", but the content of the comic was of such a nature that it really freaked them out. As white males it made them feel insecure. They hated it because it depicted white males as pathetic, impotent and weak. It was also one of the only publications that we know of to be banned completely after the first democratic elections. To us, it was a bit of a victory to have one of our books banned, and we managed to sell all our copies. Anton and I have continued to work together, ever since we first met in 1988.

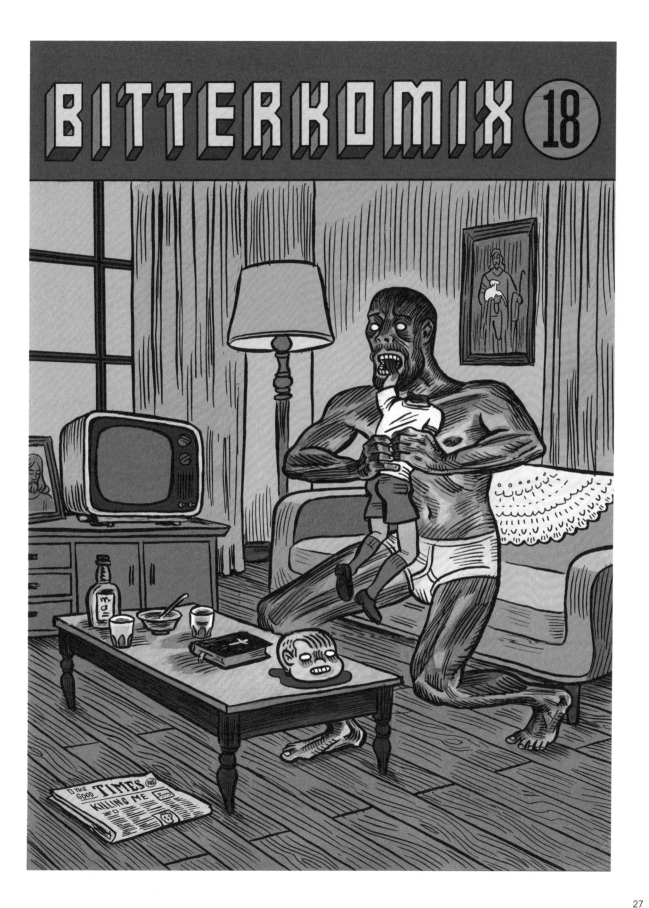

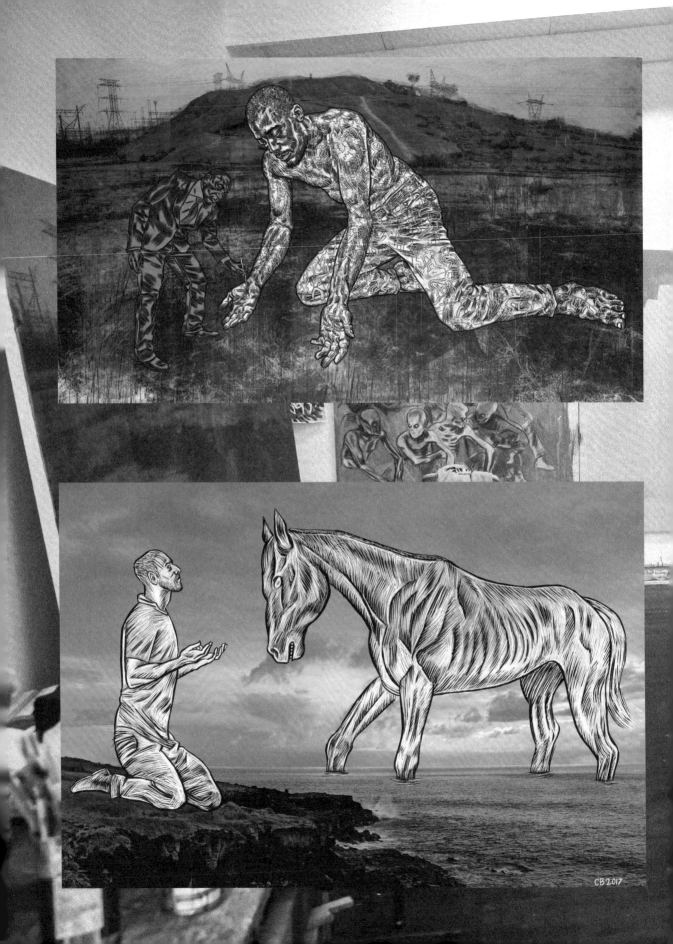

CB 2017

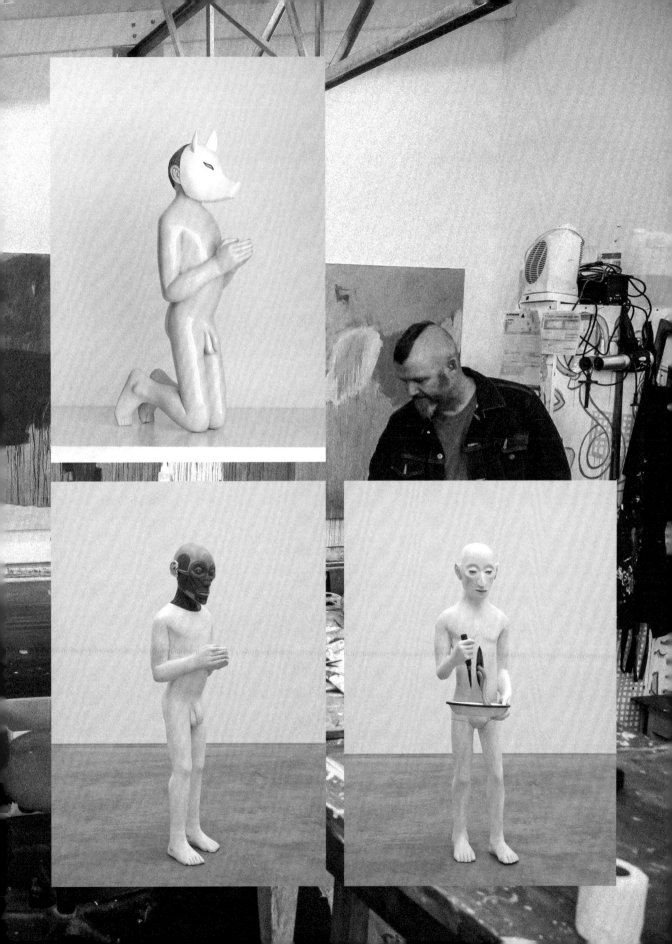

You also use yourself in your work.

Sometimes I use self-portraits because of the convenience of having myself available as a model and because I like to work on my own. I often use my wife as well; we take photographs of each other. When people ask me what a certain self-portrait means, I don't want to tell them it doesn't mean anything *(laughs)*. It was just convenient for me. I also tend to draw myself when it comes to, for example, a physically compromising position. It's a way of looking at yourself, looking at my own culture, looking at the Afrikaner.

What does failure mean to you?

When I do an exhibition, I always try to push myself to do new things. I want to challenge myself visually, conceptually and on different levels. I don't know whether I'm successful or whether I fail, because when I'm busy I can't really tell. I make something and it isn't until I look at it months later that I see that it really doesn't work, and I should've done it differently.

I guess failure is inevitable, it's just part of what you do. I will never make something and think that it's perfect. When I reach that point, I might as well just stop. Failure will always be: finding mistakes and wanting to do better. There's really a lot of work that I find really embarrassing, and I wish people never saw it, but unfortunately I already sold it and it's out there for everybody to see. If you accept that you will make mistakes then you can just carry on.

Has the Covid-19 pandemic influenced your creative life?

I am very fortunate to have my studio at home, so the pandemic did not negatively influence my work routine. In fact, it allowed me to spend more time in my studio because there were no external distractions such as fetching my daughter from school or attending meetings. Because there were no exhibitions happening either, I found myself in the fortunate position to do work I would normally put on the back burner; it allowed Anton and myself to spend almost the entire year working on and publishing *Bitterkomix* number 18, a 120-page comic featuring only comics by the two of us. It was a special year, because it gave me time to create the longest single story I've ever managed to do, *David and Goliath*, a 27-page political allegory comic about the Marikana massacre of 2012.

What is the best advice that you have heard and still repeat to others?

Try to smother your distraction and feed your inspiration. Because I am quite a procrastinator; it's part of my creative process. When I look at people who inspire me, I notice that they don't compromise, they do what they feel. Take your time to find out what it is that you want to do, rather than just doing something and discovering that you're unhappy with it. I'll know when I'm making a really big painting that it is going to take me months or maybe even a year to finish and that I'll never sell it, but I want to make it because it's important to me.

PAUL BOUDENS

I never overthink anything.

How would you introduce yourself to someone who doesn't know you and your work?

I am a graphic designer, mostly in the fields of fashion and culture. The last decade I've been designing a lot of books as well, including this one.

What kind of family did you grow up in?

My family is a typical post-war Belgian household: father, mother, four kids—I am the youngest of the bunch. My father was a clerk in the justice department of the Belgian army, my mother is a housewife and the one who keeps everything together. My parents are both still alive—at 90 and 83 years old—and still in love. I admire them a lot.

Did your childhood influence your ideas about creativity?

I think childhood always influences your life, no matter what you end up doing. Moving to Germany with the whole family in the early seventies was a bit traumatising at first, but in the end, it made me who I am. So, no complaints, really. I do remember my mother taking me to art classes before I was seven so I guess it was obvious to my parents that I had artistic tendencies.

When did you know you wanted to be a designer? Was graphic design your first love?

Actually, I wanted to become a fashion designer. I don't know where I got that idea from. I vaguely remember seeing a documentary on Yves Saint Laurent in my teens, and I used to make my Barbie dolls gorgeous evening gowns out of only one handkerchief. When I was eighteen, I moved back to Belgium to study Fashion at the Royal Academy of Fine Arts in Antwerp but I failed the entrance exam miserably. There I was: alone and with a four-year budget from my parents, but not a clue what to do. A couple of years of soul-searching followed; I started several education programmes like communication or translation but since my heart was never in it, I always failed. However, I was always making graphic stuff at home: collages, cassette covers and birthday cards.

One Sunday afternoon, I was at a birthday party where one of my cards was on display and one of the guests loudly asked "Who made this wonderful birthday card?" I answered that it was me and the woman, Anne Kurris (then an esteemed graphic designer, later a kids fashion designer), advised me to study graphic design at the St Lucas Pavillion, where she taught. I took the entrance exam, which I passed this time, and I was on a roll. I did manage to fail the first year, but never looked back after that (laughs).

You have been working with Walter Van Beirendonck for more than thirty years now. How did this collaboration come about?

In my third year at St Lucas, Anne Kurris asked me to take over her work for Walter Van Beirendonck since she wanted to concentrate on Dries Van Noten. My first assignment was a kind of publicity page for a fake perfume named *Sado*, after his dog. Walter showed me a well-prepared sketch and I asked him if I could change it—ah, that youthful arrogance (laughs). He said: "As long as you make it better", and we've been working together ever since. We're very loyal people, and there's a mutual respect. Time flies when you're having fun. After graduating I immediately started working in his studio, then later I branched out and started working for other designers. So, I ended up working in fashion after all, I just had to find my place. And in retrospect I'm very happy I'm not a fashion designer, I would've been terrible at it.

You describe your style as 'classic with a schizophrenic twist', what do you mean by that?

Man, me and my big mouth! I'm referring to the fact that I've been working for a lot of designers who all have their own style, yet apparently, I can design something for each of them that they're happy with and on top of that I can also claim it as my own work. I guess that means it's a healthy kind of schizophrenia.

What is the main philosophy behind your work?

I never overthink anything, as it takes all the fun out of the process. I work with my gut, and my gut is *always* right. The one thing I try is to make timeless work, and I do mean 'try'. I love it when things have a certain longevity, which ironically is in total contrast with the fashion world. My invitations age gracefully, yet the collections they're made for quickly become 'last season'.

What is your relationship with typeface?

As I once said: "Finding the right typeface is like falling in love. I can really develop a crush on a typeface". I guess I'm an incurable romantic. I would never be able to create a typeface though, I prefer to mess around with them.

On a personal note, I am really honoured that you agreed to design this book. I must admit I was a bit scared to ask you because you are not known for your subtle opinions. What makes you decide to take on a project?

Is that my reputation? My mother is right, I really should smile more in photographs *(laughs)*. I'm just very in-your-face and honest; it saves a lot of time. When I commit to something, I commit all the way. It's very simple: a project has to pique my interest. If that's not the case, it's not worth it.

How do you stay true to your own style when you are mostly working with other people's creative work?

It's an organic process. I try to make my clients work look even better than it is. You can make a good book, or a terrible book with the same material. It's about the choices you make. And somehow, I manage to make it my own—it's a mystery I do not want to solve.

What is creativity to you?

It's everything to me. It's life. I must have one of the best jobs in the world: every day I get asked to create something. It's fantastic and I'm very grateful for that.

When are you at your most creative?

My mind is always at work, or at play. I've become a morning person, it's when I'm the most clear-headed and focused. A couple of decades ago I was doing all-nighters and working night and day, but at a certain moment you have to make some decisions to keep your sanity. Or your social life.

Do you listen to music while you work?

Yes, very loudly, actually. Most of the time I'm so focused that I hardly notice what's playing. Until the neighbours start banging on the walls.

Is your workstation clean or chaotic?

It depends on the day. I try to keep it as clean as possible but chaos can also be creative.

Where do you get your inspiration?

Inspiration is everywhere, really. Just open your eyes. Even terrible stuff can be inspiring; the moment you start thinking about how something could be improved, you're already being creative.

I remember dragging books home from Paris or London, way back when you could really find treasures; anything to keep the fire inside burning.

Do you work intuitively or do you have a concept?

Definitely intuitively. I truly abhor concepts: they're very *in* right now but most of the time all I see is 'the concept' and the result is bloody boring. And ugly.

Do you use notebooks, or doodle in books or digitally?

No. I always start with a blank canvas, like an artist. Mind you, I would never call myself an artist but I do approach my work like one. It's about making compositions: I move text and images around on a sort of canvas, that's all I do—I play all day.

What about working on a computer? You started at the end of the eighties, a time before digital, I assume?

Yes, I am a dinosaur *(laughs)*. There were no computers while I was studying. If I remember correctly, those first giant grey things that students had to queue up for arrived in my final year. Needless to say, it was hate at first sight. But in all seriousness, I'm very happy that I learned my craft in an analogue way and that the digital way is a plus. It taught me to approach things differently. I think the mix of analogue and digital is what makes my work stand out.

INGE
GROGNARD

PAUL
BOUDENS
TRUST
ME
I KNOW
WHAT
I'M DOING
GRAPHIC
DESIGN
1990–
2010
3-09>
3-10-2010

PAUL BOUDENS WORKS VOLUME

GENK PAUL

BOUDENS 2

36 ONKGOENK

WVCVANGVASK.BE

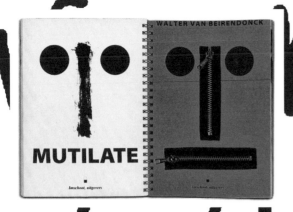

MUTILATE

WALTER VAN BEIRENDONCK

kiss me
(you fool)

Man has Fists
Roses have Thorns
There is no such Thing
as True Love
without Pain
Only the Shiny Trace
of a Falling Star
can illuminate
Eternal Love

crush

MILANO PARIS

WOMEN'S COLLECTION
SUMMER '99

I KNOW
WHAT YOU'LL
WEAR
NEXT SUMMER

INVITATION PRINTEMPS-ÉTÉ 2020
SAMEDI 28 SEPTEMBRE 2019 – 10H30
PALAIS DE TOKYO
13 AVENUE DE PRÉSIDENT WILSON, 75116 PARIS
INVITATION STRICTEMENT PERSONNELLE MICHÈLE MONTAGNE +33 1 42 03 91 00

I work with my gut, and my gut is *always* right.

What prevents you from being creative?
Bookkeeping and heartbreaks.

How do you handle deadlines?
I've never missed one, so I think I'm doing alright. Knock on wood. I do know that deadlines can be stretched until the last possible second—consider yourself warned *(laughs)*.

Does creativity have to be provocative?
Not for the sake for it. Although, in my Sturm und Drang years and while working with fashion designer Jurgi Persoons, we used to deliberately amp up the craziness, just to stand out: using my own blood for a fake wedding invitation, handmade typography, ripped lace, the works. But I've matured as a designer so I don't need the shock tactics anymore. I do miss them sometimes. Since I put my heart and soul into everything I do, there will always be a hint of crazy in my work.

How important is humour in your work?
It's never intentional but if my work makes people smile or chuckle, why not? But I never start out trying to make something 'funny'.

How important is colour in your work?
Very. That's something I learned from Walter Van Beirendonck, who is not afraid of colour, to put it mildly. But moderation is key.
Also, I love red. What's not to like? I always start a project in red, black and white because you can see all the elements very clearly, there's no hiding. Depending on the project the colours can change, of course.

Does your creativity have to create a better world?
I try to make interesting work that is also aesthetically pleasing.

Who inspires you?
I basically learned everything from Alexey Brodovitch—the man was a total genius. The work he did in the fifties and sixties was groundbreaking, and even now the grids underneath his work still hold up. You just have to soak up all this inspiration and make it your own, don't just copy it.

Who—dead or alive—would you like to have dinner with?
Alexey is definitely invited. So are Carmel Snow, the editor-in-chief of *Harper's Bazaar* from 1934 to 1958, Mel Brooks and Anne Bancroft. Amanda Lear and David Lynch. Róisín Murphy. Table for eight, please!

How important are social media to you?
Not very important, I must admit. Facebook is now for old people, apparently, but very handy for remembering birthdays. I love Instagram but I'm sure I'm using it all wrong. I just use it to post work, I never scroll endlessly, and whenever I get a follow request, I check out their account: if there are too many selfies, they're not coming in.

What is failure to you?
Failure is never pleasant, but I try to learn from my mistakes. Probably while kicking and screaming with frustration, but you live and learn. You have to accept your mistakes and embrace them. I do that reluctantly, but you have to—there's no other way.

What is your biggest failure?
Probably all the relationships that went belly-up because I was always working. Ambition is a bitch! I admit I've found it difficult to combine everything: career, love, creativity... You can't have it all, I guess.

Is it important to make mistakes? Is failure important in the creative process?
I only like 'happy' mistakes. For example, when you're working and you hit a wrong button and suddenly there's something on your screen that you wouldn't have thought of but is in fact very interesting—but I can assure you that those don't happen too often.

Has the Covid-19 pandemic influenced your creative life?
Yes and no. I consider myself very lucky because I haven't stopped working since the start of the pandemic. My theatre clients have sadly been shut down, but the rest have kept me going. Also, I work alone and from home, so I have been living in quarantine for years *(laughs)*.

What's the best piece of advice you have heard and still repeat to others?
Shut up and work.

JEN N
BROSIN I

I don't like the word creativity,
I work.

How would you introduce yourself?

I am a painter who paints paintings, so I would introduce myself as an artist.

What kind of family did you grow up in?

I grew up in my grandparents' house. All the men in my family are craftsmen and the women are saleswomen or office workers. My father used to be a car mechanic and later he owned a pub, but I have very little contact with him.

Did your childhood influence your ideas about creativity?

I can't say that I have an artistic background, there wasn't much culture in my childhood. I was always reading books, watching films, and daydreaming, which set me apart from the other members of my family. I liked creating things with my hands and I was drawing all the time. My family didn't know that I wanted to become an artist, but they liked the fact that I was a quiet child, painting and drawing all the time.

One day, I was watching TV with my grandpa and I asked him: "What should I do if I want to draw for a living?" He said: "The weathergirls on TV use a crayon to draw the weather, so maybe you could do that?", which really disappointed me. But later I saw something on TV about Sotheby's, and artists like Cy Twombly, Picasso and Basquiat. I was so inspired, and that was a real epiphany moment for me, because until then I didn't know that existed.

I wanted to go to art school but my family was against the idea. So, I tried to find a way around it and started studying design in Hamburg. But it didn't feel right, so I transferred to Berlin Art Academy.

What does a day in the life of Jenny Brosinski look like?

I really try to bring structure to my days. I wake up early before anyone else does, so I can have some time to myself to do some yoga and meditation. I am a really impatient person and it helps me keep my feet on the ground. After that I have breakfast with my boys, my husband and little son. Then I go to my studio, except on Saturdays, when I take a break. I'll be in my studio for six or seven hours and then I pick up my son from school and we play for two hours. We do some cooking, we eat together and then I put him to bed. Then it's time for some admin, sometimes some yoga and then off to sleep. I also try to go to an opening or museum once a week, just to have some distraction.

Is it important to have a studio outside of your home?

I like having a place where nobody can reach me. I can close the door and lock everybody out. I don't think about my family or friends when I'm in my studio, that's my time, and something I need every day. Often there is beautiful lighting in there, which makes me really happy. First I open the window to let some fresh air in, while I take a look at the things I did the day before. I'll sit in my chair and look around and think for a while, and then I start doing my thing.

I work on about six to seventeen paintings at the same time, so the studio looks chaotic sometimes. But working this way is important to me, because it helps me focus on what I am doing and that makes it easier to make decisions. Sometimes one painting helps me work on another painting.

What is creativity to you?

I don't like that word and the way it is used in Germany. Of course I create things, but I dislike the word creativity or saying that I am creative. I prefer the word 'working'. I work.

What inspires you?

Everything that surrounds me inspires me. I like to read books and watch films, and I like to go exhibitions. I like colours, textures, materials—basically anything can inspire me.

How would you describe your style?

Spontaneous, open, and full of subliminal humour. I try to be focused in everything I do. I don't like when my work gets too 'hard', so that's why the openness is important. I'm also loving bright colours at the moment. Maybe I'll do some black paintings in the future, I don't know. It's all part of the process.

Do you work intuitively or do you start with a concept?

I don't do sketches, but I do doodle, or try things out on my computer. Especially when a painting is nearly finished, I use my laptop to try and see what it would look like or what would happen if I changed something. I start intuitively, but there is also a concept in there so I can't say it is just intuition. I like to begin in a very open way, and end with a concrete decision. I often feel like the painting knows more about itself than I do. I have a kind of dialogue going with every painting.

Is the process important to you?

I am a process-oriented person. It may look like a painting takes me five minutes or a couple of days to finish, but sometimes it takes me three years. Usually it is a fast process, but sometimes I don't have an idea and it has to grow with the painting. When I am surrounded by my paintings and they are nearly done, in a way it feels like they are screaming. And when they are finished, they are quiet. That's when I know there is nothing more to do, when it's quiet.

You also use words in your work. What is your relationship with text?

Although I love text, unfortunately I'm not much of a writer, so that is why I stick to using words in my paintings. I am fascinated by words, but equally scared of them. When you see a painting with words, your eye is drawn to the words first. It's challenging to find the right balance in using words in my paintings. I don't like to write words directly onto my paintings, I prefer to use them in an abstract way. For example by partly erasing them, so it's just half a word that could be read as different words.

How and when do you come up with the titles of your work?

I often have a working title, which is like an inside joke between me and the painting. While biking to the studio, I listen to music and think about the words that I'll use for the painting. Sometimes I'll hear something on TV that reminds me of the painting. From the working title, the title can then evolve into part of a song lyric or a line from a book, or a combination of both. It can be anything, as long as it sounds funny to me and it reflects the character of what I am doing. I try to build a title over the course of time, so a painting has a working title while it's in progress and a final title when it's finished.

Can you elaborate on the importance of colour in your work?

Everybody has their own colour palette. Mine consists mostly of rose, yellow, white, and a little bit of black, and maybe some greens or blues. It's part of my personal aesthetic.

Do you feel that there is a difference between men and women in art?

The prevailing narrative is still that women can't do what men do, because they are the ones who have the children. I don't see myself as a woman first. First I am a human, then a painter and woman and mother. Of course it takes some of my time to spend time with my kid, but it also helps me focus on my work. Often people don't even know I have a kid, and they are surprised when I tell them. But that's okay, it is not important to talk about my family status, it is important to talk about my paintings. And I don't want to be reduced to my gender.

Do you like explaining your work to the public?

Yes, I like to exchange thoughts. I'm always alone with my paintings, so it's interesting to hear what goes on inside other people's minds. I like hearing what they're feeling or what they see in the work. Everyone has their own history and focus, so everyone sees something different. I don't even mind if people don't like my work, you don't have to like what I do.

Who—dead or alive—would you like to have dinner with?

Cy Twombly, Helen Frankenthaler and Jean-Michel Basquiat, because they are my heroes. I'd like to meet them and talk about painting with them. Then again, that's quite an obvious selection because they are big art history stars.

I would also like to dine with Zinedine Zidane. I can really relate to how focused and full of love for the game he is when he is playing soccer, even though I don't even like soccer that much. I feel the same way about painting as Zinedine Zidane feels about playing soccer. Even when he lost control that time, it ultimately made him a better person.

Are social media important to you?

By scrolling through Instagram I can look at a massive amount of paintings every day, which I like because it helps keep my mind and my vision clear. It has become a daily ritual for me. I actually consider it necessary admin work, as I use Instagram to communicate with galleries or other artists.

I don't use Instagram to look for inspiration but I like to compare it to a big art academy: it is a place where you can meet other people and talk about art. That's all it's good for, though, because nobody can tell you how to paint. You can learn about techniques but you can't learn to create a good painting. What art school offers you when you're a student is a place to spend time with people that like the same things you do.

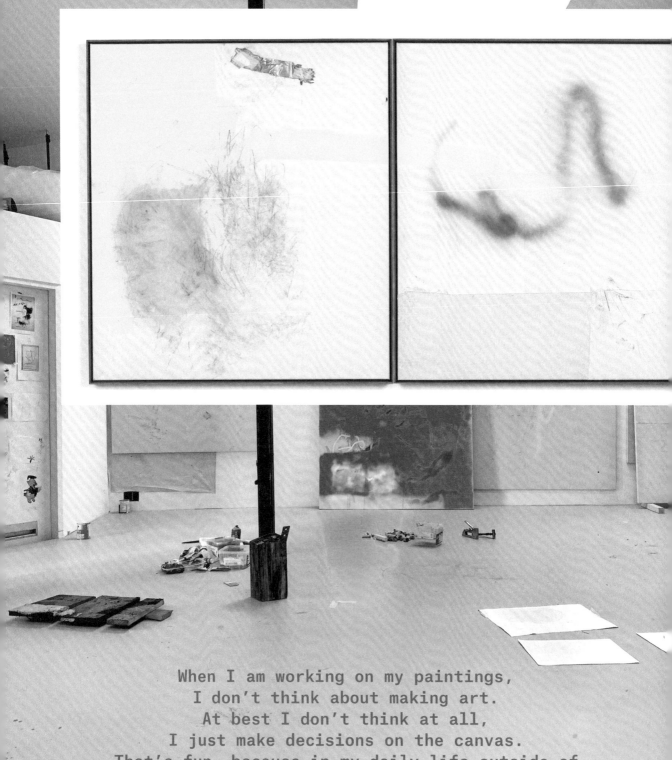

When I am working on my paintings,
I don't think about making art.
At best I don't think at all,
I just make decisions on the canvas.
That's fun, because in my daily life outside of
the studio I don't like making decisions at all.

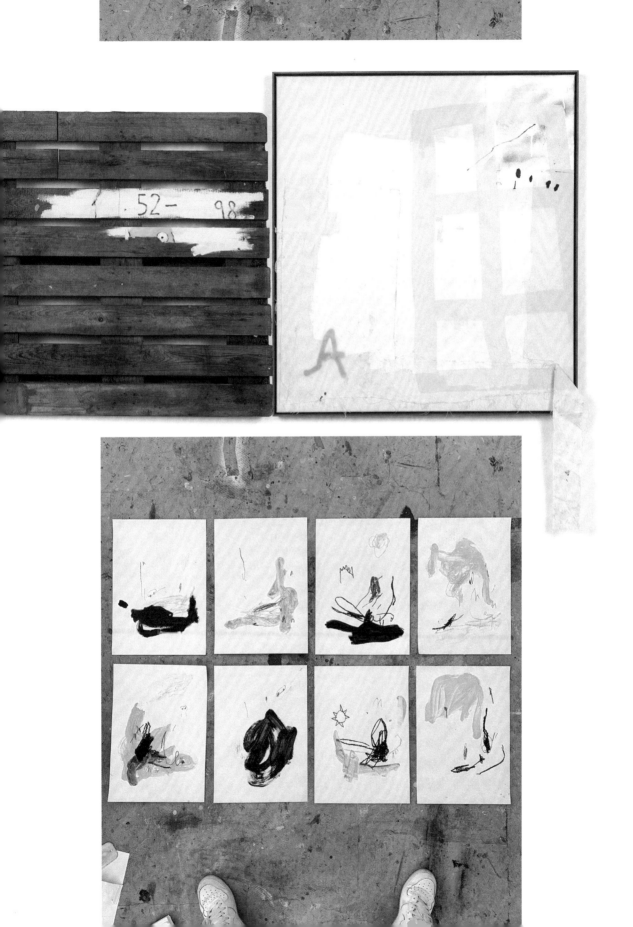

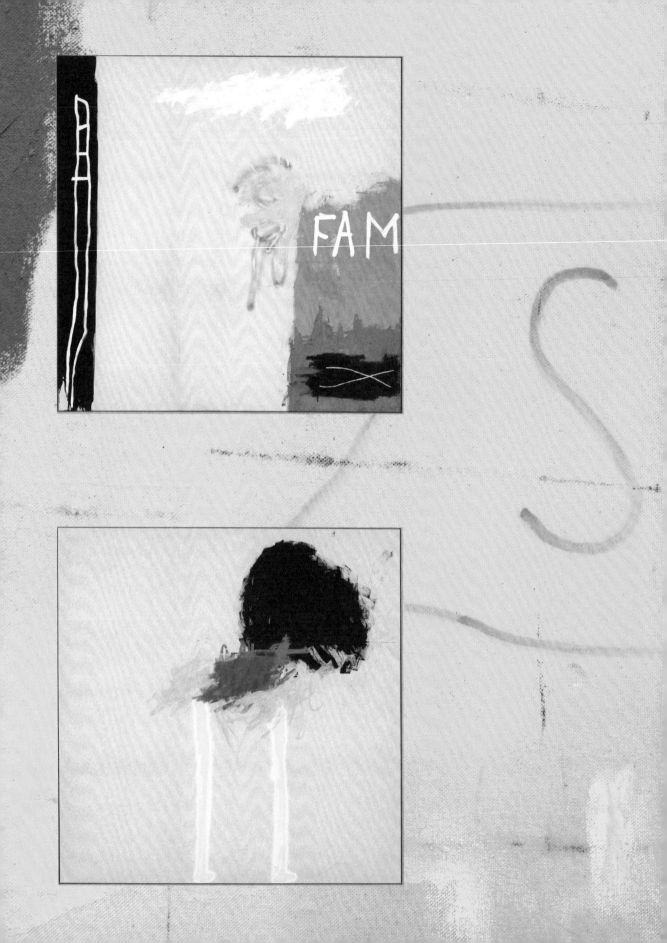

What does failure mean to you?

I wouldn't say I fail, I make decisions and each step is another step on the ladder. But failure is important. It helps you challenge yourself and not do the same thing over and over. Failure shows you the truth. There's no point in being frustrated with a painting that doesn't work, and how I react to it is up to me. I can always cut something out, destroy a part of it or erase some of it. As long as I know what to do to get a good painting in the end. Maybe that's not a typical way to paint a painting, but for me the important thing is not how I got a good painting but that I can see it and feel it and that I know what I'm doing.

Has the Covid-19 pandemic influenced your creative life?

It hasn't changed my practice or my habits, but I do feel that Covid has definitely influenced the art world—and consequently me as a part of it. Like John Donne said: "No man is an island".

Even though I have the impression that the lockdown will turn out to be a gift for me as an artist, because I am more focused on my paintings, my practice and life are still influenced by it, as I am always surrounded by different questions and structures. It has made me grateful to be an artist, because painting helps me filter my thoughts. Feelings are made up of thoughts, and it's helpful to realise that in times like these, when it can feel as if you're losing control of your whole life.

What's the best piece of advice you have heard and repeat to others?

I had a mother-daughter talk with my mother just once, during which she gave me the advice to enjoy my life, including all its mistakes and failure, because you never know how long it will last. I like that.

T A D
CARPENTER

...etters
the ... experience.

How would you introduce yourself?

I am a graphic designer and illustrator, and I co-run a designer branding studio in Kansas City, Missouri along with my wife Jessica Carpenter, who's also my creative partner. The backbone of our business is building brand identities and systems, and brand experiences. Outside of branding, we illustrate and write children's books, and we do spot illustrations or exhibition design.

I love that every day, every client allows us to do a million different types of things. I could never work for just one type of client, in one type of discipline. I like to get my hands dirty in a lot of different types of work.

What was growing up at the Carpenters like?

I grew up in Kansas City, Missouri where I still currently live. I love it here, it's an amazing creative community.

I was lucky to grow up an only child and the son of two artist parents. My father was an art director, illustrator, designer, and eventually became the creative director of Hallmark International, where he worked for nearly 42 years. He got to work with some of the most amazing artists in the world. When he became an art director, he was able to start hiring some of his boyhood idols like Al Jaffee and Paul Coker, who were amazing cartoonists for *Mad Magazine* back in the day, of which both my dad and me were huge fans. I still have an Alfred E. Newman drawing that Paul Coker gave me for my ninth birthday, of a dog peeing on Alfred E. Newman's leg.

My mother is a fibre artist, she dyes wool and crochets these amazing fibre pieces and rugs. My parents didn't just embrace being creative but almost demanded it from very early on. They really understood the value of being creative.

How did you become interested in illustration and design?

From a very early age I started to understand that I liked the idea of drawing and telling stories and making things for people. When I was in third grade, there was a drawing contest to design the season tickets for the Kansas City Chiefs, our NFL team in Kansas City. I won the contest, and my design was printed on all the season tickets for that entire season. I also won free season tickets and a football player came to my school and drove me around in a Ferrari, and an older girl in fifth grade asked me to be her boyfriend. And I can literally remember exactly where I was standing when it hit me: I'm going to be an artist. People will give me things and I can get older women, this is amazing. I really wanted to be part of the creative community.

What does creativity mean to you?

Creativity has always been a way for me to connect with my parents. And now it is something that I share with my wife. I love that we get to be creative together. Creativity to me is almost like another language. It's a language that not everybody can speak, but one that everybody can value and enjoy. I think it is really the backbone of civilisation. Creativity betters the human experience. That's why we are all here, to better the human experience for all of us through design, art and creativity. Everything in the room that we are looking at right now has been touched by a designer in some regard, at some point, to better our experience. Without creative people this world would be very cold and not a great place to live.

What kind of circumstances make you feel most creative?

I like to work under the gun—I really like tight deadlines. They force us to make some strong decisions and really work quickly. I like restrictions, they are a good thing for creatives.

I like creating on my own, but I also realise that my work is always better when I collaborate with other people who are maybe even better than I am. My wife Jessica is a perfect example of that. She's an amazing designer and brings skills to the table that I am not as good at. I also bring skills to the table that she's not as good at and every project we've ever done together is better than anything I did on my own, by far.

Do you have certain techniques to come up with ideas?

Roadblocks and creative slumps are real, but sometimes I also have to remind myself that although this definitely is a passion, at the same time it's also a profession. Your plumber won't tell you: "I can't today, I'm not vibin' to come fix your toilet". At the end of the day, we're asked to do a job and if you're having a slump, I have found that the only real answer is just to keep digging.

I think it's important to step away from your computer sometimes. Especially younger designers, who tend to think the answers are in that computer somewhere. I remember being a young designer, always feeling that I wasn't able to create the things I wanted to create. My taste level was higher than my skill level and I think that's true for a lot of young creatives. The answer to that is: just keep making things. Every mark you make and every idea you come up with, you're getting better. We forget that this is our form of practice. LeBron James doesn't just show up at the game every day and ball out, the dude has been practising his whole life at putting a ball through a hoop. It's not magic, he busted his ass. We have to continue to practise the skill that we want to be good at.

MISSING!

LAST SEEN: In the sky like maybe 5 months ago

DESCRIPTION: Yellowish orange, is a nearly perfect sphere of hot plasma, is a dope source of energy for life on Earth. Generally pretty chill.

If seen please call a friend and go outside and do fun stuff.

Where do you get your inspiration?

As I mentioned, my father is a big inspiration to me. He was born in the fifties and was a big fan of mid-century illustration and graphic design. When I was just a small child in the eighties, we used to draw together and he would bring out books and inspiration that he loved. Most of the time those were by artists and illustrators from that mid-century movement. The way that those artists and designers used colour and form and shape, humour and whimsy... those are all things that seeped into my subconscious at a very early age. The way I make things is very much influenced by this era that my dad introduced me to. I don't know if that's because I love it or because it's what I grew up looking at.

On the illustration side of things, I'm inspired by people like Alice Provensen, Miroslav Šašek or Mary Blair. From a design standpoint I've always loved Alvin Lustig and I'm a huge Alexander Girard fan. He's one of my heroes, I just love everything he ever did. One thing I love about Girard is that he never limited himself to being a fabric designer. He designed restaurants, products, books, countless objects. I loved how diverse his body of work was and that's something I always pursue as well. I very much hope my work is at its core very positive and optimistic because that's something that I like to put out into the world, especially in this era.

Your father also introduced you to one of your childhood inspirations.

When I was about five or six years old there was a book that I used to read every single night. I would try to draw the characters in my notebook and tie a little blanket around my neck every night and jump around my room pretending I was in this story. One day, my dad picked me up from school in the middle of the day and said "Somebody you really need to meet is coming to Kansas City to do a book signing". That gentleman was Maurice Sendak, the author of *Where the Wild Things Are*. I was blown away. I remember I brought my book and a stuffed plush toy, one of the Wild Things, and I stood there and shook Mr. Sendak's hand. He took the plush toy from me, and on one foot he wrote "to Tad" and on the other "love, Maurice Sendak". That plush toy still sits on my drawing table to this day. I have no clue what I missed in school that day, but I do know that will remember that day for the rest of my life.

What is your work process like?

I do a lot of writing before I start to design. I keep lots of sketchbooks and lots of loose-leaf paper on my desk at all times and when I'm starting a project, I like to do word maps and lists. I just start writing and writing and see what starts to pop up. While I am generating ideas that way, I do a lot of drawing, sketching, doodling. The idea is to generate as much shit as you possibly can. Trying to do that on the computer hinders you immediately, because the computer's goal is to make perfection. At that point in the project, we aren't about making perfection, we're about generating quantity over quality. So, we do a lot of sketching and concepting. It's always about concepts for us. Concept is king.

How important is playfulness to you?

We tend to do our best work when we are most joyful, when we're the happiest or our minds are in the best place, right? And to get our minds into that place often the answer is to play. I started a silly project that is as simple as: can I find one hour a week just to play and make things for myself? The idea was that I was going to play every Sunday, and I created a project called 'Sunday suns'. It's as silly as it sounds: every Sunday I sit down for at least one hour and design a sun. I do that before the sun rises; I get up before everyone else is awake, when it's still dark. I make some coffee, I sit at my desk and just make something for fun. It could be a logo, an icon, a painting, a sculpture, it could be whatever. I try to make as many different weird little things as I can. And, oh my gosh, it fuels me.

Tell me about your children's books.

I've written and illustrated more than twenty of those books. I've always loved children's literature. I was always pretty average at school, but something I always really loved was storytelling and books and literature, specifically picture books. Eight or nine years ago, I had an idea for a book. I started to write that book and it was eventually acquired and published and has now turned into more books, which are great examples of play. Illustrating a whole 32-page picture book is a ton of work, but they're fun and really rewarding. People have come up to me to tell me that their child is reading one of my books. That's the most amazing feeling in the world, to hear that something I made in my little office is touching someone's life. That's the value of design and the value of being creative, that we get to better the human experience and better people's lives through the things that we create.

The answer is to play.

How do you cope with failure in your creative process?

As a young designer, people don't tell you enough that you're going to create way more unsuccessful things than successful things. I create dozens upon dozens of logos and things and a lot of them are absolute, total crap. But at the end of the day all it takes is one good one.

Children's books are a great example too. Every one of the books that I ever had published was rejected probably twenty times by twenty different publishers, and that doesn't mean it's not a good book. That's what you have to remember about failure: if something doesn't succeed, that doesn't mean it's not good. There are a lot of variables that come into play, like timing. With any form of creativity, there are so many variables that determine success. A lot of times it's not actually the thing you're creating itself, it's the timing when it's being released, it's who you might be partnering with or it's about reaching the right people at the right time. So many young designers and creatives want to instantly make perfect stuff all the time, and it's just not that easy. There's no easy button you just hit and then it's done. It's good old-fashioned rolling up your sleeves and getting shit done. It takes time. Being creative is time, that's really what it is.

Are social media important for you and your work?

I don't know if important is the right word, but I think they are inevitable. They are part of our world and part of our creative vocabulary now. I'm naturally an extraverted human being, so what I love about social media is meeting new people and talking and learning about what they do and what they are into. I get energy from that. I love that they make our world so small. I think our studio and I myself probably get a fair amount of work from social media, specifically Instagram.

I think people also like it because it can feel like a little peek behind the curtain. We didn't get to see that from the people that we admired when we were going to school. We just saw Milton Glaser and Charles Spencer Anderson's work when it was done and it was perfect. It made me wonder what their process was like, what their studio looked like when they were working on it, what time they got coffee that morning. There's something kind of cool about being able to look behind the curtain every once in a while.

Has the Covid-19 pandemic influenced your creative life?

It has affected everything: the way I think, the way I feel, the way I work. We have to be more flexible now. Our entire studio is working from home, so giving one another grace and patience is key. Doing this with everyone in your life is so important right now. It feels like everything takes just a little longer than normal and we embrace that. This pandemic has made family and love so much more of a priority. If people are impatient, unkind and frankly not understanding, it is easy to walk away from working with them. Time is so important and I have no time for that.

What's the best advice that you have heard and still repeat to others?

A very simple piece of advice: learn to draw. Being able to draw is super important. Some of the most successful designers and artists and creative people I know are really good at just flat out drawing. I'm not talking about a perfectly refined Rembrandt drawing. They found a way to make marks that is perfect for them. That's what you have to figure out.

M A T T
A R

A lot of my works
are about questioning things
that we take for granted.

How would you introduce yourself?

I am an artist based in London. I am also the founder of United Visual Artists (UVA), a collaborative art practice I established in 2003.

What kind of family did you grow up in?

I'm the middle one of three brothers. Generally, I would say that I had a happy childhood. My parents didn't have much in the material sense, but we had enough for a relatively comfortable life. I guess you could say that I come from a working-class background. My mother was a part-time hairdresser, and my father trained to be a commercial artist, but he did an apprenticeship scheme rather than a degree. He was an illustrator for some magazine titles and natural history publications. He didn't persevere with his career in art because he had three children at a very young age, and the pay wasn't enough to support us all. He ended up becoming a publican of all things, so I partly grew up in those kinds of environments. It was a shame because he was talented, and I feel like he was a little bit frustrated by not following his passion. He continued to paint, but just as a hobby. Unfortunately, he passed away at a very young age. My older brother was the first person in our historical family to get a degree. He studied fine art, and he inspired me, so I followed in his path. My younger brother works in the performing arts, as an actor-director and writer, he's had a pretty successful career. I'm still quite close with my brothers and mother, which is good.

Did your childhood influence your creativity?

My father's other passion was music; he was in a couple of relatively successful bands in the sixties and spent all his money on records. He would design hi-fi sound systems, and he built his own speakers and amplifiers. He would often tell me about the incredible concerts that he went to in the seventies. The Pink Floyd concerts seemed to be his favourite; he went to great lengths to describe the theatrical stage and lighting sets and how the performance unfolded. The way he told these experiences was so compelling it must have profoundly affected me as I went on to work in that field in my early career.

Do you remember thinking: I want to do that too?

At school, I suffered from quite severe undiagnosed learning disabilities. Dyslexia wasn't noticed back then, in the eighties, so I had a miserable education. When I was about seven years old, we were given an art assignment to draw a large picture of a castle we visited on a trip. I got so intensely obsessed with this drawing, and to my surprise, it turned out remarkably well; my teacher and all my peers were very impressed. I was relieved to have finally found something I was good at because I was terrible at English and maths and everything else academic. It was because it was the only thing I could excel at and enjoyed doing.

You are the founder of a collective called United Visual Artists. How did you come together?

I studied both fine art and communication design at Camberwell College of Art in London. When I left art school, I worked mainly in live performance; designing scenography for performing artists. Someone in the industry told me that Massive Attack were going on tour, and were looking for their first visual component — I don't think they'd had an ambitious visual production before that point. I managed to get a meeting with Robert Del Naja, one of the band's founding members, and we seemed to have a lot of common interests in the visual arts. We didn't discuss specific design ideas in the first meeting; Robert talked about the inspiration for his *100th Window* album and other things we were both interested in. He liked the idea of creating a visual show using text-based information and no imagery.

So, I went away with this information for a couple of weeks, and came back with a stage design that acted as a window to a digital world, which had a narrative from macro to micro. It explored themes of information, disinformation and misinformation while localising it all to each performance, so every show would be different, interacting with that specific local audience and involving over 36 languages. Rob said, "Great, let's do it!", but I left that meeting without a clue as to how we were going to do what I'd proposed! I went along to this initial meeting with Chris Bird, who I'd worked with before, and who was a specialist in audio-visual production. He introduced me to Ash Nehru, who was the third original founding member of UVA. Ash had a background in computer science and wrote custom software for live production.

Between Rob from Massive Attack, myself, Chris and Ash we created a touring show that was considered groundbreaking at the time. That was the big trigger because it led to so many projects and a way of working that was perhaps unique at the time.

Chris and Ash have since moved on to do their own thing but the collaborative ethos of UVA continues today.

UTOPIA IS FAR

CLOSER THAN ANYONE

COULD HA IMAGINED

What does creativity mean to you?

Joseph Beuys once said that "Every man is an artist". I agree with this idea. Every man and every woman is born with creative ability; it's what makes us human. It's just that some people decide to make a living from their creativity, and others are unconscious of their potential. Most people are creative in their everyday life; you have to decide what clothes you wear, what food you are going to eat and how best to get through the working day. Then there are things like social media; the age of Instagram has given birth to a billion curators!

Creativity probably emerged as a necessary means for survival. We evolved to express ourselves to attract mating partners: "Look at me, I stand out from the crowd". It's also a fundamental means of communication. The cave paintings depicting animals 64,000 years ago almost certainly preceded words or names for things.

In contemporary society it's clear that creativity isn't something exclusive to the arts; you can be highly creative in almost any field of work. Ultimately, it's about making something out of nothing, having an idea, and manifesting it into reality, which is an amazing thing to able to do if you think about it.

What kind of circumstances need to be fulfilled for you to be creative?

A deadline, for one *(laughs)*. Joking aside, I have to be in good mental shape, most importantly. Being tired or stressed makes it impossible for me to focus on anything, so I need to look after myself.

I tend to find that constraints help me, whether they are self-instructed or set by a project's parameters. That's why I think the 'canvas on the wall' has been such a well-explored format in art. Sometimes we need constraints to be creative; otherwise, the possibilities are endless, which can be overwhelming. I did a VR project a couple of years ago, and it's one of the most challenging mediums because you can do anything as your canvas is 360 degrees. The constraints are more technological, like how much can be rendered in real-time.

Where do you get your inspiration from?

Inspiration can come from any aspect of day-to-day life, from the banal to the sublime.

My dyslexia makes reading a painfully slow process so audiobooks have an absolute revolution for me in recent years. I go on a long walk nearly every day and listen to them.

I also get inspiration from just doing the projects and making the artwork with my team. One project or idea generally leads to another so the creative act tends to be an iterative process by its very nature.

Who—dead or alive—would you like to have dinner with?

In these polarised, post-truth, Covid-19 times I would choose George Orwell, Alan Watts, Daniel Dennett, Carlo Rovelli, Marcus Aurelius, Robert Irwin and Malcolm X.

Is interactivity with the audience important to you?

It depends on the concept. When we made *Volume* some years ago, interactivity wasn't a word that came into the discussion. Responsivity, perhaps? The work consisted of fifty light and sound columns that you walked through, and your proximity influenced the installation as a whole, so you became a performer of sorts. I was looking for this kind of magical quality where you knew your presence was affecting the artwork, but you had no idea how it was happening. Around this time, the term 'interactive art' was coined and became a bit of a fad. Everything we made from that point was referred to as 'interactive art', even if it had no interactivity at all! That's why I became a bit weary of this direction of work. Having said that, you could argue that all art is interactive in some way, it's a two-way thing between the artwork and the viewer, isn't it? Our installation *Spirit of the City* isn't interactive in a technological way, yet you become a part of the work simply by participation. Your shifting reflections immerse you, so you could say this is a type of interaction. Many years after *Volume*, we did a work titled *440Hz*. For this project, we collaborated with the theoretical neurobiologist Mark Changizi. His work looks at the evolution of music and how we have learned to move our bodies as a means of survival.

MESSAGES OF DECIPHERING
MESSAGES OF DECIPHERING THE
MESSAGES OF DECIPHERING THE
 OF MESSAGES THE IMPOSSIBLE
 OF MESSAGES THE IMPOSSIBLE
 OF MESSAGES

As you enter the installation, every tiny movement you make is tracked. This data is then interpolated into something that suggests musical notation both visually and sonically. The more repetitive your actions, the more the sounds suggest a kind of music. It's quite funny watching how people behave when they interact with the work. I haven't seen many artworks that make people act so strangely.

What is your primary consideration when creating a work?

When I'm 'imagineering', which is to say meditating on a new idea for an experiential installation that doesn't exist yet, I'm always thinking about the experience and how it will make people feel. I'm more interested in how my work resonates on an emotional level than an intellectual one, in a similar way to how music works and makes you feel. Quite often, the subjects that I'm drawn to are elusive or ineffable by their very nature, so the ideas are best understood in a three-dimensional space and through the passage of time.

For example, the work *Our Time*, consisting of twenty-one mechanically controlled pendulums, was designed to manipulate the viewer's perception of time. The pendulums would appear to swing naturally and in unison, and they would then begin to move randomly at different speeds, eventually slowing down and stopping at impossible angles. It would feel like the laws of gravity no longer exist, and time is slowing down. The experience really messes with your process of inference, and you almost have a physical reaction to what's happening.

Do you want your work to ask questions?

Isn't that the point of art, to create a space for discourse and to question things? *Our Time* started with questions and it ends with them too. Our initial debate in the studio went something like: "How long is a second? Do we all experience time in the same way? How long is the present moment? Is time merely the measurement of change and therefore, only a human construct or something real?" When the public view the work I hope that these sorts of questions continue to arise.

This is partly where the desire to make installation works comes from, so that we can create space for contemplation. We seem to live in an accelerating age of distraction. Our busy lives and things like social media leave us with very little room for inquisitive reflection. It's also a selfish act, I want to create spaces where I can forget about my everyday life momentarily, so I am also designing for myself.

Is colour important to you?

Light is my primary medium, and like any medium, it has all sorts of challenges when it comes to colour decisions. Black or brown colours aren't an option, so your environment becomes a part of the palette. Light has to reflect something to become visible, so any materiality will influence light from the source. Historically, I've gravitated towards monochromatic palettes; I think that's because quite often I'm trying to take complex ideas and reduce them to their essence. They end up as kinds of graphical models of reality, one could say.

Has the Covid-19 pandemic influenced your creative life?

It's difficult, because it has lasted a lot longer than we expected and it's still not clear how it will end. At the beginning it was relatively novel, I felt a great sense of relief that I didn't have to travel for a while, I could take some time off and almost have a bit of a sabbatical. Nearly all of my projects are public-facing, so one by one, everything was cancelled or postponed indefinitely, which led to some significant challenges to running a studio. I think it will change the way I run the studio in the future. Working remotely has worked out well for both my team and I. We need to work together, especially in the workshop, but I have found it hugely beneficial to work at home alone on certain things without the distraction of a busy studio. I also want to be more conscious of what types of projects I undertake to contribute more to a better post-Covid world.

What is the best piece of advice that you've heard and still repeat to others?

If you are starting out in your career, be wary of social media. Use the internet as a tool for promoting your work but not as your primary source of inspiration. Get out into the real world to find it. It's far more nourishing to experience things first-hand, and you're less likely fall into the trap of comparing yourself to others, which can be incredibly debilitating. It's what makes social media toxic, in my opinion.

Collaboration doesn't necessarily mean compromise. Some people prefer to work alone, which is fine. Through working with others, I found that I could work on projects that would have been impossible independently. I like to have others around to bounce ideas off of. So, look out for like-minded people but make sure they have different skills to yours so you can own your space within the relationship.

JAMES DIVE

You've got to risk it
to get the biscuit.

How would you introduce yourself?

I would usually describe myself as a designer, artist and director.

What kind of childhood did you have?

Very typical. I grew up in the sprawling Australian suburbs with my family and three dogs, a shed for creativity and a big backyard.

When did you feel that you wanted to become an artist?

I actually always wanted to become an architect. However I pivoted to design at university but then soon worked out that a lot of my work wasn't really like other designers'. It always looked much stranger... I was never really focused on the visual outcome. I tended to come at things more from a conceptual viewpoint than an aesthetic one. I gradually realised that ideas rocked my boat just as much as aesthetics, and I think that probably led me to where I am now.

What does creativity mean to you?

I generally stick my nose where it doesn't belong. There's an element of the chase that I like. As I said, I really love ideas and I especially love great ideas. So, when I get a project or a problem to solve, usually my main aim is to outdo myself in terms of what kind of concepts I can come up with. So usually I put myself in a self-imposed cave, and I'll just chase that idea. It's always the idea that leads. I usually know I've got the right idea when I become massively enthusiastic about making it. Then I park the idea and switch on to the aesthetic and the execution side.

Is there a place where you are most creative?

I always laugh when people ask me how I come up with an idea. I've never had an idea walking on a beach or sitting in a café. For me it's all about work. I have a studio at home, which is just a small writer's studio with a desk in it. And I just sit there with a pad, music on, and I just write. I'll put an asterisk next to something if it's interesting, but I won't let myself stop. This goes on for a couple of days. And once I've gone through the process, then I'll review. I see it as a process that I trust and go through every time. When I am sitting there, I am doing ideas. And when I'm not sitting there, I am not doing ideas. It doesn't matter if I am sitting at my desk or in my studio, or on a plane, but it has to be a literal choice of doing creative work.

Are you a morning or an evening person?

I am definitely a morning person. I'll start at seven, usually in my studio, and my golden hours are before lunch. For me the afternoon is not very good for ideas, so those are filled with meetings and emails.

What inspires you?

Interruptive creativity. Creativity that makes you take a step back. That's the kind of creativity that I love. When you're just going to do some shopping, or catch a bus, and then you are arrested by something great. I think if I had to trace one moment that has shaped my creative career, it would be when I was sixteen. My family and I came into the city on a ferry from Manly. We passed the Museum of Contemporary Art and out in front was Jeff Koons' puppy. For me at sixteen, it was odd that something like that existed. It was outside of the gallery in the public space, and it was so unexpected. Up until that point I'd always assumed art was something for quiet galleries, and this really changed my view of what creativity could be. It felt punk in a way, and it had an audience of people who, just like me, weren't necessarily there with the intention of seeing art.

Which artists inspire you?

Jeff Koons, as I mentioned, was a big early inspiration for me. But my practice has become so diverse, I tend to seek inspiration from all sorts of creatives and projects. Jeff Wall, Cai Guo-Qiang, Heatherwick Studios, and John Baldessari have always been favourites.

What prevents you from being creative?

For me, the interruptive nature of technology. I think everyone, including myself, can get really bogged down in all that crap. Of course, technology is a massive tool, but I find I have to manage it. Otherwise suddenly your day becomes reactionary.

How important are social media to you?

I think they help open up the conversation around your work, but they must never be the aim. I love creativity that physically gets in the way, something that gives your daily routine a jab to the ribs. Sure, a social feed can do this, but nothing beats real, tangible interactions—and the tangible is on the rise as a direct consequence of our increasingly virtual lives. A recent study among 18 to 24-year-olds rated experience above everything else in terms of consumer goods. People want to feel things, they want to touch things.

How important is humour in your work?

Humour can be a great tool to start a conversation, both good and bad. I sometimes tend to employ humour, or whimsy, on a surface level that is intended as a gateway for larger conversation. For instance, the intention behind the raining house (*I Wish You Hadn't Asked*) is that the work evolves during the exhibition period with over two hundred litres of water raining into the interior of the house every minute. At the start, the work is a whimsical, detail-perfect family home. But four weeks in, six weeks in, eight weeks in, the work takes on a completely different meaning. The incessant rain causes paintings to run down the walls, furniture to crumble and household belongings to rot. The work is about a relationship slowly crumbling. At the start, it seems very light and fun and by the end it was a very oppressive environment that is undoubtedly confronting for many.

What about the titles of your work, do they have a deeper level?

Sometimes. For example, *It Wasn't Meant to End like This* was made during a period of my life where I was often being my own worst enemy. So, the title fit well with the sage characteristic of the work. People still write to me asking whether the buried digger has found its way out yet.

Does your work have a social meaning? Do you want to help people connect?

Yes, absolutely. I think that everyone feels like our community is under pressure in a way, because we communicate so much online. We tend to all look down at our phones when we are in public. One work, titled *Us*, photographed groups of strangers in the style of a school photo, arranged from tallest to shortest. What was really interesting about that work—and this wasn't planned—is that after every photo we took, and we took thousands of group photos over that period, everyone would clap, every time. We never told them to, but every group applauded once the photo was taken. The work also resulted in a recent marriage.

I've never really been so much about what I feel,
but more about how *we* feel.

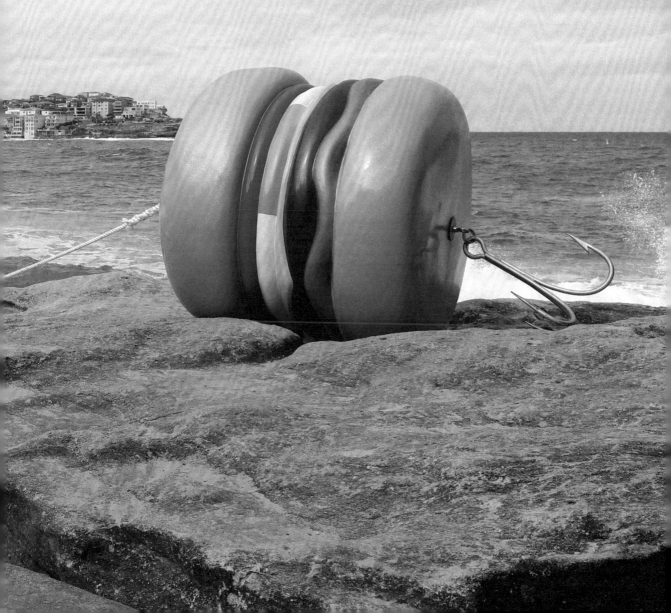

Does your art have to be provocative?

Sometimes it is provocative, but I am never provocative for the sake of it. For me it's about capturing people's attention, their imagination, and striking a chord within them. I've never really been so much about what I feel, but more about how *we* feel. There's always been a community element, like a human truth, what we go through collectively. And I think that's why people often relate to my work.

For instance, *God's Eye View* was hugely provocative. I didn't see that coming, because the idea came from my interest in satellite photography. I considered it the only art medium that wasn't made by a human, because it is scientific photography made by a machine. It went unquestioned, and it was completely trusted. So, I thought: let's mess with that trust, let's use satellite photography to show something like religion and see what happens there. I created four scenes: *Moses*, the *Cross*, the *Garden of Eden* and *Noah's Ark*. That caused a huge stir. A respectful debate, but still quite a debate, I would say.

What's the difference between your own work and your promotional work? On your website you show your commercial and personal work on the same page, which artists don't usually do.

That was a quite deliberate and recent change, because I used to keep it very separated. But the truth is I direct films, I do art installations and I like to lurk between those worlds. I work with galleries, museums, record labels, design agencies and of course just for myself. Basically, if I think there is an opportunity to push myself into new or interesting territory, that will usually make me begin a dialogue on that project. The source of creative opportunity, I believe, is always best evaluated with an open mind.

What is failure to you and how do you incorporate it into your work?

Failure is very important and I think you've just got to be willing to risk it. As they say: you've got to risk it to get the biscuit. A lot of the projects I take on are the ones that are perhaps unwise or difficult. But I think if you're not willing to risk it all, you wouldn't end up with something like a raining house.

Failure is a good motivator as well. When you are ambitious, you really need to be at the top of your game. You need to have the right people around you to try to minimise those risks.

Often an audience will not just respond to how something looks, but also to the ambition of a project. Risking failure shows heart, and you can always tell if a work's got heart.

What's the best advice you've heard and repeated to others?

There's only one thing written on the wall in my studio: "Trust the process". That, to me, says it all. Often things we do are deadline driven; you're running out of time or you haven't had an idea yet you think is good. I just stick to the same process every time, which takes the pressure off. Just trust the process, do the time and then the idea will come.

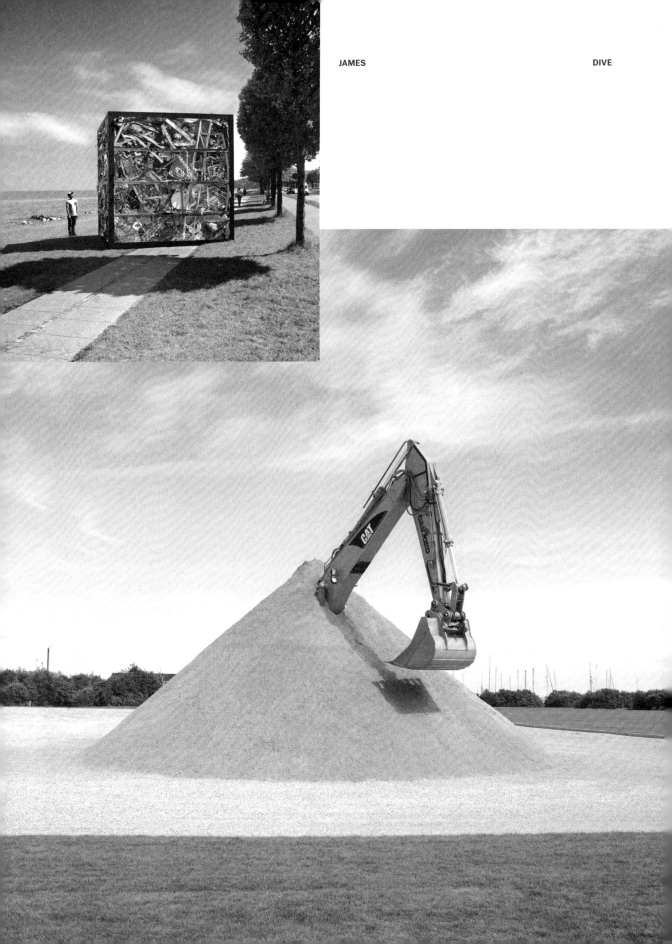

SOUKSEN

I am a visual adventurer.

How would you introduce yourself?

When people ask me what I do, I could say I'm an illustrator, but I don't think that's the right word. I call myself a visual adventurer, because I enjoy doing and making a lot of different things, so every story has a different format. I like collaborating with animators, I make paper things, moving things, jewellery. I like working together and alone. So, I would call it being adventurous in the world of image and not specifically sticking to one field.

Did you grow up in an artistic family?

I grew up in a house filled with abstract paintings. I have two fathers and they're both architects, so I find architectural drawings and the process of making maquettes and scale models really beautiful. As children we also had a room to ourselves that was full of games and toys, but also a lot of things to be creative with: art supplies, clay for sculpting,... My childhood holiday photographs usually picture us building a camp and then drawing or cutting shapes inside it. When visitors came, we would make hats for them. Making things was really a part of our daily ritual. My mom would just let us have our own adventures, in our own playground, which I think was really wonderful and it allowed our imaginations to grow.

What does creativity mean to you?

Creativity to me means being really close to yourself, in your own bubble with whatever input you've got, whether it is your own idea or an assignment. It's about forgetting about all the obligations and letting your creativity flow, and then being surprised by what comes out.

For me, creativity has never been an easy road. Sometimes I try to return to the creative flow I had as a kid, making basic things. It's a state of being that just happens to you, flowing out of your fingers and going through your mind. I ask my students this as well: "What are the circumstances you need to make your work come to life?" It isn't something that happens every day at nine o'clock. It's very unpredictable, but thankfully it always returns. Sometimes it's good to go back to the things that you are good at and enjoy doing. You can lose track of your flow because of all the distractions you deal with as a freelancer. You have to spend so many hours a week on communication, organising things, sending invoices or getting telephone calls. It's really hard to create a habitat that you can actually do your best work in.

What kind of circumstances need to be fulfilled for you to be creative?

I need an idea or a story that comes from a question that I don't know the answer to. It always excites me when I don't know exactly where I'm going. I've realised that I work well at night or when no one is waiting for me. As soon as I have an appointment later in the day, I get a bit nervous or distracted because I have that appointment on my mind instead of that feeling of endlessness, when you can let anything happen. I also need people around me to communicate and exchange ideas or concepts with, because a totally solitary process is not for me.

Who inspires you?

I like artists who play and create worlds. The world of Charles and Ray Eames inspires me. They made so many different things, from kites to toys to interiors, purely out of enjoyment for themselves and the people around them. I think that's beautiful. Another very exciting artist is Mike Kelly, who also combined many different types of projects, including more personal ones. Every story had a different format, from textile to a floating metal sculpture or wonderful big drawings.

Does your work have to brighten up the world?

I don't have 'making a more beautiful world' in the back of my mind when I'm working. Actually, the world around me is kind of crumbling. There's a lot of conflict, and sad things are happening. The future is not too bright and it hurts my heart. I am also a bit of an activist, something I get from my mother's side of the family.

When I look at the themes in my work, it's about making your day or your life a little lighter or brighter. It's not specifically an outcome I go for, but it does end up that way. I guess my choice of colours does emphasise this. But it's not like it's my mission to paint rainbows everywhere.

I've been making little good luck cards since I was nineteen. I started at Christmas time, when my mom would force me to design Christmas cards, and I wanted to create something for our family and friends that they wouldn't throw out right after the holidays. So, these 'good luck passes' are valid for exactly one year and each year there's a new one, each time with a different theme. I think I've been making them for fifteen years now. People say it really works and I believe them. Another example of an idea that started from something small, but ends up making other people happy too.

How important is colour in your work?

I work mostly in colour, and occasionally in black and white. Colour is important. I prefer not to use thousands of different colours and I'm not really a fan of saturated colours, never have been. Growing up, I was surrounded by a lot of abstract art, which also had simple colour use and simple shapes.

I do colour researches for certain projects, but when I'm making things out of paper, there aren't a million colours to choose from and somehow, I always end up with a yellow or a red and a blue. There is lots more to be discovered, so I would like to do more with it.

What is your work process like?

I start with big pieces of paper that I fill with written and sketched ideas. I didn't have a computer while I was at art school, so I actually made everything by hand. I would often cut paper or create shapes with ink and then photograph what I drew. I used to scan the pieces of paper, but that's a lot of work, so now I make very small drawings and then blow them up on the computer. That's how an image usually starts. A circle can be made in Illustrator, but usually it's inspired by cut shapes or hand-drawn shapes, and I develop it further from there.

Who or what has been the biggest influence on your way of creative thinking?

I believe that everybody is a creative thinker. I also believe that creative thinking is always happening and developing. The things that inspire me can come from daily conversations with a stranger or a beautiful picture, or the way someone sees a thing or the world. I once had a teacher who said: "A character with no eyes has no life". Those are the kinds of things that I never forget. Whenever I make a figure with no eyes, I think of him—so in this case he did influence me, but I don't always listen to advice.

I generally just really enjoy seeing people doing their own thing and being really passionate about it. Erik Kessels, for example: I think it's wonderful how he dives into these photography archives and re-archives them in his own way. Maybe it's a universally human thing to be obsessed and fascinated by something. I think sharing those fascinations with each other is really nice. Even conversations with my mom about what I'm making can be inspiring.

What is failure to you?

In my creative process, I always go through a phase of making a lot of things that don't satisfy me. I have a friend with whom I share my failures or 'ugly things', to make it okay to look at them. I always go through this rough patch where I feel lost, not knowing where I'm going. I have come to realise that I need failure to advance and grow.

I have the same conversation with students who expect to always be making better work, comparing themselves to the people next to them. Everyone has their own process. I've come to embrace the failure. Actually, a process without failure and challenge is not one that satisfies me very much. Somehow, I always know I'm going to be unhappy before I'm happy, which might be a cycle that I'm used to. Maybe that's the way life works for me.

Has the Covid-19 pandemic influenced your creative life?

The pandemic has put a lot of things into perspective for everyone. We're figuring out what is meaningful to us, what we need and miss, and what we can do without. Creatively, Covid-19 has given me more room to breathe and therefore more headspace. The assignments have continued to come in, but deadlines seem to be less rigid. I have also discovered how lucky I am to have my own studio space. I share eighty square metres with one other artist, so there was always enough distance, as well as good company. Somehow when we were inside our studio, we could almost forget what was going on in the outside world.

What's the best piece of advice you've heard?

A piece of advice that I give to students—and to myself during a creative process—is that when I'm stuck or I wonder why it's not working the way I want it to, I try to recall the last time that it did work. What was I surrounded by? What was the time of day? What was I listening to? Then I try to recreate this habitat so that I feel comfortable and ready to let the creative process bloom.

Everybody is a creative thinker.

BENDT
EYCKERMANS

I never really plan what I am going to make.

How would you introduce yourself?

That's a difficult question, because the best way for people to get to know me is by looking at my work. I am a timid person and I mostly work in my own environment and with my own inner circle of friends, whom I depict in my paintings. The easy answer is that I am a painter.

What kind of family did you grow up in?

I grew up in a very artistic family. My father is a teacher and the principal of the night school of the Academy of Fine Arts in Antwerp. He teaches art history and printmaking. My mother is a stylist, she works for magazines and big companies like McDonald's.

I remember the first time I went on a playdate at a friend's house. I was about five years old, and I was so surprised that they didn't have any sculptures or paintings in their home. That's when I realised that I had a very artistic upbringing. I was always surrounded by the works of my father and grandfather and great-grandfather, and the works of artists that they collected.

When did you know you wanted to be an artist?

I don't think there was one moment, I just went along with the flow of life and gradually I realised this was something I wanted to do.

Was going into the arts supported by your family?

Strangely, no. My father wanted me to look for a serious job so I would have a steady income. But they accepted that I wanted to study art. They just wanted to make sure that I had a good life.

Your atelier used to be your grandfather's, you are surrounded by his work. Does that feel like pressure?

It's interesting, because I never really knew my grandfather. I was three or four years old when he died, and now I live amongst his work every day. His work is a shadow of his existence and through his work I get to know him better. I also paint a lot of his works so I can understand his way of sculpting and making things.

You paint everyday scenes based what you see in your daily life in Antwerp, portraying your friends and the subculture of your own generation. Why?

Most artists function as documentary makers for their own time. Every movement says something about the time it was created in, and I think it is interesting to incorporate the vibe of this generation into a painting.

Do you implement art history into your works, transferring it to our current times? What kind of artists do you reference in your work?

I don't reference any artists directly. For a painter and an artist, this moment in time is very interesting, because almost everything has been done before. All the paths that a painter can take have been cleared, so as a painter you can look at the whole of art history and combine it in your work or recycle it and make something new out of it.

I am influenced by a lot of Belgian artists because I find it important to make my work as Belgian as possible. I wouldn't feel comfortable painting palm trees or a Chinese city. I want to incorporate my local environment into my work and I also want to be part of Belgian cultural history. Belgian painters have influenced me from the beginning. I remember going to museums in elementary school and seeing big Rubens paintings. That's where my fascination for hands and feet started. I also remember seeing Permeke and being really touched by his work.

What is your fascination with hands?

I think you can tell a lot about a person by looking at their hands. The first thing I notice when I meet someone new is their hands. Within two seconds I will have noticed if someone is missing a finger or something. I think that there is so much character in hands and in the use of hand gestures.

Is it true that you don't want to overanalyse your own work?

I overanalyse everything in life and each of my paintings has its own personal story, but I find it uninteresting to explain that to a viewer, because what's left for them to think about if they already know exactly what it means? My paintings are already so clear in their depiction of people because of their realism. A chef doesn't chew the food for his customers, they have to taste it for themselves.

Is painting a way of communicating for you?

For a long time I was a very quiet and introverted person, I would barely speak. My paintings have really helped me understand myself and they also helped my father, mother, brother and sister get to know me better. I am still learning about myself through the paintings I make.

How would you describe your style of painting?

Figurative painting. Magical realism, maybe.

How do you know when a painting is finished?

That is the challenge for every painter. I think it is a feeling. The way I see it, a painting is never finished. It is really hard to know. Maybe a painting is finished for me when when I am tired of it. Then I put it away and don't look at it for months.

Do you work on one painting or several at a time?

I only work on one painting at a time. I want to concentrate fully on the work. I work a lot around feelings, which are very volatile and evaporate quickly. That's why I want to work on one painting at a time, so as not to lose this feeling.

What does a day in the life of Bendt Eyckermans look like?

I wake up early and have breakfast. I chat with my girlfriend and then walk to the studio and paint for an hour or two. I'll sit on my sofa for a bit, then start painting again. Next, I'll eat lunch and then start painting again. And this process lasts until seven or eight o'clock in the evening. After that, I have dinner with my girlfriend and maybe watch a movie at the cinema or at home, and then go to sleep.

Can you only work in your studio?

I can work everywhere, but this studio is fantastic. It is so much a part of me that if I were ever to live in another city, I would rebuild my studio exactly as it is now. With the same statues and junk that was left lying around by my family. It is not just a part of my family or who I am, but it is also my biggest inspiration. It is truly one of the best studios a painter can have.

Is Antwerp, the city you live in, important for your work and for you as a painter?

Yes, I get a lot of inspiration from my city. When I don't know what to paint, I take a long walk and see ornaments or beautiful buildings or fascinating people on the street and photograph or sketch them. Like I said, I want my work to feel local. It should be the depiction of my world, my atmosphere.

What is creativity to you?

Creating things.

Can you elaborate on your process?

I never really plan what I am going to make. Something might happen in my life or I might get a certain vibe from a situation and I then want to incorporate that into one of my works. I just paint as the inspiration comes.

Do you use notebooks or doodle in books?

Yes, I always carry around a little sketchbook that fits in my pocket, to make sketches of interesting compositions. My sketchbook is also full of thoughts about things I see in the street or details from other artworks that I find interesting. It's a kind of mood board in a book.

Sometimes I call up my friends to come do some interesting poses in my studio. I just take pictures of them with my phone. I would love to paint from live posing but I don't think my friends have that much time. And I don't ask it of them.

How important is colour in your work?

It is common sense to me as a painter that colour is of real importance. There are times when I hate one specific colour, and I'll say to myself that I'll never use that colour again, but a few months later I'll find myself making a painting using almost exclusively that same colour. My taste changes often. The colours I use stem from the emotion I am working in. There are books that connect certain colours to certain emotions, claiming for instance that orange represents danger or that yellow has a calming effect. But I think the emotion that a colour evokes for you is very personal.

Does your work have to brighten up the world?

I like to think that my work gives beauty to the world. Some of my paintings are beautiful in an aesthetic way but are at the same time very melancholic, some might even say depressing, so I don't think I bring a lot of happiness to the world.

There is a lot of storytelling in your work, it's very cinematic.

One of the reasons why I chose to paint was because I used to read a lot about movie directors, and it turns out that a lot of movie directors or directors of photography started out as painters. I thought I wanted to be a movie director and I wanted to start painting to challenge my way of looking at the world and depicting things. But I soon discovered that I wasn't very good at working with other people. I found that as a painter, I could do everything myself. I am my own director, DOP, scriptwriter and location scout, and that works much better for me. But I do get a lot of inspiration from film and I think the cinematic part of my work can broaden the viewer's interpretation.

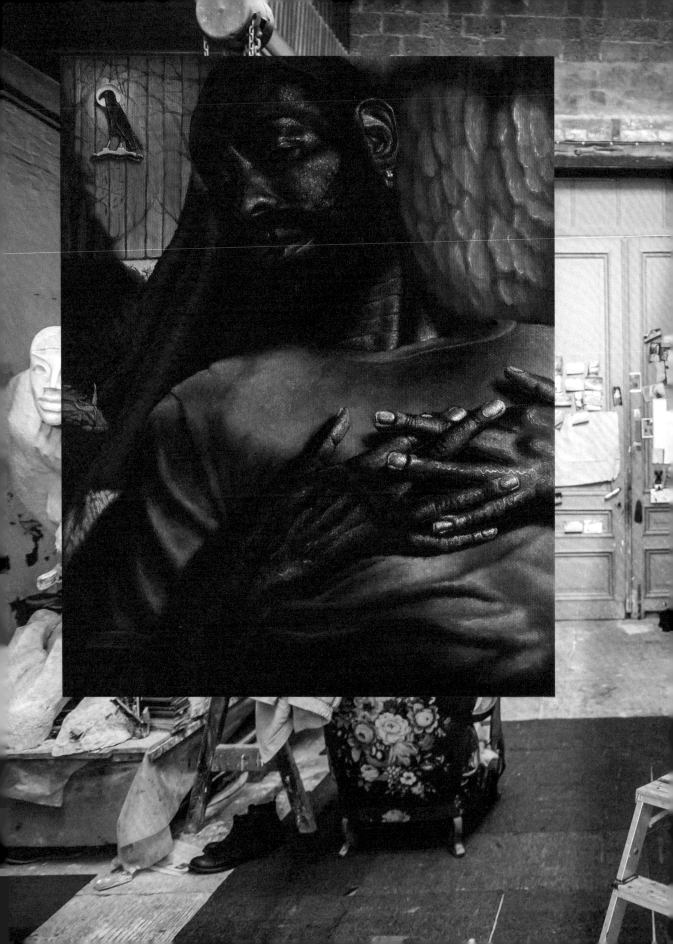

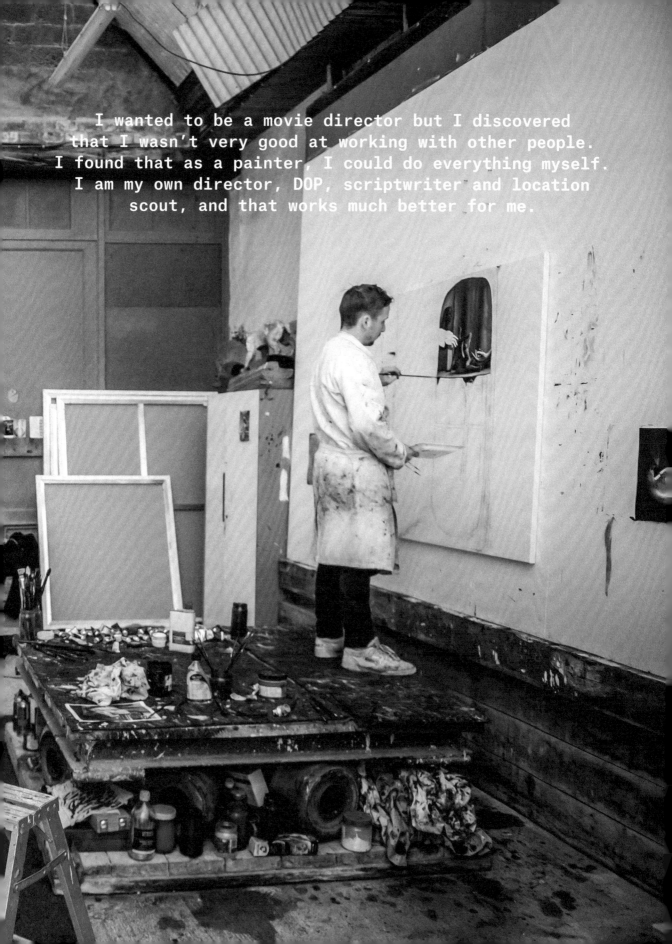

I wanted to be a movie director but I discovered that I wasn't very good at working with other people. I found that as a painter, I could do everything myself. I am my own director, DOP, scriptwriter and location scout, and that works much better for me.

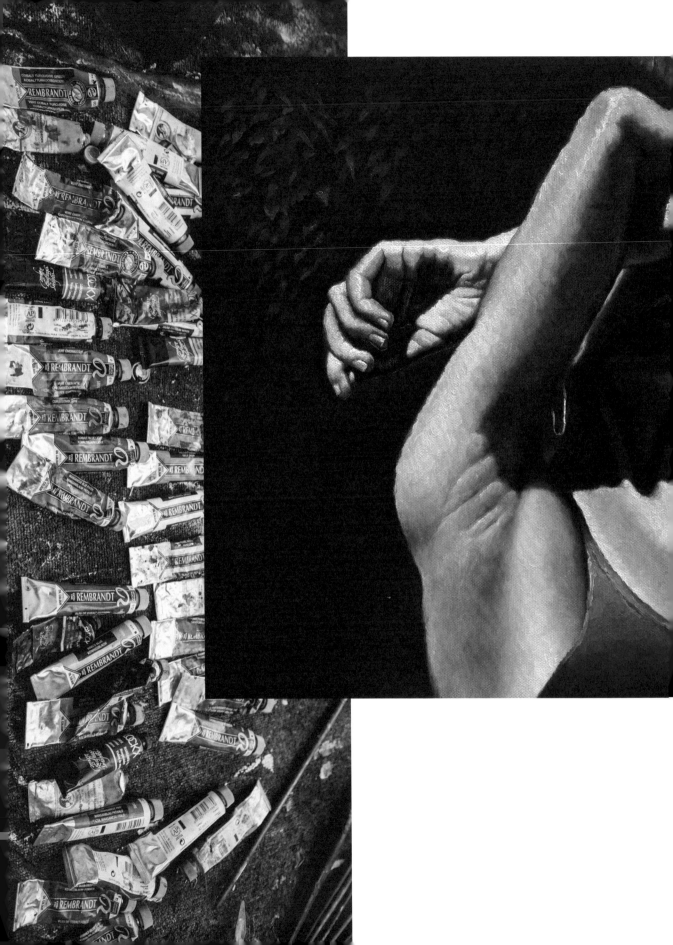

Who inspires you?

Robert Bresson. We have one thing in common, he also focuses on hands a lot. I'm also inspired by the stylistic aspect of Martin Scorsese's and Michael Mann's work. The painters Georg Baselitz, Lucian Freud, Pierre Alechinsky, Bruegel, but also Egyptian and Etruscan murals, and ancient Assyrian paintings and murals.

Who—dead or alive—would you want to have dinner with?

I was talking about this with a friend and I thought I would ask Bruegel, because I don't know him and I want to ask him what his time was like, what his use of symbolism means and talk about his painting techniques.

It would be so interesting to talk to him. More so than talking to Picasso, because we are not that far apart in time and so much has already been written about him that you can just look up. Bruegel is both an inspiration and a mystery to me.

How important are social media to you?

An art critic for *The New York Times* said that having a good Instagram account is becoming more important than getting a good review in *The New York Times (laughs)*. When someone talks about an artist, the first thing they do is look the artist up on their phone, so it is very important.

Are you very active on social media?

I don't post that much, mostly Instagram Stories. But I do look around a lot. It's a good way to find other inspiring artists to talk to. I've even traded works with another artist via Instagram.

What does failure mean to you?

Making a bad painting. It is hard to tell what a bad painting is, because you can make a very crappy drawing but someone else might think it is great. I get really depressed when I fail in my work. I often finish a painting and I know I will never show it to the world. But making bad work is almost more important than making good work, because you learn so much from it. It's a cliché, but you learn more from your failures. When it happens, I dismantle the linen from the frame and I roll it up and put it away. Sometimes I even throw bad paintings away in the trash or hide them in the attic.

How do you react to feedback?

I think it is boring when people say my work is good. But I also think it is annoying to get non-constructive criticism. I am a very stubborn person, so I don't react right away. I will think about it and if I understand why they said what they said, then I might implement their feedback or learn something from it.

Do you have people that you listen to?

Probably my father, he helps and guides me a lot. It hurts the most when he criticises my work. I also have a lot of good friends that are also artists who I can talk to about my work. I think it is important to talk about your work.

Has the Covid-19 pandemic influenced your creative life?

During the early stages of lockdown I soon realised that the measures taken by the government didn't really have much impact on my personal life. My work ethic is like that of a recluse. But I can say that, because the entire art world slowed down, I had more time to breathe, which could not have come at a better time in my creative process.

What's the best piece of advice you have heard and still repeat to others?

Follow your intuition.

EMILY FORGOT

By distracting yourself, you allow
the best ideas to sneak up on you.

How would you introduce yourself?

I am a designer. I make imagery and artwork for clients and for myself as well, in the hope that other people will want to buy it. My pieces are bold, colourful and playful.

Is Emily Forgot your real name?

I started going by Emily Forgot when I was in college, about fifteen years ago. I decided to start a portfolio website for my work and I didn't want to use my name, because it felt a bit ordinary. So, I started thinking up some personality traits that I could use as a pen name and I chose 'Forgot', because I was quite forgetful at the time. Although I've become a lot less forgetful since and I always hit my deadlines.

How did you grow up?

I grew up in a quite creative environment. I do sometimes wonder if I would I be doing what I am doing now if I hadn't. My dad was a curator at a gallery in Sheffield, where I grew up, and my mum is a French teacher. We often visited family in the South of France, where my mum is originally from. I also spent a lot of time in gallery spaces looking at artwork. Travel and art are two aspects of my upbringing that have really influenced the work I make. But I never really wanted to be an artist. I was always more interested in more accessible things like comic books and record sleeves and book covers. Although I wasn't intimidated by art and I felt at ease in these gallery environments, I liked the idea that things were made for a reason other than just to be observed. So, my love for design started quite early on.

When was the first time that you knew that you wanted to be a creative?

I knew very early on that doing something creative was my path. Even as a child, you know what your strengths are. You just know where your enjoyment lies and you notice that people often praise your drawing skills. I knew that I was never going to be a mathematician or a doctor. I would love to be more helpful, but those subjects weren't really my strengths.

What does creativity mean to you?

Creativity means happiness. I can't imagine living without it. It's like food and water to me—or perhaps more like friendship, as you could technically live without it! All human beings are creative, there are just some people who explore it more or make it their job and make a living from their creativity. But everyone is making creative choices all the time, from the way they get dressed in the morning to the music they listen to or the things they surround themselves with at home.

What kind of circumstances need to be fulfilled for you to be creative?

I need to avoid distraction, which is really difficult in the age of the internet and social media. It isn't necessarily conducive to creativity, but at the same time a lot of my work comes out of being curious and making discoveries on the internet. As long as I am in a clear headspace and nothing stressful is happening outside of work, then that's a good space to be creative in.

Do you have a preferred time to be creative?

I am sharper in the morning, especially the first half hour after I wake up. Throughout the rest of the day my concentration tapers off a little bit and then I can become distracted.

Do you have techniques to come up with ideas?

When I feel like I am trying too hard, going for a walk to get away from the problem I am trying to solve usually works for me. Sometimes thinking about it too much and being too focused can actually hinder your ability to come up with ideas. By distracting yourself, you allow the best ideas to sneak up on you. You can't tease them out, you just have to carry on thinking about something else for the Eureka moment to happen.

I seem to attract projects with an open brief. This allows me the space to come up with an idea within a sort of umbrella concept. Quite a long time ago I was asked to make a design for the Selfridge's windows. It ran at the same time as an exhibition of Alan Aldridge's work in the Design Museum. His work is quite trippy, with a sixties, seventies kind of feel, so they wanted something kaleidoscopic. I was able to explore how I wanted to interpret that theme, rather than having someone tell me exactly what it had to look like. An open brief, set within certain parameters, is the nicest space to work in. I like making my own work, but the really great projects are often when there is a perfect synergy with a client.

Where do you get your inspiration from?

I'm obsessed with interior design, furniture, architecture and interior architecture. It's not always answering the brief to filter those interests into projects, so that's why I love my personal work. It allows me to indulge in the things I enjoy. I'm interested to see how my work is going to develop over the next few years, because I would like to work more within three-dimensional spaces and continue to do more environment design.

Your personal work is inspired by architecture in a very abstract way.

My personal work is somewhere between abstract, real, two-dimensional, and three-dimensional. I'm still exploring it, and I enjoy not quite being sure how it's going to develop, but it still has common themes with the work that I was making ten years ago. I've always enjoyed the surreal elements that would find their place in my work. Those are still present in what I make now, although possibly with a more grown-up approach to it. Or maybe not? It is still quite childish.

Who inspires you?

I don't think I could pick one person. Your personal creativity and how you develop a unique way of working comes from having a huge number of influences that are all combined to create something different and new. If I had just one influence or one way of working, then I would just be remaking their work. I could be influenced by someone who works in fashion, an architect, an illustrator, a graphic designer, a film maker, or a musician, and combine all these influences in my creation. It's important that any influence is filtered through my own lens.

Who—dead or alive—would you like to have dinner with?

I would invite Sister Mary Corita Kent, she is amazing. The way she thought about creativity is really inspiring.

How important are social media for your work?

I feel conflicted about them because sometimes they can feel like a huge distraction. I don't like to feel pressured by what other people are doing and have a sense of comparison. So, I treat social media as a discovery tool. I often try to find a different path that maybe not everyone is on or looking for. The danger with the algorithms that platforms like Instagram, Pinterest, and Google use, is that everyone can end up looking in the same places. I use them almost as an indexing tool, saving imagery that I find exciting and sharing other people's work. But in terms of research, I think you might get more from going to a library and picking up a book, because not everyone is looking at that book in the same way.

The idea of being a trend is pretty horrible.

You also run a blog called *Muse and Maker*. How did that come about?

I started that blog a long time ago to feed my passion for interior and furniture design and architecture. It stood apart from what I was doing commercially, working as an illustrator and designer. The past couple of years I have been doing more personal projects and the blog was a space where I could explore without any exterior pressure. I was coming across a lot of interesting designers, artists and objects while researching for commercial projects, but these inspirations just didn't have anywhere to go, so the blog provided a nice place to store everything and share it, in a curatorial sense.

Is humour important in your work?

Humour is at the core of what some artists do, but it's not at the core of what I do. But I do like playing with perception in my work. My work is not necessarily funny, but it's not serious either.

Is colour important?

I love colour. That was the other reason I wanted to do personal work alongside my commercial work. Often in commercial work, things like colour palettes are dictated to you because you are working within brand guidelines. I really love thinking about colour and looking at colour. I like making strange combinations. I like looking at fashion for colour inspiration. I am interested in trends, but not too much. The idea of being a trend is pretty horrible.

Does your creativity have to create a better world?

Creativity is a very positive thing, but obviously we are not saving lives. I would like to make more of a difference. Creativity can sometimes feel like quite a selfish endeavour. Recently I have been involved in some more charitable projects, making work that gets auctioned off for good causes. Things like that make me feel better about being as indulgent as I am.

I'd also like to do some teaching or workshops in the future, as a way of giving something back to people. I think creativity really can enhance your life, even if it's not your day job. I want to remove some of the barriers that people perceive around being creative, because it can be intimidating in a way. I would be miserable in a world without creativity. I think it would be a sad place.

What does failure mean to you?

It's good to fail. It feels horrible in the moment, but you always learn something in the end. You just have to have faith that there was a reason that things went wrong. I've definitely failed a lot, but I've also learned a lot.

Has the Covid-19 pandemic influenced your creative life?

Something about the 'big pause' felt welcome. It has been an interesting time, creatively speaking. I was able to pursue more personal projects and reflect on the direction I wish to take my work in, without distractions.

I questioned what art means to society in times like these, but I realised that creativity can essentially bring joy to many and perhaps is more necessary than ever in testing times.

What's the best piece of advice you have heard and you still repeat to others?

Be curious. That's the core of being creative. If you are not curious and you are not interested in things outside your sphere, your creativity stagnates. The things you create are a product of your creative nature and intuition coupled with your nurtured visual vocabulary. For instance, the way I make things may be intuitive and in my creative nature, but at the same time, I am very visually aware. I'm constantly curating: editing and choosing to let influences in or dismiss them. The input that you collect and keep can also shine through in your own works.

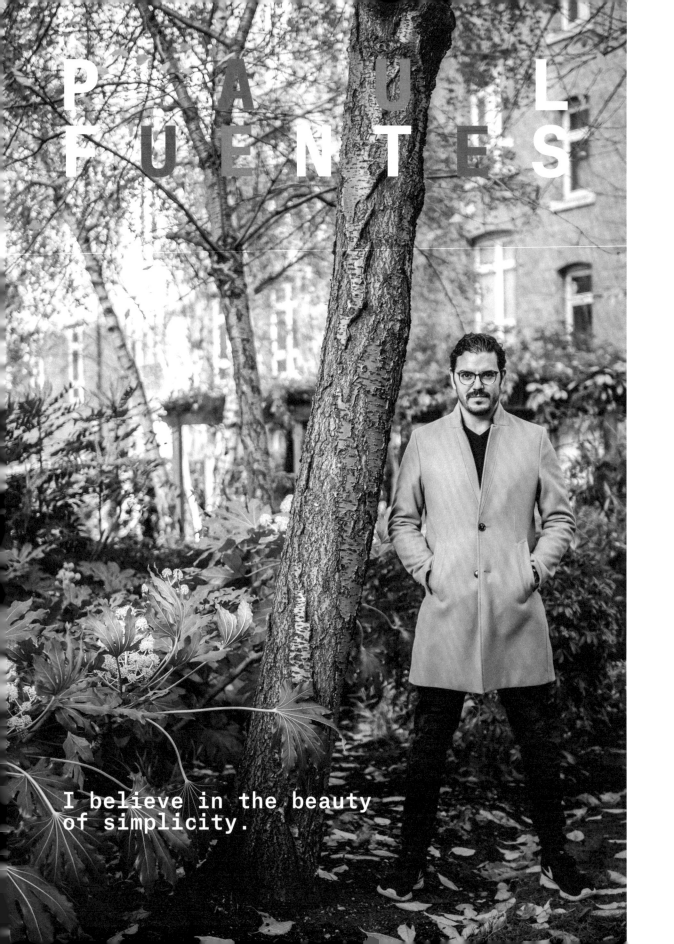

PAUL
FUENTES

I believe in the beauty
of simplicity.

How would you describe yourself?

I would describe myself as a graphic designer slash artist who creates mash-ups with photography. I do digital collages and then I turn them into objects. They are mostly surreal, creamy pop-art objects that live in a pastel-coloured, bright world.

What kind of family did you grow up in?

My dad was a musician. He used to make TV jingles. He liked photography and art and all sorts of creative expressions. And my mother was a graphic designer. She was always being creative with her hands and used to paint a lot. I grew up in a creative family. Art was always present.

Music was an important part of my life for a long time. I learned to play the piano and the drums. I loved to edit and do music post-production. I actually made two albums; I composed everything and produced and mastered the albums myself. Knowing the tools and knowing what you can do with a computer also brought me to the work that I do now.

At what point in your childhood did you know that you wanted to be creative?

At first, I wanted to be a musician. I also loved well-edited images, though I didn't realise it at the time. For example, I used to look at restaurant menus and see how delicious the steak looked, but I knew that it wasn't the steak itself—I knew it was something else. There was magic in the way they made the food look real and delicious. So, when I was about fifteen and I had to decide what I wanted to study, I felt like photography editing would be my thing. I think it was always there, but my love for graphic design came later, around age sixteen.

What does creativity mean to you?

Creativity is a kind of intelligence that we humans have. I think it is a tool and that everybody is creative in some way.

There are different levels of creativity. For me, it's how unexpected, original or unique the solution to a problem is. But even creating a problem could be creative.

Do you have a place where you are most creative? Is your work environment important to you?

More than a place, it's a state of mind, I think. I need to know the place where I work and I need to be alone as well. My mind needs to be isolated in a way. Of course, I need my tools and my computer, but there's not one specific place. Ideas can come to me while I'm having a coffee or sitting in a restaurant, but mostly they come to me in my own office.

Do you always use a computer or do you doodle in notebooks as well?

I don't doodle. I should, because it works for me. I realised that when I was travelling and I didn't have a computer with me. You can sketch faster and it's good to have the human touch while you're doing sketches. But I don't do it because I work with digital images. I also need to know what an image's limits are. So, I make really quick collages digitally, which doesn't take more than ten minutes, and then I know where I'm going.

Do you need a clean desk?

My desk isn't very organised—all artists live in their own mess, right? In order to work, I just need to know where my stuff is and where my tools are. I just need to be happy when I'm doing my work. I like having everything in its right place, so that the workflow is 'happy'. Music, as I said, is important for me as well, it really helps me to set the necessary mood to get creative.

Who or what has been the biggest influence on your way of creative thinking?

It's hard to say, too many artists have influenced me. What I like about certain people is that you instantly recognise their style. You can hear a guitar and know that it's Jimi Hendrix or see a painting and know that it's Mondrian. Having a style is important for me in order to have some kind of effect. I'm inspired by the pop artists Liechtenstein and Andy Warhol, and even Marcel Duchamp, who was a Dadaist and turned his toilet into an icon. Photographers like fashion photographer Miles Aldridge and David LaChapelle are also important for me. But films can inspire me as well—I really like Wes Anderson movies, specifically his photography and his use of colour.

What inspires you?

Simple happiness. That's it. For me, there's nothing more important than simple happiness.

And what are things that prevent you from being creative?

Getting so obsessed with an idea that it causes a blockage. For example, when I want to do something with a strawberry and it doesn't work, I'll search and search and spend hours sketching, and my mind prevents me from moving on to another idea. It traps me inside a box. So, I try not to get obsessed with ideas. If it doesn't work, we'll try again tomorrow. Doing things fast also prevents a lot of creativity. You need to be patient with creativity. Sometimes it comes, sometimes it doesn't, and you need to know that you're not a machine that can have creative ideas all the time.

What's your creative process?

Well, I like to find the match. I usually do mash-ups. So, I start with one image and then I try to find the perfect match for it: the object's most creative, most balanced and funniest partner. As long as I don't feel it, I don't go for it. If I don't feel sure enough that it's worthy, the work is not finished.

Do you want your work to have a message?

I think it's up to everyone individually to decide what the message is to them. I try to keep it very open. There is definitely happiness involved. Nowadays people get bored really easily. So, what I try to do is show you the same object you've seen all your life but with a little bit of a twist. This way, it's like you're seeing it for the first time. And that's the magic and the beauty of simplicity. Just seeing things for the first time. That's my main message.

And how important is humour in that aspect?

It's important. I don't like taking things too seriously or too personally. The world is a crazy place, and I think you need humour to find a way to deal with it. For me, humour is the best way to relate to another human being. It's a good way to connect. There's always a reason to be happy and we all deserve that. It's a good reminder that life is nothing but a joke. Don't take it too seriously.

Your work is not in art galleries, but you upload it to certain websites and people can order your work online. It's also distributed in different formats: prints, bed covers and pillow cases. How do you feel about that?

In a way, that's what pop art is to me. Art should be for everyone and it should come in all kinds of forms. It's not just for people who go to galleries and have thousands of euros to spend on a print. My idea is: if I create funny objects, why not print them on funny objects? Turn it into a towel, or a print or a phone case if you want to, because who am I to say no? If we can do it, let's do it. I'm not saying that hanging your art in an art gallery is bad, I'm just saying that pop art is about consumerism and scale, and what's wrong with that path?

Is your creativity provocative?

Yes, definitely. Creativity, and art itself for that matter, is a conversation. If it's not an interesting conversation, or if it's not provocative, or if it doesn't speak to you, then there's no message there. If I don't feel anything, then it's not art to me.

Do you use pictures you find on the internet?
Yes, I mostly work with stock images. But my works consist of about ten to fifteen images made into one, so it looks simple, but that's the point: it's not. It's too clean and perfect and that's not reality. If you were to visit the place in the photograph, you'd see that it doesn't look like that. So, there's also a surreal aspect to the photography. I control the sky in one layer and then the mountains in another layer, until they have the same temperature, same tone, same blurs, so that it makes sense.

There are never people in your work, don't you like people?
(laughs) No, I think I just want to depersonalise the photo. When I do use people, it's mostly from the back, because if somebody's face is in it, it becomes their photograph. For example, postcards don't have people on them so that you're free to decide if it's your image or not.

How important are social media for you?
Extremely important. I'm lucky to have social media. Otherwise, I would not be able to show my work. Social media have enabled me to collaborate with companies and artists, and to understand the market of people who enjoy what I do. The feedback that I get on each image is crucial for me to be able to understand what the needs or the trends are, and what people are thinking. Sometimes the difference between what you're thinking when you post a certain image and the message that people actually get out of it is quite funny. It's always an interesting experiment to just post something and see what happens. That has been successful, at least for my account, because people connect with it. You can connect as friends, just by looking at a photo. You just tag someone and that starts a conversation. I want my work to start a conversation, or make people laugh or have them send an image to their mother and be like "Mum, this flamingo made me think of you". That's the beauty of social media.

How important is colour in your work?
Really important. I was born in Mexico, where everything is colourful. Colour is one of the main elements of my work. It gives everything soul and puts the mood into a message. It's important to let colour speak for itself.

Aside from your collages, you also do photography. How is that different and how does that relate to your other projects?
I've always been into photography. I really like advertising photography, still-life photography, and black-and-white photography. The fascination was always there for me, but I didn't have the courage to act on it. Last year, I started a photography project with some photographs that I really liked, which had a kind of retro, pastel atmosphere.

I like photography because it challenges me to use different tools. It's a different discipline: understanding light, temperature,... There are more colours and way more things to control. The fact that travelling is one of my favourite things to do makes it special.

Is failure part of your creative process?

Definitely. You need mistakes in your life. You need them to understand what's wrong, what's right and how you can improve. In a way, failure actually brings success. If you understand failure, you have two options: you either go for it and try harder, or you just fail, get depressed and quit. I think the meaning of failure is very personal, speaking of course in terms of creativity. Mistakes are like lessons; you need to learn from them. Don't take it too personally, just know that it's a lesson and then move on to the next chapter in your life. It's human to make mistakes, just embrace them and work with them and be better.

Has the Covid-19 pandemic influenced your creative life?

I'm fortunate that 99 percent of my work can be done from our home studio. It has been a difficult time socially speaking, but professionally it has been a great time to rethink the goals of the studio. Our system is completely online, so honestly, we haven't struggled too much. I've been more focused on my work because of the pandemic, but I can't wait for it to end and to finally go out into a completely new world, full of inspiration.

What's the best piece of advice that you have ever heard and still repeat to others?

There's one piece of advice that I got from a maths teacher once when I was a kid. He said: "Let's say you have a problem, then you just need to ask yourself: does it have a solution? If it does, why worry? And if it doesn't, why worry? Why worry at all? You cannot control everything. And if you can control it, then just control it." That's a piece of advice that makes me feel a little bit more comfortable about making mistakes, failure, and being creative. In the end everything is going to be fine, just go for it.

What I would advise to the young creatives out there who are just starting out, is to check out a lot of other artists; you need to read and eat and sleep and dream with other artists. That's the truth. Copy, imitate, try doing it almost exactly the same way. Without claiming it's yours, of course, but that's the way to learn techniques and to push yourself and find out what you can and cannot do. Again, I'm not saying to copy the same print exactly, but to copy the idea. With time, you will come up with a process of your own. But that takes patience and you first need to know your tools and your craft.

I just want to make people happy.

RYAN GANDER

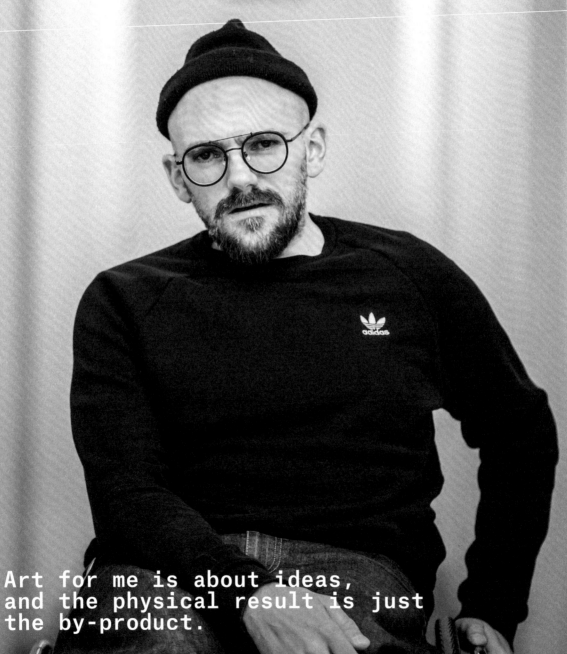

Art for me is about ideas,
and the physical result is just
the by-product.

How would you introduce yourself to someone who doesn't know you or your work?

When people ask me what I do, I often say I'm a teacher to avoid getting more difficult questions. There's a certain stereotype surrounding contemporary artists that people quickly run into.

What kind of family did you grow up in?

My father worked in a Vauxhall car factory as an engineer on quality and assurance. My mum started out as a schoolteacher, then became a deputy head, and finally a school inspector for the government, making sure that education was up to the correct standard. I had a very pleasurable suburban upbringing.

Was there room for art and culture in your family?

Not really. My dad wrote poems and my mum made clothes and taught me how to sew. My dad also taught me how to write, and how to exaggerate and tell tales as well. He taught me that fiction is lying, and you shouldn't be ashamed of it. Lying and exaggerating are good catalysts for the imagination. He said: "The truth can never stand in the way of a good story". He's a very wise man.

Did your childhood influence your creative thinking?

I probably spent about half my childhood until I reached puberty in a hospital bed. So, my socialisation was completely different from other children's. I was never alone in a room, so my understanding of public space and private space are a little bit different to other people's. Most of the time I was surrounded by adults. Because of my situation, my ability to imagine other realities outside the physical confines of where I found myself was accelerated. Being stationary for so many years led my imagination to move and travel because I couldn't.

Was there a moment where you thought this might lead to becoming an artist?

I didn't realise there was an occupation to be made from having an overactive imagination until I was probably twenty years old and at university. People from the north-west of England generally base their decisions not on what they want but on what they don't want. The north-west of England, where I grew up, was a highly industrialised place suffering from high depression rates and poverty. There's a great sense of community there, but there was also this sense that you do something to escape something else, and not because there's a goal that you want to achieve. This is why I started making art. I saw everyone doing the same thing every day, in jobs in shops and factories, and it seemed like many weren't content. Because I never went to school in the traditional sense, I didn't have that repetitive element to my life, and I struggled with the idea that I would have to do the same thing every day.

As an artist you don't really have a specific style, is that a deliberate choice?

When we think about art, we think about what something looks like. But it doesn't matter what art looks like, all that matters is how good it is. The general rhetoric is that artists make art and they have a style. But when I think about art, I don't think about the physical thing, like a painting made by a painter or sculpture made by a sculptor, I think about the story and the information that surrounds it and the ideas that it holds. Art for me is about ideas, and the physical result is just the by-product. If you think about art in that sense, then it would be absurd to talk about style.

"Art is the science of freedom", it's about the ability to do anything and set your mind on something else every day. It is absurd that artists choose that occupation and lifestyle and then do the same thing every day for forty years. I wouldn't necessarily think of those people as creative people, rather as people acting out the stereotype of what we think artists are.

It all starts with an idea.

All humans have an instinctive ability to be creative, no matter where they're from or how they're brought up. From the clothes you wear, to the sticker you have on the back of your car, maybe the way you arrange things on your windowsill or how you build a shelter—it all says something about you. Just because it happens subconsciously, doesn't mean it's done without decision. I really believe that everyone is equally creative, the only difference is that some people have more time to entertain themselves with being creative.

Do you do what you do because you want people to see things differently?

I've never had a moral or an objective to doing what I do. Although recently I've realised the true value of my work is to remind people that they are creative, and that creativity is a fantastic distraction economy It enriches your life. It slows time, it makes your life longer and more worthwhile. It makes you more content. Social media and technology are essentially basing their addictive qualities on everything that creativity can provide. We could literally swap our distraction economy with creativity and the world would be brilliant.

Do you have a daily routine?

I wake up, make the children breakfast, do one hour of emails at home and then go to the studio where the people who work here take over and tell me what I really have to do.

What is your work process like?

I take thousands of photos on my phone, which I then print and sort out into folders once a month. I lay them out on big tables and I put sticky notes on them to categorise them, associated with catalytic points for starting works. It's very organised, almost like a Swiss train. The photos are then sorted into labelled index card holders, ready to be consulted when there's a need for them. The interest could be art related, but also more related to product design. I have a company called OTOMOTO with a friend, we make design products like kitchen sinks and fireplaces, etc, clothes for different labels and trainers for Adidas. I also write things and publish books. I also make TV programmes and documentary films. There are so many different things going on at the same time, and this method helps me keep everything at the front of my mind.

Is there a hierarchy of importance in the things you do?

There are two objectives, I guess. One is to make money to be able to continue to be creative, and to pay everyone who is involved in this big, elaborate fun enterprise.

Objective number two is to surprise people and to defy expectations. When you go to a museum or a gallery to see any type of creative work, the worst thing that can happen is that it looks like what you imagined it would look like. The ultimate test of creativity is to make a quality work that contributes to history, that creates income to carry on being creative, and that defies expectations at the same time. If you can achieve all those things in in one creative act, that's amazing. People consider that a capitalist approach, but it's true.

Do you have a preferred time to work?

I mostly have ideas in the shower, in the car or while washing up, because that's when I'm on my own and I can't use my phone. And they are good twenty-minute sessions. There's this watch called the 'Slow Joe' watch that splits the hours into four increments of fifteen minutes, because as a consequence of the attention economy, the world moves so fast that we never give more than a minute to any of our thoughts. But you need a good fifteen minutes to get anywhere when you start thinking, that's just how the human mind works.

You paint portraits of people, but you only show the palette. What is this fascination with what is not there?

It's an innate human instinct to be interested in things that are incomplete, because your mind will complete them. If things are unfinished, you use your own imagination to project what's missing into the space and that's the cognitive participation element that I'm interested in. People need to not only open their minds when they're in a museum, but also when they walk into the shop to buy coffee, because the world is much better and much more interesting than the art world. We're not turned on in our day-to-day life to see how phenomenal the world is. So, in a way my work wants to offer starting points for people to recognise how great it is to be alive.

The portraits are really good, but me painting someone's portrait is not interesting. It's not an artwork, because it doesn't change, it doesn't move, it doesn't motivate, it doesn't do anything. It's a record of a moment in time. Right now, millions of people are recording moments in time on their phones. That's not art, that's just people trying to understand the world as they move through it.

I like art that makes you feel that you're being spoken to. When you whisper, people listen to you, if you shout, they just get really tired of the noise. Art should contain romance and poetry and touch upon universally human issues that everyone can relate to. I don't like art that takes political positions to gain attention.

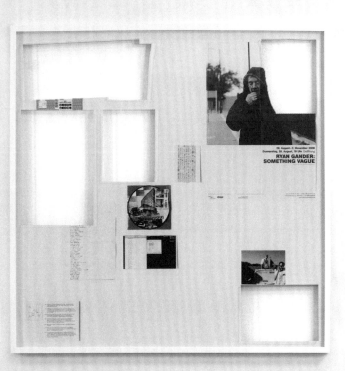

RYAN GANDER:
SOMETHING VAGUE

TO LABEL

BOOM

TO RESORT APR...

VIDEO
GAMES

When you whisper,
people listen to you,
if you shout,
they just get really tired of the noise.

Is humour important in your work?

Humour is equally as important as any of the other elements that can contribute to the construction of an experience or an artwork. It's a material that I only use in some works, often to create intrigue. One of the biggest difficulties in the construction of an artwork is the hook, the thing you use to grasp the attention of a spectator and then hold it long enough to create intrigue. When I go to a museum, I spend three to five seconds with each artwork, no more than that. The artworks that I stay with for three minutes I would consider very, very good artworks. The artworks that I'm still thinking about on the bus on the way home from the museum are genius masterpieces. So, when we think about how we value art, one of the ways we can judge it is with the amount of time it consumes us, which brings us back to the attention economy.

Where do you get inspiration for titles?

I write them down in my phone as I take photos. I easily take a hundred photos a day and I probably write down two titles a day, whether I'm working or not. I have tens of thousands recorded.

Who—dead or alive—would you like to have dinner with?

Bruno Munari, an Italian creative who wrote children's books and made art, or Barbara Hepworth—strangely they all seem to be people that are dead. The interesting thing about dead people is that we have the privilege of hindsight on them. It's only retrospectively that we understand the history, I guess.

What is failure to you?

Failures depend on how you define your successes. It's a subjective state of mind, which means it's different for everyone and a mental condition that you can control quite easily. For instance, I get massively jealous about other artists. If I'm jealous because I think their work is really good and I wish I'd made it, that's a positive kind of jealousy. It makes me want to go to the studio and do better. But then there's resentful jealousy, which is when I see someone with an opportunity that I don't think they deserve for whatever reason. But what I've realised recently is that the question isn't "Do you wish you had that opportunity?", instead it should be "Do you wish you were making the work they are making?" When I look at it that way, it's fine, because the only work I want to make is the one I'm making; I don't want to make anyone else's work.

Has the Covid-19 pandemic influenced your creative life?

The pandemic has transported me to a state of equilibrium, and has reduced procrastination. I feel like an art student again—not knowing, but knowing that not knowing is probably right, and opting for solutions that would be most likely to defy expectations.

I miss travelling. Often my mind wanders whilst washing up or driving the car, and I am magically transported back to moments in Tokyo, Montreal, Melbourne, Singapore, Shanghai or New York. Then I remind myself that my imagination is strong enough to transport myself there whenever I want.

I have relearnt, as many people have, the value of things. Time is our greatest asset and our attention is our most coveted possession, and they now mean more than money, although money is still a great enabler. These are good ways to live, cognitively and actually. We are only human, a powerful and life-affirming lesson we are all relearning. The slowness is good for research, but I can't wait to go to a rave.

What's the best advice that you've heard and still repeat to others?

When we used to come home after a fight with friends at school, my dad would always say: "Let the world take a turn". If you get an email that annoys you and you reply straight away, you instantly regret it once you press send. You should let the world take a turn, just give yourself a day because everything looks different with time. That circles back nicely to what I said about having the privilege of hindsight and a retrospective view in the moment, which is like a superpower.

HARRY GRUYAERT

There's no concept, just intuition.

Can you introduce yourself?

My name is Harry Gruyaert. I was born in Antwerp in 1941. Harry is not a Flemish name, but it's a funny story. My father was listening to the BBC, which was forbidden during the war, and he heard the name Harry. Hoping that the English would soon come to deliver us from the Nazis, he wanted to give me that name. My mother wanted to call me Jan, but my father —as always—won and my name is Harry Jan Gruyaert.

What does creativity mean to you?

For me being creative means taking pictures. It's what matters most, it's an inner urge and my way of expressing myself. I am not saying I am an artist. If people think my work is art, that's fine by me, but I am first and foremost a photographer.

Is there a place or a time where you feel you are most creative?

There is no particular time or place, because I am interested in so many different things and I have worked in all sort of places. It's more a question of light, colours, situations, and attraction: I attract things, and things attract me. My assistant often says: "It's really amazing the strange things that happen to you that would never happen to me." Everybody sees things differently and lives differently. Objectivity doesn't exist. Everything is subjective. The so-called reality is so complex and we only see a fraction of it.

Is your work intuitive or do you have a fixed concept?

There's no concept, just intuition. I never have preconceived ideas about what I am going to do. When I travel I never read about the country I am going to. I want to be open-minded. For me, it's all about attraction and intuition.

So you don't look for a story or a narrative in your work?

I only look for narrative when I'm selecting images for a book, figuring out how to put the elements together to create the right sequencing.

Where do you get your ideas or inspiration?

From life, from what I see, what's in front of my eyes: the light, the movement, the colours. Images do not come from what is inside my head, but from what presents itself in front of me.

Why is colour so important?

In my early years, I photographed Belgium in black and white. I couldn't see any colour, it looked completely grey to me. But all of a sudden, I started seeing colour in certain things. It happened after I discovered pop art in New York in the sixties. I started looking at things differently, with a certain sense of humour. I saw beauty in the banality of daily life.

In black and white, the focus is more on the person. It's more intimate. You aren't distracted by outside elements like what people are wearing or their surroundings. That's why I photographed my daughters, from their birth until they were around fifteen, in black and white. It made me feel closer to them. Photographing in colour is more physical. You are guided by your gut, not by your head.

When is a workday successful?

A good workday is about being lucky. Often, when I am working in a new place that I hardly know, I'll start working in the early morning and when things kind of come together right away, there's a good chance that will carry on all day long. But if things go wrong in the morning, because I've moved to the wrong place, or things don't work out, there's a big chance it won't be a good day. It's very mysterious—you have to be lucky and you have to attract luck. I am a street photographer and what interests me most is trying to create visual order out of the chaos that surrounds me.

Do you stay in the same place for a long time?

No. When I take pictures, I keep moving all the time. And I don't like waiting! Occasionally, if I find an interesting spot, I can wait for something to happen in the frame that will give it more meaning. That can be a change of light, or people passing by. You can have a good frame, but you need something more to make it a strong image. It happens almost by accident. Somebody moving in an interesting way, an interesting face, or interesting colours, and it all adds to the frame.

Did your childhood influence your way of working?

Because my father worked at Agfa Gevaert, we always had Rolleiflex cameras lying around, and we had a projector for 16 mm movies and a Paillard 60 mm at home. My father used to make a lot of home movies and photos. He actually didn't want me to become a photographer, because he thought it wasn't a serious profession. In the end, he had to give in. I was very lucky because the only thing I wanted to do professionally was filming and photography. I never considered doing anything else.

When I was fifteen, I wanted to travel. I went to the Brussels World's Fair in 1958, and I visited all these different pavilions, Russia, America, India, and I said to myself: I should visit all these places. I had this need to discover new things and be free. Freedom is very important to me. To not be stuck somewhere. That's why I left Antwerp at 21 years old. People told me that I was so brave to leave, but I told them it would have been much braver to stay. It was a no-brainer to me. I wanted to travel, discover things, meet different people, have new experiences. Still, it wasn't always easy. Sometimes I was completely broke, but I just kept going. It became a real obsession not to give up and keep doing what I wanted to do. So I went to Paris, London, New York, trying to meet people whom I admired.

Who were those people you wanted to meet? Did any of them influence your photography?

At the time I was also interested in fashion. I read a lot of fashion magazines, which, in my opinion, were much better in the sixties than they are now. In *Vogue* I saw some pictures by William Klein. You could instantly recognise it was his work, even without seeing his name, and I wondered how he did that. I wanted to meet him to try and become his assistant or something, in order to understand how he worked. So I went to Paris, I looked William Klein up in the phone book and called him up to ask him if I could show him my work. He said no, but asked me if I knew how to charge a Hasselblad camera. I said I did and he told me to meet him that afternoon, in St-Germain. "I have to do some fashion shoots. You will charge film into my camera."

So, here comes this big, good-looking guy, very aggressive, with a lot of attitude, and a very strong physical presence. I found that really interesting, because he looked exactly like his photographs. Suddenly, I understood his photographs. Then I went to see Jeanloup Sieff, who was a very different kind of photographer; very European, working with small cameras and such. He took a look at my work and we talked a little, and he also looked just like his photographs! It made me realise that there was no point in me trying to become someone's assistant, because what mattered was your own personality. In two days' time, I got to meet these two guys and learned an incredible lesson: what really matters is being yourself.

When I started out in the sixties, there was very little interest in colour photography. At the time, colour was for advertising, fashion and commercial work. I was lucky to find my own way. The problem for young people these days is that there are so many influences, from books to the internet. It's difficult to ignore all that. I was lucky to start out much earlier and discover my own way of doing things, without being too heavily influenced by other people.

How important is failure in your work?

I don't like failure. The only regrets I have are the shots I missed because I didn't do the right thing, or I didn't have a camera or the right equipment with me, or the good opportunities I missed because I did not meet the right people or was too shy. But I hate this feeling of frustration. Fortunately, it does not happen too often. I am lucky, I suppose.

Does creativity or photography have to be provocative or create a better world?

(laughs) I am not naïve, you know. I am not a humanitarian photographer at all. I am also not a journalist. Actually, I am quite selfish, I only work for myself. I recently had a few shows where people talked about this feeling of rapture they had when they looked at my pictures, and I thought that was interesting, because what they experienced was that same feeling of rapture I had when I took the pictures, even if it was not intentional.

Has the Covid-19 pandemic influenced your creative life?

All this time, I have not been able to travel. But I have spent a lot of time going through my archives, working on books and projections with original soundtracks.

What's the best piece of advice you've heard and you will repeat to others?

Be yourself. Find your own personality.

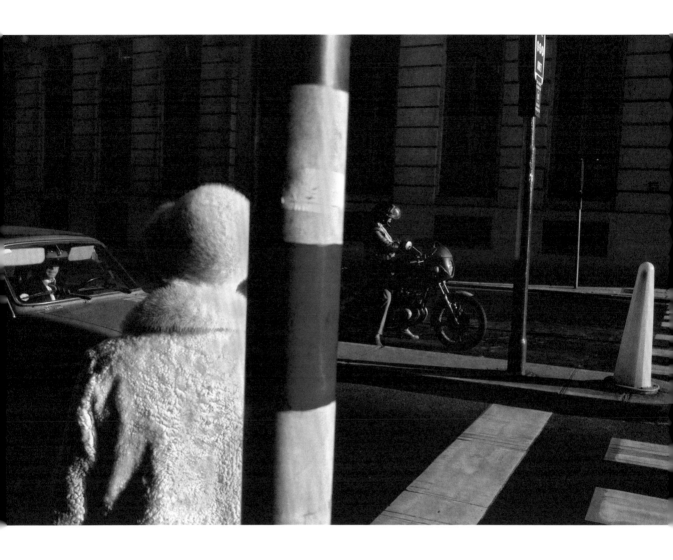

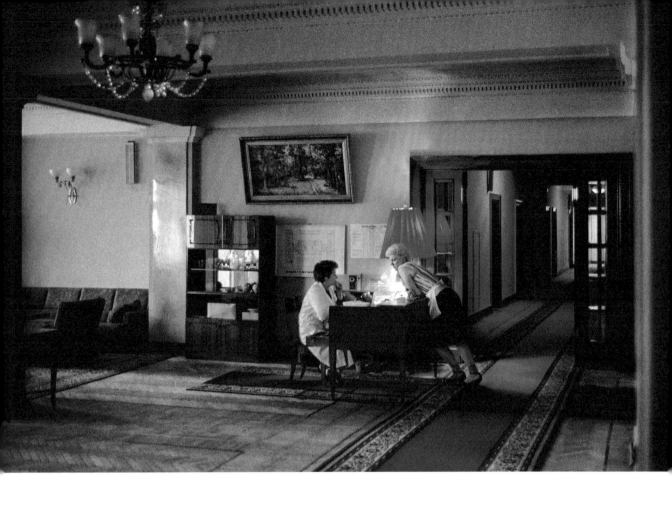

In front of a black-and-white photo you try harder
to understand what is happening between the people,
whereas with colour you should immediately be affected
by the different tones that express a situation.

The object and its colour are one and the same thing,
which is one of the principles
of the theory of perception.
Form and colour are inseparable.

TG ONY TONY GUM YM

I am wild and I am excited
about that.

How would you introduce yourself?

I am an artist in learning. I have always loved and believed in the notion of learning, whether formally or informally. I always want to be learning and I don't want officialise something that I believe I am not ready for just yet. When I feel I have graduated from this process of learning, I'll define myself as an artist.

What kind of childhood did you have?

I had a very pleasant childhood. I grew up in kwaLanga, in Cape Town, with my mother Mothiba Gum, my late father Mzwandile Gum and my two older brothers, Senzwa and Mseki. I moved from this neighbourhood, which was fun, warm and close-knit, to a predominantly old, white suburbia, where the houses were far and wide with signs of frightening dogs illustrated on the fences. It was the complete opposite of what I had been exposed to before. It affected my childhood because in some ways I found myself feeling super lonely and disorientated. I had to adapt to this new environment, and fortunately I was able to get access to this without limitation (other than the bandwidth reaching its cap): the internet became my new 'playground', my new space to have fun and feel safe.

Did your childhood influence your way of creative thinking?

My childhood definitely influenced my way of thinking and my creativity. I needed to learn to understand myself in this new dynamic where I didn't feel as though I belonged. I became more aware of the racial difference of my environment, which made me notice the same in what I was viewing on the television, on the internet or in print: that people of my likeness were rarely depicted. As a reaction I started placing myself in front of the camera. My interest in self-portraiture departed from that place, plus, I quickly realised that since my little cousin (slash photographer, Sipho Gum) wasn't going to be around as often, I only had myself to be of aid. I enjoyed fashion as a tool to get into character, to help me visualise and understand myself through the photography. As I thought it through more and more, I wanted people to gain a little more context from the images other than just receiving something pretty to look at. To create or to expand a story. That's when the self-portraits transcended from being a depiction of self, to displaying an idea of a 'people' through using myself as the medium/subject. All in all, my childhood was impressionable.

What does creativity mean to you?

Creativity is complex. It can mean a safe place for the imagination to run free and yet that very imagination can be the same place that frightens you. It also means making many mistakes, in an attempt to complete an idea.

What kind of circumstances have to be fulfilled for you to be creative?

I am still figuring out what my routine is and what I'm comfortable with. What I've learnt recently is that the best thing for me is to just start working, whether I feel inspired or not. I've always thought that having a neatly packaged idea suddenly spring to mind was the essence of being creative, but that hardly ever happens. I used to think to myself: it will just come to me, I'm gifted; but so is everyone else who wakes up early in the morning to work towards their goals and ambitions. Those who harness their skills and their craft, as well as their gift.

I believe that in order to get to that pinnacle creative point, one needs to start; one needs to go through the daunting, tiring, difficult stuff until it eventually becomes easy or at least enjoyable. And once the completion of the creative point arrives, don't fight it.

Where do you get your inspiration?

People and everything.

What kind of things prevent you from being creative?

Laziness and fear. Laziness in the sense that I have a skepticism towards starting something new. And fear that I won't perfect the idea that's in my mind.

Can you tell me about your work process?

I am a very visual person, so I think in pictures. I'll start to doodle the ideas and see which metaphors and nuances speak through the images. After those drawings are done, I'll have a narrative in mind. Then I'll speak to my writer, friend and curator Lungi Morrison. We bounce ideas off of each other and give it weight. If I'm not just working with her, I'll obviously need to do some research and speak with other people. Eventually, after all that is done and pre-production is complete, I'll get into the process of production. This means gathering a team together for the shoot: make-up artist, camera assistant and a producer. Thereafter I'll sit with the editor in post-production and we'll make the final selections. Works are framed, and then we're done!

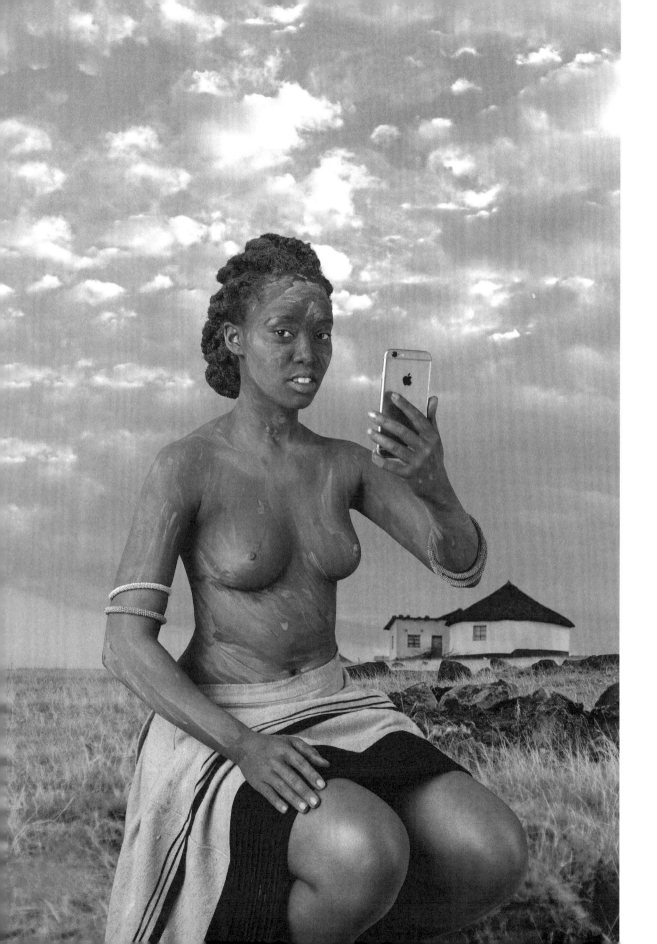

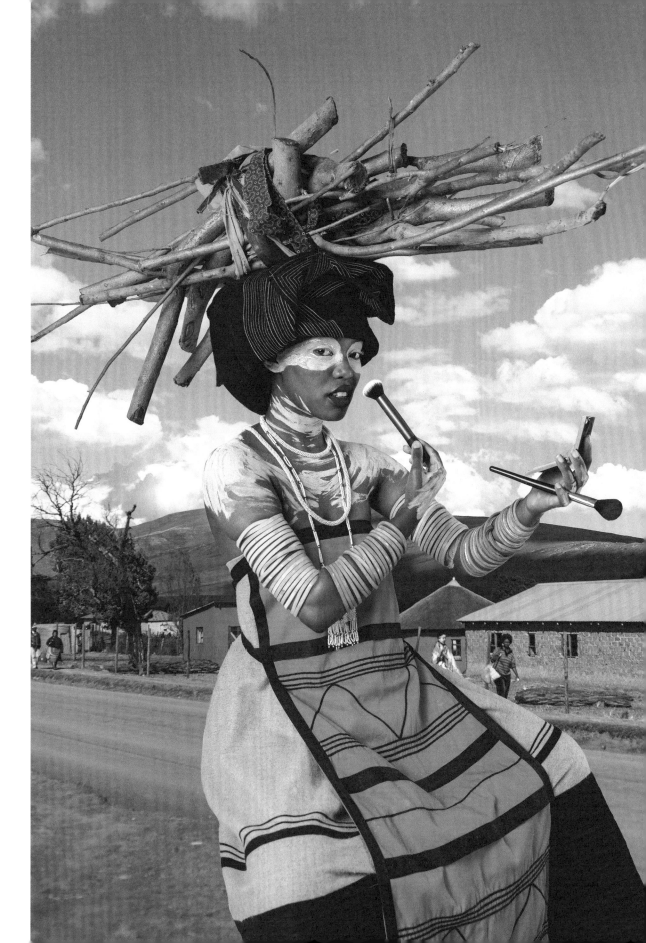

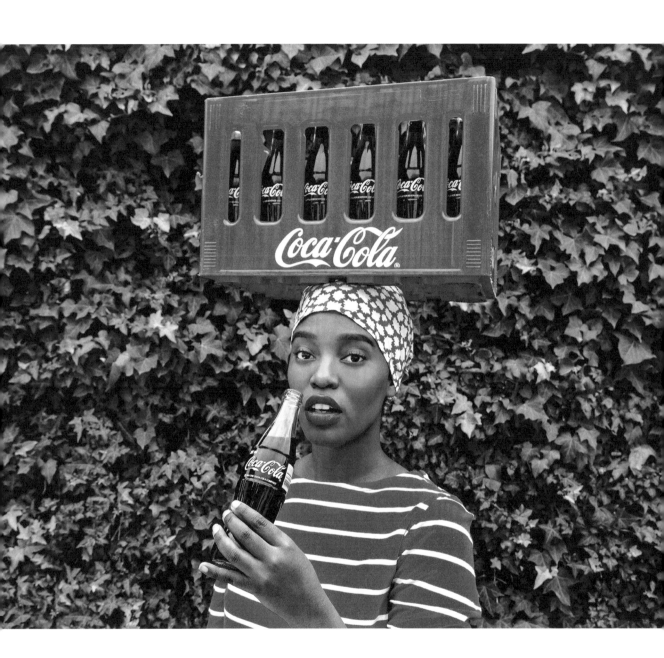

The ultimate goal is just to be human and
to love each other and to be each other's companions.
It has to be good. And that's why we are here.

When you talk to your writer, do you create an actual story?

I've always enjoyed listening to stories and that has been one of the best forms of education for me. I think it's interesting for history to be sustained through creativity, so the basis of the writing is informed by our personal experiences with the Xhosa culture. I hope to share my culture's teachings, and through that also create a story for the figures that I represent. As I said, some of my works are self-portraits and they can be personal, like Frida Gum & Kat'emnyama. But the other works are an observation of a society. It goes beyond me, a lot of the time.

How important are social media to you?

Social media played a big role in my career initially. I think I'm in a place now where I see how they can be beneficial, but they're not a necessity.

Why do you use yourself in your work?

I use myself because the ease of translating the idea in my mind through my physical body feels more precise.

Tell me about your work *Ode to She*.

Ode to She also reflects my personal identity challenges. The bulk of my childhood was a mix of suburban weekdays, reverent weekends and once in a blue moon, a mcimbi (a cultural family gathering in isiXhosa) that equally felt like a fleeting moment. As a result, I feel a bit distanced from my cultural background and its ceremonies.

Firstly, in terms of language: I don't speak my mother tongue as confidently as I would love to, plus the beauty of linguistics is in the confidence. I attended what we call a 'model-C' (formerly white-only) school, and I predominantly spoke English at home. So, through the work that I share, I attempt to rectify a displacement that I feel, whether that is through language or environment, to connect to the culture without feeling discouraged by my proximity to white modernity.

When we visited the Eastern Cape about five years ago to do some research on what it means to be a woman kwaXhosa, there were so many things that I hadn't been exposed to, like the initiation of womanhood: Intojane. In our culture one "acquires adulthood" through a customary practice, a rite of passage. A lot of these rituals carry life lessons that have been relevant to each generation.

Does your work evoke reactions from people who don't understand it?

I don't think I care for people who don't understand the work. I have always wanted to conjure up a global understanding, yet over time I've realised the necessity of having a primary audience, an audience to banter with and relate to in order for the work to gain understanding from proximity first. And once it ripples out further, I don't see the impact being any less because relation creates a pool of understanding.

Does your work have to create a better world?

I would love for my work to create a better world, but "have to"? No.

Who—dead or alive—would you like to have dinner with?

That would be Lina Iris Viktor, Jenn Nkiru, Samuel Fosso, professor Patrice Lumumba and my late father, because I would just love to get to know these minds that I thoroughly enjoy on a personal level, where the stakes are low and the lessons are high.

What does failure mean to you?

Failure is necessary. I used to struggle to truly reflect on my failures because I just really saw the glass as half full most of the time. Maybe I'm a bit too optimistic, because things could be downright failures, but I'll just say to myself: 'Better luck next time', or 'It wasn't meant to be'. I see failures as an opportunity, a lesson learnt. Regardless, you always gain something.

What's the best advice you have heard and repeat to others?

Don't complicate it.

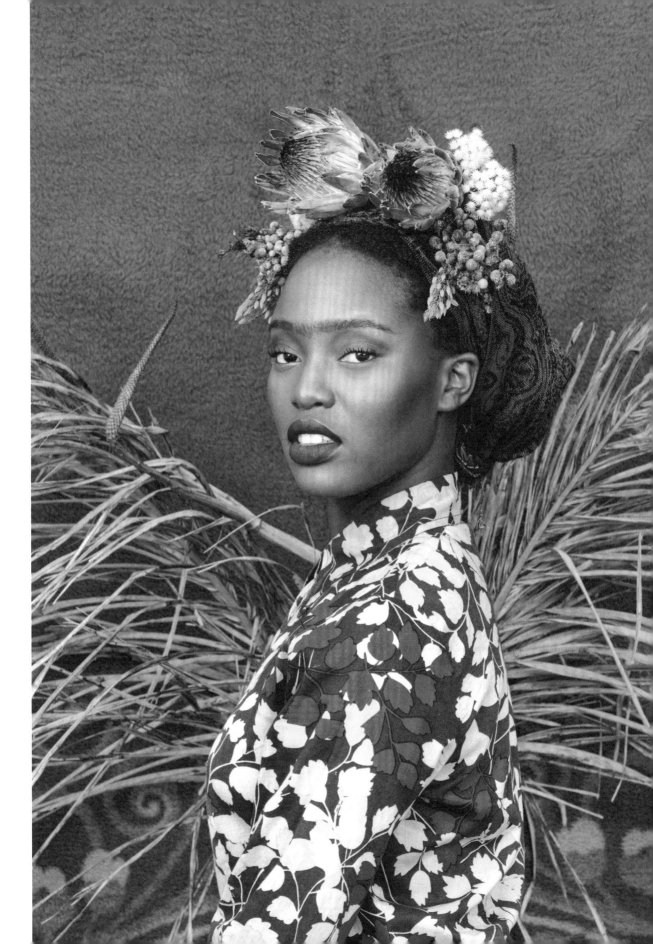

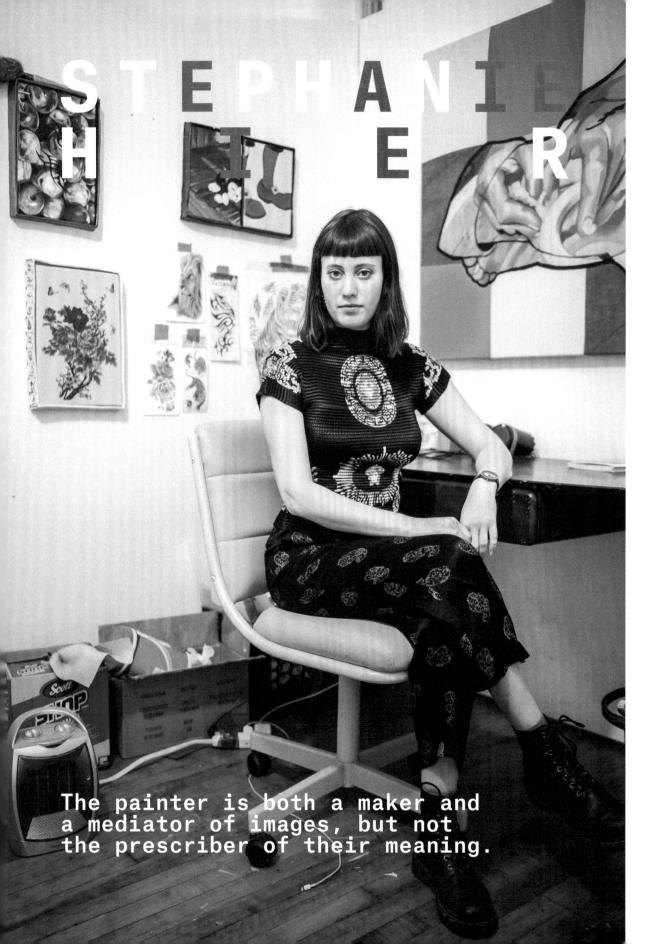

STEPHANIE HIER

The painter is both a maker and a mediator of images, but not the prescriber of their meaning.

How would you introduce yourself to somebody who doesn't know you or your work?

I'm a Canadian-born artist living in New York. I'm primarily a painter, though I also work in textiles, ceramic, and occasionally video.

What kind of family did you grow up in?

My father was a research lawyer and my mother was a dietitian for the city of Toronto. So, I grew up in a pretty middle-class family in a northern part of Toronto. I also have a brother who works in the field of art as well.

Was art present in your family while you were growing up?

Absolutely. My father is an amateur painter and photographer, so I was always immersed in art. I was always taking art lessons as a child and visiting museums and galleries.

How would you describe your work?

Broadly speaking I'm interested in exploring different mediums and references to different places in visual culture. I like to pull from very different areas, like the art-historical canon, pop-cultural ephemera, cartoons, clip art, and creating a non-hierarchical space for them all to coexist, allowing new narratives to emerge. I'm also interested in the history of particular materials, paintings, ceramics, craft culture, quilting, textiles, and how they can come together, again in a non-hierarchical way. Not delineating between highbrow and lowbrow art but creating something that's an all-encompassing vision of visual culture.

What is your relationship with hands?

Hands are really important to me. I'm interested in the labour of art and when it is made apparent and when it's covered up. For example, in photorealistic paintings or historical Dutch oil paintings where the artist labour and the brushstrokes aren't shown, I'll counter that with a direct reference to the hand or a tool that we use to create art. I like to use that as a kind of lens or portal through which to view other images and draw comparisons to create new narratives. I use the hand as a really blatant symbol for craftsmanship and labour. Hands are so symbolic in our culture, we use them to depict so many different things. So, my nude hand gestures can convey really specific ideas or emotions or anything, really.

You use ceramic framing for your paintings.

Just like the hands, the frames also act as a lens through which to view a painting. Framing is important in my work because it pulls the painting into the realm of sculpture and three-dimensionality, so that the images aren't just limited to the two-dimensional world. I'm using a direct reference to craft culture to contain an oil painting. It's a kind of framework, giving meaning to the painting that is inside of it.

Why do you use temporary tattoos and prefabricated Disney figures in your work?

The temporary tattoos act as a ready-made aspect to the work. They are a real-world reference to a very particular niche of visual culture that I'm then extracting and pasting directly on top of the painted surface. It breaks down the hierarchy between something that's generally for children to use on their bodies for fun, and then combining that with something as serious as oil painting. This way I'm creating the illusion that there is no distinction between the two.

You incorporate the whole exhibition space by painting outside of the canvas and on the ground. Is that part of the playfulness that you convey throughout the whole imagery?

By having the colour palettes and sometimes the shapes and the drawings migrate onto the floors and walls, I'm creating an immersive experience. There are so many different references in the materials that I am playing with, especially when I am doing a solo exhibition. I want to create a fully immersive environment in which a spectator can be completely surrounded by all of the references I'm exploring. In the same way that the ceramic frames break free from the two-dimensional confines of the canvas, I try to mirror that in my exhibitions in a broad sense.

Your titles seem well-thought-out. How do you come up with them and how do they relate to the work?

The titles refer to different places. Some of them are quotes from films, things I overhear on the subway or street, song lyrics,... I pick them up literally anywhere I can find snippets of language. And I use them to disrupt the narrative that emerges in the painting. They act as a reference to other places, instead of describing or solidifying the meaning of a piece. I try to subvert that and use something that completely makes your mind go in all different directions. Sometimes I use titles to create tone. Sometimes they have sinister residences or dark sides while the work can be quite playful, and I'm using wit and comedy to convey these ideas. So, there's a lot of tension between the title and the aesthetic qualities of the work.

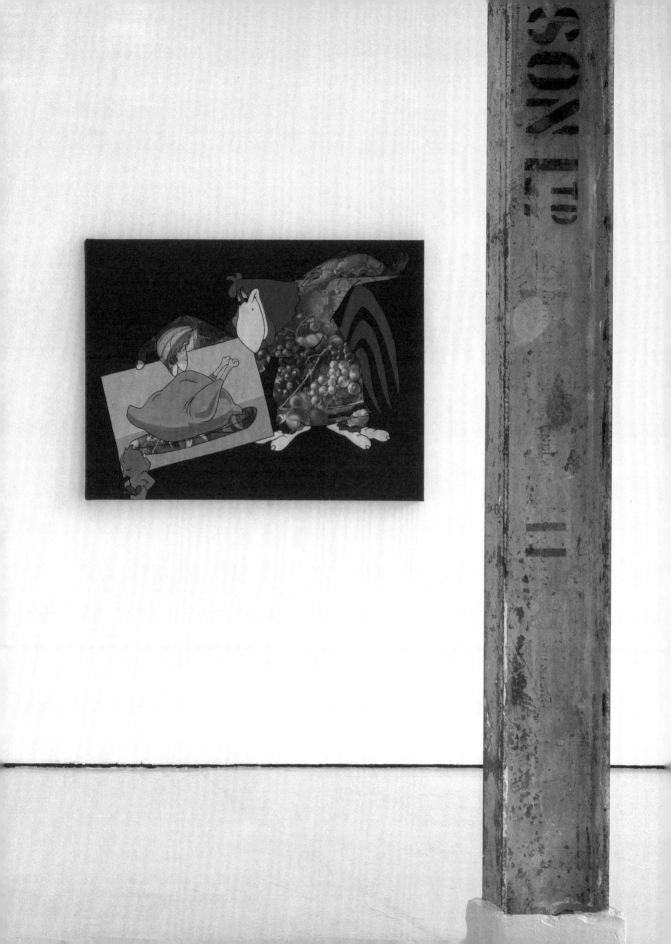

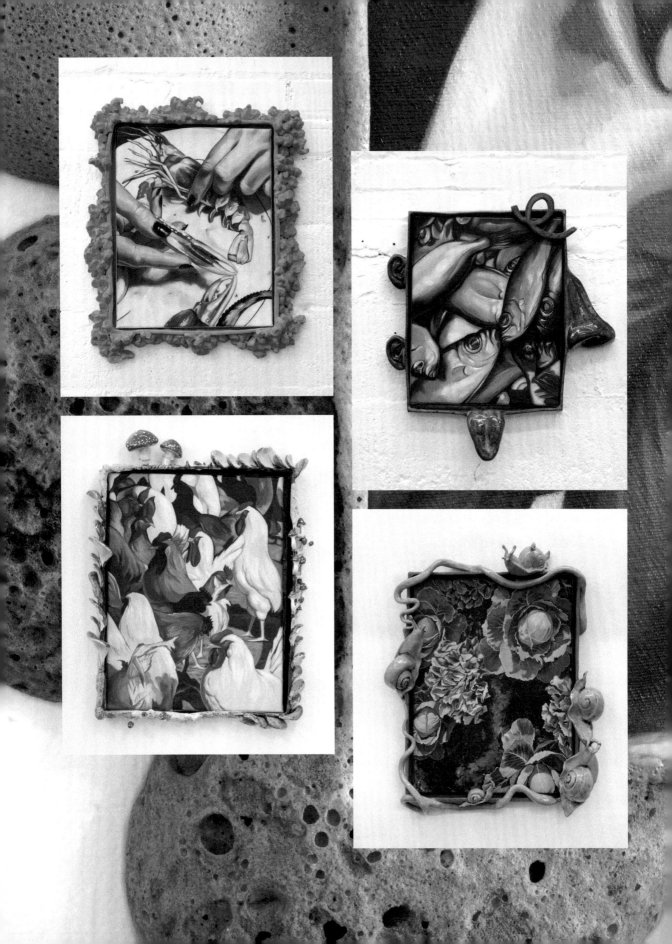

Do you want to leave the viewer with more questions than answers?

I'm not really interested in prescribing meaning to all these things. I like hearing the personal narratives that emerge for people when they see my work, for example during studio visits. People always tell me it reminds them of certain events in their life or things that they have read or seen. I want to create a democratic space where the work can speak to different people on different levels.

What does creativity mean for you?

It means taking something that exists and turning it into something new. I don't think you can create anything in a total vacuum. I think being creative is using the tools that are given to us and coming up with something new that the world has maybe never seen, or never seen through that specific lens before.

Where are you most creative?

Probably in my studio. Things here are perfectly set up for me to just dive in and get ready. I've got all my materials at hand. My studio is really conducive to creativity.

Do you have a preferred time to work?

I'm very much a daytime worker. Unless I have to because of deadlines, I don't usually like staying in the studio past eight o'clock.

Where do you get your inspiration?

Everywhere. I'm constantly engaging with other art: going to shows, museums,... Especially in New York, which is the perfect place to do that. But also get inspired by watching movies and reading books; I'm a big reader and I really like to just take everything in, even the really banal aspects of pop culture, Instagram, all these different things. For me, that creates a really comprehensive understanding of what's going on in pop culture and why and how we've gotten to where we are.

If you get stuck while working on a piece, what do you do?

One of my tricks is flipping it upside down. That sometimes gives you a new perspective on it. It takes on a whole new vibe and feeling and you can work out some of the issues with it. Sometimes I put things away for a little while. I work on several things simultaneously, so sometimes I'll step away from a piece for a couple of days or a couple of weeks, if possible. Occasionally I'll scrap it and just start again.

Do you work in silence or do you play music?

It depends on what I'm doing. Making ceramic frames can sometimes become a bit mechanical, as you're doing the same thing over and over again, so I'll put on a podcast. But if I'm doing something that requires full concentration then I need to have silence.

Does your work or your creativity have to be provocative?

I think it should be. Well, I don't think that creativity has to be provocative, but I think that in order to create an impactful piece of art you need some provocation.

Is humour important in your work?

Painting can be such a serious endeavour and I like to keep things light and witty, so as not to get bogged down. There are some really important themes that I'm dealing with in my work, but I want to approach them with some levity and not too much seriousness. Whether it's incorporating weird cartoon characters or the use of temporary tattoos, I like to keep it somewhat humorous.

How important is colour?

Colour is really important. I use it to create tone and feeling. I approached the new series of quilted works by using colour mapping. I take an image and map out the main colours that exist in it and then turn a selection of those colours into a quilt. In my most recent solo show I transferred each palette one by one so that they had a real relationship with one another, in order to create one visual language through which everything could have a seamless dialogue.

Does creativity have to create a better world?

I don't really prescribe to the idea that artists need to be the moral compass of our society. I think that creates a world where we idolise people who are just people. Naturally, it's a positive thing if art and creativity make the world a better place. But perhaps creativity can truly better the world in fields like science and medicine that actually have a direct impact on most people's lives. In terms of art, I think it's just a plus if it does.

Who has been the single biggest influence on your work or creative thinking?

Probably the people around me: my peers, my studio mate, my family, my friends, all the people who I'm in direct dialogue with every day. They have a direct impact on my work and who I am as a person. Of course, there are painters that I seriously admire and who inspire me and drive my work forward, but I would say probably the people who are actually in my life are more important.

Who—dead or alive—would you like to have dinner with?

Maybe someone like Susan Sontag. Someone who is an important cultural thinker and who I may not agree with on everything, to get into a little bit of a debate. Or maybe someone who's a great cook.

How important are social media for you?

I have a bit of a love-hate relationship with them. It's important for most artists to be on social media and to also understand the role they play in our world, because they are so present, at least in the Western culture I live in. So, I think it is really important for me to participate in them. It is also relatively easy to capitalise on the benefits of being on social media.

What does failure mean to you?

Failure is an important part of art making. I don't think that you can really hone your vision unless you've failed countless times. I don't destroy a lot of paintings, though over the years I've certainly made a lot of things that I would never exhibit. There were a lot of stepping stones to get to where I'm at now. Not that this is the final resting place of my work. It's really a lifelong journey. Failing teaches you what not to do next time.

There is a real element of failure within the process of ceramics because it's a pretty unpredictable material. When it has dried and is fired for the first time, a lot of different things can happen in the kiln. Depending on the moisture content of the piece or other pieces that are in the kiln with it, sometimes things will crack or break or warp, anything could happen. That's an aspect of my work that I suppose you could characterise as failure. Sometimes I try to embrace it, sometimes pieces will get a little bit warped or the colours will come out really different, but that exists in contrast with the very controlled nature of my painting.

Has the Covid-19 pandemic influenced your creative life?

I feel lucky that my life has remained relatively stable throughout the pandemic. With New York shut down and so few social distractions, my studio work has developed and deepened in some profound ways. I've found myself working longer hours in the studio and creating more elaborate pieces with all the new-found time on my hands. Additionally, as our lives have been migrating increasingly online, I find my desire to work with tangible earthly materials even more vital.

What's the best piece of advice that you've heard and still repeat to others?

To just keep working. That's something my father always said to me. Anytime I would do something he would say: "Keep working, just keep going." You've just got to be relentless.

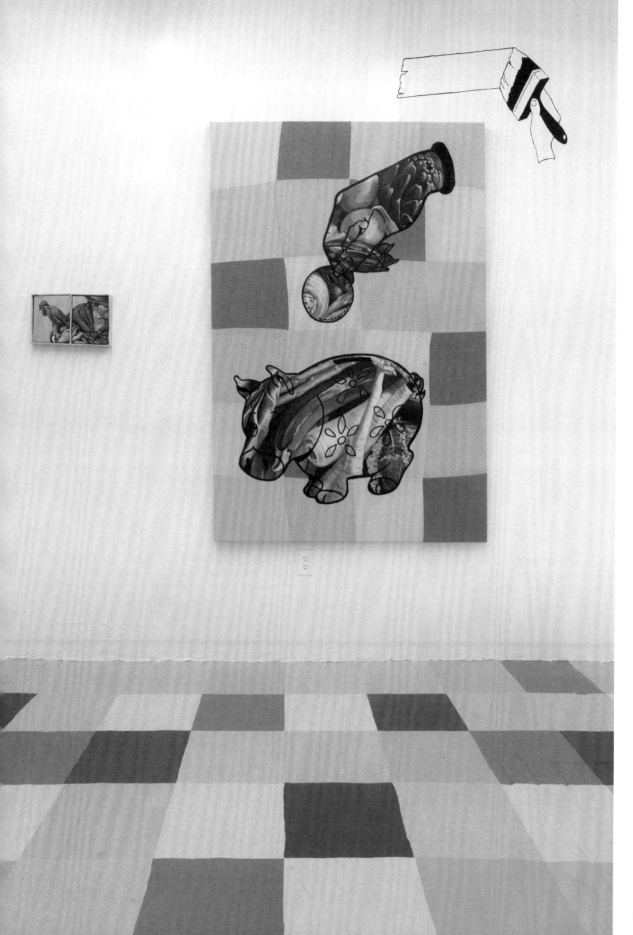

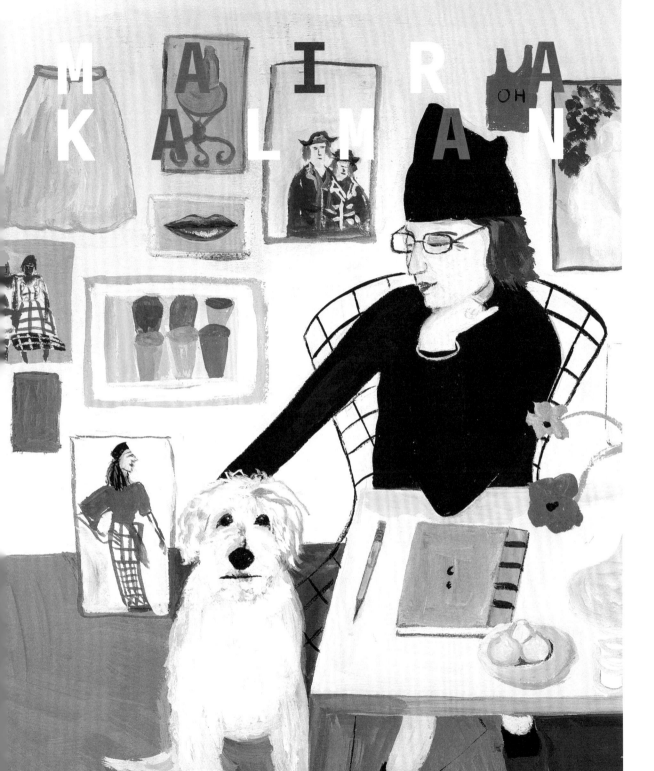

MAIRA KALMAN OH

I have many questions, but no patience
to think them through.

How would you introduce yourself?

I am an author and an illustrator.

What kind of family did you grow up in?

My father was a diamond dealer and my mother was a homemaker. Our extended family was large and very close, lots of aunts, uncles, cousins having a lot of fun.

Did your childhood influence your ideas about creativity?

Very much so. I tell the same stories over and over and they usually include stories of my mother during my childhood. My mother is a very important person in my life. She was beautiful and irreverent and very original.

She encouraged my creative life by taking me to concerts and operas. She often took me to the library and we would sit together and read. I took piano lessons and dance lessons. My mother wasn't an artist, but she was quite gorgeous and amazing and interesting. For me, she was very much a model of a person with great integrity, honesty, and someone who said what she thought. She once made a map of the United States that illustrated these things about her: in the centre of the map there was a big gap where she wrote "Sorry, the rest is unknown, thank you". That's the way I see things too: what you don't know isn't important, who cares. She wasn't about exact knowledge; she was interested in the experience of learning.

She never told me what to do, so that I could make my own mistakes, and she made sure I always knew that there was a constant of love. It's hard to restrain yourself when you have kids because you have the urge to tell them what to do. My encouragement came not from being told to try this or that, but from being loved and told that whatever I did was great.

When was the first time you knew you wanted to be an artist?

I always thought I would be a writer. Art came into the picture when I was in my early twenties, but the writing epiphany came when I was about eight years old, reading *Pippi Longstocking*. I knew then that I wanted to write like that. With humour and confidence. Later on, I was disenchanted with my writing and felt it would be easier and more fun to draw. I was still telling a story. My paintings are writing. And sometimes you don't need to say anything at all, of course — just show the image.

What does a day in the life of Maira Kalman look like?

My day starts with reading the obituaries in the newspaper, which comes with a cup of coffee. I find it fascinating to read what people have done. The obituaries are like mini biographies that inspire me. Then I go for a walk in the park, which is highly inspiring. I then take a bus down Fifth Avenue to my studio. The bus inspires me as well, as it is a good place for daydreaming, and daydreaming is the exact act of allowing unexpected ideas to enter your mind.

I solve most of my problems by not trying to solve them. Not thinking, having an empty brain, that's how ideas come in. Not knowing comes naturally to me. As you can deduce from my mother's map of the United States, we are not so concerned with getting things right. The less you think you know, the more you can explore and be surprised and find joy.

You pay close attention to the world and the people in it, and you always see the positive side and the humour of things. Is there also some darkness in Maira Kalman?

I see just as much sorrow and despair as I do joy. I probably even see more of the dark side, and I think that my paintings show that as well. Not as overtly, but I think there are layers of pathos and sadness within the humour and joy. Otherwise, I think the paintings would be idiotic.

You have to ask questions like "Why are we here?". If religion does not supply the answer, the answer must come from a personal point of view. Then you can stop asking questions and just accept the situation, and live life as best you can.

What kind of relationship do you have with words?

Words are beautiful and incomprehensible at the same time. It is virtually impossible to express yourself in this world. But then again, you still try to get close.

It reminds me of my work *New Yorkistan*, which was very funny. It was a collaboration with Rick Meyerowitz, who is also an illustrator, writer, and cartoonist. Right after 9/11, we started talking about the tribalism of New York and asked ourselves: what is New York? Within an hour, we had come up with about a hundred different names of neighbourhoods, and we thought: this might be a map, and this might be funny, and this might be something good for *The New Yorker*. They loved it and put it on the cover of their December 10 2001 issue. The response to the cover was unbelievable. You're doomed in this world if you don't laugh. So maybe it was the right thing at the right time. It's good to poke fun in a way that makes you feel optimistic. That's my kind of humour.

Soon enough it will Be ME
Struggling (valiantly?) to walk-
Lugging my STUFF around.

How are WE
all So Brave
as to take
Step
after
Step?

Day
after
day?

How are we so
optimistic, so careful
not to trip and yet
DO Trip, and then
GET up and say O.K.

Why do I feel So SORRY
For everyone and So PROUD?

138

My dream is to walk around the world.
A smallish backpack, all essentials neatly
in place. A camera. A noteBook. A
traveling paint set. A hat. good shoes.
A nice pleated (green?) skirt for the
occasional seaside hotel afternoon dance.

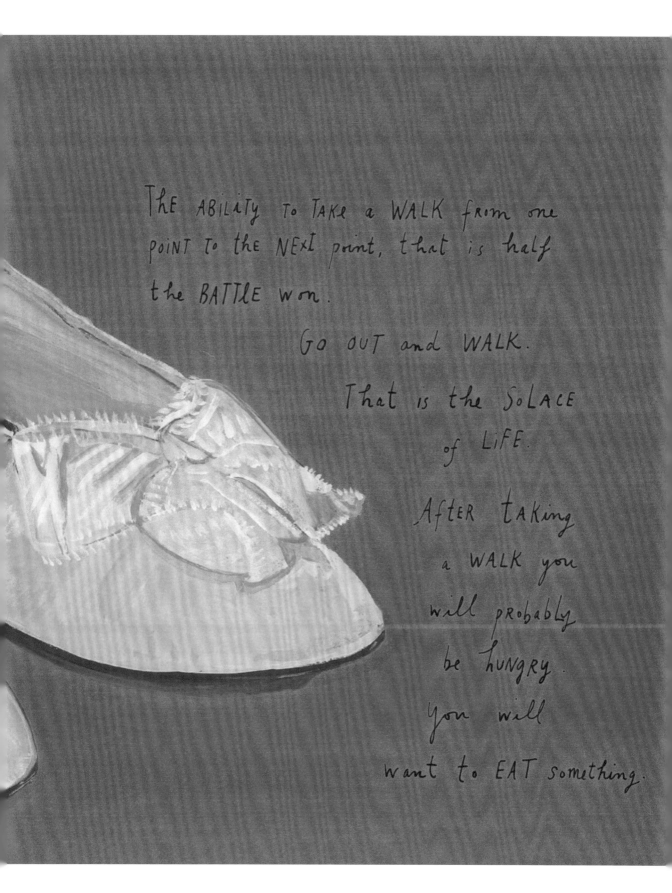

THE ABILITY TO TAKE a WALK from one POINT TO THE NEXT point, that is half the BATTLE won.

GO OUT and WALK.

That is the SoLACE of LiFE.

After taking a WALK you will probably be hungry. You will want to EAT something.

141

You make both children's books and books for adults. Is there a difference in approach or the creative process for you?

I try to remain myself when I'm writing for both adults and children. I am telling a story and I would like to include everyone. Perhaps the vocabulary is a little simpler for children. But not too much.

What is creativity to you?

My work.

Where are you most creative?

At my desk, with art supplies, books, lots of images, snippets of paper and articles on the wall, light, and music. That's it. I also need to work in the daylight, I cannot work at night. And I need neatness and order. I like things to be very organised.

What do you do to call upon your creativity?

The deadline is a beautiful thing. One works.

What kind of techniques do you use to come up with ideas?

I look at books, and I walk. Walking is the solution to all problems, big and small. Or I clean the house.

Where do you get your inspiration?

From almost everything I see. Not being bored is a great motivator. I don't like to be bored.

Do you use notebooks or do you work digitally?

I have sketchbooks that I carry with me, and I take pictures with my phone of all the references I come across throughout the day.

What are some things that prevent creativity?

Thinking too much and being pretentious.

Does your creativity have to be provocative?

No. It has to be an expression of my deep yearnings.

How important is humour in your work?

Vital. Critical.

What is the importance of colour in your work?

Colour is the foundation. I am always looking for the right colour. Sometimes I find it, sometimes I don't. I am now trying to mix a Cézanne grey using black, white, ultramarine, and ochre. Very satisfying.

Does your creativity have to create a better world?

My work is an expression of my humanity. That is all I can do.

Who inspires you?

Children.

Who or what has been the single biggest influence on your way of creative thinking?

My husband Tibor. He was a workaholic, and that made a big impression on me. The point is to not question too much, but to just do your work, guided by your instinct.

Who—dead or alive—would you like to have dinner with?

Marcel Proust.

What is failure to you?

Not being right is a very common thing. Everyone is wrong several times a day. You have to be really oblivious to think that you are right all the time. Failure also means compromising. You keep going, you don't have a choice. Failure happens whether you like it or not. And the point is to continue and make other work. It is vital to make mistakes, because they bring good.

Has the Covid-19 pandemic influenced your creative life?

In many ways the pandemic stopped time, or at least slowed it down, and in that there was found time. I was fortunate to be able to continue to work from home, and to spend a lot of time looking at trees and then painting them. I also found the time to read a great deal.

Everyone has had to take a look at their lives and decide what was important, and find a way to help the people that were struggling. It's good to realise that when there are fewer things going on, each little thing brings great delight.

What's the best piece of advice you have heard and repeat to others?

Patience and perseverance are what you need.

My Favorite obituary is that of Megan Boyd.
She lived in a tiny village in Scotland and
Spent her life making exquisite flies for
the local fisherman and for Kings.

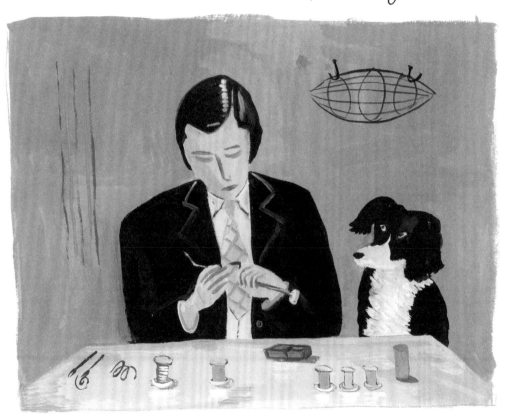

She wore a jacket and tie, skirt and boots.
Sitting at her table for 18 hours a day,
she sought a perfection that consumed her.
Her diversion was the occasional clog
dance in the village.

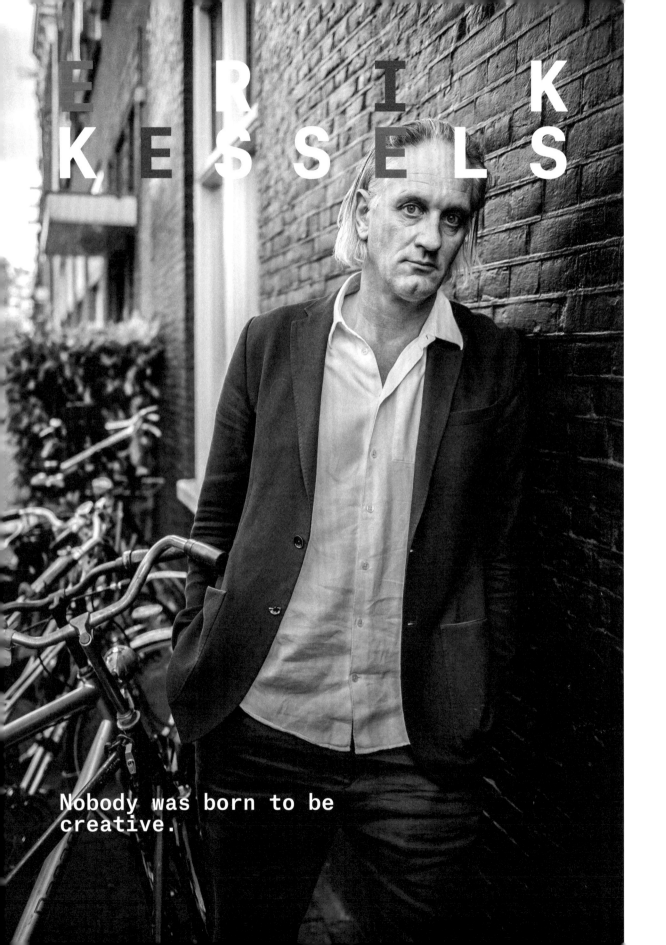

ERIK
KESSELS

Nobody was born to be
creative.

How would you introduce yourself?

I am the creative director of KesselsKramer and an artist.

What does creativity mean to you?

Perhaps creativity can be best described as trying to be different in a certain way and doing things differently. In this sense, creativity is something that really stands out from everything else we see.

Creativity is also a bit decadent, I think. Nobody expects it, nobody ever asked for it, but suddenly it appears and it touches people. People often say that creative ideas tend to be better when the economy is doing badly or there's a recession, but I completely disagree. I think creativity is much better when the economy is doing very well, because it creates a moment were everything is possible, which provides a base for the craziest ideas or the best type of creativity.

Where are you the most creative?

I know it's a cliché, but I'm most creative on an airplane and on a toilet. I've thought about it a lot, and it has to do with the fact that when you go to the toilet, you don't have anything else on your mind than what you need to do there. So, there's a lot of space open for other things. Just like on an airplane, where you're sitting in a very small space, and you can't do anything else. You're not distracted by your phone and you can really concentrate.

Do you have a preferred time to get inspired?

I think mornings work best for me. I get a lot of work done in the morning. It is almost like when you've cleaned your room and you've put everything in its place—it feels like a fresh, new start. The same goes for your mind. If you've had a fight with your girlfriend at home, you won't come up with a good idea as long as that fight is still going around in your head over the next few days. You need to be fit in your head as well.

What inspires you?

I find most of my inspiration outside of my field. If you work in graphic design, it's no good to look for inspiration by looking at a bunch of other graphic designers.

In my case, I'll get inspired by snippets of conversations I overhear on the street, or by things I find lying around on the street or at flea markets. I really like to observe how people display their goods and the practical choices they make in setting up their stalls. I also watch a lot of films and check out a lot of art, because I work as an artist myself. I work with a lot of photography and found photography. In a way, it all influences each other. I often experience a bit of an overload at the end of the day and then I need to offload it. I get enough inspiration, let's put it that way.

Do you think creativity should be provocative?

Earlier I said that creativity is everything that is extremely different. I think that the phrase "If no one hates it, no one loves it" applies here as well. It's important to be very explicit with your ideas. If lots of people hate your ideas or concepts, that's actually a good thing, because it means that there are also lots of people who really love them. I don't think ideas should be provocative for the sake of it, but within the field and the parameters of your work, they definitely should be. I've worked in advertising and design for 25 years, and I really hate advertising, to be honest. Because it's horrible. 95 percent of what you see on the television is horrible. But that's OK. I am happy that so much of it is horrible because that inspires me to make something different. Every day it motivates me to have better ideas and to fight the stereotypes.

Tell me about your work for the Hans Brinker Hostel.

The Hans Brinker Hostel is a 500-bed, very low-budget hotel for backpackers and students. The owner called me one day saying he kept getting tons of complaints from customers, and he needed our help. But when we visited the hotel, it actually was a horrible place, so promoting it would be a lie. That's when we came up with the idea that maybe honesty is the only luxury there is to be found in this hotel. We made posters that said "Now a bed in every room!" or "No more dogshit at the main entrance!", or "Get a free key with your room!". That is the kind of humour and irony that backpackers and students love. But it's also ironic to see the hotel make fun of itself, which only added to its popularity. In that sense, the idea wasn't provocative for the sake of it, but maybe it was provocative because we had no other option. Either way, it was very effective.

Does creativity have to create a better world?

Whenever you can, you should try to create a better world. Especially in advertising, but also in graphic design. For instance, I did an event in Amsterdam that was called *Jump Trump*. Visitors could climb up the stairs and jump onto a big eight-square-metre cushion with a huge portrait of Trump on it, effectively trashing his face by jumping on it. It was very popular: twenty thousand people jumped on his face in one weekend. I for one am always looking for that controversial dimension.

How do you go about incorporating humour into your work?

There is no magic formula to create a funny idea. Basically, I think that you should differentiate yourself from the mainstream any way you can. Humour, irony, and being very honest are all quite effective ways to achieve that, but they're never a good starting point.

Did your childhood influence your way of thinking about creativity?

When I was eleven years old, my nine-year-old sister was killed in a car accident right in front of my mother's eyes. She was hit by a car as she was crossing the street.

I was the only one left at home. My parents were grieving, and for about five or six years they were in a lot of pain. It made my world much smaller, and I just didn't want to cause them any trouble. I was constantly drawing in my room and making things, locking myself away in my own world. It was a very difficult time, but although it might be strange to say, for me something positive came out of it.

As an artist, you are a collector of people's collections.

As a designer and art director, I often work with other people's images. I am basically the composer of the idea that I came up with, bringing all the elements together: the copy, the design, the photography, the illustration or the video… In that sense, I am very accustomed to and almost more interested in other people's photographs. About twenty years ago, I also became quite interested in flea markets, for example the ones in Brussels, where I always came across a lot of amateur photography and family photo albums. I started looking through them and noticing the mistakes and the mark of the amateur in them. Something about these albums is very positive, very funny and light, and I started to recognise certain narratives in them.

For instance, I found an album where a family was trying to solve one of the greatest mysteries of photography: how to capture a black dog on film. This family had tried to take pictures of their black dog for fifteen years, but it was a total disaster, because the dog was almost always a black silhouette. By the end of the album, they were probably so frustrated that they started to expose the images of the dog, and for the first time you start seeing the dog's eyes and character, but then everything else was overexposed. Those are the kinds of stories I'm talking about. I started turning these stories into publications. In 2007 I had my first big solo show in Utrecht (Netherlands) in nine big museum spaces, just with the work that I had generated from found images that I composed a story with. In a way, this was also a product of my work as an art director.

How does failure inspire you?

Nowadays, people in the creative field use tools that come very close to perfection. Look at the cameras on our phones—they're so perfect that you need an application to fuck up your image, to make it look authentic. The rendering that architects use in their presentations looks better than when the building is made for real. Everything is perfect, but this perfection is not really a good starting point for a new, innovative, creative idea. To get an idea, you need to go in the wrong direction. You need to make—metaphorically speaking—a mistake.

Let me explain this using a metaphor: a lot of people only use the front garden of their house. Your front garden is like the shop window of your house; it's where you finalise and polish projects and show them to the rest of the world. But a lot of people never leave their front garden, whereas I think that people should start their work in their backyard, which is a filthy place full of unfinished projects. The mess is a bit embarrassing, so a lot of people have put up a fence around their backyard because they don't want anybody to see the horrible stuff they have lying around there. But that makes it a place where you can really be creative, because you can walk around in your underpants. Nobody can see you, and you can just experiment and find new ideas. Later on, you take your idea through the house to the front yard, and that's where you finish it. But you need start in your backyard and fuck things up and become embarrassed and ashamed of yourself and sometimes even desperate.

The Standard

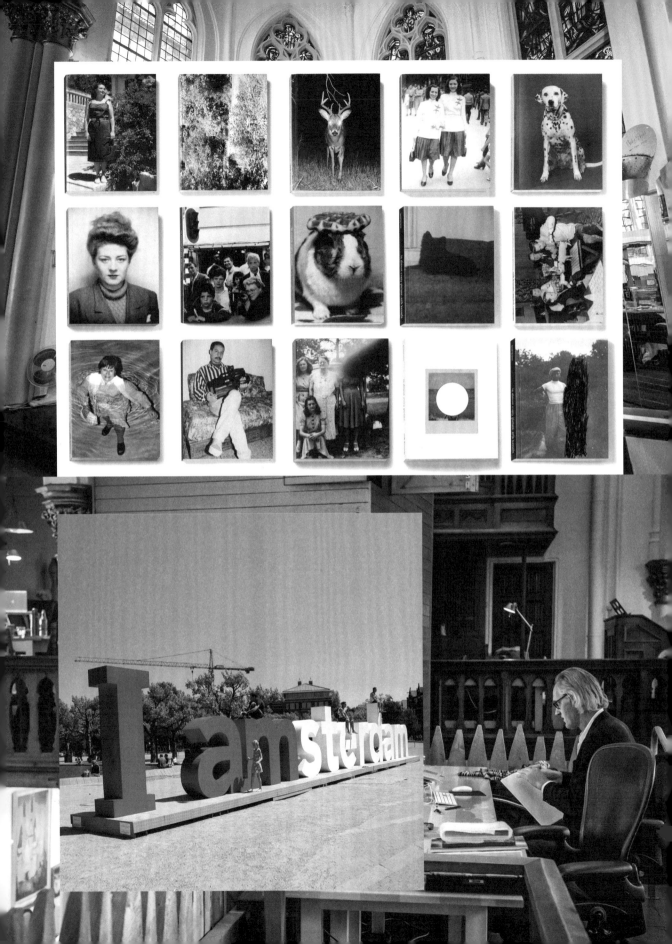

That's how it is for me. Each time I have to come up with a new idea, it's just as embarrassing as twenty years ago, because nobody was born to be creative. You can be born with different talents, but being creative is something you need to learn. You have to learn to let loose, take risks and go in wrong directions, and then feel embarrassed. You need guts to do that, and that is what creativity is to me. I don't go around shouting it to everyone, but I too come up with some very bad ideas before I have a good one. I always wonder why I have to go through this muddy field of stereotypical, shitty ideas first, but at the same time I enjoy the journey. You have to get a lot of the stuff out of the way before you end up somewhere good. But all that happens in the backyard of the house.

Has the Covid-19 pandemic influenced your creative life?

It goes without saying that the first few months of 2020 hugely changed and impacted our lives. But what is the effect on artists, photographers and creative people in general? First of all, in order to be really creative, you need to feel comfortable and fearless. Creativity needs this stable ground to accelerate on, and then become uncomfortable and risky again. This foundation was gone for some time, and that will have an extensive impact on creativity. At first sight, creativity is not essential and illogical, but in the long term it is crucial to society's progress. It's the flour in our society's cake. Going forward, the confidence and strength to be 'ridiculously' creative again needs to be regained. Creative people need to fight back and turn this devastating virus into a positive virus called creativity.

What's the best piece of advice you've heard and repeated to others?

The best advice that I can give to people starting out, is that it's very good to say no a lot. "No" to the stupid ideas you come up with, but also "no" to certain projects that you are offered. When you start your career or your own business, it's very important to be precise about what you will and won't do. The work you create in the first two or three years of your career will always stay with you, because that is the foundation of your portfolio. If you create fantastic work in the beginning of your career and you are very strict about what you will and won't do, then you'll build up a very strong creative base and people will come to you for the right reasons. You'll get new jobs based on the kind of jobs you did before. If you do lots of shit jobs the first two years, you will be surprised at how many more bad jobs you'll get, because people don't know what you stand for. So, my advice is that it's actually more important to say no than it is to say yes.

> Creativity is decadent.
> Nobody expects it,
> nobody ever asked for it,
> but suddenly it appears
> and it touches people.

citizenM.com/RoyalCitizens
#citizenM #RoyalCitizen
citizen M hotels

Help us Become the Most Likeable Hotel in the World
HANS BRINKER BUDGET HOTEL

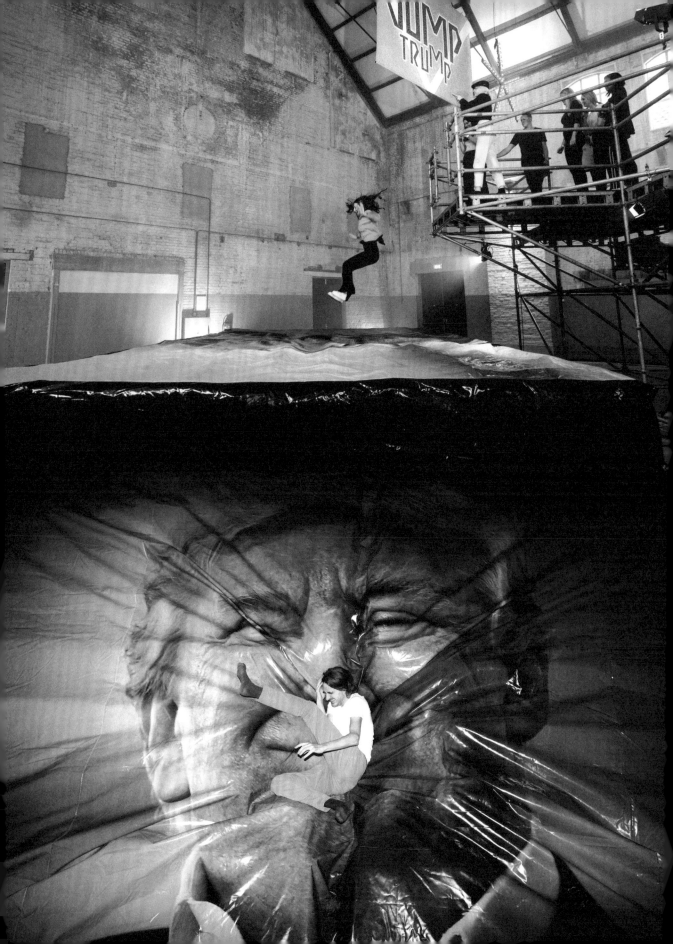

EIKE KÖNIG

Don't listen to advice.

How would you introduce yourself?

I feel like I'm alive. I am a graphic designer but I've taken several passes in my life, all related to my profession. First I started teaching and now I have an artistic practice as a graphic designer. It's really difficult to describe myself because I have a variety of personalities and they're all connected to my main identity. I would never define myself... it's too difficult.

What kind of childhood did you have?

My father was an architect and my mother raised three kids as a stay-at-home mom, but she was also very active in politics. It was an interesting mix of really diverse personalities. My father was a big fan of Le Corbusier and he was very, very strict. I would say he was a sensitive, hard father. He told me to work hard, not to use any decoration in my work, cut all my ideas down to one idea and then follow it. My mother was the opposite. She was way more preoccupied with society and your position in it, responsibility, humour, empathy... I'm a mix of both of them. I grew up in a safe environment.

I was a professional gymnast between the ages of three and seventeen, and I think that had a huge impact on me as a person. My life was really organised around gymnastics: my friends were all fellow gymnasts and I didn't take drugs or drink alcohol. When my trainer, who was like a second father to me, died, I started to revolt against this system and the peer pressure. As a teenager, I just exploded, going from being controlled by other people to doing the exact opposite and deciding to not be organised at all. That gave me a lot of power. Thanks to this experience, I know that I have to train really hard and for a very, very long time to get a little bit better, and a lot of people don't know that.

When did you know that you wanted to be a designer?

I think the biggest influence was the political situation I was born in, namely the Cold War. My parents used to read a lot of political magazines that were full of infographics about the situation at the time, for example depicting how many nuclear weapons each side had. Neighbours were building bomb shelters in their gardens. The situation was abstract, because it was a constructed fear, no one was actually pointing a gun at you. Reading those magazines, I saw the potential in there; I was really touched by the infographics and I wondered why they touched me so much. The pictures really spoke to me and I wanted to know who was behind them. Then I figured out that it was a professional graphic designer who drew these graphics. I found the act of taking a very complex situation that is very hard to describe in words and translating it into pictures that somehow explained it to a broad audience, very powerful.

What is your view on computer design versus design by hand?

When I was in school, we learned typography with wooden letters. You could feel the rules of typography with your hands. The computer didn't become mainstream until two years after I graduated, so I was still trained to design by hand. I thought it was really boring because we had to do repetitions and hundreds of variations and I didn't understand why. Years later I figured out that that's the foundation I'm building on now. It also trained me to see things differently. It's often about seeing potential in your work: if you create variations, you also have to see potential in these variations and work on them. It's about self-reflection, self-criticism and making decisions.

With the arrival of the computer, you suddenly had the possibility to go back one step, and that's just not real life. If you do something, there's no taking it back, it will influence everything else.

I instantly fell in love with the computer, and I started doing everything digitally. Before, design had always been a skill; you had to learn to do things by hand. Then suddenly there was this tool that helped you to create solutions much faster. At a certain point, after designing on the computer for some time, I felt like I was missing something. I was missing the experience. Working with a computer is one-way communication. I started wondering what the difference was, and found out that when I designed by hand it was all about the material and the direct communication with the design. I decided to start using the computer as just one of my tools instead of as my main tool.

I'm interested in creating solutions that include both tools, but also in using the programmes differently from how they were designed to be used. When you're working with a computer programme, you're designing within a grid that's very hard to leave. You have to find strategies to hack the programme, and use it in a way that doesn't make it look like Photoshop.

What does creativity mean to you?

We use creativity as a branding tool to sell work, but to be honest, everyone is creative. For example, a cook is creative in the way he puts together recipes. Even the government uses creative ways to deal with problems, and you can find those problems in all kinds of life situations. Creativity to me is the way you look at problems and the way you deal with them. You could have a very pragmatic approach: you learned how to solve a problem and then you just repeat that solution, but there are a million different ways to solve a problem. Maybe creativity is trying to figure out another way of finding a solution for a problem.

Creativity also sounds like magic, like it's 'God-given'—whatever that means—like you were born with it. Society separates the 'creative people' and the people who are 'not creative', putting them on a different level. It effectively divides a society, because the creatives look down on the non-creatives and the non-creatives don't look up to the creatives, but see them as freaks. It creates a divide. I think everyone is creative, or everyone can be creative. All the solutions and all the questions are around us, and we all breathe the same air. It all depends on how you filter all the information and then turn it into an idea that might create a solution.

Often I'm not the one who creates the solutions, I just find them by listening and connecting the dots between my own questions and other people's ideas and things I come across.

Do you have a preferred time or place to be creative?

I really need a safe space. It might sound strange, but I can't work while I'm on the road. I need my studio, my environment, my castle. I'm not a morning person, I'm more of a night owl, but that will surely change because I have a family now.

I have designed my life in such a way that it allows me to easily stop doing things when I feel like I'm blocked, or to welcome an idea and start working on it. The process of developing or designing something is not something that you can turn into a daily routine, it's not a production line. It's not fifty minutes of design thinking, fifty minutes of brainstorming with other people, and thirty minutes of putting it all together. People try to develop methods for 'creativity' but I don't believe in that, to be honest. Everyone has their own rhythm. Sometimes I need four days just to get into the mood to get closer to the problem and sometimes the solution is there in a second. I will not be forced.

How do you start?

I write everything down in my mobile phone. I'm always collecting thoughts and I need to write them down because then I can have a dialogue with them. If it doesn't have a face and it's just a thought, it will be gone at some point. When I see or read something or there's something going on in my mind, I will write it down and then I can always go back to those notes. I try to summarise the thought in a few words, maybe sometimes I will take a picture and add it to the notes. It has become like a recorder to me; other people use notebooks, I just take notes with my digital gadget.

Tell me about the list of rules you created for your work.

I wanted to write down the reasons why I wanted to run my own studio and what would be important for me if I did run my own studio. I want to have fun, although that sounds naïve, but if I have the chance to choose, why not choose more of the stuff that is interesting and fun, and less of the frightening and energy-consuming stuff? Also, if you work in an institution like a company, you always have to deal with the people and the system. If it's just me, I can decide not to work with a certain client simply because I don't like them.

When I found myself in situations where I felt like I wasn't having fun anymore, and I thought I should quit, I would look at the rules and they would help me make a decision. A couple of years ago I found them again and it totally took me back. I shared the rules in one of my lectures and people started taking photos of the list and tweeting it. I think that list is the most shared image of me on the internet. People are starting their own companies around the world and printing it out. In the end, it's definitely a naïve idea of how to run a studio, though.

Is humour important in your work?

Humour helps us get through a lot of crises and it seems to be a filter for dark days. I believe in humour as the key to someone's heart. Humour isn't always accepted in a lot of fields, but if you communicate with people verbally or visually, there's always a way to do it with a little bit of humour. I like not taking myself too seriously all the time. Maybe that's also why I don't like taking my job so seriously. Sometimes I feel like my client is taking things too seriously and I'll think to myself: it's just a shoe.

I LIKE YOUR STYLE

EGO NOMIZED CAPITALISM IN LATE ZEITGEIST

WIFI | D'AMORE

THE AESTHETICS OF BOREDOM

THE PRESENCE OF THE ABSENCE

THE FUTURE

BRANDED CONTENT

TRUTH

JETSET
JETSET
JETSET
JETSET
JETSET
JETLAG

ABSENT

OPINIONS ▭ FACTS

BELIEF
IT
OR NOT

ARE NOT ▭
FACTS ▭

ARE NOT
CRUCIAL

POSAL

OR A
NTING

Does your creativity have to create a better world?
I believe that creativity has the power to change things. If you actively use your skill as a citizen-activist, you can make a difference. I try to have an impact on my surroundings in the way that I work with people, the way I treat people, the way I show people who I am and try to give them the chance to shine. I believe in the power of a very small-scale impact, and it feels like it has already worked. I've worked with more than eighty people in my studio. How you treat people has an influence on how they treat other people. I think my legacy is not the work, my legacy will be the way I work with people. That impact is much bigger.

What about your personal work?
I love the process and the experimentation and the knowledge I gain from my private work. When I'm working with new materials, I love to fail. It's not about the final piece, it's really about the whole process: having the thoughts, rethinking them, making them clearer and then suddenly producing something and later maybe doing another version of it. In the end you might show it digitally or put it in a gallery. I really want to invest my energy into doing things that are just for myself. I could even decide not to show the result at all, just because I enjoy the process so much. Of course, at the same time I'm also trying to test things and show them to people to gauge their reactions. I can use a lot of the knowledge I've gained from working in the graphic design field in my personal work, so it's all connected.

What is your relationship with typography?
I especially like written words. Each typeface has its own story, like when it was created and why it was created, so choosing a certain typo gives your message a specific direction. I chose a typeface that is quite neutral in its character, Helvetica. Whatever I say or communicate will always be written in the same typeface, so it becomes the container of my information, without being too prominent. I don't use a typeface that already gives my message a specific direction, because language itself is a code that divides people. Language has a lot of power: you can use it to say 'I love you' or to start a war.

Is failure important for the creative process?
It's important to get out of your comfort zone. If you stay inside it, you will always repeat the same strategy you used to solve a similar problem, but you will never explore a new way. Leaving the comfort zone means taking a risk.

Has the Covid-19 pandemic influenced your creative life?
Covid-19 has impacted my whole life, including the creative part, like it has for everyone else on this planet. I miss a lot of things that are important to me, like cultural events, travelling, and meeting friends, but we are also collectively experiencing a global crisis that you cannot describe the depth of, or even imagine the scale of its impact on our society. At the same time I'm very aware of my privileges.

What's the best piece of advice you have heard and repeat to others?
Don't listen to advice. You have to go through the shit by yourself anyway, so be brave and do something good while you are on Planet Earth.

THE ABSENCE OF NOISE

SILENCE

THE FUTURE

TRUST

GEORGE LOIS

$ELLEBRITY

$ELLEBRITY

MY ANGLING AND TANGLING
WITH FAMOUS PEOPLE
GEORGE LOIS

GEORGE LOIS

There's no such thing as
a cautious creative.

What is creativity to you?

I'm a living symbol of creativity. Everything I do is creative. True creativity is edgy, provocative, dynamic, radical, sometimes even shocking. Creativity can solve almost any problem—the creative act, the defeat of habit by originality, overcomes everything.

What does a day in the life of George Lois look like?

I don't think there has been a day in my life since I became a designer, where I didn't have something to work on, or to find a solution or a big idea. What inspires me is when I get 'the big idea'. That's when I go crazy and start developing this big idea, working day and night. I don't do it anymore, but I used to go to bed at midnight, sleep for an hour and a half and then get up for about three hours. I did my best work in those three hours.

I'm so lucky because my wife, who is a painter, understands what I'm about and has never complained for one second because I was working all the time. She loves to sit down with me to hear about what I'm doing. Sometimes she has a good idea. She is a better writer than most people I've tried to write with.

Do you have a special place where you like to work?

My ideal work environment might be like the offices of the ad agencies I used to work at. The offices were beautiful and impeccable. If I had an ad agency today, it would look the same way. Everyone would have their own fucking room. An actual room, not an open space. I don't believe in people working together I believe in one person working by himself or two people working together. I work by myself, so I don't need a writer.

The biggest problem with young people today is that they have been taught to work in groups. It's ridiculous. Five terrific people together are a problem, they will argue.

When I go and talk to ad agencies and I bring up the stupidity of working in groups to young people, they get up and cheer. So the head of the agency has just found out that his people hate working in groups. It's just not the way to work if you're talented. It's in my book, *Damn Good Advice (For People with Talent!)*. I have written a bunch of books, but for this one I really sat down and made sure that I wrote a book that every young talented person could read and study, so that they would absolutely fucking listen to me. Sometimes people say to me: "Listen Mr Lois, when I stand up for myself and argue, I might lose my job." I tell them: "Okay, lose your fucking job. You want to be great? Suffer a little bit."

Are there things that prevent you from being creative?

If I can't get an idea in a couple of hours, something is wrong with what I've been told. I'm getting the wrong input. When I did the *Esquire* covers as a young man people asked me: "How do you know what to do?" I told them that I would have lunch with the editor, and he would tell me what the next issue was going to be about. He would just give me four or five things to work with. Maybe fifteen minutes later, while we were having lunch, I would have an idea. But I didn't tell him about it, I don't tell people about my ideas. And if I didn't have an idea like that, it would mean he had a lousy magazine. If I didn't like anything he came up with, I would just go ahead and do something I thought he should be talking about, and I would give that to him.

Where do you get your inspiration? What inspires you?

Everything. What I tell young people is: you have to build a DNA of creativity in your body—you have to be a sports fan, you have to love the movies, you have to love art, you have to go to the museum twelve times a year, you have to go to the theatre. You have to understand the culture.

I give classes, and one day I asked the students: "How many of you have been to the Metropolitan Museum of Art, our biggest museum in New York? Anybody?" Not one. "How about the museum of Modern Art?" Maybe twelve out of six hundred people. The teachers were all lined up in the first row. I said: "Shame on you, motherfuckers! How can you teach design without teaching the history of art? You have to study the history of art! Why? Because it means everything. It's what you're all about. It's what you believe in."

How did your childhood influence your creativity?

Actually, my talent started when I was four years old, and I began drawing. I started getting up in the middle of the night to draw when I was five years old. I would get up in the middle of the night, spend two or three hours drawing—everybody in the house knew it—drawing, drawing, drawing, drawing. It all starts with drawing. That's why I draw all the ideas I get. I have them in my head, so I could just tell the photographer what I want, but I have to put the idea down to be able to put all the details into it.

APRIL 1968
PRICE $1

Esquire

THE MAGAZINE FOR MEN

The Passion of Muhammad A

Is there a person you looked up to?

Paul Rand. When he was about 24 years old and I was about fourteen, he did some exciting work for *The New York Times*. Everything was fresh and thoughtful. I believed in him. I was thrilled that he was 24, a young guy, who didn't take any shit and did great work and got away with it—and he was Jewish. Back then, advertising was anti-Semitic, racist, anti-ethnic. I think I'm the first important person in the history of American advertising who was ethnic.

In one of your books you say that asking 'what if?' is a really good base for breathtaking ideas.

I think I even made a point of that when I decided to try to get Rubin 'Hurricane' Carter out of jail. He was innocent, it wasn't right. He was in jail for almost twenty years for supposedly killing three white people. It was an absolute frame. I got Ali to be the head of my committee. We got on the phone and we got 150 famous people to join, just to get people writing letters. One of the 'what ifs' I came up with was: "What if I could get Bob Dylan to write a song about it?" And he did: *Hurricane*. Every idea starts with: "What if I could do that?" A 'what if' has to be something you know could be done, if you've got the balls to go for it.

It was kind of my 'what if' to call up George Lois and ask him to do an interview.

Yeah? What the hell, sure!

How important is humour in your work?

Oh my God, my stuff is funny. My stuff is witty. I mean, Andy Warhol drowning in can of soup, it's better than funny, it's a riot. I called up Andy Warhol—he was always a fan of what I did—and I said: "Andy, I've decided to put you on the cover of *Esquire*." "Oh," said Andy to his people at the Factory, "George Lois says he's putting me on the cover of *Esquire* magazine." "But wait a minute, George, what's the idea?", he said. "Well, I'm going to have you drowning in a giant can of tomato soup." Warhol said: "I love it, but won't they have to build a gigantic can?" I said: "No, asshole. It's photomontage."

What's your take on failure?

If you're talented and you know you're talented, you can't learn anything from a failure. Supposedly, the whole world agrees that, starting from the day you were born, when you make a mistake, you'll learn from it. If you experience a failure, the minute you start questioning yourself, you're never going to join the Pantheon of the Greats. Everybody who starts off as a designer or whatever it is you do, should be thinking that they're the best there is. Massimo Vignelli used to say to me: "George, if you do it right, the idea will live forever." Very thoughtful. The last time I saw him, I told him: "You got one thing wrong. It should be: 'If you do it right, your work and you will live forever'." That's what it's all about. That's your very essence saying: "When I'm dead, they're going to fucking think this son of a bitch was the best there ever was." That's the only way to think. You have to be courageous. I've always said, "You could be creative or you could be cautious, but there's no such thing as a cautious creative." You've got to go all the way. But that doesn't mean you've got to go stupid all the way.

Could I call you a 'creative provocateur'?

Your work should be thrilling and above all provocative. There was this cereal for young kids called Maypo, and I asked the owner: "Why do you only sell to young kids?" He said he'd love to sell to older kids, but he didn't know how to do it. I knew how to do it. I got six of the greatest athletes that ever lived to be in the ad. I got Mickey Mantle, whining: "I want my Maypo". And then Will Chamberlain: "I want my Maypo." Then, the famous guy from the Dallas Cowboys says: "I want my Maypo, I want it!" At a certain point in the commercial the voice-over says: "Maypo cereal—the oatmeal cereal that heroes cry for." That's provocative. It's hot shit. In fact, three weeks after the commercial had been running, Mickey Mantle calls me up and he says: "Everywhere I go, all I hear is 'I want my fucking Maypo.' Goddamn it." And he hangs up on me. It becomes famous. Everything you do has to make you famous, immediately.

```
You wanna be great?
Suffer a little bit.
```

Esquire
MAY 1969
PRICE $1

THE MAGAZINE FOR MEN

The final decline and total collapse
of the American avant-garde.

Looking back, what are you most proud of?

I always talked truth to power, not just in my *Esquire* covers. I did an ad in 1960 that the advertising business went crazy over. They hated it. It's all black—supposedly with a couple sleeping, but it's black. It says in type: "John, is that Billy coughing? Get up and get him some codeine." I knew that women would be the ones buying the cough medicine for kids. I'm talking truth to power. What I'm saying is: men these days, almost all of them are macho assholes, who treat women, especially their wives, like they're maids. You do your job, I'll do mine. It ran and they had incredible sales.

I did a cover for *Esquire* at a time where things were really getting rough in America. Black men were getting pissed off the way they should've been. It was the time of the Black Panthers, and there were liberals that I knew, saying: "George, we care about racial justice, but blacks are getting dangerous." So I did a Christmas cover with Sonny Liston as Santa Claus. Everybody in America knew what that was all about. Cassius Clay, before he became Muhammad Ali, said: "Hey George, that's the last black motherfucker America wants to see coming down their chimney." It got tremendous publicity. All it was was a picture of Sonny Liston. I was talking truth to power. I was talking to every white asshole in America who was saying: "Hey, these guys are getting kind of rough here. You've got to be careful walking down the streets." Fuck you. Truth to power. I think truth to power all the time.

64.
A truly great ad campaign is driven by a Big Idea that contains:
1. A memorable slogan!
2. A memorable visual!

A memorable visual, synergistically blending with memorable words that create imagery which communicates in a nanosecond, immediately results in an intellectual and human response. The word imagery is too often associated purely with visuals, but it is much more than that: imagery is the conversion of an idea into a theatrical cameo, an indelible symbol, a scene that becomes popular folklore, an iconographic image. And this imagery should be expressed in words and visuals or, ideally, both! Shown is a sissy, superstar tour de force of some of the greatest macho sports icons of the 1960s, weeping and moaning *I want my Maypo!* (an oatmeal cereal) on TV, a single-minded merger of words and pictures that American kids ate up.

DON MEREDITH

MICKEY MANTLE

WILLIE MAYS

JOHNNY UNITAS OSCAR ROBERTSON

BEFORE

A Coty Cremestick turned Alice Pearce

AFTER

to Joey Heatherton.

ou thought lipsticks weren't important, eh?
r Cremestick trick: they're moisturizing,
y're never greasy.
o! They're on in a stroke.
ice Pearce.

Some luscious Cremestick colors:

POPPY LOVE
Wear it.
But watch it!

PINK ME UP
That's what it's called.
That's what it does.

WET APRICOT
Much nicer than
dry apricot.

SUN SHIMMER GLOSSER
For come-hither
highlights.

And:

Mistakes can become part
of the painting.

How would you introduce yourself?

I am an artist whose paintings focus on colour, balance and composition. I'm inspired by colour and the connection between different colours, but also by the connection with the viewer.

What kind of family did you grow up in? What did your parents do?

I grew up with my parents and two older brothers. My mother was the headteacher of a local primary school and my father was an analytical chemist. My parents were very open-minded and encouraged us to find our own paths, whatever they may be.

Was there a lot of room for culture and art?

Up until I was seventeen I lived in a quiet, rural town in the Peak District. My recollection is that culture was non-existent. It was only really when I moved away for my studies that I started to experience culture and art.

Did your childhood influence your ideas about creativity?

I remember being very creative as a child and a teenager, and feeling unrestricted in my ideas and creative thoughts. I had a vivid imagination. As I started to get older the self-doubt and external criticism began to influence my ideas about creativity.

When was the first time you knew you wanted to be an artist?

It was always in my mind; I was naturally drawn to art as a young child. It's where I felt the most comfortable and where I could drift off and tune out the world. I remember taking a canvas and paints on holiday to Majorca when I was fourteen. I painted the most bizarre abstract painting, but I loved it and I loved the process.

How would you describe your work and style?

Boldly understated.

How do you create a composition?

The process is very intuitive for me. I don't like to think too much of the composition initially. I tend to begin with colour and the composition follows naturally. It has to feel right when I look at it and I am directed by my gut feeling.

What is creativity to you?

Being vulnerable enough to take your own vision or idea out of your mind and into the world.

What does a day in the life of Anna Mac look like?

It varies. At the moment it benefits me to take the morning slower than the afternoon. I enjoy a long walk as it gets me in the right frame of mind and frees me from negative thoughts. I am lucky enough to be able to walk through the beautiful heaths and forests on the Suffolk coast. When I get to my studio, I paint. There is little distraction—it's just me and my paintings. I like to work on two or three simultaneously so I can work whilst paint dries. I design and plan my paintings on my iPad, which I do at home. I like to keep my studio a painting space as much as I can and use my home for designing, emails, website and so on.

Where are you the most creative?

That really depends, I think inspiration can strike anywhere.

Do you have a preferred time to be creative?

There is no preference, I'm just grateful to feel it as and when it comes.

When are you at your most creative? What kind of circumstances have to be fulfilled?

When I am painting, I feel my most creative. There's a real buzz when you feel so excited about something you're working on, bringing it to life—it can be really quite addictive. I feel it's one of those things where the more you create, the more creative you become. For many years after university I stopped creating and it felt like it was slipping away more and more as time went by.

Where do you get your inspiration?

Colour is what really connects the dots for me. I can be inspired by anything and everything if it triggers an emotion or a connection. That is the beauty of it. Buildings, negative spaces, shapes, books, fabric, textures, lines... My own work is constantly inspiring me as well, it's a buzz to see pieces come together. I can look at a painting and see future paintings. Elements I can improve on, elements I want to explore more. They are a catalyst for the next painting and so on.

Can you tell me a bit about your work process?

I design on my iPad, initially starting with some colours I am particularly drawn to at that time. Currently I'm focusing a lot on my colour studies series. To me, these series really encompass my aim of colour, balance and composition. When I'm in the studio I like to mix up the colours and create swatches. I like seeing them in real life and being able to put them next to each other, seeing how the light hits them and so on.

The way I paint feels like a game of building and
taking away. The smallest addition of a shape
or use of colour can transform the painting.

What do you do to call upon your creativity?
I don't think it ever works well when you force creativity. Sometimes you just have to do something else: go out and about, do everyday jobs, go for a walk, and then it will come. It's not something you can do on demand; it has to flow naturally.

Do you use notebooks or doodle in books?
I mainly design digitally, although I do love looking through my old sketchbooks from pre-iPad days. I think will miss that in the future as all my designs are on my iPad. I have lost the tangible beauty of the sketchbook.

What are some things that prevent creativity?
Overanalysing, insecurity, self-doubt.

Can you elaborate on the importance of colour in your work?
It's hugely important to me. It's what I see first. Colour evokes emotion and I'm fascinated by how colours converse with one another.

Do you work with a certain colour palette?
I am always very drawn to nudes, ochre and bluey greens. Most of my work contains one or all of these colours.

Does creativity have to create a better world?
It doesn't have to, but I think it does whether you realise it or not. If you think about what the world would look like with no creativity, it would be pretty bleak.

Are titles important to you? You seem to work in series with the same name, why is that?
Sometimes a title comes to you straight away and really fits the painting. A title can really add a lot of meaning for both the viewer and the artist. However, for certain collections I feel that keeping all the works under the same title gives them a real sense of cohesiveness.

Who inspires you?
Many people—friends, family, other artists, designers, makers, musicians, activists... the list is constantly changing and evolving.

Who or what has been the single biggest influence on your way of creative thinking?
The Henri Matisse *The Cut-Outs* exhibition at Tate Modern, London 2014.

Who—dead or alive—would you like to have dinner with?
Sophie Calle, Jane Goodall, Tracey Emin, Henri Matisse and Moby.

What is failure to you?
A negative way of looking at a valuable lesson. You have to acknowledge it, accept it and move forward with a better understanding.

What is your biggest failure?
Not believing in myself and letting those negative thoughts hold me back in life.

How important are social media for you?
They're so important to me. They gave me a platform to put my work out there.

Has the Covid-19 pandemic influenced your creative life?
The pandemic and subsequent lockdowns have created a lot of creative self-reflection. This time to reflect on my work and life forced me to develop my work and push deeper to new ideas. I am not sure if my work would have taken the direction it has if it weren't for the pandemic.
It also reaffirmed how important creativity is for mental health. I am so grateful to have had a creative outlet throughout the pandemic.

What's the best piece of advice you have heard and repeat to others?
Always trust your gut.

What advice would you give to the younger Anna Mac?
Stop fannying about and get on with it.

DEBBIE MILLMAN

Busy is a decision.

How would you introduce yourself?

I'm a designer, an author, an educator and the host of the podcast *Design Matters*.

What kind of family did you grow up in?

My father, who died a few years ago, was a pharmacist. My mother was a seamstress. I inherited a lot of knowledge from both of them. From my mom I learned how to draw and sew and from my father I learned about brands.

Was there room for art and culture?

I grew up in a really turbulent, abusive, neglectful family. But there was always creativity in my life because my mother was very creative. So, from a very young age I was making things: perfume from rose petals, little magazines and so forth. I remember making a magazine with my best friend, whose name is also Debbie, so we came up with the idea of naming it 'Debutante'. We spent an entire summer drawing all the pictures and writing all the stories.

I also used to make my own clothes because I wanted pretty clothes but we didn't have a lot of money.

When did you realise that you could actually make a living out of these things?

I actually didn't think I could make a living doing these things. As much as I wanted to do fine art or write fiction, when I graduated college the most important thing for me was to be living on my own and supporting myself. I didn't want to go back home. The only marketable skill that I had was old-school layout and design. My first job was in that field, but the decision to do this was specifically organised around being able to make enough money to pay my rent in Manhattan.

You have done so many different things in your career. Was it a very planned career?

There is nothing planned about my career. The reason I did so many different things at the start of my career was because I was grasping at straws to figure out what I could do well. I call the first decade of my career 'Experiments in Rejection and Failure'. I kept getting rejected from one thing to another, and so I was going with the flow, trying to get whatever I was able to get.

My first job in branding came from what I now call a "Hail Mary". I was working at a well-known design firm, and doing really poorly there. The CEO hated me, and I needed to pay my rent. One day, I got a cold call from a headhunter who was looking to place someone in a branding consultancy as a sales person. This job at Interbrand was my first real job in branding. I was in my early thirties and had already been in Manhattan for a decade, and I thought: how much lower can I go? Little did I know it was a good thing and it ended up being something I really loved… and was good at.

Although these first decades in my career were really difficult, if any of these challenging experiences in my career hadn't happened, nothing following it would have had happened. It is hard to edit out the bad things or the hard things, if where you ended up is a place you are very content with.

You do a lot of different things. Do you need all these different kinds of input?

Even when I was in high school, I was a major multitasker. I was involved in the theatre and chorus, I was on the track team, I was the manager of the boys' basketball team, I wrote for the school newspaper and the yearbook, and I was on the Mathletes team. I basically did everything I could to stay in school as long as possible and not have to go home. Other than Mathletes (I'm terrible at maths), I enjoyed all of these activities.

Now I don't consider my myriad activities separate, siloed-off experiences. Everything I do involves and informs everything that I do. I see my work as one holistic practice with various tentacles that take me to different places. For example, I do my podcast at the Masters in Branding programme at the School of Visual Arts in front of my students. I worked at Sterling Brands for twenty-two years, I have now been teaching at the School of Visual Arts for thirteen years, and I have been doing my podcast for fourteen years. So, I am very loyal and persistent doing the various things that I love, but I also like to mix it up and grow and evolve.

Has branding changed over the years?

Yes, it has changed enormously. Brands don't naturally appear on the planet: if we weren't making them, they wouldn't be growing. Oranges grow, but Tropicana is manufactured. I believe that brands are essentially 'manufactured meaning'. Once upon a time, building a brand was rather straightforward endeavour. A logo was a visual guarantee of quality and consistency, or it was a signal that a product was something new. People were willing to pay a premium for this very special manufactured thing. Fast-forward a hundred and fifty years, and we are living in a world where there are over forty thousand products in a typical supermarket.

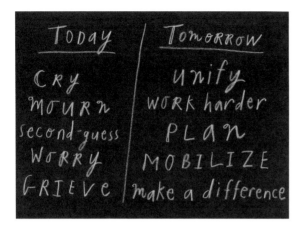

Brands—by design—signify our affiliations and telegraph our beliefs. Branding is now inextricably linked to the way in which society, culture, the environment, and business interact.

We are now at a tipping point in the way brands are being created and designed. For the last one hundred and fifty years, brands were the purview of the corporation. Brands were created, manufactured, distributed and marketed by the corporation, and the corporation controlled both the cost to the consumer and the profits the corporation collected. It was very top-down. Corporations had all the commercial control, people had little to none.

Through the advancements in technology and our mastery of computer communications, branding is becoming democratised, and the results are not, for once, relegated to the commercial. This new class of brands use the very tenants of branding that have helped propel brands like Coca-Cola and Starbucks and Amazon and Apple to the top, but these new, progressive brands don't have profit and loss statements. They have been created by the people for the people and have no financial imperative. Instead, they are connecting us with like-minded ideals in a way we've never been able to do before. They reflect collective values, they inspire us to take and demand action. Often, they can help us feel part of something bigger than ourselves, many times they are doing this for the first time in ever our culture. These new entities include the #MeToo movement, Times Up, Black Lives Matter and what I hope Trans Rights Are Human Rights will become. The design and proliferation of the Pink Pussy Hat—150 million people wore one in eight weeks' time— is proof positive that these efforts can succeed. I contend that these efforts are not only movements, they are some of the strongest change-making brands of our time. With these brands we declare: "This is the kind of world that we want".

This has created an environment wherein design and branding are not just tools of capitalism. The tables have turned and we are now living in a bottom-up environment where we have a remarkable amount of power. Now whether we use that power to make a difference and design a world we can sustainably and peacefully live in is, quite frankly, up to us.

How did the *Design Matters* podcast get started?
I was at Sterling when I started to feel what it meant to be successful. I gave it everything I had, and I gave up almost everything else. All of my other creative endeavours fell by the wayside in order to continue to be successful at this new thing I was successful at for the first time.

About ten years into the process, I started to feel that I was losing my creative soul. One day—out of the blue—I got a cold call from a fledgling internet radio network called Voice America. They asked me if I would be interested in hosting a show about branding, and I thought they were offering me a job. Instead, they were offering me an "opportunity" to pay them to produce a show for me on the network. At the time I was making good money and I thought: why not invest it in myself? It could be a creative endeavour and because they wanted it to be about branding, it could dovetail with my corporate career. Towards the end of our negotiation I decided to push the topic a little bit, and asked if I could call the show *Design Matters*. They were really reluctant at first because it didn't include branding. But very serendipitously, one of my clients at Pepsi was on an episode of *The Apprentice*, which was a very popular reality-TV show at the time. I said that if I would be doing a show about design, this would be someone I would include in the show and interview. That convinced them to let me do the show with the title *Design Matters* and include branding as part of it.

You've spoken to so many people on your podcast. What has that meant for you personally?
My talks on the podcast give me hope. I've discovered that all of my heroes have had struggles and failures and obstacles and insecurity. The only two people who I have interviewed that weren't fundamentally insecure about their work were Milton Glaser and Massimo Vignelli. I interviewed them when they were both in their eighties, so I I am hopeful that I will feel more secure about my abilities in a few decades.

Anything worthwhile takes time.

The 20th
The 20th
Regional
Regional
A Design
A Design
A 2013
Regiona
Design

You also write books: some are related to your show but others are more personal, such as *Look Both Ways* and *Self Portrait as Your Traitor*.

The original content from *Look Both Ways* came from the monologues that I was reading at the beginning of my radio show. Once again, everything is intertwined. In 2005 I took a class with Milton Glaser wherein I had to write a five-year plan for my future life. On my list I included writing a book of illustrated essays. I thought I would use some of my favourite monologues; as I had over a hundred of them. I picked my top twenty and then pitched the book to a publishing house that ultimately took it on, and that became my first book of illustrated essays. I hadn't done any illustrated artwork in over a decade, so I was really rusty! I had to go through a whole process of relearning how to make illustrated art.

After the book was completed, I was worried that I would lose the muscle that I had developed in making the book. So, I asked *Print Magazine* if I could contribute a visual essay to their website every month. I told them they didn't have to pay me, they just had to post them! They agreed, and I did that for three years. This resulted in another 36 visual essays. *Print Magazine* then asked me if I was interested in doing another book with some of the new visual essays, and that became *Self Portrait*, which is a zillion times better because of all the work I'd put into developing my craft.

The book looks like a counterpoint of working with pixels and branding, it's real craftsmanship and hand labour.

It is something I feel comfortable doing. I have learned I like making things with my hands and I don't get the same satisfaction from digital work. Although I am now drawing on my iPad and I really love that too, but there is something about the tactile I love best. I use a lot of fabric, felt, different materials and utensils. I really enjoy the actual making of physical, tangible things.

What is creativity to you?

Making things. I have different environments where I can execute things. It might be in my studio at SVA or in my house where I have a studio. I also like to work on my bed because it is very big, and I have a lot of room to spread things out. It can also be on a chair with my iPad, but it all starts in my mind: what I have thought about and want to articulate, either visually or verbally.

Where do you find your inspiration?

Living inspires me. Just the idea that we have a limited time motivates me. I am really preoccupied with the idea of how much time I have left because I have so much I want to do.

What are things that prevent you from working or being creative?

My own insecurities about whether something is good enough, and taking on too many things at once because I want to feel valued and I want to feel that my life means something. I have to be very careful of that; ultimately it can distract me from the things that have longer-term value. That is a real battle for me.

Do you want to create a better world with your work?

I would like to say yes, because I think that is the right answer, but I don't know if I would say that it is a motivation of mine. I definitely want to create a better world through my work with the Joyful Heart Foundation, which works to eradicate any sexual violence. And also through the advocacy work that I do to support various politicians that are trying to get elected.

In terms of the podcast, I wouldn't say that I am that altruistic. I think in many ways the podcast has been the biggest gift of my life, enabling me to learn from my heroes, my idols and role models. I would love to think that I am doing this for the world, but I think I am probably doing it just as much for myself!

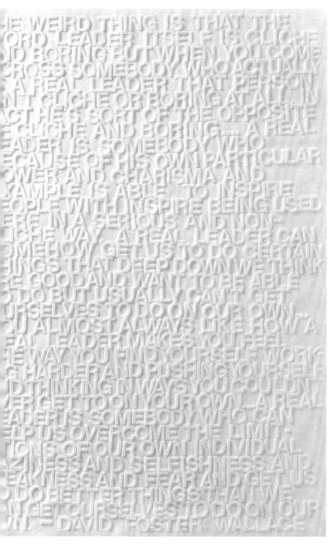

THE WEIRD THING IS THAT THE WORD LEADER ITSELF IS CLICHE AND BORING BUT WHEN YOU COME ACROSS SOMEBODY WHO ACTUALLY IS A REAL LEADER THAT PERSON ISN'T CLICHE OR BORING AT ALL IN FACT THEY'RE SORT OF THE OPPOSITE OF CLICHE AND BORING... A REAL LEADER IS SOMEBODY WHO BECAUSE OF HIS OWN PARTICULAR POWER AND CHARISMA AND EXAMPLE IS ABLE TO INSPIRE PEOPLE WITH INSPIRE BEING USED HERE IN A SERIOUS AND NON- CLICHE WAY A REAL LEADER CAN SOMEHOW GET US TO DO CERTAIN THINGS THAT DEEP DOWN WE THINK ARE GOOD AND WANT TO BE ABLE TO DO BUT USUALLY CAN'T GET OURSELVES TO DO ON OUR OWN... YOU ALMOST ALWAYS LIKE HOW A REAL LEADER MAKES YOU FEEL THE WAY YOU FIND YOURSELF WORK- ING HARDER AND PUSHING YOURSELF AND THINKING IN WAYS YOU COULDN'T GET TO ON YOUR OWN... A REAL LEADER IS SOMEBODY WHO CAN HELP US OVERCOME THE LIMITA- TIONS OF OUR OWN INDIVIDUAL LAZINESS AND SELFISHNESS AND WEAKNESS AND FEAR AND GET US TO DO BETTER THINGS THAN WE CAN GET OURSELVES TO DO ON OUR OWN — DAVID FOSTER WALLACE

Who—dead or alive—would you want to have dinner with?

Definitely Albert Einstein, Susan Sontag, Virginia Woolf, Marilyn Monroe, Steven Hawking, Barack and Michelle Obama, Hillary Clinton, the poet Charles Olson, and Gabriel García Márquez.

What is failure to you?

Felix Sockwell once wrote something really nasty about my work in a blogpost and he caused a lot of commotion for me with it. People were very upset, it was a lot of negativity and, at the time, it criticised my whole career. It was very hard. But out of that experience I ended up getting the opportunity to write for *Print Magazine* and then create the podcast. So ultimately it wasn't a failure, but it became one of the most profound experiences of my life and my career.

"Busy is a decision."

We decide what we want to do. When my students say: "I was too busy working on my portfolio so I couldn't do this or that," I say: "Well, then it wasn't that important to you". It's just a way of letting yourself off the hook. It's lazy.

What is the best advice you've gotten and still repeat to others?

Anything worthwhile takes time. We are living in an age where you see so many people become successful before they turn thirty, and now there is often an expectation that everyone should do that. And if they don't, they will live a mediocre life. I think that I am evidence of that not being true. Being thirty years old was one of the lowest points in my life: I was getting divorced, I had no permanent place to live, I didn't have a job. It was difficult at the time, but I think if you want something badly enough you just don't give up until you get it. In the grand scheme of things, my desire and my longing for a better life was stronger than my shame of what I had not accomplished.

It took a long time

JONATHAN
MONK

It's the search for the answer
that's interesting.

How would you introduce yourself to somebody who doesn't know you?

If I'm talking to an art school or to you, I would say when I was born and that I grew up in Leicester, England and studied at Glasgow School of Art, from which I graduated in the early nineties. If I'm on a plane and the person next to me asks me what I do, I tend not to go into detail.

I'm not even sure exactly what I do, because I don't really do one thing. Maybe I'm known for specific types of work. I try not to be forced into one position, so I do a lot of different things. I have always avoided having a house style. You don't generally look at what I do and say: "That's a Jonathan Monk".

What kind of family did you grow up in?

My dad studied to be an architect, but I don't think he finished his degree. He was also a jazz pianist and went to America in the fifties to play in a band. He lived there for a few years and then came back to Britain and opened a restaurant in Leicester and married my mom. She had worked in offices but when my sister and I were born she became a housewife. She did end up working in a school later.

We didn't really have art or many books in the house. Maybe I became an artist because my dad had studied architecture and he was good at drawing. I was good at sports at school and when I was fifteen, I seemed destined to become a physical education teacher. But then my art teacher told my parents that he thought I might have the potential to work in the arts or in design. That's when I really started realising that that was what I wanted to do. It seemed an ideal moment, the early eighties in Britain, everything seemed to fit together and I just went with it. And in a way I'm still doing that. I keep waiting for it to all go horribly wrong, but at the moment it seems to be okay.

Where does the fascination with working with other people's work come from?

It's about not having the control over an idea, because it was in someone else's hands. When I first left art school, I didn't really want to put myself into the work. I didn't want my hand to have controlled the work, so I was copying things, bits of paper that I picked up in the street, or paintings that I called 'holiday paintings' made from travel agency adverts. For instance, an advert that said: "Tenerife, two weeks, bed and breakfast, 199 pounds". Then I would carefully copy that exact information onto a canvas and try and sell it for the same price as the holiday. I started this series in the early nineties and occasionally still do those now. I like the idea that you have a choice to either buy the painting, which is essentially the idea of the holiday, or go on the holiday, for the same price.

You also did a series of paintings that read: 'This painting should ideally be hung opposite a John Baldessari.'

This was inspired by the idea that at an art fair a work might be hung across from a Baldessari or a Picasso or a Basquiat by complete chance. So, I thought it might be interesting to specify the importance of it actually being to the right of a Baldessari. I'm not sure, but I think the people who bought the painting actually did own a Baldessari to put it next to. It didn't say it had to be hung like that, it said ideally. My work was obviously cheaper than actually buying the Baldessari, so maybe people bought it hoping that they would eventually be able to put an Baldessari opposite.

Tell me about your *Meetings*.

I lived in Los Angeles for a while in the nineties, and because it's such a big city where people live very far apart, it was almost impossible to be spontaneous. Having lived in the UK and in Glasgow for a long time, I was used to meeting a friend in the street and deciding to go for a drink, and then going for dinner and seeing where the night takes you. It could all happen very quickly, but in LA meeting with people took a very long time. If you bumped into someone by chance, you would always try to set up a meeting for the week after or in two weeks' time. Where I came from, it seemed like spontaneity was more important. This gave me the idea of arranging a meeting with someone in a specific place, at a faraway point in the future: ten, fifteen or even twenty years ahead. Someone would then be able to buy the idea—not specifically the idea of meeting me, but the idea of this future rendezvous. I haven't sold that many. Most of the people I met were strangers to me. The arrangement just consisted of a specific place, date and time in the future that was ten or fifteen years ahead, which goes by quite quickly without you realising it. Suddenly you're there, standing on a street corner, waiting for someone. Last year, I went to LA to meet a Canadian collector on a street corner. That same year, I went to Mexico City and met some Mexican collectors on a corner as well.

What does creativity mean to you?

I don't consider it a bad word, but I often try to avoid this idea of creativity. If something is 'too creative' that can sometimes mean that it looks like someone has done it. Someone has always been involved in the production of something, by hand. Sometimes I try to avoid that. I don't mind when someone else has been involved creatively, but personally I don't necessarily want to add the final flourish, because then I feel uncomfortable. Like how you don't necessarily want to have to read your own handwriting or hear your own voice. In terms of making work, there's always a little bit of a spark that starts the process and then I just go with it. Once you start the process, you shouldn't go left and right, you should just follow in line and when it reaches the end, you start another process.

Where do you get your inspiration?

Nowhere specifically. I have been and still am interested in a lot of other artists and what they do. I 'borrow, steal, take', and I don't question any kind of copyright laws that might exist, I just do whatever I want. I use and play with other artists' work all the time and that's probably what I'm known for.

What does originality in art mean to you?

I've always found it a brilliant idea that it was possible to make a work in four different countries, even using the exact same instructions, and still get four different works. I've done that quite often and I still work with lots of different galleries. If I encourage them to produce work, then it's different every time. I like that process.

I don't know whether originality in art is even possible anymore. I think everything is different and original, even if it looks a bit like something else. If someone says that my work is similar to whoever else's, I think: they didn't do anything close to what I did. My work might visually look like theirs, but the reasoning behind the work is somehow completely different. Therefore, the work is different and the ideas are different, even if they look the same. Originality has clearly changed in the last fifty years, but recently even more so. Thanks to social media everyone is able to create their own little magic and be happy with it.

I've never really understood why someone like Jeff Koons would get sued because he wanted to make a sculpture based on a picture he had seen in a magazine. What's wrong with that? I don't get it. The person who photographed the original image for the advert was paid to do their work. Maybe they should be pleased that it affected someone so much that they wanted to make a big sculpture out of it instead of feeling like they deserve to make some money from it.

IBIZA
9 OCT 14 NTS
FLIGHT ONLY
£299

Jonathan Monk

Jack of all trades

Master of one

This painting should
ideally be illuminated by
a Dan Flavin

This painting should
ideally be hung near
a Sol LeWitt

I use and play with other artists' work all the time.

The Lion Enclosure London Zoo Regent's Park London

How do artists react when you use their work, like the deflated Jeff Koons you made?

Jeff Koons went to see my show in New York and wrote in the guestbook: "Just like mine". I think he thought they were nicely done and maybe he liked them? I don't know of any specific instances where people have been annoyed. Sol LeWitt actually owns one of the films that I made. I met him and interviewed him, and he was very generous. If artists do get annoyed, it's probably more about them than about the work.

Are these references to other artists intended as a tribute?

In a way, yes. It's more tribute than anything else. There's nothing negative to it, because I like what they do and I wish I would have had the idea.

How important is humour in your work?

As a Brit, humour is just something I grew up with. I'm sure people are funny elsewhere too, but people in Britain try to be funny all the time, which can be a bit annoying. Humour is important to me, but I don't really make works that I think are funny, at least not on purpose.

Who—dead or alive—would you want to have dinner with?

I'd like to have dinner with someone who is entertaining. Maybe Marcel Duchamp or Ricky Gervais, or Ed Ruscha. It would depend on who is inspiring me at the moment. I like Louise Lawler's work, because you get lots of other works within it and that's always good.

How important are social media for you and your work?

Until recently it wasn't important at all. I started an Instagram account because I like the idea that you can just take a photo and put it up and add a caption without having to be specific. It offered a platform to promote myself without a great deal of effort. I still don't care about social media that much, but I do have an Instagram project that I started about four years ago. The starting point had very little to do with social media, but it moved into that realm.

It's quite simple: I go for dinner, and then I make a drawing or a little painting of a work by someone else on the receipt. Exactly what was pictured on the receipt wasn't really that important, it didn't need to be a work of mine. I wanted to start selling the receipts for the price of the dinner, basically trying to find someone who could pay for me or my family and I to eat. It seemed ridiculous to sell it through a gallery, because the gallery always wants a cut of the sale and then I'd only get half of my dinner paid for. So, I started putting the drawings up on Instagram two or three times a week, adding the price plus postage, and people started trying to buy them.

Now it only takes a few seconds for people to buy one, but the first one took a couple of weeks to sell. It took people a while to realise that they could actually buy the drawings. The reason I have this many Instagram followers is because most of them are trying to get one of these drawings. I wasn't expecting people to feel like they've won something. It seems like it's not actually about the drawing or the receipt, it's a prize for them being the quickest. I'm pleased that they're happy to have it, but it's still about the idea that they're paying for my dinner.

Has the Covid-19 pandemic influenced your creative life?

I'm not sure yet. The pandemic has altered how I do things slightly, as it changed travel plans and cancelled or postponed exhibitions. I've already installed two exhibitions via FaceTime this year and I suspect that more will follow. I think the quiet time last year was good for me as I did manage to work on a lot of different things. I rely on a number of people for my work and this seemed to continue to function during the lockdown. It has become a little problematic in the last few months as my local hardware store had to close. But it is clearly not the end of the world—or is it?

What is the best piece of advice you've heard and still repeat to others?

I try not to give advice to others at all. But there's something interesting that Sol LeWitt said in relation to this idea of copyright: "Once an artwork is out in the world, you have no way of controlling it and you shouldn't control it. If people are influenced by it and want to use it for themselves then they should." I always admired his openness around these ideas of control and copyright, and I imagine it means he was very free in his creativity.

12th May 2014 lunch time

MR
BINGO

Don't forget to have fun.

How would you introduce yourself?

I am an artist. Then people usually ask: "What sort of things do you make?" And then I say: "Just look at the pictures, it's too hard to explain."

Is Bingo your real name?

No, my real name is... different. But in 1998 I played a round of bingo at Garled Bingo in Maedstone in Kent, and I won 141 pounds and 27 pence, and that's how I got the nickname Bingo. People just started calling me Bingo and it sort of stuck. I liked the fact that I had a new name and I added a Mister to it two years later, at university. I started signing work Mr Bingo when I was twenty.

What kind of family did you grow up in?

I am still growing up. My childhood took place in a little village in Kent in the south-east of the UK, which was populated with about two thousand white, quite old-fashioned, probably racist and homophobic people in the eighties. My father was an estate agent and my mum was a speech therapist—normal people.

Did your childhood influence your ideas about creativity?

There was always something that drove me to be creative from a really young age, but I don't know what it was inspired by exactly. No one else in my family did creative stuff, so as stupid as it might sound, it feels like a natural thing I was born with.

Did your parents support your creativity?

They did, actually. That's one thing I have to give them credit for. Although I am very different from the rest of my family, they always backed what I was doing. Even though I was weird, they didn't really expect anything from me. They just let me do my thing and see what happens.

When was the first time you knew you wanted to be an artist?

I spent most of my time in school writing in notebooks or drawing pictures, but at the time I didn't know that that could be a job. I grew up playing those shoot-'em-up games, where you had to kill loads of people in space, so the first creative thing I wanted to do was be a computer game designer.

What is creativity to you?

To me, it's making something out of nothing. It's really an amazing position to be in, to just sit there with pen and paper and then something will happen and I make a thing and then people react to it, and even buy it.

Before becoming an artist, you worked for ad agencies.

I was a commercial illustrator for about fourteen years. It's what I always wanted to do when I left university. In my spare time I was building up a social media presence, and I started having fans. It wasn't something I planned, but it happened organically.

In 2015 I did a Kickstarter crowdfunding campaign that did very well, and I realised that these fans were serious about backing people like me, and that this potentially could pay for me to have a career. That's when I decided to stop working for clients and be an artist. Drawing pictures for people is one thing, but drawing pictures for yourself is so much more rewarding and satisfying.

Where are you most creative?

I can be creative everywhere, but I rarely come up with ideas sitting at a desk. Most of my ideas come when I am walking around, so I spend as much time as I can just wandering around on the streets, listening to music, usually with a simple purpose like delivering something, taking something to the post office or just walking to a shop or getting lunch.

I never force ideas, I never brainstorm. I used to do that when I was a freelancer. Back then, I was given a brief to finish something in two days, and I would sit down and thrash it out, whereas now I am freer. If I don't come up with an idea every day, that's okay.

What inspires you?

Everything, every single thing. Just stuff I see around me. The other day I saw some roofs here outside the window, and I thought it would be funny to just draw some roofs, literally just because that was what I was looking at.

Who inspires you?

I'm inspired by a lot of comedians, like Chris Morris—I like his dark sense of humour. There are also a lot of different artists whose style I have copied, uhm, by whom I have been influenced over the years. And of course, David Shrigley, but I haven't met him. I find it a bit scary to meet people who have influenced me.

You say you don't have a plan, and that you engage with your audience on social media to decide on what to do.

Yes, in almost all of the projects I do, the audience decides on whether it's going to happen or not. My work process is as follows: think of stupid idea; tell the internet; internet says yes; stupid idea becomes a real thing.

When I started the *Hate Mail* project, it all started with a question: does anyone want an abusive card addressed to them? And people said yes! It ended up being a project I lived off for five years.

GET FUCKED you
MOTHERFUCKER
I CAN'T BELIEVE YOU EVEN
CONSIDERED ASKING ME THAT.
Seriously, GET FUCKED.
GET TO FUCKERY.

"IT'S A GREAT OPPORTUNITY" - FUCK OFF
"IT'LL BE REALLY GOOD FOR YOUR PORTFOLIO"
- FUCK OFF AGAIN!
I'VE BEEN DOING THIS FOR 10 YEARS
YOU MOTHERFUCKER. IT'S A JOB.
GENERALLY, PEOPLE GET PAID TO DO A JOB
What the FUCK were you THINKING?
GET THE FUCK OFF MY WEBSITE.
YOU PISS TAKING MOTHERFUCKER.

I also do an advent calendar where I photograph 25 naked people, one by one, then photograph them with clothes on. Then I draw them, and in the calendar you scratch off a layer of gold foil to discover their naked bodies. I asked online who wanted to be in it, and four hundred people applied. If no one would've applied, the project would not have happened.

My audience is a huge part of what I do. It's very interesting to work with these random people.

Tell me about the Queen project.

For my Kickstarter rewards, I thought it would be funny to start from an envelope with a stamp with the Queen's head on it, and then to draw her body underneath it. Of course, this went from drawing her body underneath it, to drawing her naked, having sex and generally being rude.

I think people are genuinely shocked by this, but no one is offended—or at least they haven't told me so yet. The general reaction I get on that project is: "Oh, you can't do that, that's crazy, that's illegal". They think I'll get arrested or killed, but it's just a drawing of the Queen. It's fine, I'm not worried.

Do people get offended by your *Hate Mail*?

People love it, it's just fun. The cards are offensive but they're not cruel, because I don't know anything about the stranger receiving it, so it's just a random insult.

I also create books where you tell me personal things about you or the recipient of the book, and then I actually attack you based on the information you have given me. Anybody who is offended by what I draw after they've ordered a book like this would be very stupid.

Do you have standards when it comes to abusive language?

I have four rules: don't go anywhere near disability, sexuality and sexual preferences, race, or religion. The last one I don't really care about personally, but sometimes when you do offensive artwork about religion, you get killed, which is a shame, and it is not worth it.

Does your creativity have to be provocative?

Yes, I do think so. I want people to have some kind of reaction to my work, although it doesn't necessarily have to be a huge reaction.

I did a piece where I made this old-fashioned drawing of a flower and labelled the parts, and it just says "Who cares" everywhere. It's just silly and it makes people smirk. It's not a massive reaction, but I definitely go for some reaction.

How important is humour in your work?

Humour is so important, it's basically all I do. It's my thing.

Do you use humour as a defense mechanism?

Humour is great and brilliant for dealing with all manner of dark thoughts, difficult things, and sad things. Mental health is a huge trend at the moment and there are lots of self-help books out there, which I think is really good, but I like to make work that instead of telling you you have a problem, offers you a solution: let's laugh at it.

I really want to create a better world. Of course, it's hard to have a big impact on the world, but if I can make a few thousand people laugh every day, I'd say that's a pretty good start.

How do you cope with criticism?

Like most people, I hate it. I would love to say I don't care, but it's never easy. You always want a 100 percent like-rate. When four hundred people say they like it and one person says they hate it, the only thing you can think about is that one person.

There is this guy called Martin Olley who critiqued me just once, in 2003. He wrote a letter to a magazine when I had just started out, and said that he hated my work, that it was out of line and unnecessary. So, I made it my lifelong ambition to subtly attack him in bits of my work. I don't really care, I just think it's fun and a lot of people follow and enjoy it.

After about eleven years of abusing him, he actually found out about it, and he answered me through an Amazon review which was quite funny. But I've never met him.

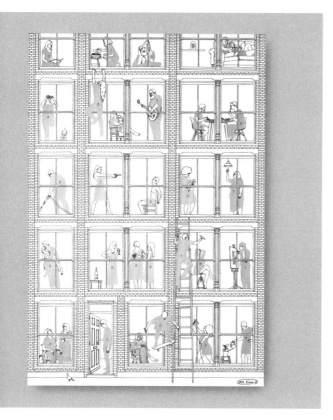

Being really honest makes you bulletproof.
If you do nothing, nothing happens.

Has the Covid-19 pandemic impacted your art practice?

I feel guilty about it, but lockdown has had zero effect on my art practice. I'm very lucky that I can work anywhere in the world, under almost any conditions. All I need to make a living is paper, pens, a scanner, a laptop and Wi-Fi.

Not being able to go to my studio in Shoreditch, I've turned my flat into my studio so I can continue working. I'm also very lucky that the shipment of my online shop orders is handled by an external company, which means my business continues to tick along in the background and takes care of itself.

Many artists have observed that, since the pandemic, the art market has stagnated. Has the virus impacted your sales in any way?

Sales in my shop went down for a couple of weeks at the start of the outbreak, but then something really surprised me: people started buying art again. I think there are a few explanations. Firstly, there are now a lot of bored people trapped in their houses looking for joy, entertainment and jokes to raise their spirits. I make funny art and social commentary, so this is a good time for me.

Secondly, a lot of people have saved money by not going out, and they're sitting in their homes thinking about nice little things they can buy to bring a bit of joy into their space. I make very affordable art and people don't think too much about buying prints and objects in that price range.

The last—and quite unexpected—point is that people want to buy little mementos that represent the current time as a way to help them understand what they're going through, as an object to mark that very significant point in history. I made a little print about socially distanced mugging that did really well; it caught the collective consciousness at just the right time. Again, I'm only realising this now. I'm not some horrific marketing genius, I just put silly art out there and see what happens to it.

What's the best piece of advice you have gotten and repeated to others?

Don't listen to advice! I can give you bits of advice I have given to myself. The main one: don't forget to have fun. This is a very important one, because everyone takes life to seriously. And we're all going to regret it in the end.

I work a lot around issues I have, like anxiety or worrying all the time, or being obsessed or being a workaholic. By making a lot of work about this stuff, I'm just trying to get it off my chest, and then I make a living by selling it, which is kind of nice.

What is failure to you?

I think I don't fail much, and I know I should fail more because it pushes you to try harder. I would love to take more risks and fuck up more often, because I think I keep things a bit too safe. Everything I do is successful, and I kind of know it will be a success before I even do it. It's very hard, because what I do is very public. I show something off on social media, I release it, people buy it and then people see that it is sold out—all of which basically makes you look like a success. Doing something that didn't work would be very tough for me.

Why is so much of your work about anxiety?

I spent way too much time in my life worrying. I never thought I did, but just recently I had to admit to myself that I get anxious about most things: Are things okay? Is this drawing okay? Will they like it? Is everything I do good enough?

MORAG MYERSCOUGH

Make happy those who are near,
and those who are far will come.

How would you introduce yourself?

I'm a designer, an artist and a maker. I would actually describe myself as a polymath, which means that you do lots of different things. I don't like labels, so I prefer that people decide what my work is rather than saying what it is myself.

How did your childhood influence your creativity?

I was born in London. My father was a classical musician, he played the viola. He was a session musician and played with The Beatles whenever they used an orchestra in their songs. My mum was a textile artist and my great-grandfather was a clown, so I come from quite an interesting family.

My grandmother was French, my great-grandmother was German and my mother was Scottish, so I only have a little bit of English in me *(laughs)*. I would absolutely say my childhood influenced every part of my creative life.

What does creativity mean to you?

That's a big one. I think creativity is life, isn't it? Creativity happens on every level, it's vitality and expression, and it's life.

What kind of circumstances need to be fulfilled for you to be creative?

The most important thing was to find a place where I would be able to do anything I wanted. I always felt like an outsider—I was a middle child and never had my own space—and when I found this building suddenly everything came together for me. My studio is a place where I can be the most creative because I can do and make anything I want. It gives me the space I need for my brain to think and also space to physically do things.

When it comes to negative circumstances, I don't like to be put on the spot. Like in a meeting, when suddenly you're meant to just *(snaps fingers)* 'come up with brilliant ideas'. It doesn't work like that for me. I have to think about things for quite a while and then let it sit. I don't even know when something is going to happen and then something happens, by doing a sketch or drawing something on the computer or making a model or a painting.

What does an average day in the life of Morag Myerscough look like?

My day looks quite dull from the outside. I start quite early in the morning—I think mornings are good. I get up and I have a cup of tea. Then I work on projects on my computer in my kitchen upstairs. I listen to the radio, I work a bit, I take the dog out and then I work some more, which could be any sort of thing, painting or working on the computer. Then I make lunch and work into the evening. But I stop at around eight or nine o'clock.

I don't really like having loads of meetings, I quite like just being in this building all day making things. The day seems to be a lot longer then. I usually work every day, even if I have a bad day. I'm not really addicted to anything else, but I'm totally addicted to work and to the highs that making such varied projects gives me. It uses all the different parts of my brain.

Where do you get your inspiration?

When I was younger, I would go to every film, every gallery show opening. I lived in London, so there was a lot to see. I looked up every book and everything else I could look at. I was a sponge, and all that stuff is still inside me and gets all mixed up.

Travelling for me is also a big, big thing. Two years ago, I went to Mexico and it was as thrilling as I thought it would be. I'd be scared to live in the countryside because I like going out in the streets and seeing changes, seeing people and looking at their clothes,... The everyday inspires me.

Who inspires you?

I really loved Andy Warhol and pop art when I was young. Memphis was also a big influence. Maybe less because of what they produced and more because of what they believed was possible. That's basically what I based my whole life on: the fact that you shouldn't be restricted by education or anything. If you want to do something, you should try and do it.

When I was in college, I saw a David Hockney exhibition called *Hockney Paints the Stage*, where he made theatre sets. That just blew my mind. I was making theatre sets at the time, and I loved this transformation of a place made up of just four walls into a magical space. My French grandmother inspired me in the same way. She was a very elegant woman, and when she moved to Holloway—which isn't a very elegant place in London—she transformed her living room into a French salon. I am fascinated by this idea of temporary escape; how you can walk into a space, and it can completely change your feelings, if you get it right.

What are things that prevent you from being creative?

Anxiety. I worry that I can't do some things or that I have got no creativity left in my body. There's that unpredictability. When I'm stuck, I like watching bad television, mundane things that don't overstimulate my brain, which then allows my brain to open up. To do something new, you've got to give yourself time and your brain has to open up. Otherwise, you will always do the same thing over again. It doesn't have to be something completely different, just something new, so that you're moving forward instead of repeating. For me, being creative is opening up my brain, and sometimes I get scared that that's not going to happen.

Colour is very important in your work.

I've always loved colour. As I mentioned, my mother was a textile artist, so we always had colour in our house. But when I went to Central Saint Martins – University of the Arts, everybody was using grey, black, white, yellow and red, and I wondered where the other colours were, like pink and orange and blue *(laughs)*. I've always fought against what was the norm at the time and kept with my own colour language.

I've always had that colour sense, but now it's completely maximised. When you're young, you're still unsure of yourself, so I love that now I can just totally express myself through my use of colour. I like how people respond to colour and more specifically how they react to things like neon, how their eye reacts to it, and how other colours react to the neon as well.

Is it important for you to see people interact with your work?

To me, the most important thing is that people don't feel indifferent towards my work. I want people to either love it or hate it. I don't mind if they hate my work, because then at least they have a passionate reaction to it. I also like it when my work starts a conversation. Because my work is in public spaces, mainly huge installations that are free for people to visit, it's about interaction. We often add swings or slides, or we make things that people love having their photograph taken in front of. People choose quite carefully what they like to use as a backdrop for their pictures, so I am always pleased if they want a photo.

When I do social projects, I like to involve people in the creation of the work. I always learn so much from working with community groups and social groups.

Does your creativity have to create a better world?

It is very, very important for my creativity to have a social impact, even in the smallest form. Aside from doing the crazy installations that are just for experience and interaction, I work in hospitals as well. A while back, I worked on the bedrooms in Sheffield Children's Hospital. Initially, when I showed my designs to the staff, they said "She's a really nice woman but she's not going to be able to do those bedrooms because she's going to kill the children" *(laughs)*. They thought the designs were too extreme, and their response was understandable, but I think they were just scared that it wasn't going to work. Then I made some models and we showed them to all the families, and 92 percent of them wanted the bedrooms. Now they're all in place and everybody really enjoys them. Some of the kids are in hospital for ten months or longer, and I wanted to make a home for them.

Tell me more about your project *We Make Belonging*.

We Make Belonging is a very important project for me. How can we make belonging in communities that are now quite desperately disconnected? Can you bring people together? How do you do that? I'm working with communities to work out how to do that. This project consisted of a bandstand that toured Sussex in the UK. We visited eight locations, each time working with community groups and trying to understand what belonging meant to them. I did lots of workshops with the groups and they made phrases representing what they believed belonging was, and put them on placards. When the bandstand went up, their placards came to the front. They owned the bandstand and put on performances. It was really important that it wasn't me dictating something. The project was made with them and for them to enjoy and do what they want with it, which introduced people that had never done anything like that before to a form of creativity.

There is a lot of focus at the moment on understanding who you are, what your culture is, how we all interact together, and what it really all comes down to is 'belonging'. Because it's a key thing in life to feel like you are part of something. But we've got to be careful that it doesn't become too tribal or too divisive, because the world is going a bit crazy at the moment.

Does size matter in the world of Morag Myerscough?

Yes, it matters a lot! You know, they say that the reason that there are so many tall things is because men like big, tall, thin things... *(laughs)*. I like tall and big. I love scale. People forget that something that you build inside a room will fill up the room, but when you place it in the centre of a square or a park, it will shrink to a small size. So, it's also about understanding how things work within spaces. I like big things you can walk into and react to, but I also understand that sometimes the space doesn't allow it.

Some of your work is temporary and some of it is permanent. How do you deal with that?

People think that something permanent has more value than something that is temporary, so they seem to think that those two require a different mindset or different processes. I think it's ridiculous and old-fashioned to say that something has to last a certain amount of time to be permanent. You've just got to do the piece of work and if it lasts, that's brilliant, and if it doesn't, well, that's a bit unfortunate. I don't destroy my temporary work. I like repurposing and second uses. That way, my temporary becomes permanent.

How important are social media to you and your work?

A few years ago, I wanted to use Twitter. But I wasn't really the sort of person who would chat on Twitter every day. So, for two years, I spoke only in colour. I'd choose three things to speak about in colour and people tried to guess what I was speaking about, which was really fantastic. After two years it resulted in this big body of data, which I then used to do a big project in Sweden.

How important is failure in your work process?

I was brought up to think that failure was a bad thing. As a classical musician, my father was all about being absolutely perfect. That's hard because it can stop you from doing things because you're too scared to fail. When I was younger, I used to read situations incorrectly; I'd think that I had done something wrong, but it was somebody else who was controlling the situation. I realise now that when you're in a group of people and something doesn't work out, it's not all your fault. There can be lots of elements that contribute to that failure. I'd rather say that you learn from your mistakes than use the word 'failure'.

Has the Covid-19 pandemic influenced your creative life?

In March 2020, basically everything for me stopped work-wise, except for three projects. After the initial shock of living through the first stages of a pandemic and being glued to the news, I decided to work on my house, which had been neglected for many years because I was always working and travelling. I was lucky in many ways as I live and work in the same place, so I could continue to work, but with more time to do things and at a slower pace. My observation of the past year is that we all need each other more than we ever thought we did. We need to work together, share and build a better world. The whole world was forced to collectively stop and we have all experienced a moment in time together, which must mean something.

In the meantime, my work has picked up again and I am asked more and more to make projects together with communities. I also notice that the value of public art is being recognised more than ever.

What is the best piece of advice that you've heard and still repeat to others?

My tutor at St Martin's, who really brought my brain into the right place, said to me: "You should always aim the highest that you possibly can and then you can always move from there. But you should never start in the middle, because then the only way you can go is down". I always think of that. It's important to me that I just go. To risk failure, but not fail—I think that might be what I aim for.

I worry that if I stop, I won't be able to do some things
or that I'll have no creativity left in my body.

NAVID
NAUUR

Nothing is what it seems.

How would you introduce yourself?

The question "What do you do for work?" is too general. It is about finding common ground instead of saying "My name is Navid Nuur, I am an artist," and so on.

What kind of family did you grow up in?

I was born in Iran. My father was an accountant for an offshore company. At a certain point, things started heating up in Iran and my parents did not feel safe, so my dad asked to be transferred abroad. At that moment the only option was to work in the Rotterdam harbour, so we ended up in the Netherlands. I was about three years old then, and we were technically refugees and had to leave our belongings behind in Iran. Still, we were lucky because we didn't need to take the risky routes to end up in a safe haven. I still have a few memories of Iran, like horseback riding on a big watermelon in the garden.

Was there room for arts and culture during your childhood?

Yes and no. As a kid you have your crayons and you do your thing, but even before I started high school it became all about getting good grades. My parents pressured me to get good grades, so that I would have good opportunities in life. Now that I look at it from my parents' point of view and what they have been through, I understand, but back then grades were not that important to me. Life was much more than just having good grades.

At that time, skateboarding and graffiti were really important to me. I owe so much in my life to skateboarding. It gets you out of the house and into the streets. Doing certain tricks or learning things that are not part of school helps you build self-esteem. It teaches you to push yourself, in the same way learning martial arts does. It is also about learning to read the space around you differently; you don't just see a bench, you see a thing you can do a boardslide or a kickflip on. Skateboarding and graffiti taught me to always look for opportunities and to see beyond the walls that surround me. I really felt that these interests were helping me build skills, while nobody outside of these subcultures acknowledged them at first. But soon these skate, street-art and graffiti aesthetics were taking off in the world of advertising, and I started doing more graphic designs for others and started a T-shirt label.

Bigger brands needed kids like me to understand how they could use this new form of communication. Suddenly I was already making money with these creative skills before I even went to art school. But studying art history really opened my eyes. It made me realise that every subculture is rife with unwritten strict rules, and that true art needs to be cultivated from scratch and comes from deep within.

In one of my art history classes I saw a painting by Henri Matisse called *French Window at Collioure*, which is mostly black, with some colour at the edges. Looking at this painting, I suddenly realised that Matisse used his subjects to chase light. He didn't actually care about his subjects, just like Monet didn't really see the gardens he painted. He just saw the waves, and how colour could move. Monet used the garden to visualise this movement of light that you cannot grasp, which means that as a subject the garden is secondary.

I suddenly asked myself: what the hell am I doing with my life? I needed to stop what I was doing and dive deep into my own private rabbit hole. Neither my parents nor my friends understood why I was letting go of all this talent and work, and all those contacts. But I needed to do some deep 'visual rehab', I don't know how else to call it. It was hard, but healing at the same time. I see it as my 'fermentation period' and it allowed my skills, emotions and interests to start blending into a matter that could soon be served.

How would you describe your style?

I don't really believe in style. Style is for people who want to conquer territory by making really clear to others exactly what it is that they do. I believe more in attitude.

What does creativity mean to you?

Being creative is something that we need to fuel within all of us. It's a tool that isn't exclusive to artists, everybody has it in them. As artists we have the tendency to claim this tool for ourselves: "I am creative because I make creative things". But does that mean that I am a creative person? No, it doesn't. Someone who knows how to maintain a work-life balance and still finds things that excite them is also being creative. Creativity is much bigger than this conversation. You are just interviewing me about the tiniest specialised idea of creativity.

Even beyond your art, you have the habit of questioning everything.

That is the only way to do it. I believe that naming things narrows them down too much and makes the world smaller, in a sense. An artist makes his work, and the viewers want to know what the work is about. They want to define it: is it a painting, a photograph, a statue? I don't want that. The problem is that when you say you make paintings or installations, it doesn't really say anything about the work itself. So, I thought I should start at the beginning and create my own word.

If you make up your own word that is sufficiently expansive, it will prevent you from thinking in little separate parts. That's why I called my works 'interimodules'. An interim is a person who is temporarily hired within a company to rearrange things so that they flow better, and then goes and hopes for the best. That describes my lifetime here: I am an interim worker, just here temporarily to change things. The word 'module' refers to the act of connecting parts of your artwork together, or how the artwork relates to the building it is in or to a person. So, the 'interimodule' is the movement of this identity that connects things and goes and grows. It doesn't have a fixed definition. You can just feel what it is about and because of that, everything is possible. By using my own word, I own it, which helps me start the work in a more open way.

Is it your intention to ask questions or make the viewer question what they see?
I like to ask questions when I look at the world, I think we all do. The bottom line is: nothing is what it seems, it's about how you perceive it with your mind and senses. It also depends on which stage of your life you are in.
One day I walked into my studio and it was just like in skateboarding: I could suddenly see how everything – all the works, the tools, even the walls and the floor, and myself – was interacting as a bigger narrative, because of the minerals present within all of these objects. This realisation kickstarted a journey of turning this knowledge into a new way of seeing my works. I realised that if I take a tree and set it on fire, it will turn into ashes. And if I burn the ashes at a temperature higher than 1 250 degrees Celsius, the ash will melt into a solid-state mineral that looks like a rock. So, a tree can become a rock, or is also a rock?
Going through this journey and seeing the tree turn into a rock made me realise that heat is a tool that could open up a new portal within my art practice. And a very important one, at that. Now the big questions are: how to use heat, and what is heat, and how does it relate to time and even to the energy of decision-making?

What is your relationship with words?
Aside from the fact that I am professionally dyslexic, words are difficult for me even when they flow out of my mouth. I don't even know how to speak proper English or Dutch or Farsi. All of them are a bit mashed up.

What about colour?
Colour is a living thing. It's a wave and particles at the same time. It moves constantly and changes all the time. Yellow doesn't know it is yellow. Blue doesn't know it is blue. The sky isn't really blue, it just looks that way because of the angle of the sun. Therefore, when you look at a blue painting and say it reminds you of the sky, that's a way too primitive take on colour. On one side of the planet yellow means poison, while on the other side of the planet people think it means sunshine. In certain parts of the world people dress all in black when attending a funeral, while in other places people dress all in white. A colour can even look different in another light. That's why we have to step out of colour and move into the light.

What does a day in the life of Navid Nuur look like?
On a normal day, I'll wake up at 6.10 am. I need to have an hour to myself before my wife and kids wake up. Maybe I'll meditate a little bit or walk in the garden, just to be on my own. Then I get dressed and wake up the kids, start making breakfast and take them to school. I enjoy this time with them in the morning, because in the evenings I can sometimes get into a flow and I don't know when I'll come home. I start working in the studio at about 9 am. I work on about 35 works at the same time, so my days are always different, I just follow my thoughts.

Can you work anywhere?
I can work anywhere; the studio is just a luxurious parking garage for your stuff. If it burned down, I couldn't care less. The work you do is in your mind and your body. I used to work with notebooks but now my work is in my mind, which is much better as it is faster and more flexible.
Usually, I work while I am asleep and when I wake up, most of the time it has brought me a step closer. But sometimes when you work in your sleep, the problem is that you have to remember to take into account things like gravity (laughs).

There is so much to learn from a rock, it has so much deep history.

PLEASE
FREE ALSO
THIS
COLOUR
FROM
PANTONE
PRISON

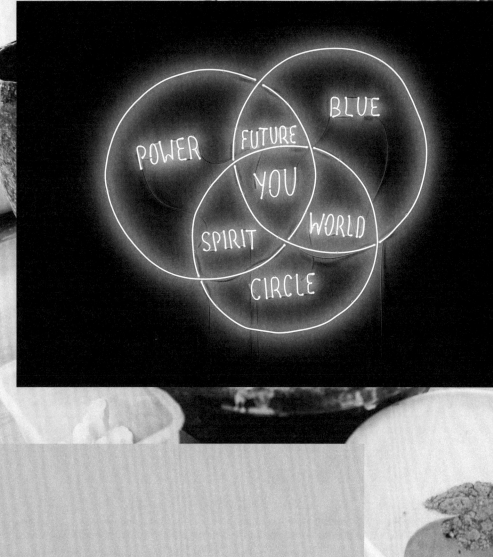

Is there humour in your work?

Sometimes it comes as a bonus. I have an artwork of a lock that looks like a fence, and people say that it's funny. But it's not a priority for me.

It makes me sad that happiness and humour are considered to be the most popular emotions. Our emotional system is messed up because of this.

Melancholy and sadness and *hygge*—a Danish word for cosiness—are also really important. You need to embrace all the feelings that can pass through your body. Artworks need to deal with as many different waves as possible.

What inspires you?

More than an inspiration, it is about a certain attitude: being open, looking around. Also, knowing that the creativity that you are looking at is really tiny, just like my lifetime. It is so short, it evaporates, and then I'll be dead. So, I have to use my time correctly. I already have too many works in my brain to finish in my lifetime, so it is more about creating the right selection process than about getting inspired.

I've also learned to have my body be more present when I'm making works. I still have the ability to ride my bike and lift things and walk, so in my current works I should use my body as much as I can. I learned this from an elderly man who is now in a wheelchair. He told me that it was such a joy to be able to hop on a bike to go buy a sandwich and eat it in the park. That inspired me not to take anything for granted.

Who inspires you?

When I was into graffiti and skateboarding, I was a vegetarian because all good skateboarders were vegetarians. That was my main reason for becoming a vegetarian: they were good, so if I stopped eating meat, I would become good too. That is how you think when you are young *(laughs)*.

When you're doing graffiti and you look at other people's work, unconsciously you'll start imitating them before you find your own way. That taught me not to be inspired by other artists' works, which are just the final result of their own long process. What you should be inspired by, is somebody who knows about the theory of process, or their attitude. But never the outcome.

Scientists inspire me, because they are about the process, and a certain vision that hasn't been visualised yet, but you can feel the idea that's in there. Poetry has this same quality. A person who means a lot me is David Bohm, he knows a lot about creativity and true dialogue. I learned a lot from him.

Who—dead or alive—would you like to have dinner with?

Honestly, I would want to have dinner with a rock. There is so much to learn from a rock, it has so much deep history. It has seen mankind come and go. It knows so much.

What does failure mean to you?

Failure always holds the potential to become the best thing that ever happened to you, while success does not. Failure is a very complex thing, and to fail fully is very hard, because you always do some of it right.

Has the Covid-19 pandemic influenced your creative life?

Here's how I see it: you should be influenced by your inner compass, not by the unstable roads in life.

What is the best advice you've heard and still repeat to others?

That would be this one from David Bohm: "The ability to perceive or think differently is more important than the knowledge gained".

During my visual rehab period, I worked as a house cleaner for the elderly. At that time, I felt troubled, wondering if I had made the right choice by leaving my creative past. I turned to these elderly people, who already had a whole life behind them, and asked them over tea whether their life turned out the way they thought it would. The advice one of them gave me was this: "Be aware of the peer pressure of your time and don't let it interfere with your life decisions. When I was a bright young woman, going to university was not an option. You were to marry and take care of your future kids. So, I did not study and I still regret it. Now that I'm old I see that it was the collective mindset of those times that was in charge, and not my inner mindset. This peer pressure weighs on you like a heavy blanket and it's present everywhere, in different weights, in different cultures. Never fall asleep underneath it or else you'll end up like me and many others." In order to grow as a human, the key is to be mindful of these blankets and stay awake.

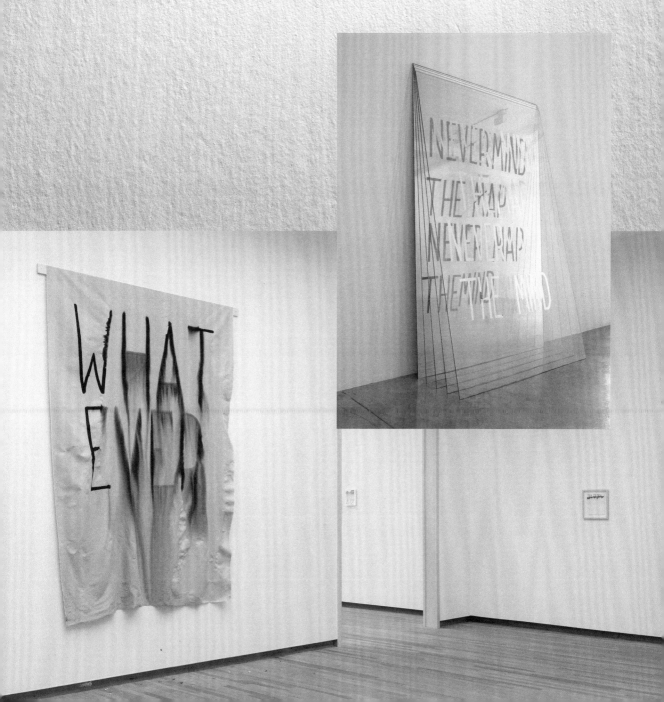

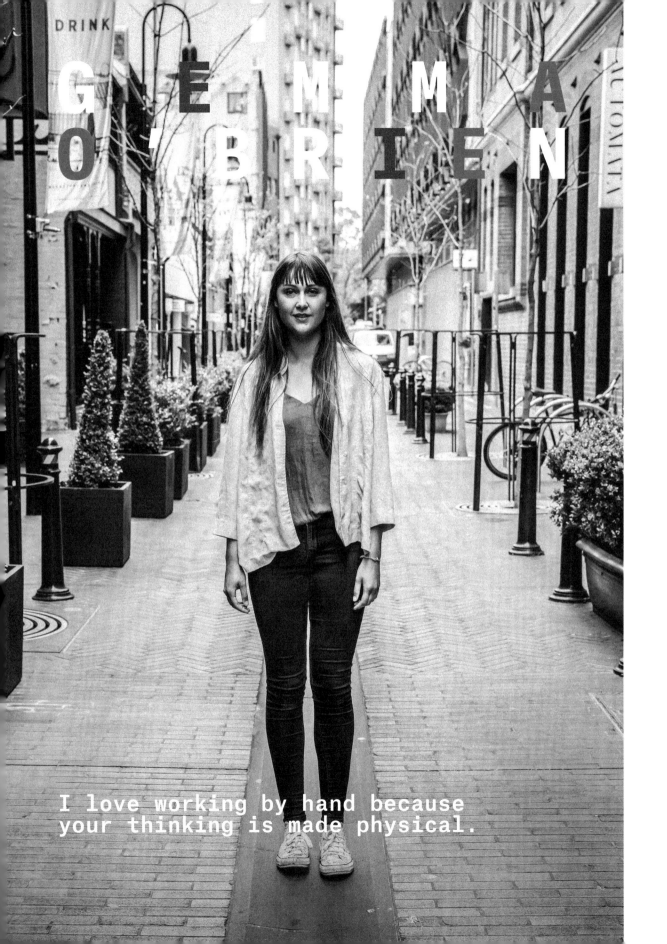

GEMMA
O'BRIEN

I love working by hand because
your thinking is made physical.

How would you introduce yourself?

I am an artist, designer and illustrator from Sydney, Australia.

Did your childhood influence your ideas about creativity?

I was definitely a creative child. Looking back, I can now see how it has influenced my ideas about creativity, however at the time I don't think I was aware of it at all. I was always making things, like little books out of the paper that my dad would bring me from work. My mum was a kindergarten teacher and my dad was an architecture builder, so there was definitely a support of creativity in my family.

How did you end up working with type?

My path to lettering and typography started a little bit later. After high school I started studying law but then I dropped out and switched over to design, because I felt I needed to do something more creative. During my first year of design school I had the chance to set type by hand in a letterpress studio. One of my tutors to took me on as an apprentice typesetter and showed me the ropes. That was when I became fascinated with the world of type. It really started my passion for the history of type, which then led to an attempt to incorporate it into my work, and that took me more into the direction of lettering and illustration.

When I was in design school I did a project —which now I look back on and I laugh at—where I wrote words all over my body and face and put a video of it on my blog. Back then blogging was a big thing in the designer world. The marketing manager of Font Shop saw this video and wrote a blogpost about me and my work that was quite critical. Afterwards, a lot of people in the German design community where the blogpost was shared came to my defense, which led to Font Shop inviting me to speak at TYPO Berlin, a big typography conference. I was twenty-one, and I hadn't done any commercial work, just this one video that went viral. They flew me to Berlin and I spoke at this big designer conference, and in many ways, it was definitely the beginning of my career. After that I wanted to come back and actually build a body of work, rather than do something experimental. But it definitely got my name out there in the early days.

Your work is very physical.

I used to think that everything that was hand-drawn was messy and unfinished, but then I realised that there is a way that it could be refined and still have a human quality. I love working by hand because your thinking is made physical, whether it's on a wall or on paper, and that is really satisfying.

What does creativity mean to you?

Creativity to me means different things, depending on the context, but generally it's an approach to things. Even if you don't have a creative career, I think that creativity is more about experimentation, play, openness and curiosity. It's an approach that allows all of these things to happen, to finally come up with some kind of end result.

Do you have a favourite time of day?

I used to be a real night owl. During the first five years of my freelance career, I always worked from ten o'clock at night to three o'clock in the morning, and I loved it. Now, I feel like I've shifted and become a morning person. The creativity has to be balanced with the business side of things. It needs a bit more structure, whereas it used to be completely free-flowing. In order to do that, I work at different times. Every now and then I still stay up really late, though.

What inspires you?

Inspiration for me can often initially come from other people's work or from scrolling through Instagram. I've got a huge folder of saved images with anything from patterns to colours. I might not know what it is that inspires me about a particular image the moment I save it, but something clicks. So, I've built up this library with reference images. Other creative fields outside of design really inspire me as well; I like to go see theatre or comedy or different kinds of artistic mediums, just to see what other people are creating. I also try to visit a lot of galleries when I'm travelling. Nature also inspires me—the things created by nature are sometimes much more beautiful than anything we could create.

Do you have a technique to awaken your creativity?

I've started to notice now when I do projects that overcome my initial resistance that comes out of fear. Working at something new can be exciting, but sometimes there is also some second-guessing. In order to overcome that, I think it's good to fall back on whatever process you normally have. For me, that usually means spending a few days looking at the inspiration materials that I've been collecting for the past five or ten years and seeing what is relevant to what I am working on. Or trying to come up with something right away, and just pulling images together and trying to see a connection between them. When I am doing a typographic piece that involves words, I'll have lists of phrases or lyrics or quotes that I'll read over and pick and choose, step by step. Then, I'll move on to pencil captures and take it back to whatever the final art might be. I think allowing that time to think about what the process will be is something that I tap back into if I feel hesitant at the beginning.

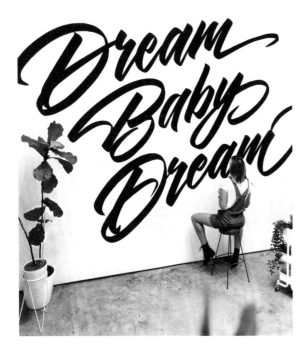

Black and white or colour?

Coming from a printing background and loving typography, I felt it was natural to go into black and white. I enjoyed working only in black and white, until a few years ago I decided to start experimenting with colours. Depending on what the purpose is, I still love working in black and white, which is often a lot faster, especially for murals. If you are working with types, black and white can have a lot of impact as well. I am however really starting to enjoy the big world of exploring colour, so that's kind of the direction I'm heading with my work at the moment.

Does size matter in the world of Gemma O'Brien?

I was always drawn to working on a large scale, even if it was just a big piece of paper. Maybe it's because I'm really tall, I needed it to be proportionate. When I visited art galleries as a design student, and even as a kid, I used to love anything that was like an installation or that was immersive in some way. Also, studying design and learning about advertising and the way we can grab people's attention led me down this path of wondering what something would look like on a really big page. So, now I am painting murals. I love the process of designing and working life-size, and I think it does have an impact.

Does it all start with a doodle in a notebook?

It depends. They could be thumbnail sketches on a plane, but I still use the digital processes. Often a mural—even though it might look like I've walked into a room and just started painting it—follows the same step-by-step process you might follow for a commercial design project. I'll make pencil sketches and then scan them, or maybe colour them in on the iPad or in Photoshop. I might do some mock-ups in the space and play around with the scale digitally. And then when I move into the room or the wall where I'm painting, I often use a projector combined with laser levels, measuring, and transfer pencil outlines, and then paint the whole anywhere in the following ten days.

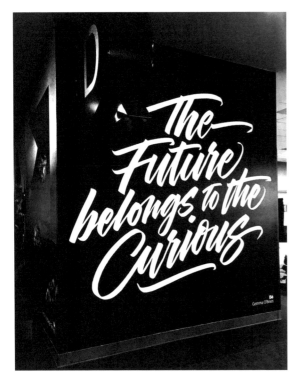

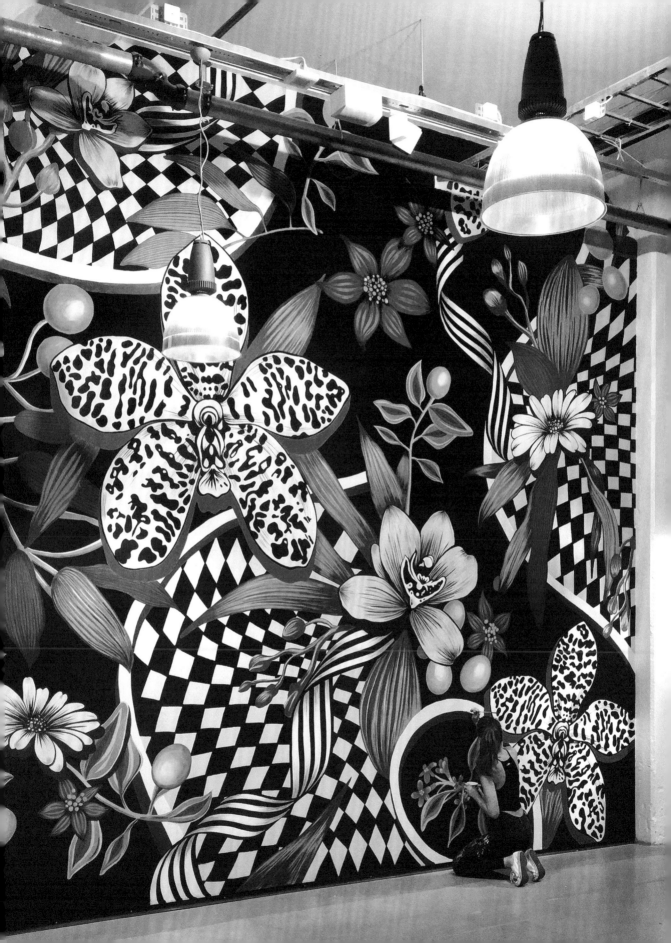

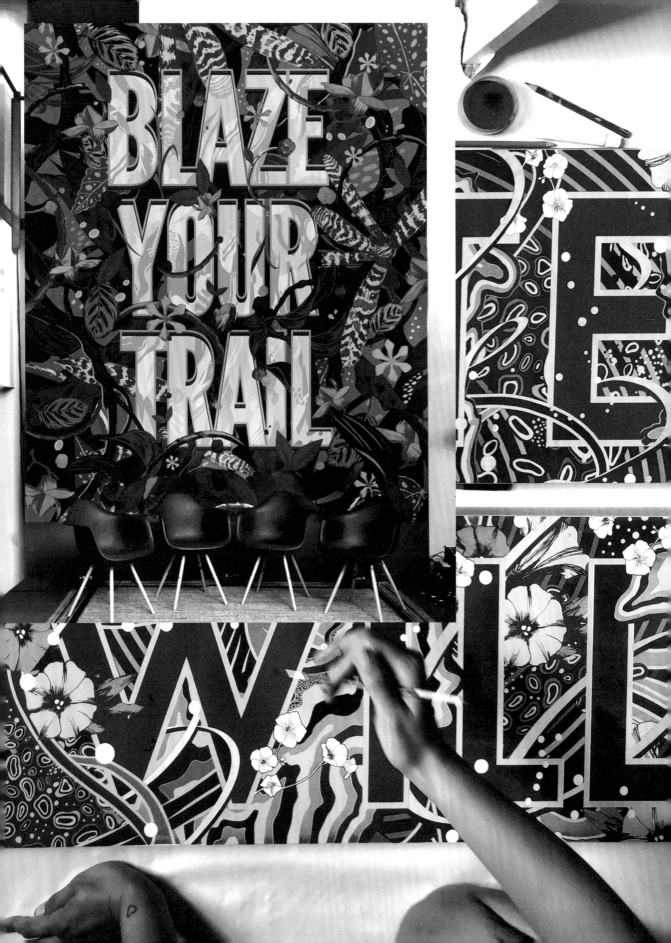

Tell me about your side project *The Spew Bag Challenge.*

In the early stages of my career when I started flying a lot, I noticed one day that the sick bags in airplanes are blank. So, I started drawing these puke puns on them each time I flew. If it was a short flight, I would just do a quick one. If it was a long flight I illustrated it more, with taglines like 'Puke-a-nucam', 'Fifty Shades of Spray', 'Everything's Coming up Milhouse!' or 'Bigger than Ben'. They all had a different word for being sick or puking in there. It became a thing that I did every time I flew, and it eventually led to an exhibition of framed sick bags. I also encouraged other people to create their own designs on social media and hashtag it #pukebag on Instagram. There were thousands of people that created a sick bag, so it was a fun little side project.

How important are social media to you?

When I started on Instagram six years ago, I didn't think of it as a business tool at all. It was pure fun and social, with pictures of my food and whatever I was doing at the time. But over the years it became something that got me work, or even connected me with other creative designers and an audience around the world. I loved it in the early days because it was a place to share experimentation. It acted like a sketchbook: you could share an unfinished idea with the world and there was an instant feedback mechanism.

I think it's different now. There are so many different social media platforms and everybody's on them, so it gets a little repetitive and in a way people are getting tired of it. I am curious to see what the next generation of creatives are going to do, are they going to abandon social media?

What does failure mean to you? Do you incorporate it into your creative process?

I think that failure naturally occurs in the creative process in different ways and different forms. For me, the mental concept of failure or the opposite of a success comes from creating something and knowing that it's not the vision of what I wanted it to be. I feel like that's a common form of failure that pops up in the creative process. It's good, though. You learn from your mistakes and from things that don't work. Sometimes it just comes down to logistics. If I'm doing a large scale mural, each new piece has new parameters: you're working in a new space or the weather is different. There are always elements that you have to deal with on the go. I have definitely experienced little failures in those processes along the way that have enhanced my skill, so that each time I do a new piece I'm better equipped.

What's the best piece of advice you've heard and repeated to others?

I've heard it in different forms and different ways, but it comes down to this: it has to be about the work first. I think that a lot of young designers are worried about building a following on social media or how they can get to travel and talk about their work. All these things are secondary to the work, and I think that it always has to start with what you create. It's about finding what you're really interested in, what makes you unique, about putting your ideas into work and putting in the time, and then everything kind of flows out of that. You can always come back to that at any point in your career. And let that be your guide.

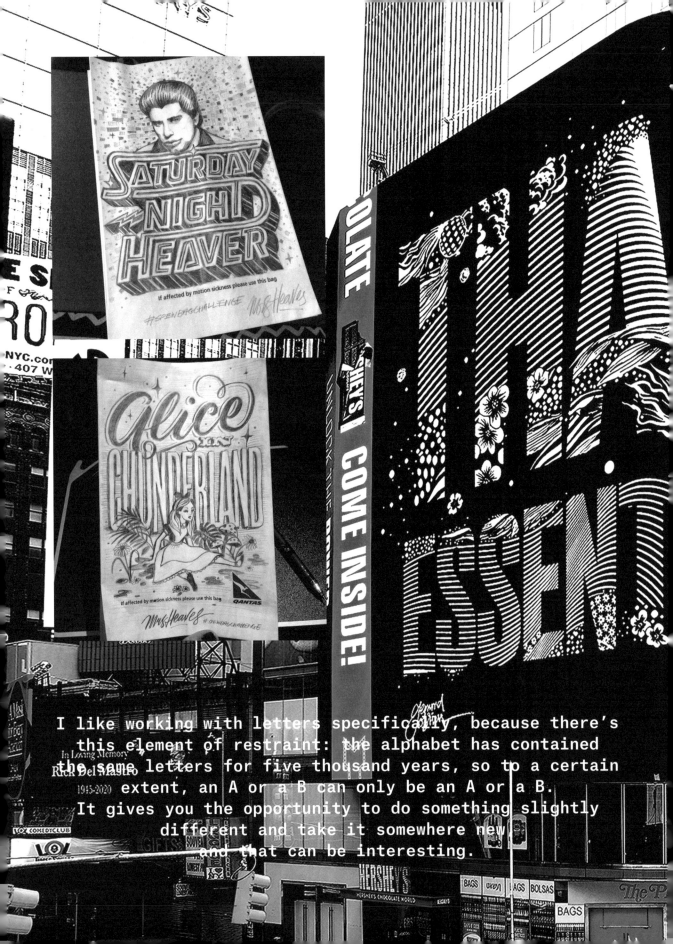

I like working with letters specifically, because there's this element of restraint: the alphabet has contained the same letters for five thousand years, so to a certain extent, an A or a B can only be an A or a B. It gives you the opportunity to do something slightly different and take it somewhere new, and that can be interesting.

MAX PINCKERS

Always question what you're doing,
what you're seeing, what you're making.
Always be critical.

How would you introduce yourself to someone who doesn't know you or your work?

I'm a documentary artist based in Brussels, Belgium. I'm also a researcher and educator in fine arts, specialised in documentary photography, at the School of Arts KASK in Ghent.

What kind of family did you grow up in?

My father is a photographer and my mother was a journalist and copywriter. I grew up in an artistic, creative environment. My parents' friends and their children, who are still very good friends of mine, are also creatively active in different fields. When I was five years old, I moved to Indonesia with my mother. We travelled around, and also lived in Australia and India. At age twelve, I moved to Singapore with my father where I stayed until I was eighteen before moving back to Belgium. There's no doubt that this influenced my way of seeing the world and how I interact with people, shaping me into the person I am now.

Was there a moment in your childhood where you realised you wanted to be a photographer?

No, not at all. I only started photography when I came back to Belgium when I was eighteen. Those friends I mentioned earlier were all studying at the School of Arts in Ghent, doing film, animation or new media. Naturally, I wanted to join them, so I spontaneously decided to study photography. Although it was never really a childhood dream, I have always been creative in some sense, trying things out, collaborating with friends on projects. The most important thing to me is the freedom that comes along with creativity.

Why documentary photography?

I find documentary photography the most interesting form of photography because it's where the fundamental questions about photography's relationship with reality become most pertinent.

While studying photography, I realised that documentary photography in particular comes closest to what essentially defines photography, which is that it always has a relationship with something in the world. A photographer needs to establish a relationship with an actual subject in front of the camera. You can't just make an image appear on a canvas like a painter does. Documentary photography comes closest to relating to reality, as opposed to, for example, studio photography or fashion photography, where you can control every single detail.

Is your work always about questioning the authenticity of the image?

People usually assume that what they see in a photograph represents reality. They believe that what the photograph shows must be true. But photographs are mere representations, and always have a subjective point of view. Images are used in different contexts to make us believe different things. That's why it's important to always question images and how they represent something, rather than believing in their transparency.

You use staging and artificial lighting, which isn't standard in documentary photography. Why is that?

Using artificial lighting is a technique from advertising or commercial photography that I apply in a documentary context, because I believe that it's important for a photograph to always contain a self-reflective element. When we look at an advertising image, we immediately recognise it as a constructed image that has been created for us to believe or desire something. But when we look at a documentary image, we don't immediately make that distinction between picture and reality. We have the tendency to immediately believe in its transparency and its truthful representation of reality. Theatrical or artificial lighting reminds the viewer of the fact that they're looking at a constructed image, even if it is a documentary photograph.

My use of staging has the same idea behind it. A recent example is the picture on the cover of my book *Margins of Excess* (2018). It shows two young Hollywood actors in a completely staged image, but nevertheless it appears in the context of a documentary body of work. The reason the photographs are staged is to draw attention to the fact that in photojournalism, there are certain recurring tropes and conventions.

For example, after a disaster or a terrorist attack, newspapers are filled with emotional images of people hugging or close-ups of people crying. These images don't show the catastrophic event itself, but are meant to help the reader identify instantly with the person in the photograph. Experimenting with those tropes, I decided to create similar images using actors that could function as a kind of 'stock photojournalism'. They are placed in strategic spots throughout the book. I make staged images within the context of a specific documentary framework, not to deceive, but to attempt different photographic strategies for revealing how things work in reality. It's not because it's staged that it has no documentary value.

227

You publish your own books. Is a published book the final artwork?

The documentary work I make usually consists of many different images, materials, texts and found footage. This comes together best as a narrative in the form of a book, and therefore it's the ideal format for my way of working. If one were to try to translate the contents of a book into an exhibition space, it would completely change the way the work is perceived. It then becomes about space, materiality and scale, for example. A space lets the spectator see all the work at the same time, depending on where they're standing, but a book always has a beginning and an ending, with only one spread visible at a time.

Another thing I like about books is that they're very easy to distribute, and that a book doesn't change once it's been printed and bound (other than decaying). An exhibition is always different, ever-changing depending on the space, cultural environment, institution, and all the other variables.

How important are titles in your work?

I find that text usually overpowers the meaning of the photograph. It takes away from its ambiguity and manipulates a personal interpretation of the picture. In my books, documentary text is usually used to create a context in which to read a set of images or even the whole book, but I rarely place individual titles or captions alongside the photographs unless they are shown somewhere outside of the context of the book.

The title *Margins of Excess* refers to a concept discussed by Christopher Pinney, an anthropologist and art historian. He describes that when you photograph something, for instance a glass, you can't just photograph the glass itself. Inevitably you also have to photograph the table that the glass is sitting on, or maybe some other elements that surround it. The intention is to photograph the glass, but everything else around it is also in the frame. All the things in the periphery of the subject are what Pinney calls the 'margins of excess'. I like this idea, because of the relationship between the subject matter that you want to focus on, and at the same time all the other things that come into the picture coincidentally. They may not seem to have anything to do with the subject right away, but they are nevertheless relevant to its meaning.

In the case of my book *Red Ink* (2018), the title is crucial to conveying the overall message of the work. It's based on a joke about communist censorship by Slavoj Žižek, a Slovenian philosopher. The joke is about a guy from the former German DDR who gets a job in Siberia. Before he starts the job, he tells his friends and family in the DDR that, because he knows that all the letters he will send back home will be censored, they should establish a code. He tells them: "If my letters are written in blue ink, they're true, but if they're written in red ink, they're false." So, he starts his job in Siberia and the first letter he writes home reads, "This place is fantastic, the apartments are huge! It's so westernised, you can buy anything you want! The only thing you can't get here is red ink." I found that a perfect way to describe what I encountered in North Korea as a photographer. This message of censorship is embedded in the photographs themselves. The fact that they look too good, too artificial and almost commercial-like gives away that what they depict must be a fabrication, a propaganda stunt.

What does creativity mean to you?

We are all creative in some sense, but some people just don't have the privilege to be able to express themselves creatively and live from their creativity alone. Being creative is stepping into the unknown, letting yourself be guided by intuition, searching for freedom and expression, which I think are very important things in life. It's also a way of reflecting on the world and your own position in it.

Are you a morning or an evening person?

Both. I like to write in the morning and do more practical work in the evening.

What kind of circumstances have to be fulfilled for you to be creative?

The freedom to make my own decisions and having control over the decision process is very important for me, although somewhat paradoxically, I always look for interesting collaborations with others.

What inspires you?

I get inspiration from lots of different sources, from reading the news to looking at work by other artists, reading books or watching films, or just having discussions with friends, family and students. It's a whole web of different things that is continuously growing.

Do you work intuitively, or do you start with a concept?

Both. The ideas come intuitively when I'm relaxed and just picking things up. Then the concept becomes more rationalised, and when I try to make something within that concept, the process becomes very intuitive again. It goes back and forth.

Being creative is stepping into the unknown.

How do you prepare? Do you have notebooks, or do you doodle?

I keep notebooks and use my laptop. I do a lot of online research beforehand and look through reference looks and read up on relevant literature in relation to the topic we're working on.

Who—dead or alive—would you like to have dinner with?

Right now, I would be interested in having dinner with Werner Herzog, because I recently visited a volcano that he also visited and made a documentary about. I would like to talk to him about his experience on the volcano. And he has a very nice voice, too.

Does your work have to be provocative?

No, it doesn't.

How is humour important in your work?

Humour is really important because it can be a way to address difficult things, things we cannot speak about in a normal tone. Think of the social function that a comedian has: they can speak frankly and address things that might be very important, but without being explicit about it. Kind of like poetry.

How important is colour in your work?

It's not a crucial part of my work. I am however attracted to colourful things, as are a lot of people. Visually and aesthetically, it's just nicer to work with different colours rather than only in black and white. But I don't consider myself a 'colour photographer' like William Eggleston or Harry Gruyaert.

What is your view on the world of social media, where everyone is a photographer?

The idea that everybody has become a photographer is true in the sense that everybody takes pictures, but I think what defines a photographer is a lot more than that. Often the question arises: are you an artist or are you a photographer? What makes a photographer or an artist, at least in my practice, is thinking critically about what it means to photograph. The act of pushing the shutter button is in fact quite irrelevant to the practice. Anyone can take pretty pictures, but that's not what being a photographer is about.

The most interesting part of the social media photography discussion is that people are getting more and more visually literate. They understand that when they see a profile photo on Instagram, it's an idealised image with a specific purpose. They are no longer looking at photographs and believing that they're truthful, but are now seeing them as visual chatter, noise.

How do you look at failure?

You have to be able to fail to be creative. Creativity is part of a trial-and-error process. Things that seem to be mistakes sometimes end up working really well, and unexpected coincidences can become very important in the work. It's difficult to see something as a failure because at the end of the day it's just part of the creative process, and trying something that doesn't work usually leads to something that does work.

You work together with your wife. What's that like?

It's so nice to be able to go everywhere together and work on projects together. I tend to use "we" when I talk about the work because I don't really like to see myself as the sole maker. It's always an exchange with many different people. For example, my last book was made in close collaboration with a graphic designer and a large part of the research was done by my wife Victoria, not to mention all the people we collaborated with to make the photographs.

What's the best piece of advice you have heard and still repeat to others?

Freedom is such an empty word these days, but I think it's important to try and reach a point where you can be free in the things that you're making. Being completely free in the decision-making process is very difficult because in the end you always realise that you're not really free in what you're doing. Always question what you're doing, what you're seeing, what you're making. Always be critical.

PIXI
PRAVDA

I never know what is going to come
out of my mind.

How would you introduce yourself?

I am an artist in conceptual and text-based art. I play with language, words and meaning. My real name is Jeroen Van der Velde, but I figured that internationally that wouldn't be the sexiest or most pronounceable name to use, so I came up with Pixie Pravda as my artist name. Pravda means truth in Russian. It's also a former Russian newspaper, so in that case it was the truth in quotes. And Pixie refers to a pixel in a photo, so it's basically like a picture of my truth. That's how I like to explain the name.

What kind of family did you grow up in?

My father is Dutch and my mother is Austrian. They met in England and I was born in the Netherlands. My parents moved to Belgium when I was about six years old, so I have lived in Belgium most of my life. My parents actually got divorced here in Belgium. My father worked all around the globe, in Venezuela, Curaçao, Saudi Arabia, during my childhood and I visited him in these different countries. My mother worked as a secretary. So, I don't come from an artistic background. Nobody in my family has anything to do with any form of art. I rolled into that by myself when I was about 35 years old.

Was suddenly discovering this poetry like an epiphany?

It actually was. I had never really been interested in arts or visual arts. I thought it was boring and old-fashioned. But I was always interested in movies and music. When I was about 37 years old, I became more into design and from there on I became interested in the art world. I think it was a Panamarenko show that triggered me and made me see that there is much more to art than just painting. And then I discovered an Austrian artist named Anatol Knotek, who really inspired me and showed me what was possible in this artistic field.

How do you combine your day job with being an artist?

I have a 'normal day job' as a headhunter. That means a lot of meetings and business lunches during the day but also some free time in between that I can use to work on my art. I combine my work and my art. Sometimes I work on my art on weekends or in the evenings. But I think eighty percent of my creative work actually happens in my office when I am between jobs.

What kind of circumstances have to be fulfilled for you to be creative?

What I need to be creative is basically peace and quiet. I have to be alone. I have to be able to focus on my art. That's why I prefer to work in my office, even though it doesn't look like an artist's atelier.

Where do you get your inspiration?

I get my inspiration from browsing the internet, looking at other artworks, reading. Or just looking at the airplanes outside of my office, which is located next to Brussels Airport. My way of getting into the zone is to browse through pages and just concentrate on thinking something up. I just let my mind wander and suddenly, I'll get an idea. That's one part of the process, the other part of it is that I also work in my bathtub a lot. The bathroom is where I have peace and quiet, where nobody bothers me, so I take a long, hot bath, often for an hour and a half or more and I just read and I think.

I have a little notebook and whenever an idea pops into my head, I just write it down.

Can you describe your relationship with words?

I am not really a big fan of traditional art, by which I mean sculptures and paintings. I like conceptual art. Conceptual art often has to do with words and language. Look at a masterpiece like Marcel Duchamp's *Fountain*, for example: it doesn't involve words, but because of the language and the explanation Duchamp gives to it, the object becomes a masterpiece. The same goes for Magritte, who is of course a painter, but *Ceci n'est pas une pipe* is basically word-based art. The combination of visual art and words is something that really excites me, and I found that that was the way for me to express myself creatively.

What does creativity mean to you?

Creativity is looking at things differently than most people would. That can be the case in art, where you have to find your own voice. It's doing the unexpected. But the same goes for publicity and advertising, for example for fast-moving consumer goods. Take Kellogg's Cornflakes: it's just cereal, but the creativity is in how you package it, how you sell it, how you distribute it. You have to create a message and a brand story around it. That's also creativity. Creativity to me is a very ample concept and can be found in many disciplines, as long as you're looking at something in a way that I haven't seen yet.

Why do you always use the same font in your art?

At the beginning of my career, I was trying to find my own voice and style. Then I stumbled upon this font, which is actually a really basic Arial font. I always put it in bold and the openings of the letters are always filled. I thought it was important to find something that was recognisable. Something people would see and immediately recognise as being Pixie Pravda. It is the combination of black and white, the words and that specific font that partly defines me as an artist.

Is your work intuitive or do you start off with a concept?

I pretty much work intuitively. I don't really have a plan or an idea when I start, but of course there is some kind of concept behind it, because I work via Instagram, which kind of limits the possibilities of what you can do with your art. A painter has a concept or medium that he works with, his canvas has certain dimensions. I do the same for my audience and for Instagram. When I make something, I contemplate whether it will work on Instagram or not. But other than that, it is completely intuitive. I never know what is going to come out of my mind before I actually start creating something.

How do you use social media?

I started posting my work on Instagram and building an audience. I build my audience through other people sharing my work on Instagram. There are some pages with a big following who often post my work, which always leads to a spike in followers. There's a Swiss page called @andymeetswarhol that has about 100,000 followers, and they posted one of my works today. Then all of a sudden, I'll see a hundred new followers on my page. That happens every two or three days, and that is basically how I develop my audience. Frequency for my followers is important to me as well. I've developed the habit of sharing one or two works a day, which is a good thing because it forces me to always come up with something new. The advantage I have, as opposed to the classical artists who work on canvas, is that I work digitally. I mostly work in Photoshop, even though I do sometimes make the works physically, but only when I have an exhibition. That allows me to develop an idea whenever I have one, without having to buy a canvas, so I can work quite quickly. Once I have the idea, I can often finish the work in ten to fifteen minutes.

Your work is very physical. It is always seemingly hanging in a gallery, as if it really exists.

I think that probably about 85 percent of the people believe that the works are actually physical. It's not that I don't want to do physical works, but I make about four or five hundred works a year, so if I wanted to translate that into physical works, it would cost a lot of money and I would need a lot of storage. In an ideal world, I would actually like to make them, but for now I only do it when I have an exhibition.

I like to create, that is where I get my kicks from, but physically making work really bothers me more than I enjoy it. I often feel like I need to explain that to people, because most artists enjoy the process of making something. People also ask me whether I use canvas or wood, and to be honest I couldn't care less. It is much more about the message that I want to convey than the medium I use.

Putting people on the wrong track is what I am after.

PEOPLE WHO LIKED THIS WORK OF ART ALSO LIKED...

DUCHAMP

AI WEIWEI

KOSUTH

BALDESSARI

MAGRITTE

WOULD YOU
LIKE TO OWN
A PIECE OF
POSTMODERN,
CONCEPTUAL
ART?

NO THANKS

NO THANKS

NO THANKS

NO THANKS

NO THANKS

NO THANKS

How do you want your audience to react to your work?
I think my work tends to be humorous sometimes, or a little provocative, but I am actually not looking to be provocative for the sake of it. I think putting people on the wrong track is something that I enjoy in other people's art and something I also try to inject into my art. A sense of humour, a funny twist or wordplay are typically things that I use as well.

Who inspires you?
I mentioned him before: the Austrian artist Anatol Knotek is someone who inspires me. Another artist that I really enjoy is a Colombian guy named Juan Uribe.
I'm also busy building the audience for a separate Instagram page I created, called @textbased_visual_artists, which is becoming successful. On that page I post a lot of artists whose work I really enjoy, but I am not a fan of art so much as I am a fan of particular works. I don't really care if it's by somebody completely unknown, if the work is good, then that is what really matters to me. There are some well-known artists who have a couple of good works, but they also have a lot of bad works. So, I don't really follow specific artists as much as I follow my kind of art. I am just not a big fanboy.

Has the Covid-19 pandemic influenced your creative life?
Other than having more time, I can't really say that Covid-19 has changed my approach or philosophy to art. My work is not political or based on current news but rather universal and timeless.

What does failure mean to you?
I really worked quite hard on my art between 2016 and 2019, when I did a show in Ghent. I think there were about thirty works on display and I sold about fifteen, but I was hoping for it to be sold out. I was also hoping that maybe I would get picked up by larger galleries. I didn't know anything about how art galleries worked, so I was a little disappointed because I thought there might be interviews. I also expected lots of interaction with other artists, but that wasn't really the case either. It's quite a lonely field. I figured that now that my art had become successful on Instagram and I had landed my first solo exhibition, the next step was coming. And when that didn't happen, I kind of gave up for a year. That was my experience with failure. I said to myself: is it all worth it? Even if the Instagram page becomes more successful, is that really going to lead to a career? But then I felt that I needed this creative outlet to be happy. I'm not in it for the money or for the fame—although if it happens that would be great. I realised that regardless of success, I just enjoy making my art and that's why I continue to do it.

KAREN
ROSY
KAR
ROSEN

I love the shapes of the letters.
They are the architecture
of text.

How would you introduce yourself?
I am a painter.

What kind of family did you grow up in?
I grew up in a small town in Texas, called Corpus Christi. My family was small, but there was a large extended family on my father's side. He was the youngest of eleven children. He and his mother and siblings immigrated to the US from Russia. My father became a physician. Among other things, my mother played word games with me and completed a crossword puzzle every day.

Was there room for culture and arts in your childhood?
Corpus Christi is a small town, so there wasn't a lot of art and culture present, but my parents recognised my interest in art. When I was young, my mother gave me art lessons. She gave me a set of coloured pencils that I loved so much that I refused to use them so I wouldn't use them up. I still have them.
My childhood also encouraged my creativity by giving me time to muse. I had a vivid imagination and spent a lot of time nurturing fantasies and exploring the natural world around me.

When was the first time you knew you wanted to be an artist?
A teacher who I briefly studied art with when I was 22 years old, told me I had missed the boat, that I should have studied art. Six years later I realised that he was right.

Which came first: the love of language or the love of art?
Language. In the sixties, during my transition between language study and teaching and art, I took a few art classes at the School of the Art Institute of Chicago—where I later ended up teaching for 24 years. I didn't follow the normal path through the art education system.

What is your relationship with words?
We are collaborators, the word and I, and we have wonderful exchanges. I respect the word and its awesome capacity to be transformed many times over from only 26 letters.
It 'speaks' to me via written or oral speech and I process it and respond via paint, pencil, printmaking, collage, or video. I love physically making the work —paintings, drawings—and creating beautiful surfaces. I know in reproductions the work looks very graphic, and it is, but it is also very tactile in person.

You say you look at language as found material and your work is doing as little as possible to reveal its potential. Can you explain?
I think of language as found material. It comes to the table with its own content and context and I respond with mine. We engage in a dialogue to make something completely new.
Economy is important to me—doing as much as I can with as little as possible. I don't care about making massive changes. I want to leverage my small gestures against the material's. My works are sparsely populated. Only one or two words.
For example, I saw in the word 'removal' the word 'oval', which made me think of the Oval Office. By italicising 'oval', setting it off from the rest of the word, I enabled the reading of two words—'oval' and 'removal'—which link on some level and resonate in the viewers' mind as 'Removal From [Oval] Office.' This was first made in 2008 to anticipate the end of the George W. Bush's presidency, and it foretold my fantasy of Trump's removal.

Do you want to challenge the viewer in the way they look at words?
I hope the viewer will be challenged. It's nice not to take language for granted, but to see fresh possibilities in it, not only semantically, but visually, as constructions and systems circumscribed by colour, scale, materials, graphics and composition.

Do you have a favourite font or does this come with the work and change accordingly?
With a few exceptions, I have favoured sans serif, generic fonts because they don't influence meaning. I want the meaning or message to be carried by the structure of the language, not by the style of the font. I have primarily used Futura, a rogue font called Commador, and currently English Gothic.

Do you have a preference for caps or lower case?
I have used both. When I used Futura, I used lower case, but with Commador and English Gothic, I use caps. There are also structural reasons for choosing one or the other. For example, in the work whose image is the single word 'tidbit,' 'd' and 'b' has to be lower case in order to mirror the two halves of the word: tid-bit. It wouldn't work with capital B and D: TID-BIT. In a work like *Taking Charge* I had to use capitals in order to show the small distinction between the letterforms C and G.

Are you a visual poet or more like a sculptor working with our linguistic and conceptual perceptions?
The poet Eileen Myles called me "the poet of the art world". *The New York Times* critic Roberta Smith called me a "writer's sculptor." I am honoured by both, but if I have to choose, I feel that I am more of a sculptor because in my work letters and words function more as surrogates for objects or performers.

Is context important for your work?
Yes. I have turned down opportunities for the smaller works because of context, mainly because the work would have had a decorative background function and I would like more for the work.
However, I think that is inevitable for the large-scale outdoor wall works because of the nature of public spaces where people are rushing past. Then again, the function and location of the site remains important for the public wall works as well. I am more interested in public institutions than private or commercial ones.

Is bigger better in the world of Kay Rosen?
Not necessarily. I am actually more comfortable with making small works that resemble the intimacy of the page or whose size falls within the parameters of the body. Smaller works are also more suitable for small discoveries in language. But when I want to turn up the volume on a message, bigger is better.

How do you know when a work is finished?
Everything is worked out at the beginning. The work is finished before it begins. If there are problems at the end, it is too late to make changes. Then I have to throw it in the garbage.

What is creativity to you?
Setting up and solving problems.

What does a day in the life of Kay Rosen look like?
Where I live, there are not many distractions, so between the studio and my desk, I spend around eight hours a day on art, including responding to emails and studio management. My studio is attached to my home, which is convenient.

When and where are you the most creative?
In the morning, but also any time, except at night when the brain cells have been killed off by fatigue and a few glasses of wine. There is a big comfortable chair in my house that is conducive to creativity if I am alone and it is quiet.

Where do you get your inspiration?

An overheard fragment of a conversation or something I read can spark an idea. Sometimes I wake up at 4 am with a brainstorm.

When I was studying at the School of the Art Institute of Chicago, I saw a Larry Rivers painting, *Lions On the Dreyfus Fund III*, in the museum, which incorporated language. I felt like it gave me 'permission' to use language in my art.

I was also very inspired in the late seventies and early eighties by the minimalist music and dance systems of Steve Reich, Lucinda Childs, Tricia Brown, and others. I think there is a correlation between their movement and form and the systems of letters and words in my work. There is a more direct link in the early non-text works of that time, like *The Exhibition*.

Can you elaborate on your work process?

Generally, I might have an idea that comes to me fully formed or that I have to doodle into being. I turn to the computer to lay it out more formally, making decisions about font, spacing, orientation, scale, colour. When it's exactly the way I want it, I enlarge the computer model and transfer the image to paper or canvas. Lastly, I paint or draw it. If it is a wall painting, I send the pattern with all of the specifications to my sign painter or fabricator for production, along with the team at the institution it is destined for.

Do you work intuitively or do you have a concept?

My work begins intuitively, with something I respond to or think of on a cognitive level. Working intuitively usually results in more success than coaxing a work into being based on a pre-formed idea.

What do you do to call upon your creativity?

My process is more passive. I wait for the muse and try to trust my instincts. As I've said, I think of language almost like these little found objects that suggest themselves to me. Sometimes I don't really go looking for them as much as they're just there. You have to be in a certain frame of mind to pluck them out of the air, to make them yours. They could be hanging around and maybe I don't see them. Your head has to be in a certain place.

Do you use notebooks, or doodle in sketchbooks or digitally?

I begin by doodling on scraps of paper or in notebooks. At some point I throw out all the bad ideas. They're depressing to have around.

What are some things that prevent creativity?

Distractions that come from real life.

Language is like found material.
It comes to the table with its own content and context
and I respond with mine. We engage in a dialogue
to make something completely new.

How important is humour in your work?

Very important. When a work fails, it is often due to the lack of humour, either the silly kind or the aha-moment kind.

Can you elaborate on the importance of colour in your work?

I would say that colour figures importantly in 75 percent of the work. Sometimes it helps to support a system in an artwork. Sometimes colour identifies with the text object itself, like the artwork *Blurred*. Sometimes it is symbolic. Other times colour in the work is neutral.

I think of paint as 'found' material in that I never mix colours; I use them straight from the can or tube, as is.

Does creativity have to create a better world?

I think creativity makes people happier and therefore can create a better world. I would love for my art to have that power, but I'm not sure if or how it does.

Is your work (always) political?

No. The work is primarily about language, so it usually goes wherever the language leads it. If it is political, it's because the language led it there, not because I led it there. However, I intentionally directed language in a political direction during the Reagan era of the eighties. For my last show in New York in 2018, I felt it would be irresponsible not to acknowledge the horror that was the Trump administration, so although language generated the message, I included only works that were political, overtly or subversively. (*Triumph Over Trump*, 2017)

How do you incorporate failure into your creative process?

Hopefully I learn lessons from mistakes and avoid similar bad choices in the future. Above all, to stop forcing a work that doesn't want to be born into being. I have to discern if I'm not trying hard enough to find the creative solution or if I'm not recognising that its recalcitrance is due to its inherent inadequacy.

What's your biggest failure?

One that comes to mind happened many years ago, early in my career. I participated in an exhibition in Washington D.C. and the curator wanted to include several wall paintings. The sign painters she hired were unprofessional, a total disaster, and they didn't come close to completing the works before the opening. It was humiliating. Since then I have been very careful about who paints my large works.

Is failure important for the creative process?

It probably is. Failure is chastening, it helps provide new rigour to the creative process, and if nothing else, failure makes one appreciate successes. I have become a very strict editor: I think it is better to not make mistakes and find the correct solutions at the outset.

Has the Covid-19 pandemic influenced your creative life?

Yes, in several ways. The messages and the language in most of my works have been inflected by the global Covid-19 crisis and by the deplorable way that the Trump administration responded to it in our country. In addition to the work's content, the lack of access to materials and resources has affected the type of work I've been making over the past year.

Many exhibitions that I am participating in have been postponed. I have also really missed visiting galleries and museums and seeing others' art. Viewing it online isn't quite as satisfying. But on a positive note, I have had so much more time to work in the studio, which has been wonderful.

What advice can you give to a young creative who is just starting out?

I have given the following practical advice to young artists and students who are just entering the art world: don't burn bridges, because the art world is small. Be persistent because the cause of rejections is usually not due to the quality of one's art, but to various other reasons.

What's the best piece of advice you have heard and repeat to others?

"I guess you can always play dumb."

TRIUMPH

S T E F A N
SAGMEISTER

One does need to start.
Without starting there is nothing.

What is creativity to you?
Creativity to me is to never having to answer a question trying to get me to define creativity.

Where are you most creative?
I'm consistently inspired by music lyrics, train rides, empty hotel rooms, art museums and objects that have nothing to do with the project I'm working on.

What kind of circumstances have to be fulfilled for you to be creative?
There are five emotions I must feel in order to create. I follow this process for idea inspirations:
1. Freshness of Spirit: I want to start thinking about a project early in the morning, as thinking might be the most difficult thing I'll do all day and so I love to start with the hard stuff and then work myself down to easier things.
2. Freedom of Thinking: I want to have all the necessary limitations laid out clearly—I love them. But within that space I'd like no restrictions.
3a. Dread and Pain: there will be periods of suffering and self-doubt. I'm going to be stuck. I'm going to suck. Very old ideas will come to mind. If it's easy, it's likely no good.
3b. Repeat.
3c. Repeat.
4. Recognition of a path: I rarely have a big, single Eureka moment, but the road gets less rocky with fewer stones to stump my toes bloody.
5. Willingness to hang in there for the execution: tenacity, interrupted by infrequent discoveries of a possibility to push the project on.

How are you creative?
Being influenced by areas outside your own profession usually results in fewer instances of imitation. When I work on a new design piece, I never look at other designs. If my design is influenced by science, literature, engineering, or music, there is usually much less of a danger of imitation.

What are some things that prevent creativity?
Being really badly organised. Being too well organised.

Where do you get your inspiration?
One of my most frequent sources of inspiration is a newly occupied hotel room. I find it easy to work in a place far away from the studio, where thoughts about the implementation of an idea don't come to mind immediately but I can dream a bit more freely.

What inspires you?
I find the obsessions of the Korean artist Do Ho Suh interesting. I also listen to a lot of Mark Lanegan and I got involved in a campaign to lower the Pentagon budget. Marc Koska, the inventor of the single-use syringe, a device that disables itself and prevents reuse, is a real inspiration as well.

What do you do to call upon your creativity?
The process I've been using most often has been described by Maltese philosopher Edward de Bono, who suggests starting to think about an idea for a particular project by taking a random object as point of departure. Say I have to design a pen, and instead of looking at all the other pens and thinking about how pens are used and who my target audience is and so forth, I start looking around the hotel room where I'm working for a random object to help me think about pens: bedspreads. My train of thought might go like this: OK, hotel bedspreads are… sticky, they contain lots of bacteria… Ah! Would be possible to design a pen that is heat-sensitive, so it changes colour where I touch it? Yes, that could actually be nice: an all black pen that becomes yellow on the touchpoints of fingers. Not too bad of an idea, considering it took me all of thirty seconds to get there.
Of course, the reason this works is because de Bono's method forces the brain to start out at a new and different point, preventing it from falling into a familiar groove it has formed before.

What kind of techniques do you use to come up with ideas?
Many designers whom I respect create (non-client-driven) experiments as a regular part of their practice. The keyword here is 'regular'. I found that experiments that are not part of a regular schedule, have a tendency to get pushed out by more 'urgent' jobs, simply because they have a deadline attached to them.

Do you use notebooks or do you work digitally?
I use large sketchbooks.

What are your thoughts on the idea that creativity and inspiration are overrated and you just have to go out and do it?
One does need to start. Without starting there is nothing.

Did your childhood influence your ideas about creativity?
My childhood not so much, but I did start writing for a small magazine called *Alphorn* when I was fifteen, and quickly discovered that I loved doing the layout more than the writing.

Failure is overrated.
I like our work to succeed.

Who inspires you?

Lots of different things inspire me: the book *A Man in Love* by Karl Ove Knausgård, the Kyoto scent by Comme des Garçons, the movie *Adaptation* by Spike Jonze, the band King Crimson, the artist James Turrell, New York City, the restaurant El Bulli, the Bamboo Indah hotel in Bali, and running.

Who or what has been the single biggest influence on your way of creative thinking?

Tibor Kalman was the single most influential person in my design career and my one and only design hero. Twenty-five years ago, when I was a student in NYC, I called him every week for six months. I got to know the receptionist at his design firm M & Co. really well. When he finally agreed to see me, it turned out I had a sketch in my portfolio that was rather similar in concept and execution to an idea M & Co. was just working on. He rushed to show me the prototype, out of fear I'd later say he stole it out of my portfolio. I was so flattered.

When I finally started working at M & Co. five years later, I discovered it was, more than anything else, Tibor's incredible salesmanship that set his studio apart from all the others. There were probably a number of people around who were as smart as Tibor—and there were certainly a lot who were better at designing—but nobody else could sell these concepts without any changes and get those ideas with almost no alterations out into the hands of the public. Nobody else was as passionate. As a boss he had no qualms about upsetting his clients or his employees. I remember his reaction to a logo I had worked on for weeks and was very proud of: "Stefan, this is TERRIBLE, just terrible, I am so disappointed". His big heart was shining through nevertheless.

Tibor had an uncanny knack for giving advice, for dispersing morsels of wisdom, packaged in rough language later known as Tiborisms: "Don't go and spend the money they pay you or you are going to be the whore of the ad agencies for the rest of your life," was his parting sentence when I moved to Hong Kong to open up a design studio for Leo Burnett.

He was always happy and ready to jump from one field to another: corporate design, products, city planning, music videos, documentary movies, children books, and magazine editing were all treated under the mantra "You should do everything twice: the first time you don't know what you're doing, the second time you do, the third time it's boring". He did good work containing good ideas for good people.

255

Does creativity have to be provocative?
No, it does not. Wonderful work can be totally quiet.

How important is humour in your work?
I love to hide surprises in places where they make sense, like books or CD covers, which are scrutinised very carefully by a small minority of readers. Humour in design is as important or unimportant as humour in life, and who gives a shit if it sells.

Is the purpose of creativity to make people happy?
Right now, over fifty percent of the world's population lives in cities. Everything surrounding them has been designed, from their contact lenses to their clothes, their chair, their room, their house, the streets, the parks, the city. These designed surroundings play exactly the same role to a city dweller as nature does to an indigenous person living in a rainforest. They can be well designed or badly designed. They will make a difference. There are of course many products out there that do make our life easier, but we tend to only notice them when they fail badly. I can be on a plane and be completely oblivious to what an incredible piece of design it really is. I'll only really notice it when it crashes.

What is failure to you?
Failure is overrated. I like our work to succeed.

How do you incorporate failure into your creative process?
The same people who talked about 'thinking outside of the box' a decade ago are now discovering 'the importance of failure'. I do know one single designer who really leans out the window very far: he takes on lots of risk while doing large jobs, and when he fails, it is neither pretty nor enjoyable. People lose their jobs, people get sued.

Has the Covid-19 pandemic influenced your creative life?
Since the pandemic, my typical day looks somewhat like this: I get up at about 6.30 am, and then I work out on my roof using my favourite new app called *Supernatural*, designed for the Oculus Quest virtual reality system by my friends Chris Milk and Aaron Koblin. After getting incredibly sweaty and a subsequent shower, I'm normally in the studio by 8.30 am, the commute being a spiral staircase up from my apartment.
Over a year ago I stopped accepting all promotional, branding and advertising related design work to fully concentrate on projects I find more meaningful. This also meant that I had already started working with designers remotely, so I was fully set up when the lockdown started in March. This was not prompted by smart foresight but caused by pure luck.
My hope is that we are moving from an overall 'more/faster' strategy to a 'less/slower/better' direction. But having lived through 9/11 in New York and having experienced that many of the predictions for a post-9/11 world did not come to pass, I don't see gigantic changes happening after Covid-19 either.

What advice do you have for a young creative who is just starting out?
Stop concentrating on your own happiness and start looking out for the happiness of others. Something my friend Marian told me.

What's the best piece of advice you have heard and repeat to others?
From Tibor Kalman: "The only difficult thing when running a design company is figuring out how to stay small".

PAULA SCHER

I am not bored yet.

How would you introduce yourself?

If somebody were to ask me what I do, I would tell them that I am a graphic designer and a painter.

What kind of family did you grow up in?

My father was a camera engineer and a map-maker. I learned about map-making from an early age on, and that's why I paint maps now. We've come full circle. My mother was a schoolteacher, she taught ninth-grade history. I had a very good education, in a public school in Silverspring, Maryland. Growing up I had wonderful teachers, all brilliant women. Teaching school was the best job they could get at that time. If my mother would have been my age, she would probably have been a lawyer.

Did your childhood influence your ideas on creativity?

No, not at all, no one seemed creative *(laughs)*. I was always interested in art from a very early age, I was always drawing and painting. I would draw and paint in my room when I was unhappy or lonely, and I still do that.

When did you know you wanted to be an artist or designer?

I didn't know what a designer was until I was already in art school. I knew I wanted to be an artist, I just didn't know what kind of artist. I wanted to make things and the things that I wanted to make were visual. I had a teacher in high school who had put up a glass frame in the hallway outside of his classroom, and he would pick somebody's drawing or painting every week to hang in there. I used to get Picture of the Week a lot, which made me very proud.

How did your love for typography and words emerge?

That was much later. Initially I studied graphic design because I was good at coming up with ideas. And when I first took a graphic design course, it was with a sort of problem-solving approach, almost like in advertising where you made messaging and figured out an idea based on a premise. I didn't know how to do the type.

If I designed book covers or record covers I wouldn't know how to design the typography because I didn't know how to draw the type. I told my teacher, a Polish illustrator, that I didn't do the type, I didn't understand what I was to do with it because it didn't make any sense to me. He said: "Illustrate with type". When he said those three words to me, in a very heavy Polish accent, he gave me my whole career!

You started your career doing record covers.

I was a corporate art director inside a corporation called CBS Records and I was responsible for 150 covers a year. Sometimes I would design for a popular band who were making a lot of money, so I would have to do what the band wanted. Most of the time that meant letting them be shot by the hottest photographer of that time. I just had to book styling and make-up, do some retouching and design some typography for it, and that was actually really boring work. I would do it to make the company happy and because I knew how to. But when there was a jazz album that nobody cared about, I got total control and I could do what I wanted—those were the most beautiful jobs.

I had a couple of wonderful clients like Blue Sky Records, managed by Steve Paul. He had some excellent people like Johnny and Edgar Winter. I also did the covers for Muddy Waters, and I really loved that work. I worked for Bob James who had a jazz label called Tappan Zee Records, and we did a series of covers for all their artists, all small objects blown up out of scale, like a matchbook, a nickel, and a football. Then I worked with Bruce Springsteen and Billy Joel. I like the covers more now than I did back then. I always hated the Boston cover that everyone knows me for and I am afraid that is what I will be remembered for when I die. That's pretty awful.

It was interesting to be in the pop business and the recording industry, especially in the seventies in New York City. I was in my twenties and it was very exciting, but it wasn't the real world. When I look back on it, I am amazed that I had that opportunity as such a young woman. Sometimes I wouldn't appreciate the music until much later and I didn't realise how wonderful the things were that I had to work on, because I was just a kid.

How did you get into identity design?

I was once interviewed for a book about the seventies band Cheap Trick. They asked me questions about the album cover that I designed for them. The stuff I did, the typewriter type, the way the band was shot—the pretty guys at the front and the funny guys at the back—became the look for every single subsequent album, and all of that is part of Cheap Trick's identity. Those were all details that I had forgotten about all those years later, but that was identity design.

It is not so much different now: someone comes to me and tells me what their business is, how they want to appear to the public, and what their hopes and dreams are, and I take that information in and process it in a way that it comes out in some form of system and methodology. On the other side of my brain there are all the things I like: the typefaces I think are terrific, all the colours I like to work with, all the shapes I think that matter. I think about their business and all the other businesses that I've ever thought about, and it comes out as an amalgamation, it is half them and half me.

Tell me about the Citigroup logo.

The sketch was done an hour after the first meeting I had with the company, but it took almost a year and a half to finalise it. It was an awful process, which was why I started painting. If you have a merger between two full corporations and you have to deal with the corporate presidents and all the people on the various levels, it takes about a year and a half to get it through. That first sketch was right because it was the right analysis of the merger. The logo is twenty years old now, and nobody remembers that it was a merger. They think the arc is a rainbow or a metaphor for optimism or something. They don't realise it was the umbrella of the Travelers Group, which was merging with Citicorp at the time. I think that is very charming because so many people have no idea where it came from, and I can tell the story.

All of your ideas stay so fresh, what's your secret?

I am not bored yet. I have periods of high creativity and some more shallow periods, no one is always one hundred percent. I try to use the periods where I am failing or don't like what I am producing as a signal that something has to change, and then I change something, and I usually make a discovery.

You have been working with the Public Theater for 25 years. Is this long-term engagement important for you as a designer?

At the Public Theater, I'm in a very creative position where I have a lot of control, which is a very unusual situation. In the beginning I was more selfish about my designs. I wanted to make posters that were recognisable, and a lot of the work became trademark of me. But then I realised that the theatre itself did not necessarily benefit from this approach, because even though the graphic design community knew all of the posters and they were featured in annuals and museums, most people who go to the theatre aren't graphic designers. So, a lot of people didn't know the Public Theater, because it didn't produce enough general advertising to be recognised easily in the streets of New York. Now, 25 years later, it is recognisable. But it was a long road to get there.

In the past five years I changed the approach dramatically: I would create the campaign for the free Shakespeare in Central Park, which was the one campaign that everybody in New York City saw, because it was in every subway and on the street and around the theatre. This design would then become a template for all the things that are produced in the theatre in a whole year, always using the same graphic but modified to each play. I would keep the look for the whole season, and the next year it would be another one. It works terrifically because people really notice it.

Is bigger better? Environmental design is something you do as well.

I love it. I'll tell you why I like environmental graphics so much: if you make a book cover and you pick type and an image and present it to your client based on the information that they gave you, they will ask you for a couple of changes. Then, when it's time for the book cover to go to press, they forgot there were five lines that had to go on it. Then somebody who didn't see it yet didn't like the colour, so you have to change the colour. By the time your book design goes to press, it only slightly resembles the book cover you decided on six months ago. That is a little frustrating.

But if you design a building, and you put typography on the building, you make a fantastic photoshop rendering of it to show the client what it is going to be like. If the client likes the rendering and it is within their budget, it will come out a year later looking exactly like the photoshop rendering. That's why I prefer to do the building: it takes longer to come out but it looks exactly like the design *(laughs)*!

261

Is working for a good cause good for creativity?

It is exceptionally good for creativity. I use pro bono in different ways. Sometimes I'll do it because I like the cause, sometimes I'll do political posters or something on behalf of some good service. I always see if I have the time to do it and if I need to do something fresh, and I will use it for that. Sometimes I'll do it if it's a bigger project, because I want it to be seen, like the work I did for Shake Shack. I designed the logo and the banding around their Madison Square Park kiosk that was designed by an American architect named James Wines. I put typography on it and that became the Shake Shack logo. I did that for free! I probably get more calls for business based on that identity than because of Citibank. It is amazing, and that's because it is a millennial identity and people like that.

The Highline logo I also did for free, because the founder Robert Hammond actually came to Pentagram for another job. He asked me if I would consider working for free for the park he wanted to start in New York City. I thought he was crazy, and I didn't believe he could do it, but I wanted the other job, so I thought: alright, it's a railroad track and it's called the Highline, so I'll make the 'H' look like a railroad track. I gave it to him, and that became the Highline logo. It's kind of an iconic thing in New York and it was totally accidental. He never gave me the other job, by the way.

Who inspires you?

Many people: my husband Seymour, my friends, my students. But New York is a very inspiring city as well; everything is going on at once, every day you are totally bombarded by media, by noise, by the crush of people, by diversity. Sometimes you take it all in, sometimes you wipe it all away, but when I look out of the window, I can see all this infrastructure of things and people. It's both aggressive and beautiful.

What does creativity mean to you?

I hate the word creativity, it's creepy. I hate it when people ask me "Why are you creative?", "How did you become creative?" What does that mean? If you are left alone in a room with nothing, you are likely to become very creative, and you are likely to have thoughts you haven't had before. You might have an idea because you see something lying on the floor that looks like something else. If you have a sketchbook you might make some fantastic drawings simply because you are killing time. The drawing might trigger something new. But if you are looking at your iPhone you are never creative. I used to be very creative when I smoked because when I stopped for a cigarette break, I wasn't doing anything else other than smoking so I was able to think about other things. Now it is very difficult to be creative because I am always looking on my iPhone.

I once described creativity as a slot machine: on one side of your brain you have the brief and on the other side you have everything you have ever absorbed in your life, every book and piece of poetry you have read, every exhibition, movie or television programme you have seen, every person you know; it is all in there spinning around and around, and you put the quarter in and the cash comes out *(laughs)*!

You are at your best when you are uncomfortable or you can play.

If I know how to do something, it's very hard to do it again. But if you don't know how to do something and you are really unqualified, you make a lot of stupid mistakes and therefore you make discoveries. You don't make discoveries when you already know how to do it, so it is important to be ignorant when you take on a job.

You are also a painter. How important is this in your life?

Very important. It is the physical opposite of design and of what I am doing at Pentagram. It is not really problem-solving; it is using time in a different way. It is more expressive through colour and form and I am always discovering things with it. The process of painting is incredible.

You say: "I haven't made my best work yet".

Yes, I don't think anything is really good. I rather think I haven't gotten good yet. And I totally mean that. I start every project that has potential thinking it is going to be the best piece I have ever done in my entire life, and then I get into it and it never is, which is always a little disappointing.

What is the best piece of advice that you give to your students?

Stay with it, love your work and learn how to explain it to somebody else. Your job as a designer is not only to design it, but also teach somebody else to see it. The reason why you are a designer and they aren't is because you see stuff like that and they don't. Not because they are crazy or not normal, the designers are the ones that aren't normal. They have to teach what they see.

`I haven't made`
`my best work yet.`

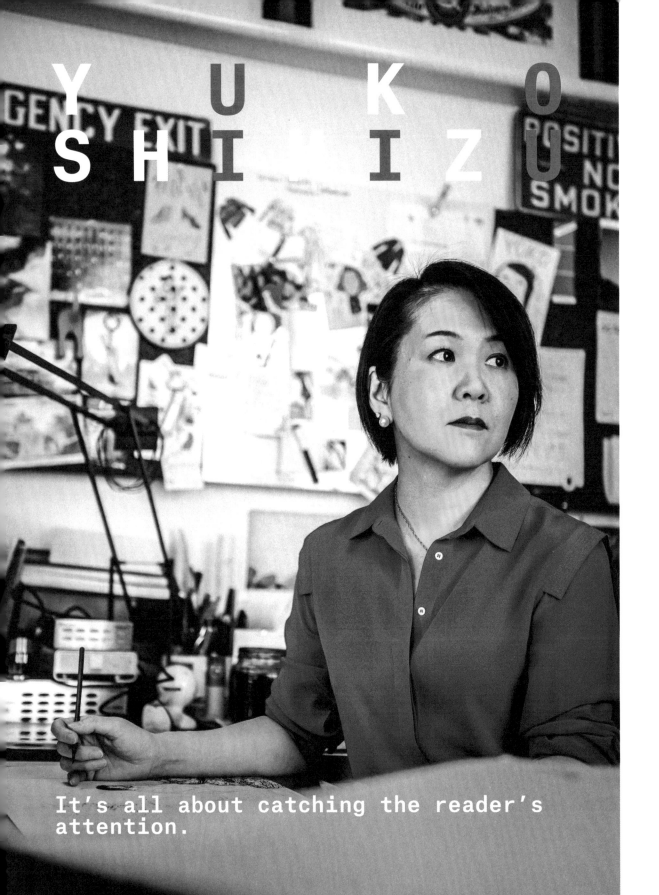

YUKIKO SHIIZOU

It's all about catching the reader's attention.

How would you introduce yourself?

Illustrator is not an occupation a lot of people know, so I always say I draw pictures for newspapers, magazines and books.

And that you're not the Hello Kitty designer.

We have the same name, which sounds very exotic if you're not Japanese but it's actually a very common name—the Japanese equivalent of Emily Smith. The confusion is a bit annoying, but it's not like I get harassed every day.

What kind of family did you grow up in?

My father was a businessman and my mother was a stay-at-home mom, which was very common when I was growing up in Japan. Everyone's dad worked and everyone's mom stayed at home, pretty much. My parents are still together so I grew up in a pretty stable, regular, middle-class Japanese family.

Was there room for culture and art in your family?

My father started learning Japanese calligraphy after he retired, and he got pretty good at it. My mom always used to make her own clothing, as well as clothing for my sister and I when we were growing up. There was some creativity present, but that was pretty much the extent of it. My parents wanted us to get a good job. Their dream was for us to become either a lawyer or a politician.

Did growing up in Japan influence your way of creative thinking?

I was always drawing. My mom said that one day, when I was two years old, I drew a circle and a line with crayon on the newspaper, and I haven't stopped since. The other kids at school played dodgeball during breaks, but I would just stay in the classroom and draw. Japan is a very old-fashioned country where people want you to think and act a certain way. There are a lot of unwritten rules. Unlike in the US, where you're praised for being different, parents in Japan will worry about you if you are different. My parents worried that I might get bullied or that I might not get into a good school, which didn't make for a particularly encouraging environment.

However, when I was growing up in the seventies, Japan had its first big manga and anime boom. Astroboy was a very famous early manga and anime that was born from its creator Osamu Tezuka's obsession with Disney, and was inspired by Mickey Mouse, which started the whole Japanese anime and manga boom. Japan is both a great and a terrible country for creative people: you are expected to obey the rules and try not to stand out. It's fascinating to see that there are still creatives doing tons of creative and innovative work in spite of that.

You didn't start out in a creative career.

My parents are old-fashioned and knew very little about what a career in art entailed. They thought I was going to starve—probably because the only artist they know is Van Gogh. They just wanted me to find a good husband, which was considered the best 'career' option for women. But I also spent part of my childhood in New York. My father's job brought our family here when I was in middle school. Thus, I experienced both the very traditional Japanese way of life and the American way of thinking. The juxtaposition between the two, I guess, comes out in my personality and in my art as well.

I attended a regular university in Japan, majoring in business advertising and marketing, because my parents were really against me pursuing art. I then worked in corporate PR for eleven years, which was torture and fun at the same time. I still like PR and publicity, but I knew I didn't fit in in the Japanese corporate world. So, at the age of thirty I asked myself: is this what I want to be doing for the rest of my life? I always wanted to pursue art, but I was never committed enough. At eighteen, when I started university, my mind wasn't set enough to go against my parents' wishes. I was young, and I didn't know what I wanted to do with my life. But by the time I turned thirty, I believed in myself enough to take the leap. If worst came to worst and I couldn't make a living in art, at least I had tried it and then I could move on. It still took a few more years before I saved up enough money, applied to art school and moved to New York.

Why illustration?

I studied advertising in college. And I had on occasion worked with illustrators for company ads or corporate brochures during my corporate PR tenure. It's a big plus to know the client side as well.

Illustrations only have a limited amount of time to grab people's attention. How do you stand out?

By trying to be as true to myself as possible. When I do editorial illustration, it's all about catching the reader's attention and getting them to read the article. After that, my job is over. People think illustrators are people who can come up with ideas like switching on a lightbulb. That's not true. Ideas come to us because we are good researchers. Research is a big part of illustration. I read articles and do research about the topics at hand, and by doing research I might encounter things that could work visually. The more research I do, the more ideas come. I try to pick the best ideas and always remain true to who I am. The client could have called anyone else, but they called me. That means they want something that I make that other people don't make. So, I shouldn't be thinking about what the client wants, but about what I can offer the client.

How would you describe your style?

People say my style is a mix of Japanese and Western influences. When I go back to Japan, people tend to treat me like I'm not one of them, although I speak perfect Japanese. I guess I act differently because I've been living in New York for more than twenty years now. Then again, in New York people think I'm very Japanese. The same goes for my work. Japanese people see my work as very Americanised, while an American audience sees them as very Japanese. That pretty much sums up who I am, and if my work feels like me then I am fine with that.

What does a day in the life of Yuko Shimizu look like?

I try to wake up early and prepare a pretty big breakfast. I even make juice every morning. I eat, then I take the dog for a walk and go to work around ten. I do all the important emails in the morning and really take my time to write them. Because of my background in public relations, communication is important to me. I start on my actual work after lunch. I'm actually not an evening person but I end up being more focused after five, when everything gets quiet.

What does creativity mean to you?

The word creativity is put on a pedestal. Creativity isn't just for so-called creatives. Everyone is creative. The last time I was really creative was when I had to figure out how to move a car that ran out of gas in the middle of Manhattan, without a driver's license. Stay-at-home moms are creative because they have to come up with good meals for their kids with a limited amount of ingredients in the fridge. I hope that we will shift the way we think about the word 'creative' and give it back to everyone.

What is your work environment like?

If my apartment is too messy, I can't relax. My apartment is much more organised than my studio. In my studio I'm fine with a little bit of mess, as long as I know where things are, and I have space to work and it's clean enough.

Can you work everywhere?

No, I can only work in the studio. From time to time, I get contacted about an artist residency, where they offer me a quiet environment to work in a cabin somewhere, but just thinking about it stresses me out. I need to feel very comfortable in the space I work in.

Where do you get your inspiration?

New York is pretty stimulating. Just by walking around the city you will meet the coolest people and see the weirdest things. I don't have an internet connection at home and I don't own a TV. As an illustrator, a lot of reading is involved in my work. If I'm drawing a book cover, I have to read the whole book. Even though it's not expected of me, I prefer it that way, because it helps me come up with a better idea than reading just one paragraph about the book. I still read slower in English than in Japanese, so I started reading more books in English to get better at it. On Sundays I like to lie on the couch and read books about countries I have never been. That provides me with pretty good inspiration as well.

Can you describe your work process?

I make pencil sketches, which I then blow up to the size I want. I cut the paper and trace the drawing quickly, and then I use brush and ink to draw. Once the drawing is done, it's scanned into Adobe Photoshop. The final colour illustration only exists digitally as an Adobe Photoshop file.

Does your work have to be provocative?

It depends on the subject matter. Provocative subject matters should be provocative, but not everything needs to be. I like a bit of tension, but only when the image calls for it. If everything's full of tension, then the tension loses its meaning and just becomes a gimmick. I treat every single image differently by figuring out how it should be drawn. Some images are more subdued and subtle and some have a lot of tension, some are a mixture of both. Figuring that out is part of the fun. I don't want to settle on one thing and keep making variations of what I have done in past.

Is humour important in your work?

I think humour is important in life.

How important is colour in your work?

If I had a choice, I would love for everything to be in black and white. It's not that I don't care about the colour, but the part I enjoy the most is drawing in black and white. The colouring part is just a necessary step to finish things.

Do you have a certain colour palette that you stick to?

I like a warm colour palette that's slightly muted. The same colours tend to return in different illustrations, I can't help it. The rest depends on the subject matter. I try to be little bit offbeat whenever I can.

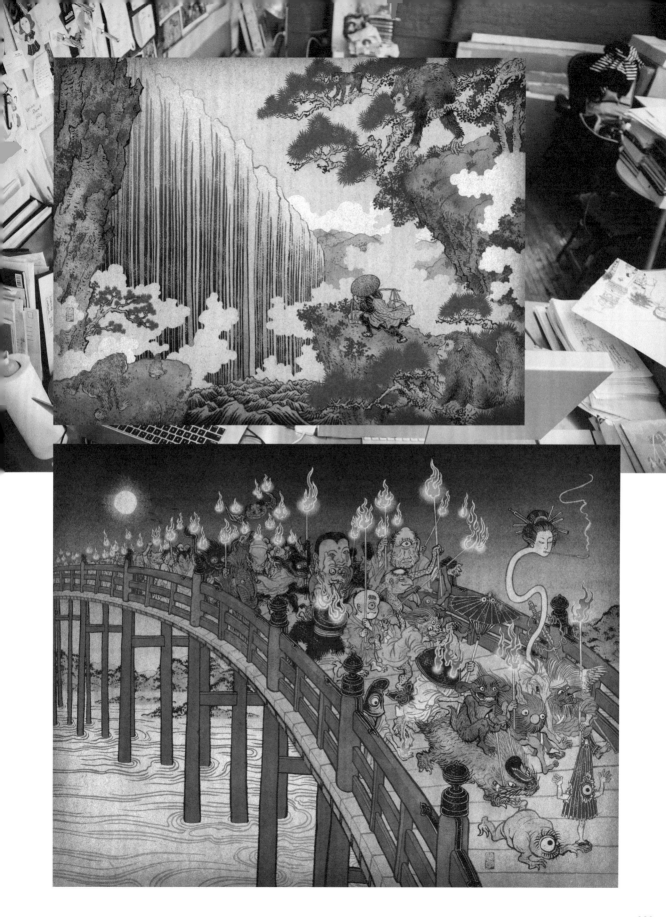

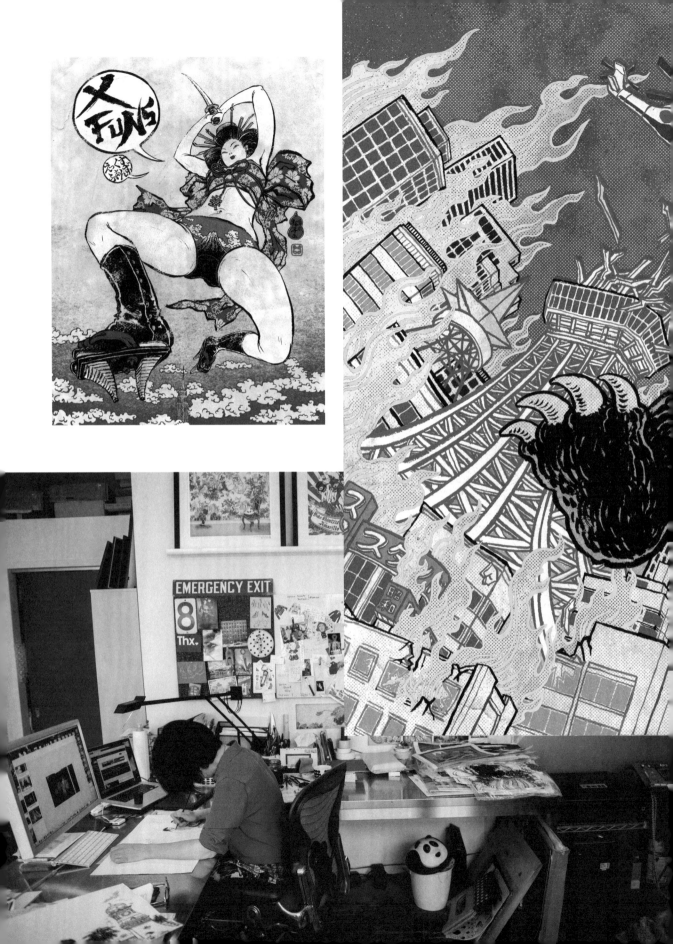

If I had a choice,
I would love for everything to be in black and white.

SAMMY SLABBINCK

It's just about trying.

Please introduce yourself.

I am a collage artist from Belgium. I mainly work with pictures that I cut out of old vintage magazines and I make new compositions with these found pictures. I also call myself a 'reanimator', which is a play on words. I use old pictures that would've been thrown away and make something new out of them, giving them a new life.

What kind of family did you grow up in?

A family of artists. My dad is a painter, and so is my grandfather. My brother is an artist as well. My mother taught art school. There are creative genes in my family.

Did your childhood influence your way of thinking about creativity?

Yes. My dad had his studio at home, and after we came home from school we always used to play around in his studio, which really annoyed him. But we also went to a lot of art fairs and galleries. Art was always present in our household.

What did you study?

I was a very bad student. I finished high school and after that my dad didn't really encourage me to pursue creativity. He thought I was the smart one of the family. He wanted me to go to university, but that wasn't really my world. I tried political science but that didn't work out, so I went to France. The main purpose of that trip was to study French, but I ended up in a quite rural area where I spent six months working as a zookeeper. Then I came back and bought a van, mainly to travel, but also to collect furniture and sell it. I've always had a thing for vintage furniture. My first real job was basically antique dealer.

When you go treasure hunting at yard sales and jumbo sales, you come across a lot of vintage books as well. I was intrigued, and I started buying these books without any specific purpose, just because I liked the look of them. I did that for a few years, until a friend of my dad's asked me to manage his gallery. I said yes and I stayed there for three years. After that, I started my own gallery and did that for three years as well. Then the financial crisis hit in 2009 and my lease on the gallery ran out, but I didn't want to take the risk of finding another space. Meanwhile I had already been experimenting with collages...

Can you pinpoint the exact moment of your epiphany?

Yes, I actually can. I remember sitting in the attic of my house and suddenly being impressed with what I had just made. I realised this might really be something. At first, I was like a kid who makes a drawing and wants to show it to his dad. You create something and you want to show it to the world. Social media were the ideal way to do that. I just started putting my work on Flickr and Tumblr and then suddenly it all went quite fast. I started noticing that other people liked my work and before I knew it, I had my first commercial assignment. That was in 2012.

What does creativity mean to you?

It's something unique. It's an everyday quest, facing your own limits and trying to overcome them by always trying to find something new. It's a mind game as well, which can be frustrating sometimes. You can make something and when it's finished you have fifteen minutes of satisfaction before you have to start all over again to get that same feeling. It's almost like a drug, the adrenaline that you get from making something. Creativity is a blessing but it can also be a burden.

Where are you most creative?

Mainly here in my studio, which also has its disadvantages, because for a while I couldn't stop working. I'm addicted to it. So, every day I would return to the studio after dinner and suddenly it would be three o'clock in the morning. I was always busy. Now I intend to do the nine-to-five thing. My house and my studio are two different places, so I can close the door and hopefully close my mind off and do other things as well.

What does a typical day in the life of Sammy Slabbinck look like?

I'm not a morning person. We were taught in school that you have to get up at 8.30 am. When I was finally independent, I could just decide that I wasn't going to get up at 8.30 am. I usually get up around 9.30 or 10 am. Then I come here and I go through my emails. I have a lot of commercial assignments, so my mailbox is always something I need to check in the morning, and I answer what needs to be answered. After that it depends on whether there are assignments I need to work on, like album covers or something else that takes priority. Sometimes I already have pictures or an idea in mind, and sometimes it's just looking through clippings to find an idea. Sometimes I'm already in the process of finishing something and then it's putting the finishing touches to it. The best days are when I can just work for myself.

You made the cover art for Leonard Cohen's last album. How did that come about? I can imagine that that's quite a privilege?

It really was a privilege. It happened via social media: his son was on Instagram and I noticed that he started liking my posts. I just decided to send him a message, thanking him for liking my pictures. He was a very friendly guy and he told me he enjoyed my work and that was it. But a few days later he contacted me again and said that they were in the middle of producing his father's new album, which would be his last. He wanted his dad to focus completely on the music this time, because he used to make the album covers himself. So, he had the job of finding somebody to create a cover. He asked me if I was up to the task and I said "Let's give it a try". And we ended up with what is now the cover of his final album.

Is your process physical or digital?

It always starts physical, with clippings from magazines. The strange thing about creativity is that sometimes there are days that it just doesn't work. You don't know why, it's just the way you feel. Those are clipping days for me. I just sit and browse through magazines and cut out everything that I find interesting. Then when I start working for myself, I just go through these clippings and there's always one image that triggers my imagination. It's almost like I'm a storyteller. I try to complete the story with one picture and turn it into something new. I need to find a base image to start off with and then I complete the artwork.

As I said, I prefer to work with the original magazine paper. But the idea is more important than the technique, so if an image gives me a good idea but the picture is too small for what I had in mind, I can scan it and make it work digitally. That's the advantage of the computer. But I'm not a Photoshop guy, I always want to have the feel of real paper. It doesn't have to be clean or perfect at all. I like the grain and the colours in the pictures.

So you don't see a difference in originality in your work being made on a computer digitally or paper cut?

A lot of people say that there's a difference, but I disagree. It's because digital collage sounds so cheap. We should find another word for it. The idea is the most important part. If the idea is good, then why shouldn't I make it that way?

You mainly work with images that are not contemporary.

There's a noticeable change in photography technique around the eighties, so that's where I tend to stop looking for material. The eighties are not very well known for their good taste, in my opinion. *Playboy Magazine* is a good parameter: if you look at *Playboys* from the fifties, sixties or seventies and compare them to a *Playboy* from the eighties, suddenly there's a kind of fog hanging around the models and the colours are much too flashy. I might use them in an ironic way, almost making fun of them, but there's not much style to them. Recently I bought a bunch of magazines from 1933. The pictures are very nice. As long as they have style and a nice quality of print, I'm up for it.

How important are the titles in your work?

Titles are hard. Sometimes they come easily, but mostly the process is difficult. I often end up browsing through my iTunes library looking for song titles that match a piece. Sometimes they're funny, sometimes they're boring. But every work is different, so you have to find a unique title for it.

Where do you get your inspiration from?

I've always been a pop art fan. I remember when I was at university and we had to get through the whole of art history. I was half asleep all the way up to about 1940, then came the surrealists and abstract modernism, and suddenly you end up with Liechtenstein and Warhol and Oldenburg, who was one of my favourites when I was younger. The way they made work with found objects almost, intrigues me. There was a freedom in what they were expressing, but they also criticised the very commercial environment that they were in at that time. I think that got into my DNA. You absorb a lot by going to museums and galleries, creating a kind of catalogue inside yourself of what you like and what you don't like.

Creativity is about facing your own limits and
trying to overcome them by always trying
to find something new.

I try to avoid looking at collage artists too much, because seeing other people's ideas can make me jealous. Or I would copy it without even knowing that I was copying it because the idea is already in my head because I saw it somewhere.

Do you want people to see your work as a commentary on today's society?
Ideally you can make works that aren't just a pretty picture, but have a deeper layer to them. Works that can touch people: they look at them and instantly they know exactly what you're talking about. But I don't want to make that a rule for myself either. Sometimes a work is just a pretty picture and hopefully there's some poetry in it.

A subject I like using in my work is the concept of Instagram likes. We've become a society dominated by 'likes': everyone wants to be on social media, and everyone wants likes. It has become a kind of rewards system. If you have a lot of followers and a lot of likes, you're hot. Things didn't use to be that way. That's something I like to play around with and hopefully it gets people thinking about how maybe that's not the right way to judge art or creativity.

How do you play around with it?
I use the symbols. All those social media have symbols, for example an Instagram like looks like a little square with a heart in it. Nowadays kids don't talk anymore, they just send emoticons to each other. If you integrate the symbols of social media into a fifties picture, the contradiction of the era becomes apparent. The anachronism in there is funny almost. If you find the right balance, it makes a good image.

How important is humour in your work?
Very important. I don't start off thinking I'm going to make a funny picture, but do I sometimes start laughing out loud when I'm making something, and then I know that it is probably a good picture. I've always had a knack for absurd humour. I grew up watching a lot of Monty Python and The Muppets, so I always try to find the fun side of things or twist it into a way that it becomes humour. But sometimes my humour can also be dark and biting.

Does your creativity have to create a better world?
I don't think it does. It's not up to the artist or other creators to make a better world. I think the only thing that you can dream of is that people enjoy your work and that it's in some way uplifting or inspires them to create a better world.

I don't make my work for other people either. That has been my starting point from the beginning. You don't want to feel like everyone is looking over your shoulder and telling you what to make. I always make things for myself first, and then I release them into the world, not the other way around.

How important is failure in the process?
Failure is a daily thing. Creating is a mind game. You're always trying things out and then noticing they don't work. It's kind of like a failure, but you don't call it that, you call it a work in progress. Then you try something else. And if that doesn't work, you go out and do something else. You start over completely with another image. Failure is always present, but that sounds too harsh. It's just trial and error.

Has the Covid-19 pandemic influenced your creative life?
Since the start of the outbreak, my working days still look more or less the same. I go to my atelier nearly every day and work on new collages that are either commissioned or for myself. One of my exhibitions did get cancelled because of Covid-19 and there has been a bit of a lull in the number of assignments I'm getting.

What is the best advice that you've heard and still repeat to others?
"If you try it and if it fails, try again and fail better." Basically: don't let yourself be discouraged by failure. It's not failure, it's trying. All the best inventions have come into existence because of failure. When they tried to invent cameras or lights, I don't think it worked the first time. You just learn more about your subject and about what you want to do, and you get better at it so you're failing better. I think that's a very poetic way of looking at creativity as well. There are no winners or losers in this game. It's just about trying.

LETA
SOBIERAJSKI
& WADE
& JEFFEREE

We're interested in bringing
maximalism and functionality together.

How would you introduce yourselves?
We are graphic designers and art directors and we have a studio called Wade and Leta.

Did your childhood influence your ideas and your path to where you are today?
Leta: I grew up as an only child in what I like to call Bumblefuck, New York. It's literally in the middle of nowhere in the woods, where you hear nothing but birds and cicadas. Your ears ring from the silence and you can go a week without having to see a single person. Because I had all of these natural resources near me, I became really resourceful, making things out of sticks or rocks or by tying blades of grass together.

It's a very primitive way of handling materials and trying to make something new out of something you've found, using this sort of ready-made approach. That has evolved into the way that we work now, working with conventional materials that are repurposed into something new.

Wade: Both of us were stimulated by visuals when we were young, which we then wanted to learn to recreate ourselves. I wanted to recreate the creatures and the vehicles from the video games I played and the comics I read. I'd try to make them out of cardboard by cutting up old cracker packets and taping those together. I still do that kind of stuff now. What we're doing now is very much rooted in what we were like as children. From an inspirational point of view as well; we still watch a lot of the same things we watched when we were kids and teens. That's one of the things we connected over when we first started dating: our shared love of anime, manga and comic books.

What does creativity mean to you?
Wade: The idea of exploration and freeform thinking that could potentially lead into something physical. It doesn't always have to be physical, but it's the idea of thinking of something that may not exist or expanding on something that does exist to give it additional meaning.

Leta: Creativity is a pursuit of something in the unknown. It's searching for a solution that has no answer and trying to create something organic and original.

Wade: You could also say it's problem-solving to some extent, which is a commercial component of creativity. But even if it isn't for a client, you're trying to find some kind of solution by being creative. You can't see the forest through the trees—you're trying to find the forest.

Where are you most creative?
Leta: We're the most creative in the least expected places. While we do spend a lot of time at home and in our studio, our inspiration is also fuelled by the places where we aren't actually executing our work. Whether that's on our walk to the studio, or on a plane ride, or when we're in a different country; that's typically when most of the ideation can occur.

Wade: For instance on train rides, in the middle of nowhere, we'll be in our own heads thinking about random things. That usually starts a conversation, where we find new pathways into problems we have with clients or new self-initiated work. But it's usually the stimuli around us in a new place that inspire us the most.

Leta: I also pride myself on my misinterpretations, which tend to stem from either a conversation with Wade or me imagining something in my head that isn't actually what it is and creating something new.

Wade: Because we do work together on largely everything, it's usually the conversations between us that drive the most creative or interesting solutions.

Do you have a preferred time to be creative?
Leta: Any time is a possible time to be creative, whether it's first thing in the morning or staying up way past bedtime to make something that has popped up in your head. I think that we're fortunate to be able to take the liberty to create whenever our instincts tell us to. That's something that we've organised our lives around and it's what we live and breathe for.

Wade: I'm most productive between the hours of 7.30 and 11 am. Usually I'll go to the studio by myself in the morning and burn through a bunch of work, or sit in total silence so I can just think and sit and sketch and do nothing else. That's when I can create things efficiently, because I'm deliberately not checking emails so that I can purely be in my own headspace. We also love going to bodegas and dollar stores to find things that we don't usually buy or have around us. I also love walks through the city when I have a specific destination. My mind just spins into randomness and I can think about whatever I want because I know where I'm going.

Leta: You put your body on autopilot and just can focus on whatever you want until you reach your destination. I feel the same way.

Where do you get your inspiration?
Leta: We try to travel a lot, to see amazing things that aren't accessible to us in New York. The point of our travels is to see phenomenal things, but also the journey in itself—the different landscapes and the different cultures that you are immersed in while travelling. On one of our previous trips to Japan we visited the architectural sites by a couple called Arakawa and Gins, who are now both deceased.

Arakawa was an architect and Madeline Gins was a poet, and together they created these mind-boggling architectural structures that are scattered throughout Japan. All of their pieces inspire you to grow backwards in age, so they're very physically challenging, like an apartment where the floor is slanted and bumpy, and there is a swing and handrails. You can't just walk around on autopilot as you would in your own house. Visiting their structures has inspired us greatly over the past couple of years. It has helped us think about how we work with our bodies and how to make conventional products more unconventional.

Wade: I think it's really about trying to absorb different ways in which people think, and looking at different methodologies. We try to understand their perspective on the world or on art or design. By seeing that there are other ways to do things, you can form new rhythms within your work.

What if you're stuck and you don't see it?

Leta: We get away, go for a run. If we're not able to fully escape, we at least get away from our desk or have a drink. We'll go up to the rooftop of our building, which has a beautiful view of the Manhattan skyline. It's a great place to experience silence and to remove ourselves from the intensity of the city.

Wade: If you're not hitting it right at that moment it's important to take a break. We do some weird little stretching exercises as well.

Do you use notebooks or do you work on the computer?

Leta: It's a combination of anything and everything we can find around us. We ideate in notebooks as well as on scrap paper and blocks of wood and whatever else we can find in our studio, and on the computer too. Our biggest goal is not to be constantly working on a computer. That's why so much of the work that we make is physical and oftentimes requires our bodies as well, because we don't want to be stagnant all the time. We want to exercise our bodies as much as our minds in every instance that we can. We're just trying to explore a multitude of applications with the work that we make.

Who inspires you and what has been the biggest influence on your way of your creative thinking?

Wade: Arakawa and Gins are the pillar of what we strive for. They have a saying: "We have decided not to die". It's about taking aging into your own hands and trying to be as energetic and fulfilled as possible in everything you do. Whether that is taking three steps to go pick up a glass of water across the room or making a big canvas piece of art. We try to see every moment as something to contemplate and be energised about, and we try to be somewhat optimistic overall.

How important is colour in your work?

Leta: Colour is extremely important. Before we met, Wade used to work primarily in black and white, but I was very focused on the colour studies and theories of Josef Albers from the Bauhaus period. When I was in school, I took classes on colour pairings and the optical illusions you could create by pairing different colours together. I'm also interested in how you can use colour as a method to convey certain emotions or to personify what you're working on. Studying colour brings up questions like why blue is so heavily used in Tech. What's the psychology behind using blue versus using yellow? And it's just so fun to pick out three different colours that do not go together and then finding the fourth that's going to bring them all together.

Wade: It's about understanding that you can make someone feel good through colours or even provoke a potentially jarring reaction. You're essentially getting an emotive response out of someone, which can be striking in a good way or a bad way. There is something powerful about doing that, instead of always playing it safe.

Humour is our constant companion.

Is humour important in your work?

Leta: Absolutely. Humour is our constant companion.

Wade: If we can have fun making things we want to make, why not do that? Why not inject colour? Why not make people feel good? Why not make clients feel good about the process?

Leta: The use of humour is related to the choice of minimalism versus maximalism. Sometimes minimalism is filled with a certain type of personality, but by focusing more on maximalism you can give what you're making a bigger, bolder presence. It allows us to inject more of our personalities and our humour into our making. We don't specifically want to label ourselves 'maximalists', but we do think that with everything we make, we want to find some way to have some of our influence in it. Be it through the colour, or through the tone of voice. Growing up, I was told that design should be selfless, that it wasn't based on personal preference and it had to be this sort of sterile production that had no personal connotations. I don't believe in that way of thinking.

Wade: There's a common idea that maximalist design isn't functional, and I think that is a misconception in a lot of ways. Bringing those two elements—maximalism and functionality—together is what we're really interested in. We create design that provides clear information or communication but wrapped in something that's graphically strong, colourfully loaded and also invites the viewer to form a relationship with it.

Is it better to work in a team than separately?

Wade: Working by yourself all the time, you start to have moments of doubt and indecision. By working with someone it becomes much easier to keep those emotions out of your head. In a partnership, you can instantly inject confidence into the person you're working with. When someone shares a few words of encouragement, you're instantly re-energised to keep pushing and making with a sense of confidence.

Leta: Finding a person that you can give your absolute trust to is very difficult. Neither of us are hesitant to take risks because we get positive affirmation from the other person. It provides a confidence in your making skills and the knowledge that whatever you might think, they'll have something to add to it to make it even better. Our collaboration has become a gradual building of ideas. We're together first and foremost because we like the way the other person thinks.

Wade: Natural collaboration will yield better results, because there are new perspectives coming in. It inspires you to make something bigger and to continue to build on an idea and help things grow. You're always going to learn from collaboration, because the other person has a different background. They might be a specialist at something or they can be more open-minded or more rigid than you are, but they're bringing something to the table that could help something grow.

Charles and Ray Eames said that a partnership is more than the sum of its parts. Is that part of why you relate to them?

Leta: Yes, I would say that we wouldn't be making what we're making now if it was just Wade or just me. Not only are you giving your love to another person, but you're giving your absolute trust and your vulnerability to the other person.

Tell me about your project *Complements*.

Leta: *Complements* was a project that was initiated by our developing relationship. Wade and I met online, through a dating website called OKCupid. We were both looking for intimate partners who were somehow creative as well, because we wanted to be able to talk about our work with each other. Some couples don't know what the other person does for a living, but that's not us. We met, and on our first date we clicked. We had an amazing time together and after that we started spending as much time together as possible.

Wade was working full-time and I had just gone freelance, so there wasn't any way for us to work on client projects together. We were waiting for an opportunity, but there hadn't been one yet and so we decided to try to come up with a project that would help us explore what we like to call the 'universal strangeness of love'. Every relationship is different and weird and beautiful, and we wanted to find a way to personify those feelings. So, we started a portrait series at home. We developed a visual vernacular that we liked and launched a website about it. Slowly it evolved into this wonderful routine of coming up with new ideas, figuring out the way in which we ideated differently. We were bouncing new ideas off of each other all day and it was a project for us to become more familiar with each other. We weren't trying to create a working relationship by any means, it was just a means to find a way of collaborating. Going on dates is great, but we wanted to become even closer with each other by involving our personal interests.

Wade: I think it all stems from the fact that we both really love what we do. We were both trying to find someone who was equally invested in their work and would understand if you stay at work for another two hours because you're on a roll.

The project built on what was accessible to us: we had a very simple lighting setup and a couple of papers and colours, nothing fancy. We would go to the bodega to find things that were visually interesting that could add to the impact of the images of us. Even though we finished it at 58 images, we could see the growth of our relationship through those images. Also, my hair was growing throughout the whole process, so you can sort of follow that information.

We ended up finishing the project when we got married, because we took what we think is the ultimate *Complements* photo. We got dressed in clothes we really loved and got a really close friend of ours to shoot it. Our progress led us to realise that we wanted to start a studio and make this a bigger thing for us for the rest of our lives.

What is failure to you?

Wade: I don't think we've ever felt like we truly failed. There have been bumps in the road, but we think that those inevitably help you learn and grow.

Leta: Failure is such a negative term and we don't have a lot of negativity in our lives. It's a term that we don't use very often and try not to think about too much. It happens to everybody. We define failure more as a moment of growth or a moment of realignment.

Wade: Things might be tough, but that's when you can analyse that situation and really think about why it is tough. It bothers us a lot when people say "It's nothing personal", because everything that we're fucking doing is personal. If you're putting yourself into your work like we do, or you're a graphic designer or an agency and you feel like you're being misunderstood, having a moment of clarity is so important. We've all had tough job situations, but afterwards it helps you realise what you do and don't want, and that it's time to move on and evolve. It's a matter of figuring a situation out and not letting it happen again.

Leta: I want to pull a George Lois and just say "Fuck failure". Failure is not a finite thing.

Wade: You shouldn't be afraid of failure. Just go with it, see what happens. If it doesn't work, something great will come out of it eventually.

What the best piece of advice that you've heard and that you still repeat to others?

Leta: "Don't be an asshole and work your ass off." It's a very primitive piece of advice from Stefan Sagmeister but I think those are two very core things that we follow and they seem to be working.

Wade: Another one is: "The work you do is the work you get". If you are only showing work that you didn't like doing and you don't want to keep doing, you're not setting yourself up to do the work you want to be doing. So, create a self-initiated project, do the thing that you want to be making and show people that that's what you want to be doing. It's the same thing for us, the work we do is the work that we're growing and building with, and clients are coming for that perspective. We're growing with our clients as much as we're growing together.

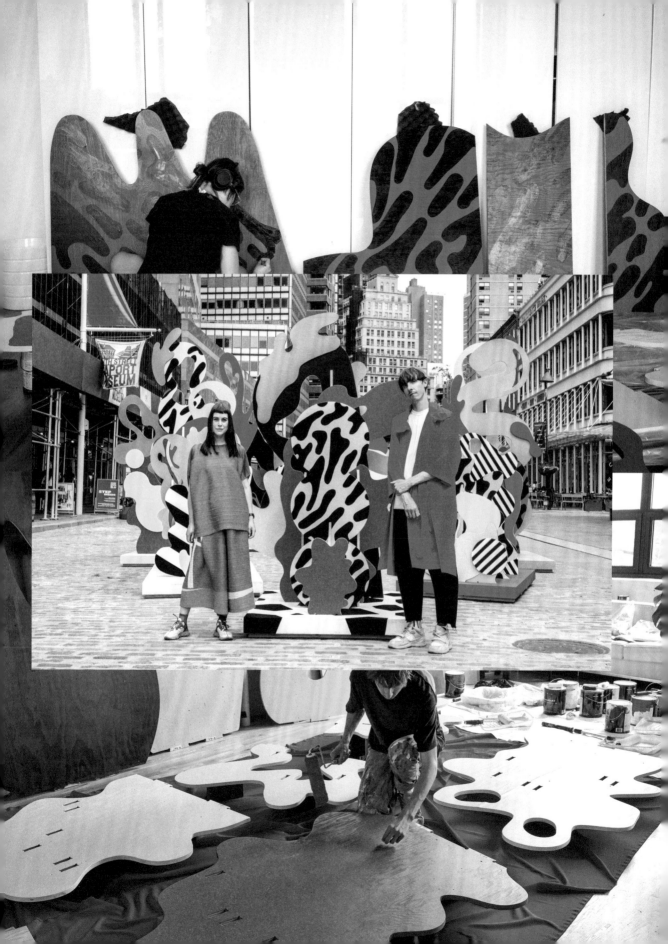

JOHN STEZAKER

I don't seek, I find.
Because collage is play.

How would you introduce yourself?

I am an artist working mainly in collage.

What kind of family did you grow up in?

I suppose you would call it lower middle class. I think of it as teacher-preacher class, as everyone in my family was a teacher. They are people with a social conscience, I suppose.

Did growing up in a family of teachers influence your creativity?

It made me determined not to become a teacher and it made me very apolitical. Everyone in the family had a social agenda of some kind. I reacted against that and I think that was the reason I wanted to go into art, even though there was no real history of artists in our family. I thought being an artist would mean I could live outside the social contact that teaching involved, but I didn't realise that being an unsuccessful artist meant teaching. As a child I was introspective and I liked being on my own. My favourite thing was when it rained, and I was allowed to stay in and paint.

When did you know that you wanted to be an artist?

I think people recognised it in me even before I did so myself. The decision to become an artist actually took place when I was about twelve and my mother brought home a book of Van Gogh paintings. I immediately started painting like Van Gogh, copying him as closely as I possibly could. So, for my birthday my mother bought me his letters to Theo, and that was it. From that moment on, I knew that I had to be an artist. I was completely enthralled by those letters.

Was your creative side encouraged by your parents?

No. I was quite good academically, so they assumed I was going to go to Cambridge, like a lot of my family did, but I defected at the last minute. I didn't have the courage to tell them that I had changed my mind about it. I just went along with it and when the shit hit the fan, so to speak, I literally ran away.

What does creativity mean to you?

It's not really a term I use. Let me explain why: creativity is always associated with the idea of creation ex nihilo, out of nothing, as in: God created the world out of nothing. And I don't believe that happened. I'm not one of those people who suffers from the agony of the empty canvas or the empty page and sits and waits for inspiration. It doesn't happen like that for me. The images are already there, waiting for me to find them. For me, creativity has more to do with play. Picasso said: "You don't sit around waiting for inspiration, you have to be working already."

My creative activity is the product of something that has to be there already, rather than something that I plan or seek. In fact, the 'heading towards' is usually the major obstruction to 'seeing'. So, to me creativity is when I'm not trying to find. That's when images find me.

When is the best time to work for you?

I work at night, because that's when I get tired and start to lose control. I have to somehow be absent. That's when I see the flashes of possibilities. Not all of them pan out immediately, but when these little flashes occur, they tend to lead to something later. Often when I'm combining male and female heads for example, there will be a gradual process by which those collections of photographs will find a natural scale order, so it is easy to combine them. But I don't go around arranging them in convenient order in the first place. That often means I can't find anything, which is quite good because within a minute or two of searching for a specific image, something else will come up that seems more pressing. Once I have digressed twice from the original path and I'm lost, that's when I start to 'see'.

Why the interest in collage?

Initially I felt there was no acknowledgment in the art practice of the fact that when we produce images, we do so in the context of a sea of existing images. I wanted to find a practice that would acknowledge that context. I didn't want to add to this multiplicity, but instead find a way of subtracting from it. When I was at college, most artists' answer to the problem of the multiplicity of images was to avoid images altogether, leading to iconophobic movements like minimalism, conceptualism, etcetera. But my interest in art had fundamentally to do with my fascination with images. So, in order to overcome this problem, I had to somehow incorporate, conceptually, the idea of the multiplicity into the production of the single. And I guess that's collage.

You only work with images that have existed since before you existed. Is that important to you?

That's not quite true, but my image fascination gradually seemed to draw me to images from before 1949, the year I was born. There's a fascination for the world that came before you, that you weren't present in. The Irish philosopher Burke describes the sublime as an experience of the world in your absence. I discovered that my image fascination was related to something that was outside myself. I was not interested in anything that was tainted by my personality.

The images I use are, on the whole, no longer of any instrumental use. They have lost their original legibility. I tend to be more interested in images in which the figures are no longer recognisable—forgotten film stars, lost scenarios. Then the images are less conduits and more pure images.

How do you find your images?

I used to spend a lot of time wandering around junk shops that I knew had collections of film stills. After a while there was only one specialist shop left in London. When it closed, I initially panicked. I thought my career was over – with no more material to use. But by then I had made sufficient money selling my collages to buy the shop's entire stock. So, I now have enough materials for the rest of my life, but I still collect. The weird thing is that I can't stop the process of collecting and I keep accumulating on a stupidly massive scale. I don't know what I'm going to do with it all. The collection has never been ordered but I am constantly in the process of sifting and ordering it. People have asked me if I need help to put it all in order. But I don't want that. Order is not creative.

How much do you have to do with a photo to call it a work of John Stezaker?

The minimum is to do nothing whatsoever to the original found images. I call these my 'unassisted ready-mades'—after Duchamp. They are quite rare and I see them as very special. I like to keep them with me. Most, however, are violated in some way—by accident or wear and tear. Some kind of violence to the image needs to occur usually.

There is something very odd and unnerving about cutting through a photograph. It sometimes feels like I'm cutting through skin. When I was about fifteen, I saw *Un Chien Andalou* by Luis Buñuel, and I was unprepared for the image of the eye being cut with a razor. I don't think I have ever been so shocked by an image in my life. And when I started cutting photographs, that image kept coming to mind, because the glossy surface and the white bits of a photograph reminded me so much of the eyeball. There is something very crude about cutting and there's something very subtle about the photograph. There's a violence about the act. You are cutting a skin—a skin of representation, you might say. I still find cutting photographs uncomfortable. I like to get it done quickly.

How do you come up with titles for your work?

I don't like titles. I don't like words really, so my titles are as minimal as they can be. I use them mostly for identification purposes. My favourites are three-letter or two-letter words, like 'he' or 'she'. Nice and simple. I like them to be obvious, even banal, so that they don't get in the way. My idea is to try and liberate images from words, really. Because words and captions appropriate only one meaning to the image, and what I want is the ambiguity of the image. I want the image to provoke a sense of the other. I want to be able to see into it and for it to open up a depth and a sense of the unknowable. This sense of the image runs counter to its reception as legible in the usual sense. Legibility is the anchor in language and that's what I'm trying to cut.

Is humour important in your work?

A lot of people think my work is witty. I don't know why. I suppose that makes it even funnier. Sometimes, when I do something I think of as really good, once in a blue moon, my immediate reaction is to laugh out loud. So, there must be something comic then. But I see my work as much more tragic than comic. Maybe it's tragicomic? Maybe I'm tragicomic.

Who influenced you?

Jean-Luc Godard who said: "It's not where you take things from, it's where you take things to". That's a perfect metaphor for my work, really.

Joseph Cornell is probably the most enduring influence on my work. I first encountered *Une Semaine de Bonté* by Max Ernst as a student. I had already been making collages but I used them as sketches for paintings. Only after I met Marcel Broodthaers, who was also a big influence for me, did I have the confidence to accept surrealism as a primary point of contact in my work. It was then that the collages started to become the focus of my activities. Broodthaers showed me the way out of the cul-de-sac of conceptualism. Through him I found not only Max Ernst, but also Joseph Cornell. The philosopher Maurice Blanchot talks about the artist and the writer as being "an exile from life in the world of images", and I can't think of a better example than Joseph Cornell for that. He really did cut himself off from the world in order to immerse himself in the world of images, and I've always seen that as a model. It was not possible for me to live up to his ideal of exile as I had to support myself as a teacher, but since I gave up teaching fifteen years ago, I have completely immersed myself in the world of images in the way Cornell did. I think he's wonderful, but he was a very strange man. I had the chance to meet him but I missed it. I'm usually too scared when it comes to actually meeting my heroes.

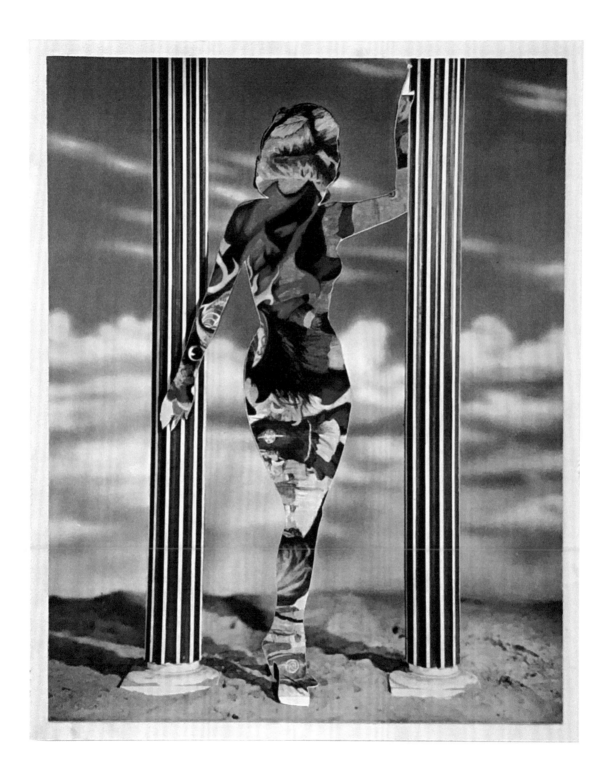

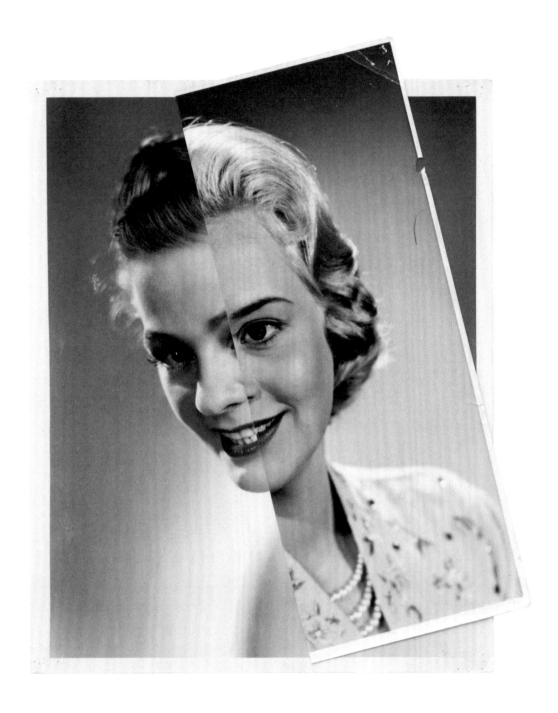

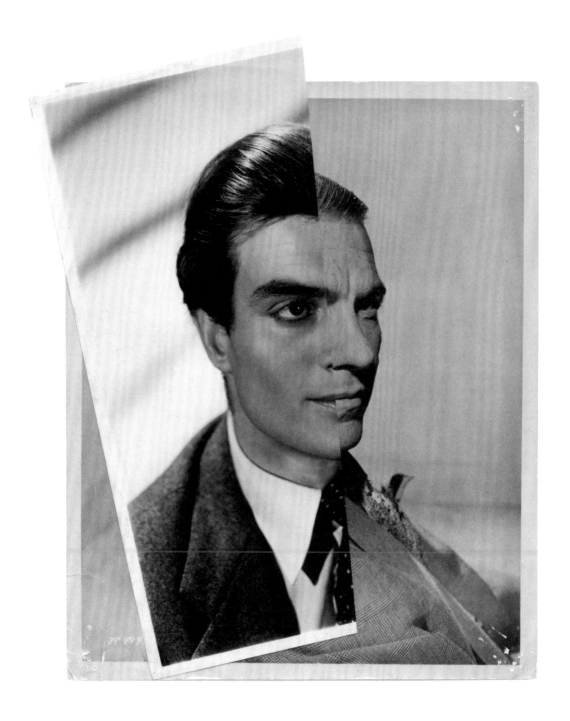

What does failure mean to you?

I have had a quite a lot of experience of this and, as one would expect, it has been painful. But I do recognise that failure is really important. I think things have to fail to succeed. The Orpheus myth is about failure. Orpheus goes into the underworld and is given unique access to Eurydice, his muse, who stands for inspiration. To bring the muse back from the underworld he's told not to turn around and of course he does. He's impatient. We all are. We want to see the results and we have to look and that means we fail. Objectively we know that we cannot reanimate the dead and yet we act as though we can. The same with Orpheus. He sings to bring out the muse from the world of the dead but when he pauses to see the effect of his song, Eurydice disappears back into the underworld. We try to bring the muse from the nocturnal world into the real world in some way and bring things back to life, but they will never come back to life. So, failure is a mark of success, I think.

We have to accept failure as we have to accept death, but of course we can do neither. When I'm talking to you now, we're communicating and we have to act as though in communication we have established a continuity, but you've got a completely separate world and I can't know your world, ever. The only thing we have in common is our shared fate and that confrontation with our separation and death is something that art communicates and this has nothing to do with instrumental communication. Art touches on the most important connection we have, which is our disconnection. Our failure to connect.

Has the Covid-19 pandemic influenced your creative life?

Lockdown has simplified my life more than it has disrupted it. Without the diversions of social life, exhibitions and the cultural life of London in general, I have been able to more fully concentrate on my work. Since March I have not left my South Coast studio, which is the main storage space for my image collection. So, I've had an abundance of material to work with. I have the sea within a few yards of my front door. Also, paradoxically the biggest change to my routines have been that I now spend a great deal more time outdoors, on the beach, swimming or walking. I tend to go out when no-one else is around, often at night. These nocturnal experiences have affected a lot of my new work.

The other big change has been my relationship to digital technology. I have had to overcome technophobia because, in the absence of my normal support from assistants, I am doing a lot more communication myself. After holding out against this for years, I have had to learn to use a computer and a smartphone and generally join the integrated circuit of communication out of necessity. Whilst at first this seemed to open up new prospects for me, I have quickly tired of the new "freedoms" digital technology offers: images, music, communication at our fingertips and I am finding myself already retreating into my pre-digital world.

What's the best piece advice you have heard and still repeat to others?

The only advice I've ever given to my students is: "Just work". Because I don't believe that some people are better than others. I don't believe in virtuosity. I think the only virtue is hard work. When I was teaching, I knew which of my students was going to succeed. It was always the one who had no other alternative than to work. And it's usually because they don't think very highly of themselves, actually.

There is something very odd and unnerving
about cutting through a photograph.
It sometimes feels like I'm cutting through flesh.
I like to get it done quickly.

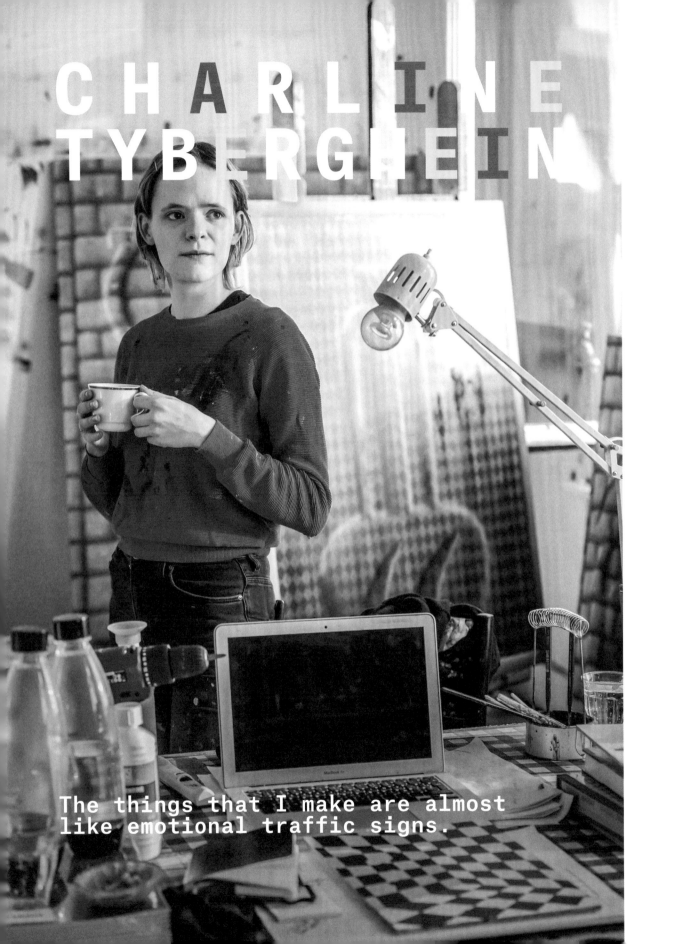

CHARLINE TYBERGHEIN

The things that I make are almost like emotional traffic signs.

How would you introduce yourself to someone who doesn't know you or your work?

I guess by saying that I'm a painter. I just graduated from the Royal Academy of Fine Arts in Antwerp. Usually when I tell people I paint they ask whether I do abstract or figurative painting, which makes me want to get away as fast as possible. I paint full-time now; I don't have to work in a bar anymore, which is very nice. But I'm still trying to figure out how to make everything as comfortable as possible for me and my practice.

What kind of family did you grow up in?

My mom worked in a hospital, making the appointments and helping out the doctors and the nurses. My dad passed away when I was two years old. But I grew up in a very warm household with my mom and my brother. My mom is always very supportive, trying to make it work as a single parent, which isn't easy. I grew up in a very straightforward family: no frills, no art – that wasn't really a part of our lives growing up. It's not that my mom was against it, but she had a full-time job and two children, which means you don't really go to a lot of museums or art shows.

Did growing up in that kind of family influence your way of creative thinking?

I think so. It took me a really long time to get used to the idea that being an artist is a career option. Before I attended art school, I never even thought about becoming an artist because to me, it wasn't a job. People did artistic things on the side, or they worked in the applied arts as a graphic designer, but being an artist wasn't really a thing. Even now when I say that I'm an artist, I'm almost apologetic about it.

How would you describe your work?

I would describe it as simple. The things that I make are almost like emotional traffic signs. To me, it's all very clear, these symbols combined with trompe l'oeil. I can't really paint in a 'painterly' way, so I have to find other ways to insert emotions or feelings into the painting. I do that by using symbols and pictograms. To make the image more exciting to look at, I combine it with trompe l'oeil.

You create your own world with simple daily objects like shoes, candles, bricks, cigarettes, placing them in a surrealistic environment.

It started with all the symbols having a very set meaning. For example, the image of a brick means silence or rest, but now I try to limit the set of symbols a bit, like an alphabet. They don't keep inventing letters and numbers, so I also try to restrict my 'image alphabet'. The symbols get different meanings in different compositions, and they become more of a representation of an idea instead of having a set definition.

What does creativity mean to you?

I actually don't consider myself a creative person at all. When I think of creativity, I don't immediately think of art, but more of a way of designing your life in general. I think of people being creative with their finances but I don't really think of people being creative with their art. Maybe I just have a weird, negative connotation with the word.

What does a day in the life of Charline Tyberghein look like?

Every day is basically the same. I try to wake up early, even though I'm very bad at it. Then I drink my coffee and I start working in my atelier. I'll work until about eight o'clock, then I have dinner and then I go to sleep. That's my very boring life.

Do you always work in your atelier or can you work anywhere?

I always work in my atelier, but I think it would be better for me to take a step back sometimes. My studio isn't huge, so it can get messy. There are paintings and paint everywhere, and things get stressful. It would be a good idea for me to go outside once in a while, or to go see a show somewhere else, but of course I don't do that. I really need to work on that, because I always notice that when I do take a step back, even for just one day, that it really affects how I view paintings that I've been struggling with for a while. When you're this close to a painting the whole time, you just keep poking at it instead of leaving it for a second and then realising what needs to be done.

Do you have a preferred time to work?

Yeah, usually the thirty minutes before I have to leave to go somewhere else. That's always when things magically start working out. Mostly that's in the afternoon because I take a really long time to wake up. The light is the nicest in the afternoon because that's when the sun shines straight into my atelier, so I think I get some energy from that as well.

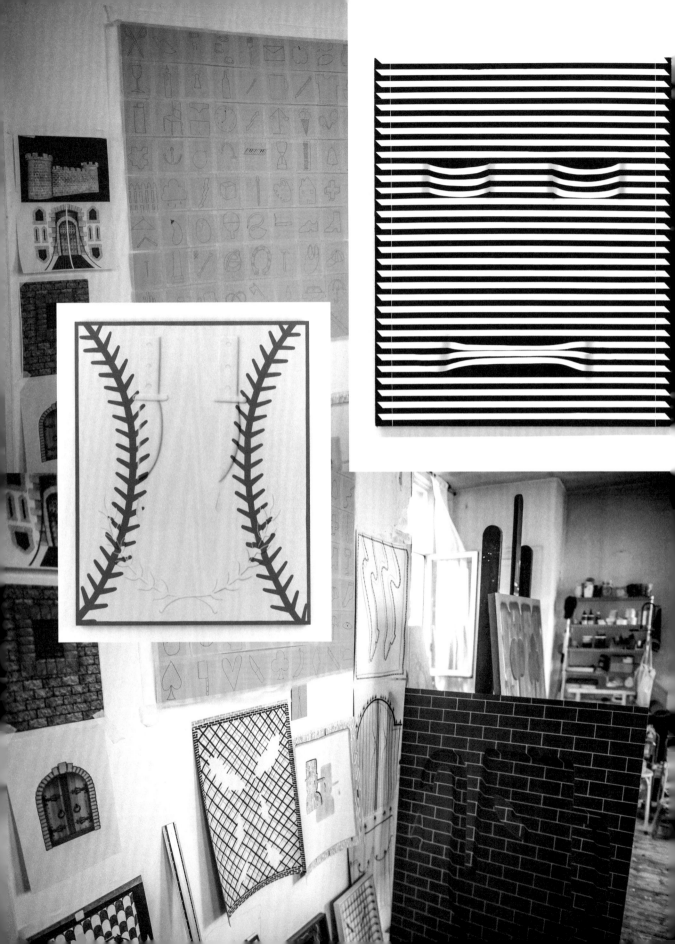

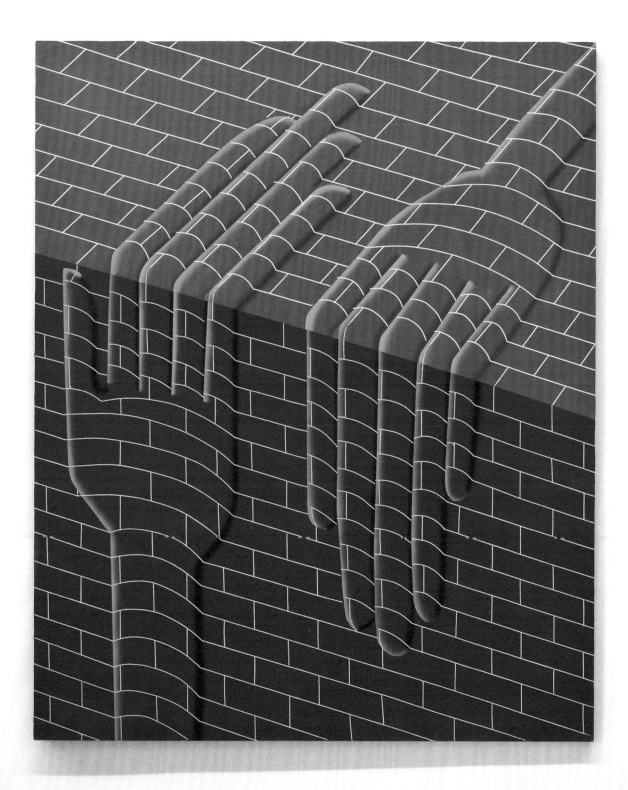

I like it when people get frustrated
about my mistakes.

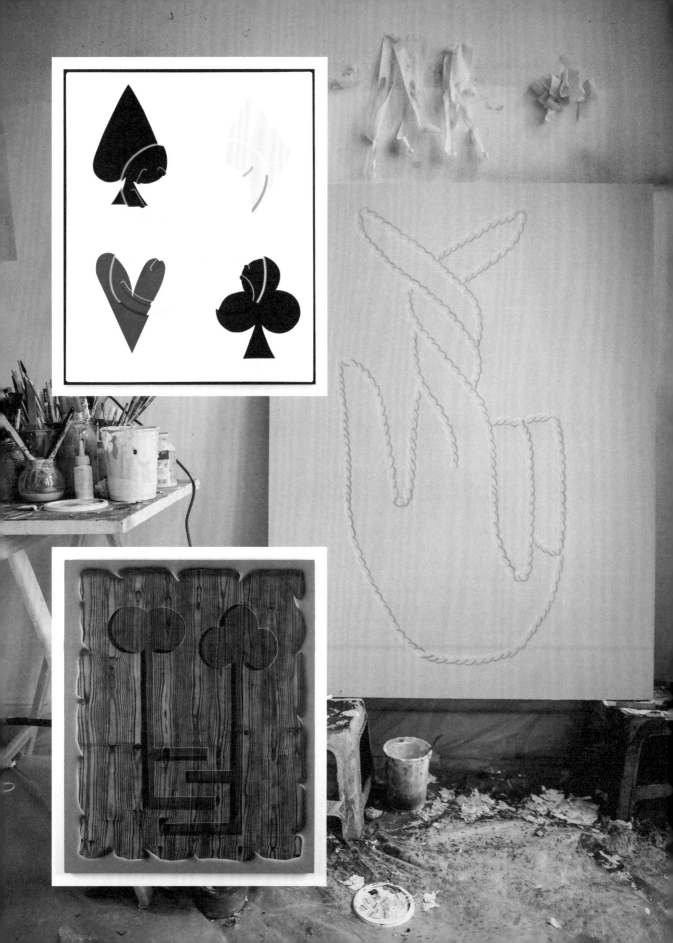

Do you work on one thing or on several paintings at a time?

I work on multiple things at the same time because otherwise it would be too intense. It would also be too sad if it doesn't work out, because of course it happens that a painting isn't what I wanted it to be. I have to make most paintings three or four times because there's always something that didn't work out the way I wanted it to. So, to lower the pressure I always have two or three paintings going at the same time.

Where do you get your inspiration?

A lot of things inspire me. I'm lucky that my subject matter is so simple and broad. So, I can be sitting on a train, looking at all the weird Flemish houses passing by and see a weird construction or the way the light hits the wall. Then I just get an image in my head and I save it or write it down in my phone. But I've also noticed the opposite: it's very difficult for me to look for inspiration. If it just isn't coming and I start forcing it, that never leads to a good painting. Of course, I do research and I look in my books as well, but I kind of have to wait for images to come together and create an image for me.

My absolute favourite book is the *Symbol Sourcebook* by Henry Dreyfuss, which is a kind of dictionary of symbols. Dreyfuss also digs into the history of symbols and how people respond to certain images. If I want to express something, I can just go look up the literal symbol for it and then see what to do with it. Combined with Magritte and Vasarely, this book has been my biggest inspiration in the last couple of years.

Avery Singer is a very important artist to me as well. She makes these very big spray-paint airbrush-like paintings that helped me understand how to paint a shadow. She's amazing. I'm also inspired by Ginny Casey, even though unfortunately I have never seen a work of hers in real life. I discover a lot of artworks solely on the internet, which is a pity sometimes but it's also a very big part of where I get my inspiration and discover new artists. I've been looking at a lot of Peter Saul and Roger Brown as well, so I'm inspired by a very wide array of artists.

Can you tell me a little bit about your work process? Do you work intuitively, or do you work out a concept first?

I don't work intuitively at all, unfortunately. I've tried it, and it's just not for me. I start with an image or a vague idea and then I make drawings. I usually also make a small A4-size version of the painting. Then I try to figure out if it will work on a larger scale, because very often my paintings are quite monotone in their colouring. I'm learning now that it can work on small scale but you have to be careful when you blow things up. Then, depending on the kind of painting, I make a chalk drawing on the prepared piece of wood and I start gradually building it up. And, again depending on the painting, if it's spray-painted or acrylic, I have to follow different procedures to get to where I want to go. I really like working with this much structure because I wouldn't be able to just start something.

It's very important for me to keep my cool and make a plan, but sometimes I get too frustrated and too energised to really figure things out and then I always have to start over.

Does creativity have to be provocative?

For me, it doesn't. I'm generally an anxious person so I don't really enjoy provocation. I also think very often provocation is unfounded, a bit in the way that a teenager would communicate. I like art that asks questions or that confronts, but I think provocation is very often just trying to start a fight.

Is humour important in your work?

It's never been a goal of mine, because I think that would effectively undo all the humour. I really didn't realise for a long time that there's humour in my work, until people started telling me so.

I guess I use humour because I don't like overly melancholic paintings or artwork. I'm just not interested in other's people misery. Obviously, there's nothing wrong with communicating your fears or your sadness, but I've always tried to balance out my misery and the result of that is sometimes a bit humorous.

How important is colour in your work?

I'm starting to realise that colour is very important. I used to just wing it and see where it took me, but now it often happens that I finish a painting only to start it all over again in just a slightly different colour. I'm becoming a lot more sensitive in that respect and becoming more of a perfectionist. That might be the only intuitive part of my work where I can just feel when it's not right. Maybe that's why it's becoming more important to me, because everything else in my process is becoming more structured and this is where I have this last bit of wiggle room left.

What does failure mean to you? Your work process is very structured, so what happens if a painting is a failure?

It's very, very frustrating. This week I remade a painting five or six times and it kept on not working out, which really, really, really drives me crazy. Something like that can keep me up at night. That's something that I have to learn to deal with a bit better. But on the other hand, my whole practice came out of failure and not being able to do one thing and finding a solution for it, so I have a very complex relationship with failure.

Has the Covid-19 pandemic influenced your creative life?

I'm a pretty solitary person as is, so the lockdown didn't influence my practice all that much. At first it was difficult because of the anxiety that comes with living through a pandemic. Those feelings did stunt my working process because I could only think of the fact that the world seemed to be ending. Other implications were more practical, like not being able to buy material to paint. I didn't have any wood to paint on so I started making embroidery, which was mostly a therapeutic thing to help with the aforementioned anxiety. But now we're almost a year in and the panic has subsided.

Another unexpected effect is that I really miss openings. I never really liked them before, but showing a new painting just isn't the same without a glass of wine in your hand!

What kind of advice would you give to your younger self?

Don't try to invent a style for yourself. Don't be preoccupied with figurative versus abstract or having to find your signature style because it will come on its own, because you're the one who's making these paintings.

Do you want your creative work to create a better world?

It's not my intention to do so. If my work brightens someone's day, that's good, but if it makes someone's day worse that's also fine by me. I'm very selfish in this respect. I'm more concerned with what my work means for me than what it could mean for other people. It makes my life better, and that's something.

Who—dead or alive—would you like to have dinner with and what would you ask them?

For some reason Werner Herzog pops into my head, maybe just because I really like his voice. I wouldn't ask him anything, I could just listen to him read the dictionary aloud and I would be fine.

How important are social media for you?

Social media are a bit of a job for me. I know that they're important for visibility, but I really have to remind myself every couple of weeks to post a painting on my Instagram. I only use Facebook to post my shows or my events. I'm quite happy that it's not super important to me because I get very self-conscious when I post something on Instagram, which makes it quite stressful. Sometimes I get random messages from people who like my work and I'm always very flattered, but it doesn't happen that often.

D A V I D
U Z O C H U K W U

I'm always fascinated by the strength
that lies in honesty and openness,
and not being afraid to be vulnerable.

How would you introduce yourself?

I would introduce myself as a photographer, I guess. Photographer is fine, even if I personally struggle with it. In communication it's just easier.

What kind of family did you grow up in?

My father studied for quite a long time and then worked in the IT scene. My mother jumped jobs quite a bit and ended up working for the European Parliament. So, no artists.

Did your childhood influence your way of creative thinking?

Throughout my childhood I spent a lot of time reading, which shaped me as a person and as an artist. I also spent a lot of time outside, going on walks and taking in nature. I grew up amidst a few different cultures and in multiple countries, which means I had a lot of different sources of input and experienced both the feeling of being a stranger and the feeling of being at home. All these different influences are reflected in my work.

When did you know that you wanted to be an artist?

The first time I discovered that photography could be art, was when I was around eleven years old. I didn't know that I wanted to be a professional photographer per se, but I knew that I wanted to make stuff that felt like the images I saw online. Later on, everything kind of snowballed and I was suddenly doing it. Not a lot of it was planned.

You just picked up a camera?

Yeah, I picked up my mother's camera while we were on vacation. She had a regular point-and-shoot, like most families do, and I started documenting everything around me. I became addicted to the feeling of being able to capture specific, small moments and archive them and go through them afterwards and recategorise them.

You started out mainly photographing yourself, why was that?

I actually started photographing myself when I was about thirteen, so about two years after I started taking pictures. From the start, I knew that I wanted to photograph people. I was just so scared of making really bad work and I knew from having seen a lot of stuff online and in books and galleries that when an image of a person is bad, it's really bad. It hits so close to home and I really wanted to avoid having to include other people. That's why I started doing self-portraits.

What does creativity mean to you?

Creativity to me is a way to adapt to a situation. It's a surprising way of combining different elements or concepts in a way that seems new or in a way that hasn't been done before. It's the creation of something new through the materials that have been presented to you.

Where are you most creative?

Mostly when I'm surrounded by nature.

Are you a morning or an evening person?

I definitely feel like I'm at my best either very early in the morning or very late at night. Anything that doesn't feel like the everyday and any time when my brain is just a little bit out of it helps me make connections that I otherwise wouldn't make. Then again, as long as you create a space for yourself to properly work and surround yourself with what you know you need to focus on the task at hand, pretty much any time can work.

Do you work intuitively, or do you start off with a clear concept?

I rarely start off with a very specific concept. I usually start my process with a mood, a certain feeling or atmosphere and almost instinctively an image comes up. Then I have to interpret the image, I have to make sure there's background to it. The whole thing builds up inside of me to a point where I can't think about anything else. That's when I know I have to get it done and I'm motivated enough to do it. So, I have these vague images and feelings bubbling up inside of me. The more I think about them and the more I try to link them to specific concepts and backgrounds through research or through a lot of thought and introspection, the more actualised they become. I sketch out all of my images. Going into a shoot I usually know exactly which result I want to get. That doesn't necessarily mean that that is what I'm going to get, but usually it is what I will go for from the start. However, I always leave some space for real life to positively or negatively influence the image.

What inspires you?

Music is a very important element for me, which I've been told is funny because my images seem rather quiet most of the time. I can count the images I've made where the character's eyes are open on two hands. But in order to really let a concept develop and let this mood inside of me grow into something visual, having acoustic background music on really helps.

Every single time I shoot,
I still learn something.

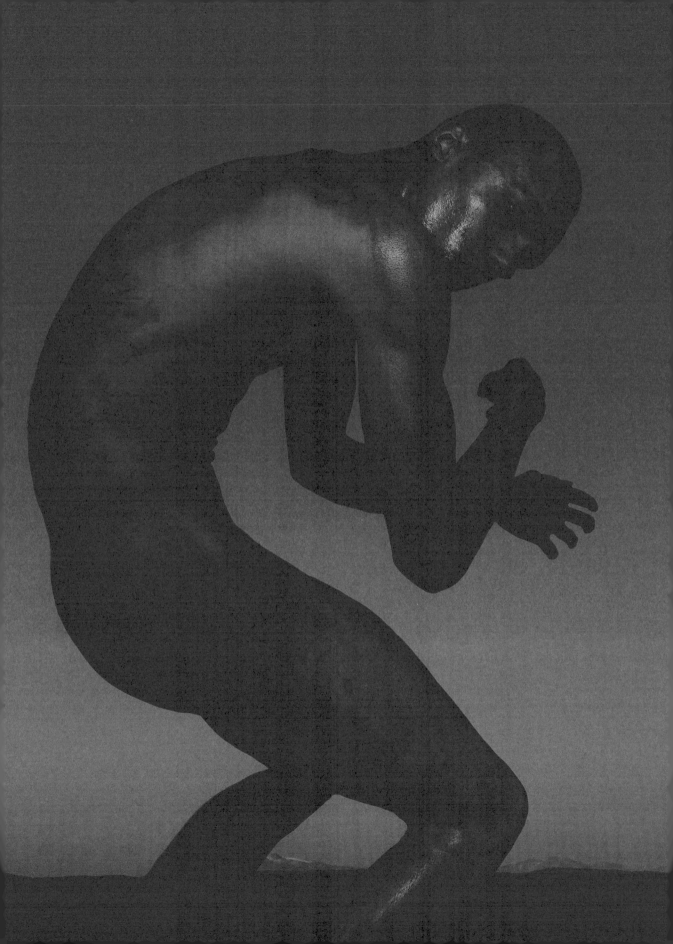

Your subject is often a human form in an isolated environment, mostly in nature. Where does this fascination for nature and the everyday person come from?

I am deeply fascinated by sunrises and sunsets, and the reflection of the sky on puddles in the street, to a degree that I don't observe in the people around me. I'm fascinated by anything that changes the everyday into something very unique and particular, those small switches that can shift your entire perspective in an instant. In my work I build this shifted world, this strange perspective, this unusual setting for my characters to live in forever. This is their everyday moment, a setting in which they feel alive. I feel like that is the theme I pursue.

What prevents you from being creative?

Everyday life is a struggle. Ideas have to build up inside of me until they get to a point where I can't ignore them any longer and then I make them happen. But obviously real life goes on, you need to go shopping, you need to clean your flat, you need to make sure that you're properly insured and stuff like that. So, I actually feel like the everyday maintenance that comes with occupying a physical body constantly gets in the way of creating.

Does your work have to be provocative?

I never set out to be provocative and often when people do feel provoked, I'm very surprised by it. I do set out to make work that challenges me, that isn't just entirely comfortable the way it was when I started out, when I was making work that made me feel at ease and that made me feel lighter afterwards. I've started to dig a bit deeper into my psyche and I now try to make work where just making the work disturbs me and makes me uncomfortable, and not just physically. So, I guess I'm trying to provoke myself.

Does your creativity have to create a better world?

Oh, God. I know that through creating, I've made myself better as a person and that has had a direct effect on the people around me as well. I guess to a certain degree it does make the world better. In a way, the work that I want to be making is work that I should have seen when I was a child. In that respect, I do want to be making work that changes something. I want my work to be honest and to say something that isn't just purely aesthetic, but actually holds a personal meaning. I'm not necessarily setting out to change the world, but I am filling a gap in the public sphere.

Is colour important in your work?

Colour is definitely important in my work. I think it's very interesting how our moods or our feelings correspond to visual things and how that translates into imagery. I love playing with sad imagery that looks very bright and colourful, or dark imagery that is rather colourful, and having that contrast in there.

Who inspires you?

A lot of people inspire me: artists, but also a lot of people just living their own life in an open and brave and honest way. And pretty much anyone who is passionate and has a way of going about their life like it means something and making sure that they leave something good behind in the world.

When I started out as a thirteen-year-old boy, I discovered a few young photographers who were making work that really blew my mind. For example, this German girl named Laura Zalenga who was also making self-portraits—very clean, powerful and vulnerable work. There was also an American photographer called Alex Stoddard making self-portraits at the time. It was almost like a movement of young people who were turning towards photography and post-production to turn their vision into real life. As soon as I started to delve deeper, I discovered more established photographers, like Gregory Crewdson and Tim Walker, who both do amazing set design and manage to build actual physical worlds.

These days, everybody is a photographer. How do you stay original in a world that's already so full of images?

By being ridiculously tough and selective when I am making work. I try to really listen to my gut and then if I end up making work that looks like someone else's, that might be the case. Sometimes people are on similar wavelengths and that's alright, but once you let yourself explore and make a crazy amount of work, you'll start to feel what you're attracted to and what you're not that into. That's when you'll begin to develop a language that feels like your own, that just completely makes sense.

What are your challenges as a young photographer?

It's always a challenge to keep growing and to keep making interesting work and engaging myself in the first place. But I also want to reach a point where I'm confident in my process and can start looking outwards more. Then I can start thinking about other people as well, and the way that I include them in the work. Obviously as an artist you need to be self-centred to a certain point. You need to prioritise your vision and your ego in order to make work. But I've started to think a lot about what my work stands for in the real world and to the people that surround me, and how I might turn this relationship into something that is healthy and nourishing for all parties involved.

You have said: "I'm always fascinated by the strength that lies in honesty and openness, and not being afraid to be vulnerable."

There's this concept of strength floating around in there, which is also deeply rooted in the concept of masculinity. As a man, you're expected to almost be stoic in the traditional sense of the word. In everyday life, you're conquering your emotions and you push them down and try to master them. But I really feel like there's so much power in being open and being true to yourself. Instead of trying to fight these emotions all the time, you can gain so much energy from trying to be one with them and understanding them. It takes courage and a lot of work that should be appreciated and pursued.

The characters I'm interested in are men who are vulnerable or women who are strong, or where those two intersect. Then again, I feel like it is a very outdated concept to separate the two, and to consider certain attributes to either be masculine or feminine. That doesn't necessarily do justice to the way the human psyche works. People are multidimensional and they can be strong or weak, or be in touch with their emotions and at the same time be powerful. All these different, interesting energies can be held within a single person.

How different is your commissioned work from your personal work?

With commissioned work, you're selling something, and a client might be very interested in certain things that you might not be interested in. It's up to you to figure out how you can best combine your vision with whichever message the client wants you to communicate. How do I bring this product into my world, and can I bring this product into my world in the first place? And often the answer to that question is no, so I do turn down a lot of commercial work.

Commercial work is always a very collaborative effort, as opposed to a great part of my personal work, where I'm literally working alone. It's as exciting as it is challenging to be able to get together with other people who are also doing inspiring work and to be able to collaborate in a way that uplifts the whole project and turns it into something that you never would've been able to make yourself.

How do you deal with failure in your work?

I just have to try again. I reshoot when I can, and otherwise I just shelve it. Every single time I shoot, I still learn something. And I always feel like I should be shooting more, just because I know that there are so many things that I still want to be doing and so many things that I have left to learn. Failure is almost the standard and the exception is when something works out and I actually like it.

How important are titles in your work?

Titles are pretty important but most of the time they also seem to be the result of a natural evolution. Once I've made an image and I've gone through the process of shooting it and I know what it means, putting a title on it is like giving it a label. Then I can literally shelve it and I'm done with it. I've wrapped up the emotion, the thought process and the physical experience all into one package that is hopefully both pretty and meaningful.

What is the best piece of advice you've heard and repeated to others?

The main one that just keeps floating around, but is just so true, is to make a lot of work. It solves so many problems. It gives you less time to doubt yourself; you just need to make more work and the solution will come to you. Honestly, this is solid stuff. Whether you're happy, sad, or angry, making work will a) help you through it and b) actually help you go forward in life.

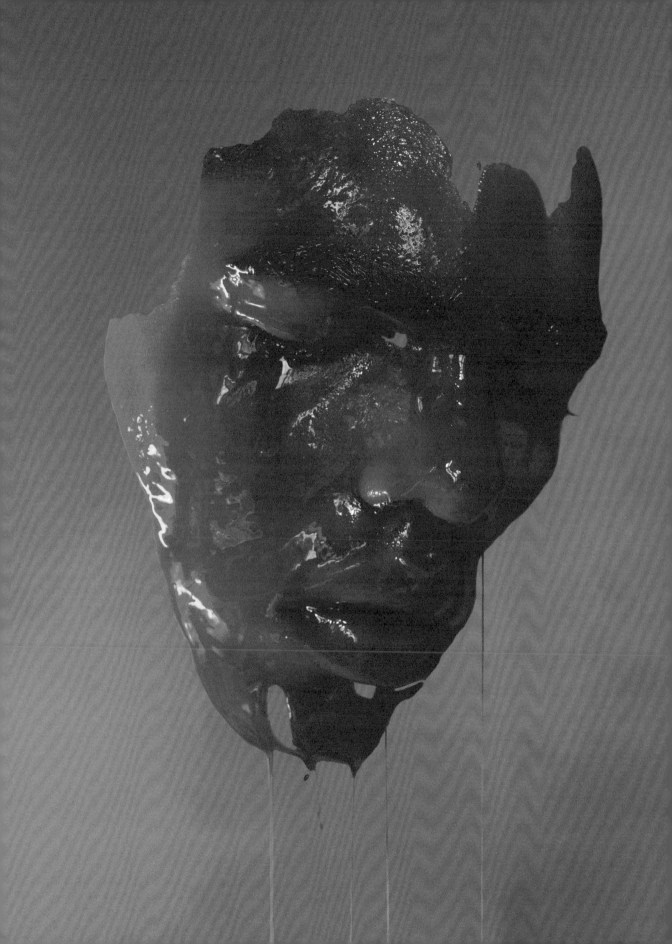

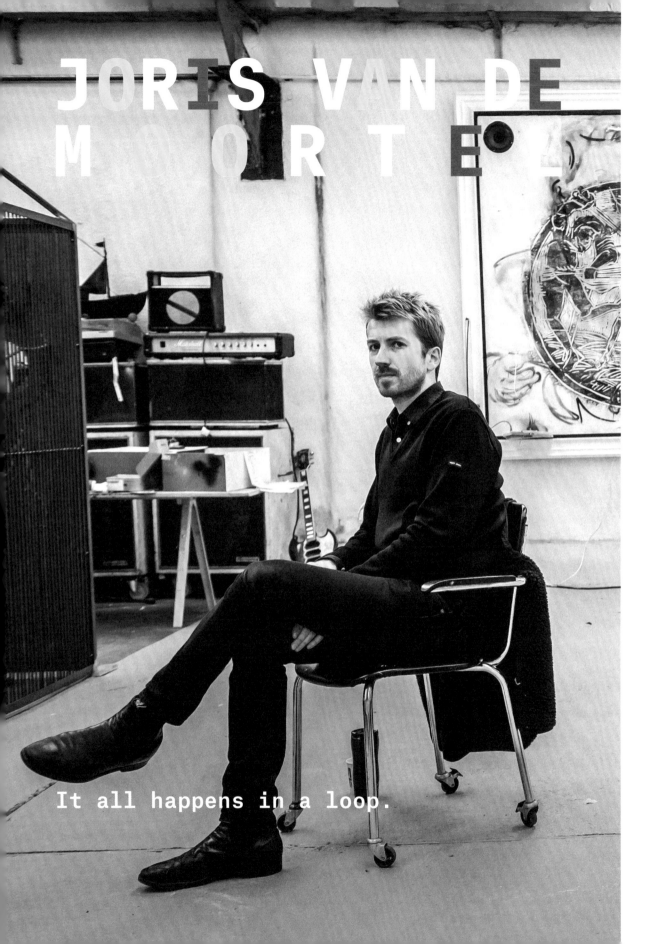

JORIS VAN DE MOORTEL

It all happens in a loop.

How would you introduce yourself?

I wouldn't talk too much, I would just start showing things. Ideally the introduction would take place in the studio. But never after a performance, because you should accept the performance as an introduction. What I do like about the idea of introductions is that you step into a particular universe, which is different with every studio visit and depends on the person you talk to.

What kind of family did you grow up in?

They always say that the older you get, the more you see the link with your parents or your childhood. I refused to think about that for a long time, because in the literal sense there was no link at all between my background and the artistic world. It's kind of a problematic and chaotic story that would make a good book one day. But I don't want to romanticise it. Basically, I have little to no contact with my family now and I have stopped trying to control it, especially since I've had children of my own. They are the most important thing to me and they have given me a new start that I'm not going to mess up. I do regret the fact that my kids don't really have grandparents on my side of the family.

Did your childhood influence you as an artist?

I was allowed to be creative and go my own way, there were very few limits. I didn't go to school until I was five, under the influence of my mother, who was very good at not dealing with reality. Her father was very handy and good at drawing.

But I prefer not to talk about my childhood. Let's say I quickly went my own way, which made me independent from a young age. I started working when I was still young, first as a gardener, then in a record store when I was fifteen, while renovating student houses at the same time. These jobs were all very interesting and helpful, and I met some great people.

When I was eighteen and living on my own, I started working in bars to support myself financially. After I got into HISK (Hoger Instituut voor Schone Kunsten Vlaanderen) in 2008, I lived off welfare for two years, because the combination of the professional artist life and the bartender nights became really hard to maintain. Shortly afterwards I became self-employed, so I never had an official job.

I never saw the fact that I wasn't supported by my family as a problem. It's because of my background that I do what I do now, so in a way I'm thankful for everything that happened in that part of my past.

Your artwork entails a lot of performance, and you also make music. Is the performance the artwork or are the remains of the performance the artwork?

The artwork can be any of those things, it's not one or the other. A performance can happen inside an installation, as a temporary sound installation or for a longer period. But the artwork can also be the moment that the sculpture and installation are actually made. Let's say that it's a collaboration between different media and I'm the conductor of it all. My work can go in so many directions, and it grew very naturally and spontaneously, from a source that is well fed with beautiful spicy ingredients.

What is the starting point of a work for you?

The work is cyclical. It all happens in a loop, so there's really no beginning or ending. When I focus on a new project however, there is of course a starting point when I think up a group or a collection of works, which requires a lot of writing and research. I make scrapbooks with articles, things I've written, and add pictures of former works, images, records, whatever. I also write in notebooks a lot and make collages. Once I end up in a new loop, I attach it to another one and I can step in and out of them. It doesn't really matter where I end up in the loop, as I will reach all of its extremities eventually.

Why do you use musical instruments and neon light in your work?

In both light and electric music, electricity is involved. Basically, there's electricity in everything, as you can feel when you rub the fabric of your pants. The electricity is in the space between things; in electric guitars it's the pickup, which consists of a magnet and copper wire that communicate the vibration of the steel strings when you play them. In that moment, you're make electricity—a guitar is like a small power plant! The amplifier picks up the signal and translates it into sound. It's a transition of something completely invisible into something audible.

These waves can then be manipulated with effects. You can distort, bend, pitch, or add echo to the molecules of sound, creating all these different shapes out of a single wave. It's so magical! When you take this to a deeper level, you're basically like a magician or an alchemist. That's a big part of my art practice. The guitar is a very explicit tool to demonstrate that mindset.

Neon light also works in a loop. You can see the electricity inside the tube thanks to the little piece of mercury —one of the four elements of the alchemist—and the neon gas, of course. It makes a constant loop, lighting up the tube in blue, green, yellow, or whichever colour you want. You can also shape the light in whichever shape you want, so it's like painting or making sketches. And finally, I like neon because it's made of glass, which is a natural material, made from sand, another classic element of the alchemist.

You often work with white paint. Why is that?

There are so many aspects to it, ranging from religious to scientific and psychological, but the simple explanation is that it clears the mind to paint something white. It's a natural approach, for instance when something didn't work out on a canvas, you paint the canvas white to prepare it to start over.

What's your relationship with words and how important is language to you?

I write a lot; it comes very naturally to me. As I mentioned, I have stacks of notebooks filled with a combination of sketches and words. I never leave the house without a pen, ink, and a notebook. Never.

What does creativity mean to you?

Creativity is part of all of us. I agree with Joseph Beuys who said that everybody is an artist. Unfortunately, that doesn't apply to today's world. We've destroyed our creative primal soul, and with that our instinct, our drive and our creative force, in a very problematic way. That is why art is so important in this world, and why many people love it and many hate it, as they don't understand it anymore.

When you look at societies where creativity, art and music are naturally part of life, there is no need for organised occasions like concerts and galleries, and all that rumble in the urban jungle. But we all know that we destroyed that part of the world... so there's some work to do! In the meantime, artists can fill the gap. Creativity is linked to creation, and creation is life, so when you open your senses, look closely and listen closely, it's a very natural thing. That's why kids are very good at being creative. If there's one big task for politicians, it's to make sure not to destroy all these young wobbly, muddy, sparkling brains. And maybe then we can get somewhere. All the things that we've unlearned can be very quickly regained.

What does a day in the life of Joris Van de Moortel look like?

My days are good. That's my only problem, knowing that many people deal with terrible days, while I have the best 'job' imaginable. If I didn't do what I do, I couldn't live in this world. I would move to a mountain-top in Andalusia. As each day has its own challenges and presents new perspectives, you just have to accept that each day is different. That's what I embrace in the art world, that each day can be different, or the same. In this other world that surrounds the art world, it seems that every day should be the same, except for the weekend. That's when you're supposed to do something else *(laughs)*. I'm glad I escaped that dance.

I spend my days trying to connect with my thoughts, connecting them to a certain output. It's hard to answer this question as the concept 'day' is linked to time, and time is just not a parameter that you can apply to art. In my life, a day doesn't mean anything. I don't like to think in days.

Do you always work in your studio?

I can work anywhere. Like I said before, I never leave the house without a pen, a notebook, a watercolour set and even a musical instrument. I'm always writing, sketching, capturing ideas from the sources piled up in my head. But I do also need a studio. I have all my tools there, and my instruments. I have a music studio upstairs and an improvised cinema downstairs, and all these beautiful materials, like paint, plaster, wax, and this beautiful light. I've always had a studio and my biggest fear is for this place to be taken away from me.

What inspires you?

Inspiration is like digging from a well, from different sources and springs even. I feel like I've created a never-ending source, so I don't suffer from writer's block *(laughs)*. The biggest problem is selecting, editing, deleting... My biggest frustration is that I can't realise all the ideas I have, so I have to find ways to write them down and look for art forms that can contain a lot of content, like film and performance.

Is humour important in your work?

Humour is a part of language and essential in communication. It's a pity that this is even a question, it should be natural, there's no question about it.

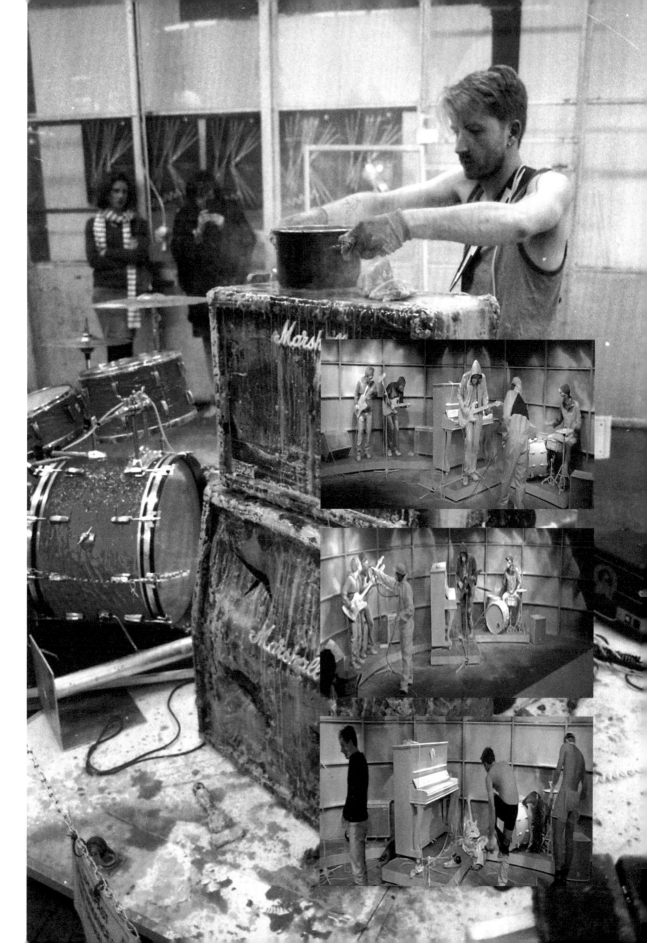

I have a big list of destroyed works.

The Hero do Wells set out
The Hero do Wells set out

WORLD-SHIP
FOR A dubious
Liminal time

ANATHSIA
ANIMISM

NOT FIXED

Ritual
RITUAL

OOO
Object-Oriented-Ontology
OOO

Fool
FOOL

Pilgrimage
PILGRIMAGE

HORROR
HORROR

Shrine~Altar

The Ship

UNDEAD

Liminal time

We killed the future we built it
if we don't solve it solve this
we all bear hollow lives
if the new Ritual is into shipping

How important is colour in your work?
I used to have a band, and we always used to rehearse in a shabby garage that was lit only by a green neon light. When we would leave rehearsal after a few hours, everything outside seemed purple to us. This is a very practical example of the fact that light is essential and has a major influence on all of life, so including it in what I do is an obvious choice for me. I'm very thankful that I can play with its aspects. It's a form of respect and awareness.

Who inspires you?
I think that's too private to answer. There's not just one person or thing. I'm inspired by ideas, movements, philosophies, religions, rituals, life. It's a chaotic mixture, a mess, really. Ideas and inspiration can't be claimed by anyone, they are part of a movement that you can pick up or be part of, or contribute to. I don't believe in quotes either, no one ever invented anything all by himself. Everything I say and do has been said and done before in some way or another. My art practice deals with that, and my mantra and inspiration is "Allowing things to happen".

Who—dead or alive—would you like to have dinner with?
That's also private. What if I name someone, and everyone reading this book chooses them too? By the time I send out the invitation, they will be fed up with all these dinner invitations.

How do you know when a work is finished?
When it's sold *(laughs)*. I'm kidding, but in a way it's true because I have a big list of destroyed works. If the gallery wants to keep a work available, then they better not send it back to the studio, because chances are that I'll take pieces out of it. Usually it's because I need a neon or a microphone or just a part of it, and then all of a sudden, the old work gets eaten by something new. To answer your question: it's finished when you stop working on it.

What does failure mean to you?
Failure is progress and can be a very positive energy when you bend it the right way. I like to make decisions quickly, and act in the moment. When something doesn't function just when it really has to, then you should immediately turn it into something that does function. You can even turn it into a joke. For instance, when things don't go as planned during a performance —not that there ever is a plan—you have two options: you can either say "I'm sorry, I can't go on", or you can turn this "I'm sorry, I can't go on" into the work itself. That's the beauty of improvisation. There's always something you can do, so there's no such thing as failure. That's the freedom I need and take from art. In a world that's so structured, why would you implement rules into a creative process?

Has the Covid-19 pandemic influenced your creative life?
Just as everything leaves a mark, so does this pandemic. During a phone conversation in the first week of the lockdown in March 2020, my gallerist Nathalie Obadia said these very reassuring words: "As an artist you don't need to fear, you will always have your work".

What's the best piece of advice that you've heard and still repeat to others?
I'm no good at taking advice, but I'll share with you the most practical advice I ever got. It was from Jan Van Imschoot, who said—not even particularly to me—that you can't mix oil paint with white spirit. Yet you see it being done everywhere, by painters, students, teachers, and it's like pure chemical death. The annex to his advice was: "White spirit should be used to clean your brushes with and that's it."

ANNE-MIE VAN KERCKHOVEN

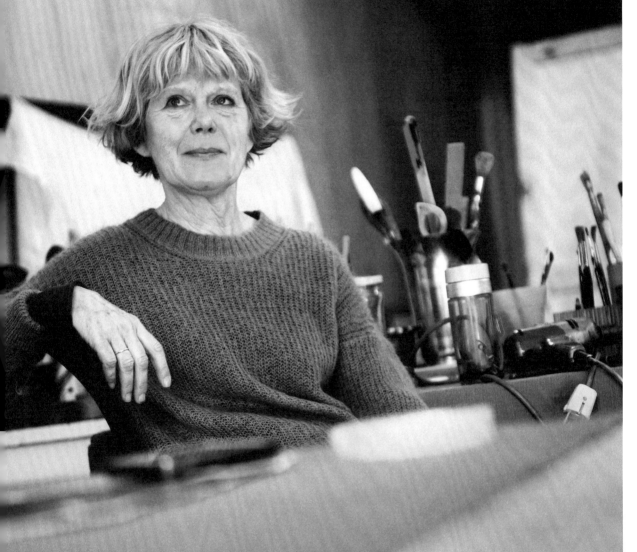

Sometimes it all starts
with a word.

How would you introduce yourself to someone who doesn't know you or your work?

I started making drawings in 1975 and in the meantime, I have become a multimedia artist. I use practically every medium you can imagine, except for sculptures. I'm also still interested in everything that's new, that challenges boundaries or experiments with brain science and art.

Your name is Anne-Mie Van Kerckhoven, but you go by AMVK as well.

I started using my initials when I was a kid, at about fourteen years old. I have a very long name, and when you sign your drawings with a long name like that, it doesn't look good. I was also inspired by artists like Albrecht Dürer who signed their works with their initials. Later on, I realised that I liked the fact that when I used my initials, people couldn't tell whether I was a woman or a man.

Is the fact that you are a female artist present in your art? Or do you want to be free from gender?

I'm convinced that on a subconscious level, there is no gender. Especially not on the level of creativity.

What kind of family did you grow up in?

My parents were caterers. They organised big banquets at our house in Antwerp and their clientele was made up of very rich people and noblesse. In my family there wasn't much of a difference in power between men and women. My grandmother was the boss of the family. She was the one who made the business successful. It was only when I started art school that I found out that there was such a big difference in the perception of female artists.

Did your parents support you when you wanted to become an artist?

Not really, no. My father had had a lot of bad experiences as a young artist in Antwerp, being treated badly by older artists. He never spoke much about it, but he was very creative, in music, drawing, painting.

When I was young, I actually wanted to become a sculptor. I used to make things out of anything I could find that was solid enough. So, when I was nine years old, my father took me to the atelier of Albert Poels, a good friend of his. At the time, Poels was working on the *Lange Wapper*, the tall statue next to Het Steen in Antwerp. He said that I could start as his assistant when I turned twelve.

The next time we visited his studio, I was really eager to start making my own things. But Poels told me that for the first year I would just be cleaning the clay trays. Then, for the next two or three years I would be making copies of his work, and at about sixteen I would finally be able to start making my own things every once in a while. So, I declined the apprenticeship, because I didn't want to spend years making figures of Tijl Uilenspiegel and the Virgin Mary. It was not what I had in mind. My parents were very angry that I turned down that offer. I had always been good at writing too, so they wanted me to stay in school until I was eighteen and then decide what direction to go in.

Did you get to go to art school after finishing high school?

Yes, I attended the Academy of Fine Arts in Antwerp. My interest in sculpting had diminished over time, because by then I didn't want to choose between image and word. Graphic design was the right choice for me because I loved working with letters. As a child I was fascinated by the colourful signs in the streets. In the fifties, sixties, and seventies they were still really beautiful and stylish. I also chose graphic design because I didn't want to focus on just one discipline. I could learn how to make photos, drawings, silk-screen and much more. Of course, now I would choose Multimedia but that didn't exist at that time.

From the start I wanted to work with animation film. I asked my parents if I could transfer to Ghent because they had a very good animation atelier, but they said no, so I started teaching myself in Antwerp. When I was 33, I took an evening class at the Academy in Merksem. I have been doing a lot of different things, but the place where everything comes together is in animation films.

I read that you draw every day.

I started consistently making drawings when I left the Academy. I made them to get a grip on my inner world and to digest everything that I couldn't cope with in my daily life. Very soon I was exhibiting them and people thought they were very intriguing and special. Shortly after that, I made my first computer movie, in 1977. I also started making recordings of my installations whenever I did an exhibition. At first my work consisted of drawings, but soon I started to make colourful paintings on leftover Plexiglas. My first act as an artist was to edit a map with seven silk-screened drawings that exemplified my worldview, which in fact hasn't changed since then.

And what is your worldview?

I'm concerned that there are too many people on this planet, and we all have to deal with this over-population. I also believe that there is too much pressure from political and economic powers and, as a child of the seventies, I simply cannot stand being told what I can and cannot do, for instance by the police or the powers that be.

What's also important for me is the idea that sooner or later mankind will really conquer space, and that there is a lot of salvation to be found in the idea that we can leave this planet. I've been fascinated by space travel ever since I was a kid, when the first rockets went up into the sky in the sixties. I still have all the newspaper and magazine clippings. Maybe it's a kind of escapism, because even when I was a kid, I didn't like life as it was.

Was art a way out for you?

Yes, probably. People often tell me that I always said I would be an artist, even as a child. My parents and grandparents had subscriptions to magazines like *Paris Match*, where I saw all these images of Paris in the fifties. It was like the beat generation but in France, and I wanted to be part of that. I was drawn to people who were free and didn't follow the rules.

My work is about trying to find out how our brain copes with all the information it receives. I have a fascination for the naked body and artificial intelligence, or basically everything that has to do with the future, the cosmos, and new inventions.

How do you want the viewer to perceive your work?

In a way, I feel like a shaman who takes spiritual trips and tries to heal society. I'm really convinced that you can cure the world by making artworks and that's also why some people like me. Then again, every self-respecting artist does this in his or her own way. It can be interesting for a viewer to enter my paradigm and to see how I deal with things. It can refresh their ideas of what reality is and what it can be.

I believe that any evolution is good and that all bad things turn out good eventually. I myself am actually a person who suffers a lot when things don't work as they should, so I try to provide ways to look for new solutions. I'm part of evolution, and evolution comes with trial and error. That's what I do: through trial and error I look for new ways to solve problems.

Words seem to be very important in your work. Are titles important?
Yes, very important. Sometimes it all starts with a word. Music is also very important. The way I deal with materials is very often related to songs that I listen to, both from old and new music. I actually make music myself, too. I like noise and rhythms, and I also really like death metal and those kinds of genres.

What does creativity mean to you?
It's this whole evolution that we are part of, looking for new clues to be able to evolve.

What does a day in the life of Anne-Mie Van Kerckhoven look like?
I get up quite early. I have coffee and then I read something by the Dalai Lama. I have a book of 365 quotes of his. I also read the moon calendar and sometimes I play cards. Then I start thinking or reading something, I'll write something down or start making drawings or go to my computer or my studio. It depends on the day, really.
I also try to always be reading something that relates to my interests, and right now I'm reading the letters and personal notes of Wittgenstein in English and in German. Sometimes I'll read *New Scientist* magazine or books on space travel and cosmology.

Can you work anywhere?
Yes, I can work anywhere.

Are you a morning or an evening person?
Both.

Are there things that prevent you from working?
I hate deadlines.

Can you describe your work process? Do you work intuitively, or do you have a concept? Do you do a lot of research?
I do a lot of research, but I don't call it that. At certain times in my life, I'm very open to new things; I collect them, and I arrange and rearrange them. Sometimes I'll suddenly get an insight from reading an article or watching a documentary on television. I have several notebooks where I write ideas down. At first, all these notes seem very random and chaotic but when they come together in the notebook, in the end they always add to one another and that can be the start of a new big project.

Die Reichen
müssen noch
reicher
werden

Wählt
christdemokratisch

I'm very much attracted to expensive magazines, especially when they have a certain grittiness or a hint of perversion. I have an addiction to what tends to be perverted. That's what I do as well, I pervert things that are good and beautiful. I like to take texts or things that people say that are seen as good and noble, and use them in a very bad way. I believe that our society is perverted to the core on every level, so I think it is really the biotope of the artist to deal with these perversions and turn them into something benevolent again.

Do you want your art to be provocative?

I think every good thing that is in any way new or that adds something important to the world, is provocative.

Is humour important in your work?

Yes, very important. I like silliness in everything. Sometimes I make certain combinations that are very unexpected and that makes people laugh. I actually like to laugh a lot myself and I prefer being around people who make me laugh.

Is colour important?

People say that I have a very specific colour palette and that I use combinations of colours that are very unique. When I make something on the computer, I keep on working at it, often for months and months on end, until I have a combination of colours that I'm really happy with. It's really my personal concept of beauty and people say that's unique.

How do you look at failure in the creative process? Is there a lot of failure in your work?

Yes, but I would not call it failure. When you use a machine to print and something comes out differently than you intended, then that's a solution made by accident. So, I would call them accidental things that happen beyond your will.

Who—dead or alive—would you like to have dinner with?

I would like to have dinner with David Lynch, Michel Houellebecq and Rei Kawakubo, the founder of Comme des Garçons, I like her a lot.

Are you on social media?

I have an iPhone and a Facebook account that only makes me nervous.

I was one of the first people to have email, because I already knew in 1980 that the internet was coming. I don't block social media out of my life but I do block out all these people talking to me, because I'm very easily influenced, and I quickly get depressed and lose my focus. I'm interested in absolutely everything and in everyone's ideas, so I have to be very careful and protect myself from all that input.

Has the Covid-19 pandemic influenced your creative life?

Yes and no. Until mid-October 2020, I was living under the strain of deadlines. Since then, I have been in gentle chaos. The thing is, when you are creative, you are at the same time both focused and subject to what's happening around you at that moment. Who you see, what you talk about, what you experience at home, on the street, in traffic, in shops and in media is actually the material that feeds the solutions you create in your work. There always has to be something to fight, something pushing you. The situation we are in today makes it difficult to be determined. Voices are being silenced, and leisure and distractions are restricted, which leads to other ways of perceiving input. The pandemic is changing certain aspects of the world's energy.

Before the pandemic, my entire creative life had been a commentary on the things I loathed about Western society. The work I made was a product of the pain caused by the incomprehension and distance I felt towards what I have been seeing around me for almost seventy years. And now that so many voices and media are expressing the same critique, I don't know where to start anymore.

What's the best piece of advice you've heard and still repeat to others?

Stay true to yourself, believe in yourself and just do what you feel is right. And try to avoid doing things that you don't really want to do.

I often feel like a shaman who takes spiritual trips and tries to heal society.

DOMINIC
WILCOX

I am deadly serious about
being playful.

How would you introduce yourself?

I try to think up ideas that make the things around me more interesting, then I make them or draw them and show them to people.

What is creativity to you?

Being creative is like playing a huge game. It's fun to play and everyone can get involved. The game board is the whole world around us, and the challenge is to transform the things you see and experience in the world into something more interesting, surprising, useful, moving or thought-provoking. The prize is the thrill you get when you create something you are happy with. Sometimes other people set the game challenge for you by asking you to be creative on a certain subject. Other times you have to create your own rules and goals for the game, like when I set myself the challenge of making something creative each day for thirty days.

Where are you most creative?

I've tried to work this one out for years. I don't think it's a physical place. It's more about being in the right mental place, a place where I am relaxed and focused while in a playful mood. That way your mind is focused on the subject but still able to make unusual and surprising connections with other things in your brain. Creativity is found in a place far away from the well-trodden path.

Do you have a preferred time to be creative?

When I wake up with my eyes still shut. I seem to be able to focus on coming up with an idea without distractions, relaxed but with a clear mind. I would stay there all day if I could.

What kind of circumstances have to be fulfilled for you to be creative?

I sometimes think that I am only creative for a few seconds a day. In those brief moments, good ideas can come to me if I'm lucky. Then the moment passes, and distractions or other thoughts move my mind out of its creative thought zone. I think it can be like meditation and trying to get your mind in the right place. If I can extend that period of creative thinking then I am happy.

What inspires you?

The other day I was in a museum that exhibited some glass pots that were used to hold cremated Romans in the year AD 100. It led me to think about this subject, the fragile objects and the way they were glued together again. What object could I break apart then glue together that would look more interesting than the original perfect object? This is the sort of creative thought process that inspires me, looking at interesting things from the past.

Who inspires you?

Different people have inspired me over the years, but mostly I'm interested in people's approach to creating their work and the thoughts they have about life in general. Thinking and behaving in certain ways can help open up your creative mind. I always liked the poet and singer Leonard Cohen, and other singers like Tom Waits and Neil Young. Their music helps put my mind in a good place for ideas.

Who or what has been the single biggest influence on your way of creative thinking?

My teacher in the first year of university called Charlie Holmes. He first challenged me to think of unusual ideas and draw them. A door in my mind was opened that I never realised was there.

Did your childhood influence your ideas about creativity?

I was a shy and quiet child. I did a lot of thinking and observing, and working out how I could get through situations without having to say much. I think this may have helped my ability to communicate visually without words.

What are some things that prevent creativity?

A lack of confidence that you are able to think up a good idea. You have to have self-belief.

Side signage rings to bring more attention to your engagement ring.

Does creativity have to be provocative?

I have a quietly provocative nature that I get from my father. I used to follow my dad around a lot when I was young. If he saw a shop assistant that looked bored, he would quite often say something funny or surprising to make them smile or laugh. I think I enjoy provoking, but I do it with drawings or things I've made. I don't think creativity has to be provocative but I do like it when it takes me out of my expected thoughts.

How important is humour in your work?

I think you have to express your personality through your work. If you are a serious person then go with that. I tend to have a dry sense of humour, but I also have various interests like old craft techniques and the potentials of future technology. Sometimes humour is a good vehicle through which to provoke thoughts and ideas on serious subjects or within unexpected contexts.

Your creativity is often used for commercial purposes How does this work for you? And how is this different from your personal work?

I quite like being challenged to apply my creativity to a particular subject. The brands that commission me want me to be myself and so they don't tell me what to do, they just tell me about the subject matter they are working on. I usually send them a few ideas and through discussion we agree on what to develop. In my personal work it is quite random, it requires more self-discipline and setting myself challenges. It enables me to do things that are new or surprising to me.

How do you prepare yourself? Do you use notebooks, doodle in books, or do you work digitally?

I usually doodle on paper or just make a model. Sometimes I hold an idea in my head and then forget it. Recently I've started drawing on an iPad for finished drawings.

What is failure to you?

I don't think anyone wants to fail. The important thing is to learn to not be afraid of potential failure. You're not going to find the big, deep-sea fish if you only tiptoe out into the shallow water where everyone else is fishing. Taking a risk is exciting and the rewards can be big.

Hairdryer

How do you incorporate failure into your creative process?

I build in time for things going wrong from the start. I try to get through that stage early and then when I land upon something that works, I have time to develop it. Or sometimes I just go for it and take an educated guess that it will work out, even though I can't fully predict the outcome yet.

Do you allow for failure?

I think failures are more likely when making physical prototypes but they open up new possibilities. You can't think everything out in your head or on paper. When you make things, they usually don't quite work as expected. Sometimes it's disappointing but then you just see it as part of the journey and you can keep going or change direction until you're happy.

What has been your biggest failure?

I don't remember many things that ended in failure because I keep trying until it works. I once sent an idea to a fashion show in New York using chain link fence as a backdrop. They ordered about a hundred metres. Then when I arrived at the gallery, straight from the airport, on the night before the show, I saw it laid out and realised that it wasn't staying in the beautiful, wavy positions I thought it would in my drawings. It just sagged down like fabric. About twenty people—including the fashion designer—were looking at me. I just took a deep breath and started moving it around to see what I could do with it. In the end I decided to go with the way the material wanted to move and accentuate it. I was improvising on the spot to fix something that had been planned for months. They seemed happy with the way it looked in the end but my heart was beating pretty fast!

You said: "I am deadly serious about being playful". Can you elaborate on that?

Playfulness is an important tool to find ideas and creative outcomes. It helps you kick your mind off of the predictable path it naturally moves in. I think some people may dismiss playfulness as just a bit of fun, but I know it is a serious method to find new ideas.

Has the Covid-19 pandemic influenced your creative life?

It has been challenging to concentrate with all the bad news and worries in the world. So, creatively I've been focusing more on practical things that make a difference to people. I started a creative organisation called Little Inventors back in 2016 that still continues today. We challenge children to draw their invention ideas on different themes and then ask expert makers to bring them to life for exhibitions. During lockdown my time has been filled by creating creative challenges for children stuck at home and asking adult makers to make them real.

Should creatives worry about what other people think?

When I studied at the Royal College of Art, there were lots of famous designers all giving their opinion and I started to listen and try to do what they advised. I did lots of work and some of it I think was good, but I lost a bit of my own direction and personal style. It took a few years to get back on track but I'm still using all the valuable experience and knowledge I gained at the RCA. I think it's important to try to find your own voice.

What advice can you give to a young creative who is just starting out?

I think young creatives are lucky today as they have so many ways to show their work to the world. Before the internet existed, you needed to know the right people and show in a gallery or maybe a magazine. It's a case of finding out who you are and what you enjoy doing in your life, and then expressing that in a creative way and continuously showing it. If you do good things then good things will come to you.

Genetically modified square peas
to stop rolling around on plate
for easier eating.

MATT WILLEY

I'm fascinated by how confidence works or, in my case, doesn't work from time to time, in a world like design.

How would you introduce yourself to someone who doesn't know you and your work?

I suppose I would say that I'm a graphic designer. And when people look underwhelmed, as they invariably and understandably do, I might add that I used to be the art director of *The New York Times Magazine*. I haven't got used to saying I'm a partner at Pentagram yet.

A detailed explanation of what I do would be excruciating, and of no interest to anyone.

What kind of family did you grow up in?

My father was a poet, and my mother had been a dancer before she hurt her back. She was 'spotted' by a model agency when she was 58 and has had a fun late modelling career. My dad also worked with deaf and blind adults, and with young adults with learning difficulties later in his life, but he never stopped writing poetry. My maternal grandmother was a composer and pianist, and my maternal grandfather was a portrait painter. He also ran the St John's Wood Art School in London and later he made violins. My paternal grandmother was an English teacher and my paternal grandfather was the Labour MP for Sunderland and Sunderland North from 1945 right through to when he retired in 1983. An interesting bunch.

Did your childhood influence your ideas about creativity?

I was lucky. I grew up in a very loving family. It was, looking back, a fairly idiosyncratic and slightly dysfunctional family, but it was interesting. I was surrounded by a lot of interesting people doing interesting things in slightly odd ramshackle houses filled with books and art and music and dilapidated upright pianos. It seems inevitable that some of that would rub off on me somehow.

I was born with severe hearing loss, and my parents were told I would never be able to speak properly or go to a normal school. That, more than anything else, shaped my childhood. My early life was entirely focused on—and consumed by—dealing with that; I worked extremely hard with an amazing speech therapist and my equally amazing mum. I speak well enough now that I don't think anyone would guess. I was the first person with my level of hearing loss to make it to a normal comprehensive school—but I found it hard to follow what was going on and struggled academically. I enjoyed art class. I liked drawing, it was a solitary pursuit, I didn't have to talk to anyone.

In a very direct sense, overcoming that obstacle had more bearing on me pursuing something 'creative' than anything else. It is the clearest through line I can make between my childhood and what I do now.

When did you know you wanted to be a designer?

I became interested in the idea of doing art when I was at school, because that (and football) were the only things I was any good at, the only things I enjoyed. But there wasn't really one moment where I thought I wanted to be a designer. I sort of fell into it. I scraped on to art college to do illustration. I had wanted to paint but wasn't brave enough, and illustration was a compromise. I didn't get along with the course and switched to photography, and when that didn't work out (photography didn't really exist as a stand-alone course), I moved across to the only other course in the building, which was graphic design.

I got hired off the back of my degree show (more to do with the reputation of the college than any talent on my part) but back then I really just saw it as a way of staying in London. I had moved from the countryside to go to college and didn't particularly want to go back. I figured I could work as a designer, and just keep thinking about what I wanted to do.

When I joined Vince Frost's studio in 2002, five years after leaving college, I remember thinking that I had to start taking the *idea* of being a designer seriously. Partly because working in Vince's studio demanded a certain commitment, but, far more significant than that, was finding out that I was about to become a dad for the first time.

The fact that becoming a designer had felt so accidental—the result of happenstance rather than the result of a more deliberate decision on my part—used to bother me a lot. I felt like it couldn't possibly be what I was 'supposed' to be because I didn't feel like I had chosen to do it. But I'm glad things panned out the way they did.

What is creativity to you?

I don't like the word 'creativity' much, I don't find it particularly useful. I suppose it means the act of making stuff in connection to your imagination.

Do you have a preferred time to be creative?

I seem to work better in the evenings. When I had my studio in London I used to enjoy staying late, after everyone had left, when there was an uninterrupted stretch of time ahead. Time to think and try things out, mess about a bit, experiment, play. For me, the process of making something good often depends on trial and error; just pushing things around trying to make something work, and often that takes a bit of time.

A looming deadline can sometimes feel debilitating, other times that same pressure seems to really help. I don't have a blanket approach: different projects work differently.

DONATED TO THE BUYFONTSSAVELIVES INITIATIVE.
WITH ALL MONEY GOING TO CANCER CHARITIES.

ALL CAPS.

$9.99
£6.57
¥1196.93
€8.29

aYAG

AaBbCCDdEE 123

ZILCH

TIMM

№67

TOKYO

AMEN

The New York Times

The Return of the Pop Prodigy

Understanding the strange musical vision of Lorde. By Jonah Weiner

The New York Times

THE KING
BECOMES HER
By Parul Sehgal

CAN A WOMAN
PLAY SHAKESPEARE'S
LEAR?

GLENDA JACKSON
MAKES THE QUESTION
IRRELEVANT.

HE'S
GOTTA
HAVE
IT

What happens to a provocateur like Spike Lee when the culture catches up to him?

"THE WAY TO SURVIVE
IT WAS TO MAKE A's"

They were the first black boys to integrate the South's elite boarding schools. They drove themselves to excel in an unfamiliar environment, only to prove that they could achieve just as much, or more, than their white peers. But at what cost?

MAKING A MOTHERLAND
BY CARVELL WALLACE

FOR AFRICAN-AMERICAN AUDIENCES, "BLACK PANTHER" — A MOVIE ABOUT A BLACK SUPERHERO AND HIS THRIVING AFRICAN KINGDOM — POSES AN EXISTENTIAL QUESTION: WHAT COULD WE BE IF WE'D NEVER BEEN PUT IN CHAINS?

PHOTO ILLUSTRATION BY NAJEEBAH AL-GHADBAN

REI

When I was at *The New York Times Magazine* we had very tight, finite deadlines and quick turnarounds. I learnt to really enjoy that and I think I've done some good stuff working that way. But I also really enjoyed the projects I did outside of that, like the titles for *Killing Eve* for example, or the *Mongolia* book, or *Port* magazine. I would work on those projects at my kitchen table, with a glass of wine, and it was a very different way of working.

I also find it hard to turn that creative process on and off, like some sort of switch. It just doesn't work that way for me. That was one of the challenges of working somewhere like the *NYT*. Creative work doesn't always fit neatly into the more rigorous nine-to-five working culture.

Are you confident about the work you do?

I'm fascinated by how confidence works or, in my case, doesn't work from time to time, in a world like design.

Doing what I do means I'm often putting forward my taste in something. I tend to have strong instincts about how something should look or work or feel, and sometimes that's all it is, an instinct. Sometimes I can't justify it beyond "I just really like it." It works on a subjective and visceral level, which I think is—or should be—valid. It's why design-by-committee often doesn't work. Sometimes something unusual or interesting or just really beautiful can get compromised or dismissed or made less interesting simply because of this peculiar need to over-explain or over-rationalise everything. Sometimes something just looks great, and sometimes you don't need to justify it beyond that.

Confidence is, generally speaking, hugely overvalued as any sort of meaningful indicator of anything significant about a person; it's just not important to me, it has no bearing on someone's ability, or their decency or really anything that's of interest to me about a person. It's peculiar to me that so much importance is attached to it.

What is your relationship with fonts? You have designed a few yourself.

I've always drawn bits of type for my own use. Usually the kind of stuff that works for headlines: rather simple, slightly crude, letterforms. I'm not a type designer (I'm a designer who pisses around with type... there's an important distinction there) but I do have very strong instincts about how type works, especially in the context of a magazine. It was often much easier for me to draw what I wanted, and I liked having the control to adjust the headline type exactly as I wanted, or to draw something to fit a specific space, or to make certain characters sit next to one another in a certain way. I used to draw the headline type for some of the smaller magazines I worked on, like *Elephant* and *Port*, where I had the leeway and license to do that kind of thing, but I also did that quite a bit when I was at the *NYT*, on special issues.

A lot of the type I'm drawn to is technically incorrect. I like the idiosyncrasies, the imperfections, the irregularities, and sometimes making a typeface technically precise or accurate removes the thing that I find exciting about it.

It never occurred to me to make my typefaces available, but I got into a conversation with a chap called Paul Harpin, who started a wonderful initiative called *BUY FONTS SAVE LIVES* which sells fonts in order to make money for cancer charities, and I wanted to help. Cancer is shit—I lost my dad to cancer. I recently donated all my typefaces to the cause, and we just completed a redesign of the website.

I still feel a little uncomfortable that these somewhat peculiar typefaces are out there, but it's also fun to see people using them.

You did the redesign of newspaper *The Independent*. How does one start on such a project?

You just jump in. We had three months to do the whole thing. The brief, from the editor at the time —Amol Rajan—was a good one. When *The Independent* launched in 1986 it had been a serious and elegant broadsheet, but it had gone through a lot of redesigns over its relatively short life and it felt (in 2013 when I worked on the redesign) like it had lost its way, visually. It didn't look or feel like *The Independent* anymore. In 2004, one of the redesigns saw it go from being a broadsheet to being a tabloid, or 'compact', format. We were stuck with that format but Amol wanted *The Independent* to return to that feeling of being a serious and sophisticated newspaper again. The elegance of that big broadsheet in this compact size.

Creative work doesn't always fit neatly into the more rigorous nine-to-five working culture.

It was a complete overhaul. A rethink of pretty much everything; new grid, new structure, new typefaces (drawn by Henrik Kubel), new hierarchy and navigation. There was a new editorial approach. Everything was stripped back and simplified. I worked in-house with Head of Creative Dan Barber and Stephen Petch who, at the time, was the art director of the *The New Review*. I really enjoyed working on that redesign. It was big, tough, complicated job. I fought very hard for what I wanted and there was something satisfying about coming out the other end feeling like it had come together as I had hoped. I learned a lot.

The most visible act was putting the name of the newspaper on the left-hand side and not at the top. Why did you do that?

By running the logo vertically, we could give a fairly long name some scale. It could still be a pretty prominent bit of branding, but putting it to one side also meant that you could read straight down, directly into the news. The story of the day could be at the top, you didn't have to get past all that 'stuff' that was usually up there. I liked that hierarchy, it gave the actual news a higher billing. And the tall shape that it created, the seven-column space to the right of the logo, was almost exactly the same proportions of the old broadsheet format. That shape was just a much nicer thing to design within. The previous design had a logo that used a big condensed typeface—which makes sense, it gave the logo some scale—but it took up a lot of height, roughly the top third of the paper, which left a tight uncomfortable space below. the new shape suddenly made it much easier to get scale on photographs, for instance. There was more room to make a more dynamic front page... I'd have to draw you a diagram to explain this!

You previously worked for *The New York Times Magazine* as art director but recently you made the switch to design agency Pentagram.

Yeah. I'd spent five years at the *NYT*, and loved it, it certainly wasn't an easy decision to leave, but joining Pentagram felt like an amazing opportunity and I thought I'd maybe always wonder 'what if' if I didn't give it a go. The way things worked out, I started eight weeks before Covid-19 really hit and I've been working from my kitchen table for over a year. It's been a tough start.

Working at the *NYT* was really exciting, I miss working on a magazine with that much editorial clout, reach and influence, on something that varied and ambitious, week in week out. The collective effort of that machine was an exhilarating thing to be a small part of. I was surrounded by people who were exceptionally good at what they do: story editors, photo editors, fact checkers, production editors, research editors, designers and so on. It was intoxicating to watch that magazine get put together so brilliantly every week.

Who inspires you?

It's hard to unpick all the influences that have coalesced over time and point out a single influence. I wouldn't know how to explain how I think creatively, let alone define how that came to be. Saul Steinberg was important to me when I was a kid, and still is. The same goes for the *Tintin* books and *2000AD* comics. There were lots of painters who I was interested in when I was a teenager; Rauschenberg, Manet, Tàpies, Larry Rivers, Pollock, Rembrandt, Francis Bacon, John Singer Sargent... then there's designers like Vaughan Oliver, Willy Fleckhaus, Corita Kent, the illustrator Hans Hillmann, photographer Robert Frank, Blue Note Records... I could point at a thousand influences, but not one.

Who—dead or alive—would you like to have dinner with?

My dad. He was a wonderful human, I miss him.

How important are social media for you?

They're not. My life would be better without them.

How do you incorporate failure into your creative process?

It's part of the process. I wouldn't know how to separate it. Rather than incorporating it per se, I just accept that it's a part of getting anywhere good. I think most designers—whether they're prepared to admit it or not—are driven by a fear of failing in some way, which brings us back to the matter of confidence and the subjective nature of what we do.

SHAWNA
SX

I want my artwork to connect people to parts of themselves they have been hiding from.

How would you introduce yourself to somebody who doesn't know you and your work?

I usually introduce myself as a visual artist and designer.

You go by Shawna X. What does the X in your name stand for?

X is the first letter of my Chinese name Xia Yun, which means 'Summer Rue'—a healing herb. I started using it in middle school as an homage to my identity. Shawna is how I've always been known since I was a young child in the US.

What kind of family did you grow up in?

My parents came from the academic world. My grandparents, who were both maths professors, were a huge influence in my life. They were very strict and demanding, which taught me discipline. My dad went into computer science and my mom is an elementary school teacher, so their backgrounds are very different They've always pushed for the traditional and stable types of work, something you hear of quite a bit in Asian families.

Was there room for culture and art in your childhood?

Not really. In my family creativity, from drawing to creative fiction was seen as a waste of time, a hobby. I think my father was actually a very creative person, but he struggled to pursue a career in the arts because of the pressure from my grandparents.

When I was young, I was very interested in drawing, so my parents enrolled me in a Sunday arts school. But it was very technical, and they approached art as a skill, rather than an expression, which is my practice today.

I don't fault them though, as I believe immigrant mentality focuses on security, since they've struggled so much themselves. We all want what we think is best for our children.

Is your heritage as a Chinese-American woman something you always carry with you?

Yes, even more so now because I am a mother, and I want to teach my children the beauty of cultural nuances, especially from perspective of the Asian American identity. The physical distance between me and my family in America—me in New York and them on the West Coast, and then their family in China does however make it difficult to preserve specific cultural traditions. I'm holding on to some parts of my heritage because I think some Chinese traditions are pretty amazing especially when it involves raising children.

Is this influence present in your work as well?

My heritage influences my work in a very subconscious way. I'm not constantly aware of being a Chinese person while making my work, but being Asian American has definitely shaped my experiences in life, which ultimately translates into my work. How I feel and who I am consists of all my roots and upbringing.

What does creativity mean to you?

I think creativity is translating what you see from your own lived experience and perspective, and then channelling it in whatever way that suits you, be it visually, musically, or verbally. Creativity is not strictly a visual thing; it's how you interpret the world, how you choose to filter it and how you let it back out into the world.

What kind of circumstances have to be fulfilled for you to be creative?

I can work anywhere because my inspiration comes from personal experiences that have been collected over time. If I find something inspiring, I take that feeling and information home with me. I used to travel to see and meet different kinds people and types of environments. But now, being at home, I'm able to see and appreciate mundanity. These days, I'm able to zoom in on the details of the mundane objects I take for granted, like a glass on the table, which has been really helpful for my creative process.

Do you have a preferred time to work or be creative?

At night. In the morning and daytime, I like to get out of the house, grab coffee or just walk around, especially when it's beautiful outside. Night time is when I come back and I'm able to sit down and open my laptop or notebook and focus.

What is your work process like? Do you work intuitively, or do you start off with a concept?

I do both. If it's an editorial or a commercial project, clients ask for a specific type of work around certain concepts. I usually take those concepts and play with the visual execution in my head. I go back and forth and intuitively between my laptop or the sketchpad. If I'm in a really intuitive place, my process is so streamlined that I just go directly to Illustrator and bang it out. Generally, my process has always been really fluid and that's when I make the best work.

What are some things that prevent you from working?

As much as I'm inspired by all the work I see online and in different publications, I also feel pretty bombarded by all this information. I've realised that I cannot work very well after I've been too consumed with the media and the outside world. If I allow that presence into my own psyche, it changes who I am intrinsically. A lot of the creative people I talk to are going through the same thing because there's just so much information everywhere. There's new input everywhere and production times are so short now. Even though I do get a lot of inspiration from technology, it also holds me back from being with myself and understanding my creative process better.

Do you try to block it out entirely when you work?

I know I'm in a good creative place when I am not constantly checking social media to see who else is making work, but I am just being. At my worst I'm constantly searching and never finding, so I just waste time scrolling.

Is there a difference between a designer and an artist? How do you see yourself?

I feel like the distinction is fading more and more. For a long time, I had an issue with being labelled. "You're an artist, you're an illustrator, you're a designer." Even though you have to label yourself as such because otherwise the world doesn't understand you.

It all depends on what you're making. An artist is someone who creates work based on what they've analysed and internalised for themselves, and filters that input back out through their work. A designer is thought of as someone who creates work for another voice, like a client, a museum, or a brand. Now, thanks to the internet and social media, that definition is changing. There's so much mutual influence between the two. It's not really about the outcome or whether it's digital or sculptural; it's about the message and the intention of the project.

Human emotions are often the most challenging concepts to depict, is that an important topic for you?

We live a society rejecting the sensitivities of humanity. Because of challenges in our past or the traditional roles that we've been forced into, a lot of us have problems conveying our inner selves. Being able to channel that in my work and creating a platform to talk about this in a very open, objective way, has been really important for me. I really want my artwork to connect people to parts of themselves they have been hiding from.

It's important to create a female form
that expresses sexuality in an honest way.

A lot of your work features the female body and sexuality, why is that?

Especially in America, sex is such a confusing topic. It's such a natural part of human existence, but there's so much pressure, especially for women. I try to create work that I think is important for people to see. As a woman who understands the female experience, I think it's important to create a female form that expresses sexuality in an honest way.

Is bigger better in the world of Shawna X?

I used to think it was, but now it depends on the message. If I am trying to appeal to a mass audience and I can get my message across more efficiently with something bigger, then yes, that is better. At the same time, Instagram is a platform we all use and it's a little square on a screen that is so intuitive and inspirational for a lot of people. So, in that sense, sometimes bigger is not better.

Is humour important in your work?

I enjoy light-heartedness and I think that's who I am intrinsically. Humour is a really important part of my work, but I'm certainly not always funny.

How important is colour in your work?

I love colour, and that really speaks to my light-heartedness; my inner child is very much a colourful thing. Colour defines a lot of my work, especially saturated colour. I've tried to go for pastels or neutral tones in the past, but I realised it just wasn't me. I'm trying to challenge myself to do more monotone work in the future, just to see if I'm able to create a message that's just as powerful.

Who inspires you?

I'm still inspired by the comic artists that inspired me as a child. For instance: Lynda Barry, who draws stories about the pre-teen years and coming-of-age stories for girls. I read them when I was in seventh grade and felt so seen by her work. I'm also inspired by musicians and composers who create work that is intrinsically them, like Björk. She has always made her own shit, regardless of trend.

Who—dead or alive—would you like to have dinner with?

I prefer to keep my heroes far away because meeting them might change my perception of them.

How important are social media for you?

Social media enable you to connect with people everywhere. As long as they have a phone or a computer, they can access your work. In that sense, it's a very important tool for an artist, because a true artist shares their work.

What does failure mean to you?

I'm currently feeling a type of failure—or maybe it's more of a challenge—in deciding in which direction I want to take my work. Right now, I see two very strict paths in front of me in terms of aesthetic but also the place in which they exist, and I don't align with the paths that have been traditionally set for illustration. So, my challenge is to find the in-between. Failure will help me understand myself more. It is actually one of the best things you can ever experience.

The conversation on gender equality in the arts has ramped up lately. As a female artist, what is your take on this?

The world—including the art world—is still ruled by men. Art made by women is historically taken less seriously, and the epitome of the successful artist is the male painter, sculptor, designer. If a woman makes something, it is seen as gendered, and crafty, but when it's a man making the work, his gender is irrelevant. There are deep issues standing in the way of gender equality on many levels, and I don't know if equality will be achieved within our lifetime.

In the past, clients have hired me to fill certain quota or to give their brand more personality. I've also been hired because I am a woman of colour, either because the client believes in representation or because they want my presence to help their brand come off as inclusive. But it's never black and white; there are a lot of grey areas.

What advice can you give to a designer or artist who is just starting out?

Get your shit together, have some stability, whether that's monetary or otherwise, and then you can do whatever you want. Maybe that's a very traditional standpoint, but having that foundation and knowing your values is what allows you to go for it.

What would you say to your younger self?

It sounds so cliché, but that's why clichés exist. Understand, expand and follow your intuition. Making a decision based on intuition is a lot more challenging than you might think.

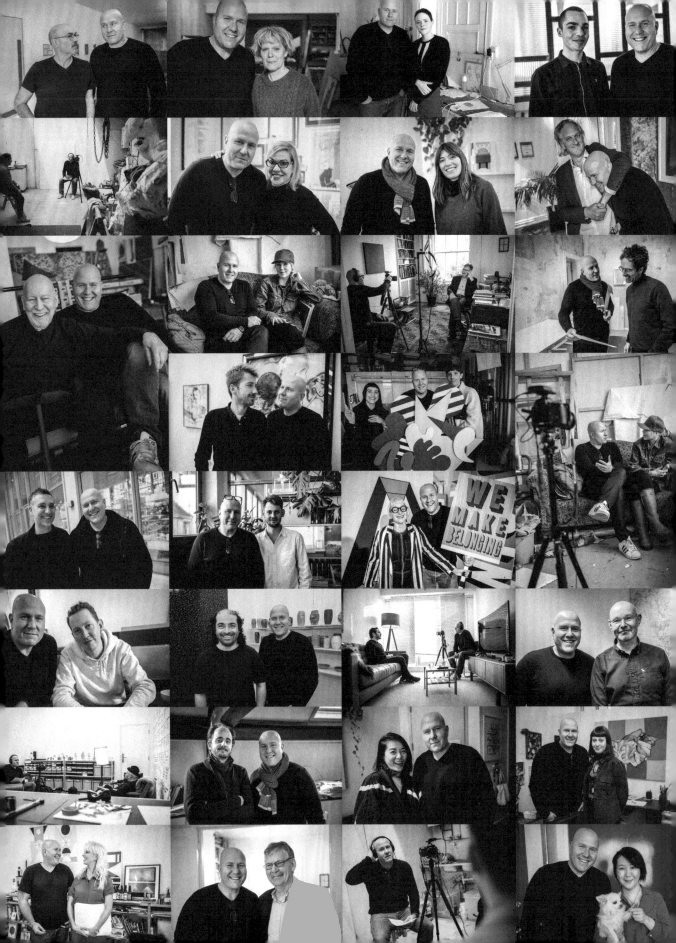

Sofie Van de Velde—my love

Otis, Stella, Henri & **Matisse, my kids**—for being creative individuals

Joost Joossen—for being my best friend and companion on this adventure

Marc Verhagen—my publisher, for his patience and trust in this project

Paul Boudens—for designing this book, it has become more than I had ever imagined

Stella Brouwers, Otis Brouwers, Eveline De Smet, Evelien Geysemans—for transcribing the talks

Louise Vanderputte—for all her work on editing the texts

Mieke Geenen—for grading the photos

Jef Brouwers & **Helga Somers**—for raising me

All the people at **Promax**—especially **Vanessa Sheldrick, Lester Mordue, Rajika Mittra** & **Steve Kazanjian**

US by Night & **Rizon Parein**—for bringing so much creativity together in mind-blowing conferences in Antwerp, Belgium

Isabelle Deschamps—for giving me a place to stay during my South African trip and **Mirabelle Wouters** for doing the same in Australia

SBS—for believing in my creativity for almost 20 years now

Ludo Luykx & **Lieven Van Overbeke**— my creative mentors

To all the artists and their galleries

To creativity in all its forms

NEL AERTS
nelaerts.com
plus-one.be
@nel_aerts

P11 *The Rise*, 2017-2020, Acrylic, paper and textile on wood, 61 × 45 cm
P12 *Double Delusion*, 2019, Acrylic and oil on wood 97 × 69.5 cm
P13 Clockwise from left top:
Achter klap, 2012-2018, Acrylic on wood 61 × 61 cm; *Der Schlangenbeschwörer*, 2019, Collage and felt-pen on paper in aluminium frame, 32 × 24.5 cm; *Narzissmus*, 2018, Acrylic on canvas, 140 × 190 cm; *IJskar Man*, 2012-2018, Acrylic, lacquer paint, wax and oil on wood, 30.5 × 30 cm
P14 *Nel Aerts – The Waddle Show*, 2019, Museum M, Leuven; *Delirium Portrait*, 2020, Acrylic, pastel, spray paint, coloured pencil, sequins, varnish on wood 71 × 57.5 cm
P15 *De Verzopen Verzuiper*, 2011-2018, Acrylic on wood, 46 × 40 cm
All works courtesy of Plus-One Gallery, Antwerp

ALAIN BILTEREYST
biltereyst.com
@albilt

P18 *Goings On*, Xippas Gallery, Paris, 2020 Photography: Frédéric Lanternier; *Untitled (888-3)*, 2020. Acrylic on plywood, 23 × 17 cm
P19 *Leaving the house*, Jack Hanley Gallery, New York, 2019. Photography: Brad Farwell; *Untitled (586-3)*, 2017. Acrylic on plywood, 23 × 17 cm
P21 *Leaving the house*, Jack Hanley Gallery, New York, 2019. Photography: Brad Farwell
P22 *Untitled (801-3)*, 2019. Acrylic on plywood, 23 × 17 cm
P23 *Elsewhere*, Loods 12, Wetteren (Belgium), 2016. Photography: Alexandra Colmenares Cossio

CONRAD BOTES
conradbotes.com
@conradbotess

P27 *Bitterkomix 18*, cover, 2020, Ink and acrylic on paper, 43 × 31,5 cm
P28 *The Goliath Protocol*, 2019, Acrylic on canvas, 2 × 3,5 m; *Equus*, 2017, Ink on C-print, 41 × 60 cm
P29 *Wit wolf*, 2011, Oil on wood, Height 70 cm; *Banker*, 2012, Oil on wood, Height 90 cm; *Lawyer*, 2012, Oil on wood, Height 90 cm
P30-31 *Sabbath*, 2020, Oil on canvas, 2 × 6,7 m *Cain and Abel* (two pages), 2009, Ink on paper, 31,5 × 43 cm

PAUL BOUDENS
paulboudens.com
@paulboudens

P34 *N°A Magazine*, 2001
P35 Solo exhibition *Trust Me I Know What I'm Doing (Graphic Design 1990-2010)*, The Wapping Project, London, poster; *Paul Boudens Works Volume I*, monograph, 2003; *Inge Grognard Ronald Stoops (Work) Paul Boudens (Ink on Canvas)*, exhibition poster, 2005
P36 *Walter Van Beirendonck, Mutilate*, book design, 1997; *Jurgi Persoons, Help! Persoons-Tours*, S/S 1997, showroom invitation, 1996
P37 Jurgi Persoons, *Double Bill* S/S 1999, double showroom invitation, 1998; Haider Ackermann A/W 2011-12, fashion show invitation, 2011; Haider Ackermann S/S 2020, fashion show invitation, 2019
P38 Y's Yohji Yamamoto & Y's for Men Yohji Yamamoto, A/W 2003-04, direct mail postcards; Yohji Yamamoto Femme, S/S 2004, direct mail postcards; *Yamamoto & Yohji*, (Rizzoli International Publications), book design, 2014; Yohji Yamamoto Femme & Homme, A/W 2003-04, direct mail postcards.

JENNY BROSINSKI
jennybrosinski.com
plus-one.be
@jenny_brosinski

P43 *A big thing or a small*, 2020, Oil, oil stick, spray paint on glued canvas (oak framed), 232.6 × 182.8 cm
P44 *A smile from a veil? (I)*, 2020, Oil, charcoal, dirt, duct tape on canvas (oak framed), 117.6 × 107.6 cm; *A smile from a veil? (II)*, 2020, Oil, spray paint on glued canvas (oak framed) 117.6 × 107.6 cm
P45 *A smile from a veil? (IV)*, 2020, Oil, spray paint, charcoal, oil stick, on glued canvas (oak framed), 117.6 × 107.6 cm; *Drawings*, photo Jenny Brosinski
P46 *nothing real*, 2020, Oil, spray paint, pencil, oil stick on canvas (oak framed), 217.9 × 217.9 cm; *Feed me, eat me*, 2020, Oil, oil stick, spray paint on canvas (oak framed), 217.9 × 217.9 cm
P47 *Fridges & freezers, heating & boil (vulture)*, 2020, Oil, spray paint and dirt on canvas (oak framed), 217.9 × 217.9 cm; *Victor Wooten (Duden)*, 2020, Oil, oil stick, fabric on canvas (oak framed), 217.9 × 217.9 cm
All works courtesy of Plus-One Gallery, Antwerp

TAD CARPENTER
carpentercollective.com
@tadcarpenter

P48 Photo by Bethany Hughes
P50 *SUNday Sun* N° 100, *SUNday Sun* N° 225
P51 *SUNday Sun* N° 200, *SUNday Sun* N° 194
P53 Children's book illustrations: *Trick or Treat – A Happy Haunters Halloween*; *Ninja, Ninja, Never Stop!*; *Sad Santa*; *Zoom Zoom! Sounds of the City*
P54 *Please wear a mask* poster, 2020
P55 Fanta ad

MATT CLARK
uva.co.uk
@matt_clark_uva

PP58-59 Massive Attack concert scenography in collaboration with Robert Del Naja. Photos by James Medcraft
P60 Message from the *Unseen World*. Photo by James Medcraft
P61 *440 Hz. Volume*. Photo by James Medcraft
P62 *Other Spaces Exhibition, The Great Animal Orchestra*. Photo by Jack Hems; *Other Spaces Exhibition, The Great Animal Orchestra*. Photo by Jack Hems; *Other Spaces Exhibition, Vanishing Point*. Photo by James Medcraft
Courtesy of United Visual Artists

JAMES DIVE
www.jamesdive.com.au
@jamesdive_

P66 *I wish you hadn't*
P67 *God's Eye View* (*Ark, Christ, Eden, Moses*)
P68 *Hot with Chance*
P69 *What A Tasty-looking Burger*
P71 *GayTM, It Wasn't Meant To End Like This*

SUE DOEKSEN
suedoeksen.nl
@sue_doeksen

P74 SCAPE 01
P75 SCAPE 02
PP76-77 *Miniature Moments: At the beach, In the meadow, In the hut*, designed by Sue Doeksen & Jeroen van Leur; Pins; Horizon mobile restored
P78 *Timid twins* sue big
P79 *Pictoplasma* carpet

BENDT EYCKERMANS
sofievandevelde.be
@bendteyckermans

P83 *Het gesprek (The conversation)*, 2019, Oil and ink on linen, 180 × 160 × 2.5 cm
P84 *Le Belge Afrique*, 2019, Oil on linen, 50 × 40 × 2.5 cm
P86 *De vergissing (The mistake)*, 2019, Oil on linen, 50 × 40 × 2.5 cm
P87 *Nachtlicht (Night light)*, 2019, Oil on linen, 50 × 40 × 2.5 cm
All images courtesy Galerie Sofie Van de Velde, Antwerp

EMILY FORGOT
emilyforgot.co.uk
museandmaker.com
@emilyforgot

P90 *Art of ping pong*, 2017, Paint on plywood; *The Arch* from the *Villa* series, 2017, Paint on plywood
P91 *Sense of place* exhibition series, Vancouver, 2019, Paint on plywood; *Souvenir* series, 2020, Paint on plywood
P92 *Trappenhuis Rug*, 2019, Hand knotted wool
P93 *Strebelle Rug*, 2019, Hand knotted wool
P94 *Head in the clouds, feet on the ground*, Chair from the *Neverland* exhibition, 2016; *Neverland Assemblages*, 2016, Paint on plywood
P95 *Colour construction*, 2018, Paint on plywood

PAUL FUENTES
paulfuentesdesign.com
@paulfuentes_design

P98 *Banana Heel*, 2018; *Mondrian*, 2018
P99 *Flower Tongue*, 2016
P100 *Pig Pool Party*, 2020
P101 *Unicorn Lama*, 2016; *Weekend*, 2017;
Paint Egg, 2015
P102 *Skate Flamingo*, 2016; *Pink Lion*, 2016
P103 *Giraffe Palm Springs*, 2018

RYAN GANDER
lissongallery.com
@ryanjgander

P105 *A Moving Object, or Economy of distress*,
2017. Photography by Youngjun Choi.
P107 *Associative Template #1 (Your partner's
funding application)*, Debit and Credit by
Dan Fox, first published in *Frieze*, Issue 119,
Nov-Dec 2008, 2009.
Photography by Ken Adlard.
P108 *Two hundred and sixty five degrees below
every kind of zero*, 2015.
Photography by Jack Hems.
P109 *Porthole to Culturefield Revisited*, 2010.
Photography by Ken Adlard.
P110 *Upside down Breuer chair after a couple
of inches of snowfall*, 2017
Photography by Roman März.
P111 *Self Development Portrait – The Artist made
up as a zombie by Adrian Rigby*, Solid House,
Suffolk, 23 June 2016, 2017.
Photography by Youngjun Choi.
All images courtesy of the artist © Ryan Gander

HARRY GRUYAERT
harrygruyaert-film.com
magnumphotos.com/photographer/
harry-gruyaert
www.gallery51.com

P115 *Rue Royale, Brussels*, 1981
P116 *Russia, Moscow*, 1989;
Thermes, Ostend, 1988
P117 *USA, Las Vegas*, 1982;
Belgium, Brussels. Place Flagey, 1981
P118 *Trans-Europ Express, Belgium*, 1981
P119 *Carnival, Antwerp*, 1992
All photographs © Harry Gruyaert,
Courtesy of Gallery Fifty One.

TONY GUM
tonygumstudio.tumblr.com
@tony_gum

P122 *Intombi I* from the *Ode to She* series, 2017
P123 *Umfazi* from the *Ode to She* series, 2017
P124 *Pin-Up Lady* from the *Black Coca-Cola*
series, 2015
P126 *AbaThembu* from the *Rock Cause Analysis*
series, 2018
P127 *(reworked) Free Da Gum*, 2016

STEPHANIE HIER
stephanietemmahier.com
@stephanie.temma.hier

PP130-131 *Walnuts And Pears You Plant For
Your Heirs*, Installation view.
Courtesy the Artist and David Dale Gallery
P132 (Top left) *Wonderful for other people*,
2020, Oil on linen with glazed stoneware
sculpture, 20 × 17 × 2.5 inches; (Top right)
Heart and stomach of a king, 2020, Oil on linen
with glazed stoneware sculpture 23 × 20 × 3.5
inches; (Bottom left) *Spring now comes
unheralded*, 2020, Oil on linen with glazed
stoneware sculpture 20 × 16 × 3 inches;
(Bottom right) *Green grass finely shorn*, 2020,
Oil on linen with glazed stoneware sculpture,
30 × 26 × 6 inches
All images Courtesy the Artist and Franz Kaka
Gallery
P135 *Gridded and Girdled*, Installation view
Courtesy the Artist and Y2K Group NYC

MAIRA KALMAN
mairakalman.com
@mairakalman

P136 Maira Kalman, self-portrait
PP138-139 *The Principles of Uncertainty*, 2007
(Penguin Books)
PP140-141 *My Favorite Things*, 2014
(HarperCollins Publishers Inc)
P143 *The Principles of Uncertainty*, 2007
(Penguin Books)

ERIK KESSELS
erikkessels.com
kesselskramer.com
@erik.kessels

P146 *Failed It!*, Phaidon
P147 *The Standard Hotel*, Erik Kessels,
KesselsKramer
P148 *In almost every picture*, Erik Kessels,
KesselsKramerPublishing; *I Amsterdam*,
Erik Kessels, KesselsKramer
P149 *Citizen M*, KesselsKramer London
P150 *Hans Brinker Budget Hotel*, Erik Kessels,
KesselsKramer
P151 *Jump Trump*, Erik Kessels, Photo Pleasure
Palace Unseen Amsterdam

EIKE KÖNIG
eikekonig.com
hort.org.uk
@eikekoenig

P153 *A.L.I.A.T.I.*, 2020, modeling paste and
enamel on canvas, 160 × 120 cm
P155 *Who Do You Think You Are*, 2018, screen
print on mirror, alu framed, 210 × 200 cm.
Installation view from the solo exhibition *The
Aesthetics of Boredom* at Künstlerhaus Bonn,
Germany, 2018; Installation view from the
solo show *Context is Everything* at The Space,
Lucerne, Switzerland, 2018
P156 *I Like Your Style/Problems*, 2017,
3 colours animated neon, 130 × 200 cm.
Installation view from the solo show *I Like Your
Problems* at Âme Nue, Hamburg Germany;
Truth, 2021, modeling paste and enamel on
canvas, 160 × 120 cm
P157 *JETSET JETLAG*, 2018, 2 colours animated,
130 × 200 cm. Installation view from the solo
exhibition *The Aesthetics of Boredom* at
Künstlerhaus Bonn, Germany, 2018
P158 *I / YOU / EXPECT YOU / ME / TO
RESPECT / ME / YOU*, 2017, graphite and
linoprint on paper, 72 × 102 cm
P159 *The Absence of Noise*, 2021, modeling
paste and enamel on canvas, 160 × 120 cm;
Silence, 2021, modeling paste and enamel
on canvas, 160 × 120 cm; *The Future*, 2020,
2 colours neon, 120 × 160 cm; *Trust*, 2020
2 colours neon, 120 × 160 cm

GEORGE LOIS
georgelois.com

P162 *Esquire* cover, April 1968
P163 Mohammed Ali as St Sebastian,
original drawing 1968
P165 *Esquire* cover, May 1969;
Maypo advertisement in *Damn Good Advice*
PP166-167 Coty advertisement

ANNA MAC
annamac.com
@_anna_mac_

P170 *Colour study 07*, 2019, acrylic on plywood,
11" × 14"
P171 *Colour study 04*, 2019, acrylic on plywood,
20" × 24"
P172 *Stillness by the pool*, 2019, acrylic on
plywood, 20" × 24"; *Colour Snap* exhibition,
UH ARTS, Photo © Rob Harris
P174 *Shadows in the alley*, 2020, acrylic on
canvas, 20" × 24"
P175 *Self reflection*, 2020, acrylic on canvas,
33" × 39"; *Green chair*, 2020, acrylic on canvas,
24" × 30"; *House with two chimneys*, 2020,
acrylic on linen, 24" × 30"; *Mellow*, 2020, acrylic
on linen, 24" × 30"

DEBBIE MILLMAN
debbiemillman.com
@debbiemillman

P178 *Today*; *Design Matters* logo
P179 *Stress*; *Insects*; *I love you*
P180 *Print RDA*, 2017; *Print RDA Cover*, 2013
P181 *Print Regional Design Annual*, 2013
P182 *New York City*
P183 *David Foster Wallace quote*;
It took a long time

JONATHAN MONK
lissongallery.com
@monkpictures

P186 *Waiting For Famous People (Andy Warhol, Diego Maradona, Fidel Castro, Godot)*, 1995-1997, colour photograph, 50 × 70 cm.
Courtesy the artist and Galleri Nicolai Wallner, Copenhagen
P187 *Holiday Painting (Ibiza #548)*, 2019; *Installation View Exhibit Model Four*, Kindl Berlin, 2019. Photo © Jens Ziehe
P188 *Jack of all trades...*, 2017 Ed. 1/3, coloured neon lettering, 100 × 175 × 6 cm.
Courtesy the artist and Meyer Riegger Karlsruhe/Berlin
P189 Installation view *Family of Man*, Centre d'art Contemporain Domaine de Kerguéhennec, Bignan, France, 2005; *This painting should ideally be illuminated by a Dan Flavin*, 2004 and *This painting should ideally be hung near a Sol LeWitt*, 2004. Acrylic on canvas, 149.5 × 114 cm.
Courtesy the artist and Galleri Nicolai Wallner, Copenhagen
P190 *Deflated Sculpture I*, 2009. Stainless steel 104.1 × 68.6 × 45.7cm; *Deflated Sculpture II*, 2009. Stainless steel, 71.1 × 73.7 × 39.4 cm.
Deflated Sculpture III, 2009. Stainless steel, 43.2 × 90.2 × 47 cm.
Courtesy the Artist and Casey Kaplan, New York
Various Restaurant Drawings; *Meeting #63*, 2003, *The Lion Enclosure London Zoo Regent's Park London 12th May 2014 lunch time*.
Courtesy the Artist and Lisson Gallery

MR BINGO
mr.bingo
@mr_bingstagram

P194 *Does Mr Bingo work for free?*
P195 Advent Calendar 2019 (mint); Advent Calendar 2018 (pink)
P196 *Mystery Drawing*; *Anxiety Circle*; *Dirty Queen*; *Hate Mail*
P197 *Don't forget to have fun*, Handmade concrete gravestone
P198 *Hate Mail*; *Mugging*
P199 *Trump* cushion

MORAG MYERSCOUGH
moragmyerscough.com
@moragmyerscough

P200 Morag Myerscough photographed by Gareth Gardner
P202 *Movement Café*, Greenwich, London, Photo Gareth Gardner
P203 *Temple of Agape*, Southbank, London, Photo Gareth Gardner
P204 *Eye See*, The Other Art Fair 2018, Spring Edition, London
P205 *Sheffield Children's Hospital Bedrooms*, Photos by Jill Tate
P207 Top: *Belonging bandstand*, Brighton, Photo Morag Myerscough;
Bottom: *POWER*, Battersea Powerstation, London, Photo Gareth Gardner

NAVID NUUR
navidnuur.net

P211 *Thresholder (As Pillar II)*, 2007-2010, floral foam blocks, hardener 100 × 30 × 218 cm. Image by Cathleen Schuster and Marcel Dickhage. In the collection of Vehbi Koç Foundation, Istanbul; *Tentacle Thought nr 3 (Try)*, 2006-2008, custom lightbox, wire, neon tubes, size variable. Image by Navid Nuur.
PP212-213 *Untitled*, 2007-2021, 250 × 380 mm, Offset Uncoated White 150 gms, Pantone Reflex Blue (100% cyan, 95% magenta).
P214 *The Tuners*, 2005-2015, prepared linen canvas, mixed media, 182 × 138 × 5,5 cm; Installation view, *When Doubt Turns Into Destiny*, Max Hetzler Paris, 2019.
Photo © Charles Duprat
P215 *Mindmap*, 2013, glass, neon, 140 × 162 × 6 cm. Image © Jack Hems. In the collection of Bonnefanten Museum Maastricht; *Untitled*, 2014, argon gas, light bulbs variable dimensions. Photo © Antoine Espinasseau
P217 *Untitled (I am just an idea between the tape and the wall)*, 2008-2013, tape, marker, size variable (image by Navid Nuur); *Untitled (What ever)*, 2006-2013, canvas, home brewed ink, water, time, gravity, 300 × 220 cm. Image © Peter Cox; *Untitled*, 2013, scraped mirrors, 180 × 114 × 40 cm. Image © Stephen White

GEMMA O'BRIEN
gemmaobrien.com
@mrseaves101

P220 *Dream Baby Dream*, Sydney, 2019; *The Future Belongs to the Curious*, San Diego, 2017
P221 *Flora*, Boras, 2017
P222 *Blaze Your Trail*, San Francisco, 2019; *Fate/Will*, Sydney, 2018
P223 *Women Supporting Women*, Nuremberg, 2018
PP224-225 *Spew Bag Challenge* artworks, 2012-2015; *Thank You Essential Workers*, Times Square, 2020, Photo by Ian Douglas

MAX PINCKERS
maxpinckers.be
@maxpinckers

P229 From the series *Margin of Excess*, 2019
PP230-231 From the series *Red Ink*, 2018
PP232–233 From the series *Will They Sing Like Raindrops or Leave Me Thirsty*, 2014

PIXIE PRAVDA
@pixiepravda
@textbased_visual_artists

P236 *The Concept*
P237 *Missing*; *Stop making sense*; *Here & There*; *Without you*
P238 *People who liked this work of art also liked...*; *A/PART*; *Carpet Diem*
P239 *Turn around*; *Too soon*; *The weight of my words*
P240 *Would you like to own a piece of postmodern, conceptual art?*
P241 *Ego*

KAY ROSEN
kayrosen.com
@kayrosenstudio

P242 Portrait © Kay Rosen
P244 *Taking Charge*, 2005, 15" × 22-1/4", coloured pencil on paper; *Skeleton Key*, 2007-2008, 13" × 22-1/2", enamel paint on canvas; *IOU*, 2017, letterpress print, 25" × 44".
© Kay Rosen, All images courtesy of the Artist.
P245 *This Means War...*, 2016, billboard, Cincinnati, Ohio as part of *I-71*, a billboard exhibition © 2015 Kay Rosen, Courtesy of the Artist
PP246-247 *AIDS, Ongoing, Going On*, December 1, 2015, Projection for Visual AIDS on Metropolitan Museum of Art, New York, New York © 2015 Kay Rosen, Courtesy of the Artist
P248 *Triumph Over Trump (Blue Over Yellow)*, 2017, 22-1/2 × 30-1/2", acrylic gouache on rough watercolour paper © 2017 Kay Rosen, Courtesy of the Artist
P249 *Blurred*, 2015, acrylic on wall, Art Gallery of New South Wales, Sydney, Australia © 2003 Kay Rosen, Courtesy of the Artist; *Removal From Office*, 2008, acrylic paint on wall, Yvon Lambert Gallery, New York © 2008 Kay Rosen, Courtesy of the Artist

STEFAN SAGMEISTER
sagmeister.com
@stefansagmeister

P250 Portrait © Stefan Sagmeister
P252 *Everybody Always Thinks They Are Right*, 2006
P253 *Drugs Are Fun In The Beginning But Become A Drag later On*, 2006
P254 *Beauty Show*, 2019; *The Happy Show*, 2012
P255 *Things I have learned in my life so far*, 2008
P256 *Take It On*, SVA NYC, 2013
P257 *The Happy Film*, 2016; *Things I have learned in my life so far*, 2008

PAULA SCHER
pentagram.com
@pentagramdesign

P258 Portrait by Jake Chessum
P259 Original sketch for the Citi logo
P260 Logo for Citi, 2000
P261 *The Diva is Dismissed* poster for The Public Theater, 1994; *Bring in 'Da Noise, Bring in 'Da Funk* campaign for The Public Theater, 1995-1998
PP262-263 Center: *The United States* map painting, acrylic on canvas, 2009; Left: *Paris*, acrylic on canvas, 2007; Right: *Tokyo*, acrylic on canvas, 2008
P265 Environmental graphics for the Lucent Technologies Center for Arts Education, a school affiliated with NJPAC, 2001; Shake Shack identity on the original kiosk in Madison Square Park, 2004; Logo for The High Line, 2001

C O L O P H O N

CONCEPT & INTERVIEWS
Steve Brouwers

PORTRAIT & STUDIO PHOTOGRAPHY (EXCEPT WHERE NOTED)
Joost Joossen

GRAPHIC DESIGN
Paul Boudens

EDITING
Louise Vanderputte

PRINTED IN ITALY BY PRINTER TRENTO

Steve Brouwers is a Creative Director at Belgian broadcaster SBS and a member of Creative Belgium. He has been working in television for over 25 years, reads three newspapers every weekend, receives about a hundred emails a day, and has more friends on Facebook and Instagram than he could ever take out for coffee. He lives with his blended family of six, whom he loves dearly.

Steve is also the author of the book *Almost Everything You Need to Know About Blended Families*. He is an inspirational speaker whose talks are well attended all over the world. As a creative, he suffers from imposter syndrome, as well as being a procrastinator and a deadline junkie. When asked to jump, he doesn't ask "Why?", but "How high?"

ISBN 9789460582837
NUR 640, 765
D/2021/12.005/4

© 2021, Luster Publishing, Antwerp
& Steve Brouwers

lusterweb.com
@creativesoncreativity